Alive Still

ALIVE STILL

Nell Blaine, American Painter

CATHY CURTIS

OXFORD
UNIVERSITY PRESS

OXFORD
UNIVERSITY PRESS

Oxford University Press is a department of the University of Oxford.
It furthers the University's objective of excellence in research, scholarship,
and education by publishing worldwide. Oxford is a registered trade mark of
Oxford University Press in the UK and certain other countries.

Published in the United States of America by Oxford University Press
198 Madison Avenue, New York, NY 10016, United States of America.

Library of Congress Cataloging-in-Publication Data

Names: Curtis, Cathy (Writer on art), author.
Title: Alive still: Nell Blaine, American painter/Cathy Curtis.
Description: New York: Oxford University Press, 2019. | Includes
bibliographical references and index.
Identifiers: LCCN 2018031464 (print) | LCCN 2018036828 (ebook) |
ISBN 9780190908829 (updf) | ISBN 9780190908836 (epub) | ISBN 9780190908843 (oso) |
ISBN 9780190908812 (cloth: alk. paper)
Subjects: LCSH: Blaine, Nell, 1922–1996. | Painters—United States—Biography. |
Women painters—United States—Biography.
Classification: LCC ND237.B597 (ebook) | LCC ND237.B597 C87 2019 (print) |
DDC 759.13 [B]—dc23
LC record available at https://lccn.loc.gov/2018031464

9 8 7 6 5 4 3 2 1

Printed by Sheridan Books, Inc.
United States of America

To T. R. M.,
who has enriched my life immeasurably.

Contents

Alive Still

Prologue

IT IS 1959. A thirty-seven-year-old painter from Virginia has become increasingly well known in the New York art world. Reviewers praise her work, represented by a leading gallery; the Whitney Museum of American Art purchased one of her recent paintings. Beloved by her friends—painters and poets, mostly—she has flung herself into romantic entanglements with both men and women.

Now she has finally saved up enough money from graphic design jobs to travel to the island of Mykonos in Greece. Why Greece? Because an artist friend has told her about the incredible quality of the light and the low cost of living . . . and because she is always up for adventure. She is amazingly energetic, freelancing by day, painting by night, and playing the drums at her famous loft parties. Even the way she paints—running up to the canvas to attack it with her brush—attests to her exuberance and vigor.

Although it takes a while to get comfortably settled on Mykonos—her first studio is chilly and lonely—she soon meets interesting people. An American working at a hotel bar lets her stay in his spacious clifftop house and doesn't mind her insistence that she be left alone all day to focus on her work. She paints the dazzling ocean view from the windows of her room and sketches the local architecture.

Months go by, and an artist friend in New York writes to complain jokingly that she never mentions even the tiniest negative thing about her impossibly wonderful life. In fact, something *is* troubling her: she has begun to feel strangely weak, too tired to paint. One day, she can no longer walk. A local doctor diagnoses flu. But Nell doesn't seem to be recovering. A worried friend locates a German doctor, a fellow tourist, who finds that she has been stricken with polio. She will later learn that she had the worst form of the disease, and doctors did not know if she would live.

This is the biography of a leading artist who suddenly became a paraplegic. She would never walk again, never be able to run up to a canvas. Her right

arm was significantly weakened. But she retrained herself to use her left hand for oil paintings, her right hand for watercolors. She willed herself to turn the limitations caused by her disability into a positive force, producing landscapes and still lifes that became infinitely freer and more exuberant than her earlier work. Although she would exhaust herself to paint them, they reflect her continuing delight in the visual world—and in being alive to see it. She would have many more exhibitions at top New York galleries, and her work would receive glowing reviews and be purchased by discerning collectors. She would travel to far-off places—the Caribbean island of St. Lucia, Paris, the English countryside, and a mountaintop house in Austria—which provided enticing subjects for her art. And she would continue to share her intimate life with women: at first a young English nurse, and then an accomplished painter who remained at her side for her last twenty-nine years.

Strong-willed, bossy, ferociously competitive, and single-minded about her work, she was also loyal, tenderhearted, and a lot of fun. She led a life of passion and rage and joy—a life that has never been fully revealed, until now.

A note about the art reproductions: This book was written before reproductions were sourced. Book production costs and the unavailability of certain images made it impossible to include photos of all the works mentioned in the text. In some cases, a reproduction of a similar painting has been substituted. Sadly, Nell's early painting *Lester Leaps* is available only as a black-and-white image. The good news is that color photos of several paintings not discussed in the text are included to help illuminate the breadth and development of Nell's work.

1

Richmond

WHEN NELL BLAINE WAS A TODDLER, she lived in a world of blurry colors. Her earliest memories were of the huge dahlias that flourished in the Blaine family garden in Richmond, Virginia, and the rows of arching elm trees that turned the suburban street into a green tunnel.[1] Severely nearsighted, she also had astigmatism and strabismus (crossed eyes), which gave her double vision.[2] At age two, when her mother tied a pair of glasses on her head with a ribbon, she was dazzled by the vivid reality of objects, touching them and calling out their names—"water! tree! flower! house!" It was a moment to rival Helen Keller's discovery that water had a name. But the operation Nell underwent at age five—followed by a long period when her eyes were bandaged, casting her into darkness—failed to cure her double vision.[3] Throughout her childhood, she held her head at an angle, in an effort to banish the extra image. Her lopsided pupils and strange posture made her a target of taunting children. "I was beaten up for it…by the boys," she recalled, "but I kicked back and stood my ground." (They nicknamed her "Tiger.") Resentment of male privilege would linger years afterward. "I have often felt the sting of this superior attitude of the male," she wrote, "even among my closest male friends."[4] Yet Nell's attempts to befriend girls were not necessarily reciprocated; one of them, a next-door neighbor a few years older, "would sock me or snub me." Other attempts at friendship were scotched by her mother, who would find fault with other children, "due to her possessiveness or narrowness."[5]

As a child, Nell was often ill with diseases that included severe anemia—treated with sunlamp exposure, a standard therapy at the time—double pneumonia, and scarlet fever. She stayed home from school one year to recuperate, tutored by her mother, a former schoolteacher who also read nature and adventure books to her. Inspired by the resourcefulness of the characters in *The Swiss Family Robinson*, she tried to build a clubhouse from old boxes, apparently hoping that other children would want to join her. During the months she was cooped up indoors, Nell drew pictures based on images in magazines and books. Drawing was her "private pleasure," she said later, "a way of making

myself feel like someone." At school, one of her teachers had the class draw still lifes, an exercise she found "thrilling." By then, she had already decided on a career as an artist. Her nightly prayer included a plea: "God, please make me the *greatest*."

Nell's fiercely competitive spirit had its roots in these years, when she enjoyed having a skill that other children envied: sketching convincing likenesses of her schoolmates for which she charged twenty-five or fifty cents. Years later, she said that the heads she drew looked like "a naïve idea of a Renaissance medallion…an innocent kind of academic art." Her more fanciful drawings were meticulously detailed in quill pen, obsessively filled with hundreds of tiny dots—a precursor of the rhythmic, large-scale stippling in her mature work. Some of her drawings and poems were published on the Children's Club page of the *Richmond Times-Dispatch*. Nell's "farewell" contribution at age sixteen was a silhouetted image of an equestrian soldier playing a bugle. It was accompanied by a flowery verse about her gloomy thoughts "when evening's blushing sun doth drop into the sea"—a conflation of the day's end with her retirement from Children's Club—and her confidence that a time would come when "childhood memories up the path will urge me."

She grew up in a society that viewed art as a "genteel thing, prissy, and somewhat bland," which she found extremely irksome."[6] Making art was strictly the province of women, the female cousins who painted banal images of deer in the woods, sailboats on the river. Gentility was the basis of the code of behavior expected of middle-class girls growing up in the American South. They were supposed to be demure and soft-spoken at all times, and not engage in rowdy play or even energetic physical activity. A young lady was never permitted to attract public attention by what she did or said, or how she said it. Self–control was one of the greatest virtues a girl could possess. Rebelling against these strictures, Nell sometimes acted out, climbing on rooftops and bullying and chasing other children. At age five, already in thrall to lively music, she ran off to march along with a band passing through town. Decades later, on a trip back home, when the fury she had felt toward her family had dissipated ("my mother seems like a sweet little witch now"), Nell wrote to her painter friend Jane Freilicher that she had "forgotten how many manners one observes here. The little twists on what one does & doesn't do and why are so complex and numerous."[7]

Nell Walden Blaine was born on July 10, 1922.[8] She was the only child of Eudora Garrison Blaine and Harry Wellington Blaine, a middle-aged lumber inspector at the Miller Manufacturing Company who had supervised the

building of the family home. Harry came from a family of farmers. He passed on his love of the outdoors to his daughter, bringing her with him on lumber-buying trips to forests that would inspire her lifelong fascination with trees. As he tended his garden and meticulously sorted and stored his dahlia bulbs, Harry instilled a love of flowers in his daughter, who would inherit his drive to categorize and organize. He also was prone to frightening outbursts of temper. "A couple of times he nearly killed me by accident," Nell told an interviewer, without explaining further. "On the other hand, he could be very gentle."[9] Harry had remained deeply troubled by the death of his beloved first wife in childbirth, and his erratic behavior may have been exacerbated by frequent salary cuts and ill health during the Depression. A heart condition and asthma eventually made him an invalid; the months he spent lying under an oxygen tent prefigured Nell's iron lung treatment decades later. The summer she turned sixteen, she was sent to visit relatives; when she returned, she discovered that he had died.

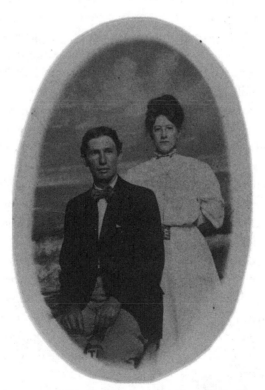

Harry Wellington Blaine with his first wife, Margelia R. Alvis Blaine.
Courtesy of Carolyn Harris.

Eudora—known as Dora—was the youngest child in a large and prosperous Richmond family. Her father, Edward Christopher Garrison Jr., had been a machinist in an ironworks, high constable (a position similar to sheriff) of Richmond, and a pillar of the Leigh Street Baptist Church. During her youth, he worked in real estate, an occupation that supplied the Garrisons with summerhouses. One was a 125-acre farm where Dora enjoyed watching lizards and snakes "from a safe distance." As a teenager, she traveled to New York with relatives; years later she recalled visiting the Metropolitan Museum of Art and acting "stuck up" about the big-city trip when she returned home.[10] She was part of a close-knit group of boys and girls who amused themselves by making candy, taking walks, and singing songs around the piano while she played.

This idyllic life came to an end during the years Dora trained to be a teacher. Her mother, Eudora Catherine, developed tuberculosis;[11] a servant had to be hired to care for her—Dora had to rush home from school to give this woman time off—and eventually the family boarded with her married sister Nelly Susan Spence (for whom Nell was named). In March 1917, at age twenty-nine, Dora quit her forty-dollar-a-month teaching position at the Fairmount School in preparation for her wedding. She went back to work briefly during World War I, when there was a teacher shortage, and resigned permanently when she became pregnant with her first child. This was normal behavior for middle-class women in the workforce; some school districts did not even permit teachers to be married. After the stillbirth of her son, she became active in the Barton Baptist Church as a deaconess and Sunday school teacher in an effort to recover from her grief and fill the empty hours. Perhaps it is no wonder she lavished so much attention on Nell, whose birth two years later finally allowed her to assume the maternal role she longed for.

According to Nell, her mother was the dominant parent, accepting her father's paycheck at the end of the week and doling out a meager dollar to him in return. ("He said she managed [money] better than he did."[12]) After Harry's death in 1938, she worked at the Miller & Rhoads department store as a saleslady, demonstrating Wiss scissors and O-Cedar brushes and wax. But during Nell's childhood, Dora threw her energies into doting on her, in ways that felt smothering to Nell. Once, when her daughter failed to receive the first prize in a grammar school drawing contest, Dora marched into the classroom and—to Nell's embarrassment—lambasted her teacher for her error in judgment.

Dora's father lived with the Blaines after his wife died in 1920—around the time Dora lost her baby—until his death at age ninety-three.[13] Nell had fond memories of this "remarkable man, much loved for his vigor, his warmth,

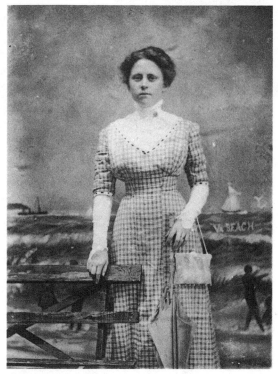

Eudora Catherine Garrison, before her marriage to Harry Blaine.

Courtesy of Carolyn Harris.

his sweet spirit."[14] As a fifteen-year-old, he had watched the battle of the *Monitor* and *Merrimac* in March 1862. The following year, he enlisted in the Confederate Army. Yet after the Union forces captured Richmond, when he saw President Lincoln walking down Main Street in a beaver hat and a long-tailed coat, he revered him as "a great man."[15]

Nell was a shy, unhappy loner, a skinny, freckled girl ill at ease in the ruffled organdy dresses her mother made her wear and the permed ringlets that covered her ears. She was prone to venting her rage at her parents' strictures by fighting with other children and refusing to eat. Her insistence on staying home from church on Sundays (claiming that she preferred to read the newspaper) was one of several tinder points. Another was the color bar in the segregated South. She would recall playing in the dirt with an African American child until shocked white adults snatched her away.[16] Apart from her cherished solitary pursuits—drawing, writing poems and stories, and working in

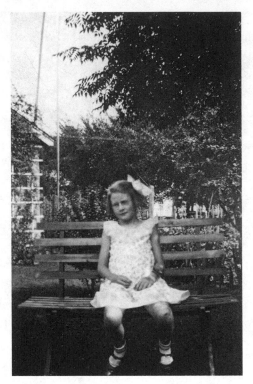

Nell Blaine, age eight.
Courtesy of Carolyn Harris.

the garden—the few bright spots in her young life occurred during summers at the country homes of relatives.

Visits with her parents and grandfather to the colonial port town of Urbanna—the summer home of her aunt and uncle Nelly Susan and John Moreland Spence[17]—were filled with the kind of adventures Nell loved. She fished in the early mornings on a beach littered with seaweed, fiddler crabs, and stinging nettles that burned her legs and chest. At age five, Nell wandered into the swift-flowing Rappahannock River, saved by her quick-witted cousin Charlotte Spence, who jumped into the water fully clothed.[18] Once, while playing near a woodpile, she suddenly felt a stab of pain inside her clothing. Instructed not to disturb the grown-ups, she kept quiet—the stoic side of her rebellious nature—and only later did they discover her black widow spider bite. As a teenager irritated by the conventional views of her relatives, she admired John Spence, a doctor at Johns Hopkins Hospital. He was "tall, handsome, cleancut, charming, polished and always friendly, always polite and patient…an extremely disciplined person of fine controlled character."[19]

These were the virtues she had been trained to admire, and she never lost her appreciation of them. Spence had refined tastes in art and literature, but she was unhappy when he patronizingly informed her that an adolescent girl should avoid the classics and stick with Enid Bagnold, author of *National Velvet*.

At another cousin's home, situated on a wooded hill above Carter's Creek in Irvington, Virginia, Nell spent long hours rowing, enjoying the way the river wound gracefully under the trees. Sometimes she used just one oar, pretending to be a gondolier in Venice. Other happy summers were spent at her grandfather's cabin on Mobjack Bay, which offered the novel opportunity to watch snakes crawl under the widely spaced floorboards. Decades later, she would recall riding to the cabin in a Model T, "holding the ice on the running board with ropes" while her aunt Nelly played word games.[20] In the backwoods, where tall pines grew, people sold "melons and other incredibly beautiful fruits in abundance…on wooden-slat and white sand roads.…It was a way of life as well as beautiful country, a magic place in my memory."[21]

When Nell was fourteen and fifteen, she had a series of operations on her eyes at Johns Hopkins that finally restored her vision.[22] During the weeks her eyes were swathed in bandages, she was haunted by phantasmagoric mental images of faces and rooms—a dream state that would recur decades later when she was in the grip of polio. Because normal eyesight was only gradually restored to her, she would be particularly aware of the role of vision in her painting practice. "As I paint I see more," she once wrote. "[Nothing] comes all at once—or I should say very rarely."[23]

No longer an outcast, Nell tried to fit into the demure southern-girl mold to attract the thirty-year-old son of one of her cousins. But despite "keeping my knees together and following him everywhere," her efforts to elicit "any little sweet word" were in vain.[24] More productively, she poured her pent-up energy into a mind-boggling array of John Marshall High School clubs. She served as assistant to the editorial and business staffs of the school newspaper, the *Monocle*, and joined the Art and Posters Committee of the Student Association, the Van Vort Debating society, Quill and Scroll (the journalism honor society), and the Spanish and drama clubs. Somehow, she also found time to be art editor of the *Record*, the school magazine, and *El Águila* (the Eagle), the Spanish-language school newspaper.[25] These positions required her to solicit ads and deal with the printer—experiences that would come in handy decades later when she worked at *The Village Voice*. She also put her art skills to work creating the set for a drama club production on a tiny stage, the

precursor of sets she would design on shoestring budgets for friends presenting avant-garde theater and modern dance in New York.

Nell claimed to have had only one close friend in high school, a "bright, freckled short gal with red hair."[26] A few years after graduation, when she returned to Richmond from New York to visit her mother, her friend—accustomed to playing a dominant role in their relationship—coldly informed her that she had no interest in hearing about Nell's cultural discoveries. Her 1939 yearbook photo shows an attractive young woman with a close-lipped but amused expression. At sixteen-going-on-seventeen, she looks more self-possessed than her fellow classmates. The dark striped vest worn over her frilled blouse suggests an early attempt to assert her own sense of who she was and how she wanted to look.

Many childhood loners find their niche in college, but Nell would claim that she was not one of them. Socially awkward, she did not fit into the coed mold. At that time, the schools associated with the Richmond Professional Institute of the College of William and Mary were run as independent units, housed in a miscellaneous assortment of buildings, including a former private home. Nell signed up for both fine and commercial art—not understanding the distinction between them—as well as journalism. Half of her tuition was paid by a working scholarship, which involved dusting easels in the mornings and answering dorm telephones at night.

Regionalist painter Marion Montague Junkin—who later recognized the talent of a young Cy Twombly but apparently failed to perceive Nell's promise—taught art history and anatomy.[27] Nell's drawing and painting instructor was Theresa Pollak, whose artistic heroes were the French painter Georges Rouault and the American social realists.[28] She attempted without much success to get her pupil to abandon the detailed, illustrational style she was so proud of in favor of "art that had more depth and less facility."[29] Decades later, Nell mused that she was "too shy & young" to get to know her teacher, but that she would always remember her supportive attitude: Pollak had told her, "You're better than you think."[30] During her college years, her creativity was more apparent in commercial art, which was taught with an emphasis on European poster design. In a watercolor contest, she won honorable mention, praised for her "perfection of technique" despite a "slightly commercial" quality.[31]

Introduced to reproductions of paintings by Rouault,[32] Picasso, and Matisse, Nell had no frame of reference to understand these bold, strange-looking images. The first modern art she saw in person was an exhibition of the Chrysler Collection at the Virginia Museum of Fine Arts, which had

opened in 1936. Drawings by Fernand Léger struck Nell as both "meticulous," a quality particularly important to her at the time, and "inventive."[33] A three-day college-sponsored trip to New York—where, she said later, "my heart jumped when the bus turned a corner onto Fifth Avenue"[34]—gave her a chance to visit museums and see significant works by Piet Mondrian and other European modernists. Firsthand experience of these paintings was a revelation, an introduction to a thrilling new world. Her parents were aghast at her enthusiasm for art they believed to be degenerate—Picasso, in their eyes, was "an insane creep"[35]—which led to fierce arguments. "They were ready to throw me out," she said later.

Echoing her high school pursuits, Nell served as literary editor, then editor, of the weekly college newspaper. Her lifelong fascination with female movie stars received an early boost when she interviewed Jeanette MacDonald, Martha Scott, Grace Moore, and other actresses, bringing along a drawing based on a fan photo, in hopes of getting an autograph. After meeting Scott, Nell gushed to her diary, "Martha, Martha—I adore you! Never have I felt so much like the process of ice-cream making—on the inside."[36] This was her charmingly naïve way of describing physical attraction. Nell also wrote a gossip column for the paper under the heading "Hors d'Oeuvres." It was quite daring for the times, judging by a surviving sample: a woman student had bragged that she had "both sex and temperament," Nell wrote. "We thought this a profound statement until we found her reference was to an assigned chapter in sociology."[37]

Her book reviews reveal a probing intelligence and a confident if some-times clumsily expressed point of view that honored the values she had absorbed from reading classic literature. She noted that Hemingway's *For Whom the Bell Tolls* "contains all of the blood, strength, and brutality of his previous works, with a far more intensive skill, delicacy, care, and most of the other usual superlatives." Richard Wright's *Native Son* "undoubtedly establishes [him] as the greatest of contemporary negro writers," she wrote. "The author is struggling with Dostoievsky subject matter, the human soul." She was concerned that "the plot often trembles with as much indecision as an aspen leaf"—the natural world already serving as her frame of reference—but she concluded on a positive note, praising the novel as "a revelatory intellectual experience, profound and of undoubted moral importance." Decades later, similar remarks about books she had read would fill the last pages of her annual diaries.

Nell had to drop out of college after two years.[38] Her family's straitened circumstances had worsened during the Depression, and they could no longer

afford her half-tuition. Working at Richmond Advertising, she earned about twenty-two dollars a week doing paste-up and drawing illustrations while gaining experience in typography and layout that would prove useful when she needed to support herself with freelance design jobs.[39] Nell worried that doing this work might distort her visual awareness or stunt her painting ability. But her overriding goal was to make enough money to be able to leave home.

Soon after she began working at the agency, Nell saw an exhibition at the Virginia Museum of Fine Arts of work by Esther Wörden Day.[40] She later realized that Day was heavily influenced by Picasso and Giorgio de Chirico, but at a time when abstract art was virtually unknown in Virginia, these drawings struck her as unique and fascinating. Another show at the museum— work by two European abstract painters, Pierre Daura and Jean Hélion— would also intrigue her and have far-reaching consequences for her own

Nell Blaine, *Untitled* [detail], 1941.
Pen and ink on wove paper, 11-7/16 x 7-1/4 inches.
Virginia Museum of Fine Arts, Richmond; gift of
Yvonne Carignan in memory of Mary Morrison
Carignan. Photo: David Stover. ©Nell Blaine Trust.

painting, as we shall see.[41] Nell signed up for an evening class at the museum with Day, who had returned to Virginia after studying art in New York.[42]

As Nell wrote later, her teacher helped her "connect with the world of ideas in relation to painting." Day passed on precepts she had learned a few years earlier while studying at the Art Students League in New York with Vaclav Vytlacil, a former student of painter Hans Hofmann at his school in Munich.[43] (Decades later—when she was struggling, her work passed over in favor of fashionable artists—Day began claiming that she had worked directly with Hofmann.) Her teaching stressed the importance of the two-dimensional nature of the canvas. "It was very exciting," Nell said later, "and I suddenly felt more stimulated than I'd ever been in my whole life." Persuaded to try abstraction, Nell felt that her efforts fell short; they were more like designs than serious paintings. Yet her insecurity about her abilities was tempered by Day's encouragement—her first deeply personal connection with an art teacher[44]—and by the thrill of discovering a new path to artmaking. Day had spoken of Hofmann as the ultimate master. With her romantic attachment to difficult goals, Nell was not dissuaded by her teacher's description of Hofmann as impossible to fully understand. If only she could manage to study with him, she would learn the secret of abstraction.

Some of Day's advice was oddly contradictory. She persuaded Nell to recognize her attachment to the familiar landscape of her hometown, encouraging her to take early-morning bike rides across town to paint watercolors of ravines, railroad yards, and views of the James River. At the same time, Day talked up the excitement of New York with "stories of incredible parties and sexual promiscuity."[45] So this great city was not only the home of the Master and wonderful places to see art; it was also a place where Nell might finally explore her deepest impulses, free of her parents' strictures. Feeling "inspired and stimulated," she was buoyed by her belief that she was destined to be a success.

Nell's mother had hoped that her daughter would find work as a secretary or (improbably, given her rejection of the Baptist Church) a missionary. But the twenty-year-old painter had heard the siren song of Manhattan. Ignoring her mother's pleas and threats,[46] she left home in September 1942 with a suitcase, her portfolio, the ninety dollars she had saved, and her inchoate hopes and dreams. Her departure was, as she said later, "the crucial act of my life."[47]

2

New York

AS SOON AS SHE ARRIVED IN MANHATTAN, Nell headed for the Hans Hofmann School of Art, still clutching her suitcase. When Hofmann student Albert Kresch opened the door, he saw a startled young woman peering into the blackness. The lights had blown out at the school that night, and flickering candles dimly illuminated the interior. After reviewing her watercolors, Hofmann told her she was very talented, but he added that her oil paintings looked somewhat like patent leather.[1] "I thought that was a wonderful remark," she said later, "and I got rid of that quality very fast."[2] Believing in her promise, he appointed her a class monitor—a scholarship position that involved easel dusting (again!), cleaning up, locking up, and posing models in Hofmann's absence.[3] Nell also enrolled in the Art Students League to study with Will Barnet. But she dropped that class to spend all her time with Hofmann, thrilled at the way he entered the room "like a great actor" and radiated an extraordinary level of "warmth and excitement."

Born in Bavaria in 1880, Hofmann had moved with his family to Munich as a child. After training in a local art school, he went to Paris at age twenty-four, assisted by funding from a patron. At the evening sketch classes he attended, Matisse was a fellow pupil. During his decade in the City of Light, Hofmann met other up-and-coming artists, including Picasso and Léger, while experimenting with Cubism and Expressionism. Trapped in Munich during a visit to his family that coincided with the outbreak of World War I, and no longer receiving financial support, he opened the Hans Hofmann Schule für Bildende Kunst. The school was popular, attracting American students who traveled to Europe after the war.

Hofmann immigrated to the United States, heeding the warnings of his wife, Maria ("Miz"[4])—who was unable to rejoin him until 1939—about the oppressive atmosphere in Munich that would lead to Hitler's seizure of power. In 1932, after teaching briefly in California, he settled in New York, where his former student Vaclav Vytlacil helped him obtain a position at the Art Students League. The following autumn, he opened the Hans Hofmann

School of Art. It moved to several locations in the city before settling into its final home, on the second floor at 52 West 8th Street, above a Western-themed restaurant and nightclub. Always alert to graphic design, Nell recalled that the school's sign, modestly attached to the side entrance of the building, was in "a chic lowercase…sans serif type." Following his European practice of teaching summer sessions in Capri, St. Tropez, and other attractive destinations, Hofmann also established a summer school in Provincetown, Massachusetts. In 1941, he became an American citizen.

In a statement about his methods, Hofmann wrote that he "never belonged to any group" as an artist and treated every student "from the beginning as the individual he really is" by "cultivat[ing] his creative instincts and keep[ing] them alive."[5] Landscape painter Wolf Kahn, who studied with Hofmann in the 1940s and became his studio assistant, wrote that when students drew the nude model, they were instructed also to draw the space around her, thus sharpening their awareness of the structure of form. "Beauty," Hofmann said, "is in the empty spaces."[6] At that time, according to Nell, the only reproduction hanging in the classroom was Cézanne's *Boy in the Red Vest*.[7] Between 1888 and 1890, the French artist painted four versions of this subject in different poses, to study the figure's relation to space.

Hofmann made his rounds of the students on Tuesdays and Fridays, leaving them free to work on their own the rest of the time. Perle Fine, an older artist who attended Hofmann's classes intermittently, recalled how everyone "followed him around…as he criticized the students' work. They clustered six deep and stood on stools and windowsills to watch him demonstrate" on someone's drawing.[8] Hofmann would make energetic corrections on the student's work, sometimes with such gusto that, Kahn said, "the charcoal would explode." To make a point, he might ask permission to tear up the drawing and then put the pieces together with tape or thumbtacks. According to Kahn, Hofmann had "an uncanny ability to make his students anxious."

Nell felt differently. She said that Hofmann was "extremely sensitive" in his approach, aware of the effect of a negative remark. What he did with the torn-up drawings—showing how to create a deeper sensation of space—was so effective that "you'd just feel the space more, right in your belly." Her views were more in line with Kahn's description of the students as "like a religious order[,] united by the same demanding vows in the search for formal perfection." In a letter to her former painting teacher Theresa Pollak, Nell wrote that Hofmann was "a great inspiration—truly a great, genuine teacher with tremendous insight. I have never felt so released, so free, and so intense about painting as I am now." Because he has "<u>so</u> much more to offer," she added,

"it would be disastrous not to continue with him next year."[9] Nell, who would use similar terms to support her fanatic adherence to abstraction in the 1940s, once said that studying with Hofmann was "almost going into psychoanalysis."[10]

Eager for mentorship, and aware that her previous instruction had been rather scattershot, she did not mind spending her entire first year of study making drawings of a model in various styles ("diagrammatic, Cubist, analytical"). Hofmann believed that students needed a firm grasp of proportion and space before being overwhelmed by the possibilities of color. Nell's second year, supported by a $1,000 junior fellowship from the Virginia Museum of Fine Arts, consisted of painting five still lifes he set up—over and over, in color, from every angle.[11] "I was a true disciple," she said later, avidly soaking up his ideas about "flat" and "deep" space in painting and "how each color should have a life of its own, each one clean and fresh."[12] She recalled that he painstakingly arranged the still-life setups, "using cloth and objects to delineate movements into space," and would be "annoyed or bored" when students were not receptive to his passion for observing exactly "where things were positioned in space."[13] He used the term "push-pull" to define the spatial effects of color on the canvas—warm hues (red, yellow, orange) appear closer, while cool hues (blue, green) seem to recede; in tandem, they give the effect of movement. However theoretical his strictures might seem, they were rooted in the real world. Hoffman trained artists "who liked to use nature as a jumping-off point," Kahn said, "to look at landscape analytically, to see the space as a whole." Nonetheless, students "tended to think that a tree was relevant only if it defined the edge of a plane, and the sky only insofar as it was a volume and exerted weight."[14]

Unlike many of her fellow Hofmann acolytes, Nell had little trouble with his thick German accent and gnomic remarks. She believed that he "seemed to have a perfect eye" for the successful and weak spots in a painting: "He could tell what you were feeling when you put down a single brushstroke."[15] Her friend Jane Freilicher, whom Nell—aware of her promise as a painter— had urged to study with Hofmann, said later that his students "caught…the contagion of art—what it meant to be an artist—the seriousness of it." They also absorbed "a sensitivity and responsiveness to measure, value and proportion, and care for the vitality of the surface."[16] Yet, despite his standing in the art world, Hofmann could be jealous of younger artists. As someone who desperately wanted his approval, Nell was hurt when she heard about a sniping remark he had made about her work two years after she concluded her studies with him.

During her first year in New York, Nell said later, "everything exploded for me. I rushed from one revelation to another, full of wild enthusiasm for art in all its forms."[17] Her abstract work "began to crystallize more and more"— with one significant exception. In the summer of 1943, on a visit to Sullivan County in upstate New York, the countryside inspired her to work from nature "in a way I never had before."[18] Nell once remarked that Hofmann "never really turned away from nature" and his approach was essentially intuitive, "a way of liberating you."[19] In a document that saluted "visionary experience," Hofmann wrote that his own work began with "the capacity to sense the mysteries in nature and reveal [them] through the act of creation."[20] This aspect of his teaching freed Nell to depart from rigorous abstraction and experiment with a looser approach to landscape, as in her watercolor *The Gay Patchwork (Viaduct)* (1943, plate 1).[21]

Hofmann's emphasis on "organic" work was vitally important to Nell, who understood it to mean painting that directly reflects the artist's body rhythms and "the rhythm of nature." This is the sensibility that animates her mature landscapes, with their pulsing waves of color. In the 1940s, her key influence was bebop, the new, fast-paced jazz style that incorporated dissonance, sophisticated harmonies, and more abstract chord-based improvisation than swing music. Nell took up drumming,[22] which helped her perceive how jazz embodies "the ever-freshening, always spontaneous, renewing creativity I felt keenly in being a part of modern art." She compared "each color in abstract painting" to "each improvisation in jazz." In jazz, she explained, each player's "voice" created "oppositions" within the band."[23] Working with abstract forms, she sought an equivalent to "the way drum breaks marked the time or [jazz tenor saxophonist] Lester Young created a line"—soaring upward and suddenly dropping down.[24] Even her manner of holding a paintbrush was influenced by the way she deployed a pair of drumsticks.

When she arrived in Manhattan, Nell initially stayed at a rooming house for women on the Upper West Side, which she hated. Then, as now, downtown New York was the place to be. Thanks to a tip from a teacher at the Art Students League, Nell quickly found a studio at 128 West 21st Street, an abandoned industrial loft that she shared with her college friend Polly Bates. For twenty-five dollars a month, she had two desirable amenities: a skylight and northern light. But the kerosene stove gave off little heat[25]—in winter, she could see her breath—there was a rat infestation, and the splintered wooden steps leading to her floor were propped up none too securely with an iron rod. No wonder the fire inspector warned Nell that the building was a firetrap. When her mother came to visit, she became hysterical at the horror of it all.

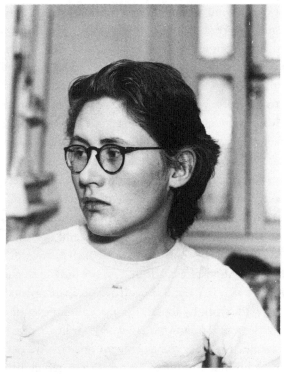

Nell Blaine, ca. 1942–43.
Photo: Robert Bass. Nell Blaine Papers, Archives of American
Art, Smithsonian Institution.

In an age when women wore skirts and dresses in public, she may also have been aghast at Nell's daily uniform of slacks and layers of T-shirts, and her refusal to carry a purse.

Despite the inconveniences, Nell was thrilled to make the space her own, building shelves, cabinets, and storage racks—all painted white, as were the walls—and arranging plants against the south-facing window. Edith Schloss, an artist and writer who lived nearby at number 116, explained that one reason artists who moved into these spaces favored white walls was "to offset the gloom—because of the height of the neighboring factory buildings, little daylight came in."[26] Fifteen years later, when Nell still lived and worked on the same street, she told an interviewer that the neighborhood had "all the industrial sounds you've ever heard or imagined. All at once, and all day long, until 6 o'clock. Then it stops."[27] Working at night, often until 5:00 a.m., she still had to put up with the urban racket. In winter, the dilapidated iron shutters of the loft buildings—required by the fire code—would crash

open and shut in the wind. Other players in this city symphony were burglar alarms that regularly went off "for no reason at all," as Schloss wrote, the grating sound of the idling motors of delivery vans, the clatter of garbage trucks, and, in the early morning, the "soft clip clop" of the horse pulling a milk delivery wagon.

The New York that Nell encountered in 1942 was a tarnished version of its famous self. With the country at war, blackout curtains were mandated at night, and even the Times Square signs had gone dark. Life was grim for many, with massive unemployment that led to a huge number of vacant apartments and rationing of clothing and foodstuffs. In 1941, fourteen paint colors were requisitioned for the war effort, removing such familiar pigments as titanium white, cadmium red, and cobalt blue from painters' palettes. The forty-cent beans-and-sandwich Automat dinners Nell and her friends ate were a distinct comedown from the southern bounty she had known.[28]

In this dispiriting atmosphere, cultural events provided much-needed diversion. In March 1942, the exhibition Artists in Exile opened at the Pierre Matisse Gallery, with work by fourteen European émigrés, including Léger and Mondrian, whose paintings would be a major influence on Nell's evolving style. In October, heiress Peggy Guggenheim opened Art of This Century, four galleries in a building on Fifty-Seventh Street, which introduced New Yorkers to the last word in European art. Among her coups was the first US show of work by the German-French abstract sculptor and painter Jean Arp. Architect Frederick Kiesler designed the Surrealist, Abstract, and Kinetic Galleries, which contained permanent exhibitions, in a deliberately eccentric fashion. The more conventional Daylight Gallery, with windows that looked out on the street, showed work by New Yorkers in a series of temporary exhibitions. Nell acknowledged Guggenheim's outlandish side, saying that she looked like "a sexy witch." But she later praised the dealer for taking a chance on young, unknown artists (including Jackson Pollock) and for the personal magnetism that made Art of This Century "the liveliest gallery around at that time—and perhaps any time."[29]

Nell and Polly initially took part-time jobs at Lord & Taylor. Stationed on the first floor of the department store, Nell attached the initials of wealthy women to the alligator purses they had bought. The sole redeeming feature of this work, she said later, was her newfound skill with pliers. Hofmann's secretary, Lillian Olinsey,[30] helped Nell get a new job as a clerk at New York Life Insurance Company, touting its perk of free lunches. But Nell found the atmosphere "claustrophobic," and she was eventually fired.[31] These were the first of a long line of "junk" jobs that would later include making deliveries

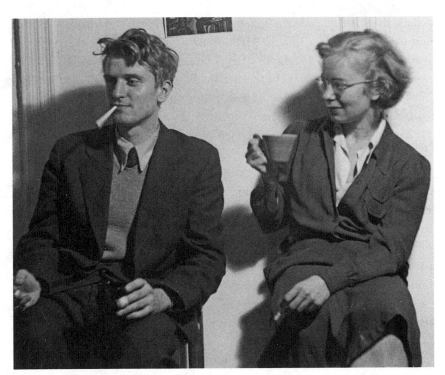

Robert De Niro and Virginia Admiral, ca. 1942.
Courtesy of Carolyn Harris.

for a false teeth factory, painting neckties,[32] and packing objects at a mail-order company.[33]

Nell's real New York life began when she returned to her loft to paint and get together with her new circle of friends. Among them were Robert De Niro (father of the actor), Al Kresch, and his best friend, Leland Bell, a fellow jazz enthusiast—all of whom shared Nell's birth year. De Niro, whom a friend called "a kinetic dandy," had an anarchic spirit that led him to invade the sacred space of the setup at Hofmann's classes by throwing a crumpled sheet of paper in front of the model. He and his artist wife, Virginia Admiral,[34] held gatherings in their Greenwich Village loft that were frequented by painters and writers, including Henry Miller and Tennessee Williams. Kresch, who would abandon pure abstraction for quasi-abstract landscapes, was engaged in "a search for a seamless resolution…of the paradox in painting between structure and freedom."[35] He had introduced Nell to Lee Bell, a self-taught artist with dogmatic views. Bell was a follower of French émigré painter Jean Hélion, who came to the United States in 1932 and settled in New York—a city he loved for its modern spirit—in 1936.[36] Seeking greater proximity to his

artistic hero, Bell became the superintendent of Hélion's apartment building and eventually babysat for the Hélions' first child. (In 1946, the artist had married Pegeen Vail, daughter of Peggy Guggenheim.[37]) When Bell showed up at their apartment to make a repair, the Frenchman was amazed that New York handymen were so knowledgeable about modern art.

Nell found Bell to be the most aggressively articulate of her new friends. He had attacked her work when Kresch brought him to her studio, soon after she arrived in New York. In addition to Hélion, Bell worshipped Mondrian because he had eliminated subject matter in his paintings, using only rectangular forms in black, gray, and primary colors. She was initially convinced by Bell's insistence that she forfeit her allegiance to Matisse and Picasso in favor of Mondrian ("for the verticals and horizontals") and Arp ("for his curves").[38] Nell said later that she was "impressed by [Bell's] uncommon confidence and passion and in awe of his audacity and nerve."[39] After his tutelage, Nell announced gravely to an interviewer that "art should be an anonymous whole. I can't even sign my pictures anymore."[40] Ironically, Mondrian himself—who moved to New York in 1940—had been relaxing his style, morphing his black lines and large blocks of color into more sprightly compositions.

Nell invited Lee Bell to a party, telling him that "two Icelandic girls" would be there. One was the painter Louisa ("Ulla" to her friends) Matthíasdóttir,[41] who had immigrated to New York in 1942; they married two years later. Impulsive wartime marriages were popular, which may explain why Nell and Robert Bass tied the knot in July 1943, just three months after they met at a party.[42] Bob was another friend of Al's, a French horn player and photographer from Brooklyn who was about to start army basic training. Nell met him at a party, too; she had arrived with another man, but Bob made a beeline for her, and they wound up at her loft, where he admired her paintings. A pacifist, he managed to wangle a stateside army assignment playing on the radio and for troops embarking for the European theater of World War II in France and Italy. This day job left him time to perform in the orchestra of *Up in Central Park*, a Broadway musical that opened in early 1945.

Nell's decision to make her relationship with Bob official is somewhat puzzling, since she would have more than thirty lovers of both sexes, often several at a time during her younger days. Perhaps Nell was motivated by a desire to placate her mother, who required weekly letters from her daughter and to whom she had only recently stopped sending her laundry to be washed. She also felt close to Bob's Jewish family—"charming people" who may have put pressure on the couple to marry. They honeymooned with the family in an old house "with all the windows broken" in Mountaindale, an upstate

hamlet that had become the home of poor Jews resettled from Manhattan sweatshops. Not much is known about Nell's subsequent life with Bob; on the surface, the marriage seems to have been a clash of personalities. "He was almost too nice," she said later. "He was very devoted and did everything for me and I got bored."[43] Surely there were other issues, including Nell's roving eye. But in the early years, she enjoyed hanging out with Bob, Al, and Lee, feeling "like the fourth fella."[44] (During these sorties, Ulla was probably at home with her infant daughter, Temma; a photograph taken by Bob shows the painter in a dress she had ingeniously fashioned out of cloth diapers laced together.) Meanwhile, Nell's friend Polly had become seriously depressed, partly at not being able to meet Mr. Right, and returned to Richmond. Her despair was exacerbated by watching "somebody who wasn't even very oriented to men," as Nell put it, manage to snag a husband.

Judith Rothschild, a fellow Hofmann student, had encouraged Nell and Bob to visit Gloucester, Massachusetts, on the Cape Ann promontory north of Boston. Nell would remember their two-week sojourn, in the summer of 1943, as "magic and productive."[45] She and Bob joined up with a group of artists living in the rambling Reed Studios building, a hodgepodge of turrets, gables, balconies, and porches adjacent to the Thurn School of Art, where Hofmann had taught a decade earlier. The communal aspect of this dwelling appealed to Nell, who pooh-poohed Rothschild's complaints about people drinking more milk than their share. But the couple somehow wound up with the only studio lacking a skylight or large window—"like a meatpacker's warehouse"—which obliged Nell to paint by electric light, a harbinger of her practice in later years. She was disappointed to discover that her building mates were "unsuccessful…painters of the local scene…extremely dull people mostly eaten up by jealousy and preoccupied by petty gossip." She preferred the more cosmopolitan artists she met in Gloucester, like German-born Karl Schrag, who told "wonderful ghost stories," made up on the spot. Nell exhibited with the Gloucester Society of Artists—described as "headquarters for experimental artists who 'summer' in the Cape Ann region"—along with her émigré artist friends from New York Ilse Getz and Edith Schloss, who would marry photographer and filmmaker Rudy Burckhardt four years later.[46]

Nell was delighted with the maritime life of Gloucester. Drying fishing nets were spread on the wharves, dry-docked ships awaited repairs, and the harbor, with its fishing boats and canneries, was a hub of colorful activity. In her bookish way, Nell romanticized the lives of the Portuguese and Italian fishermen and admired their white-painted cottages festooned with climbing

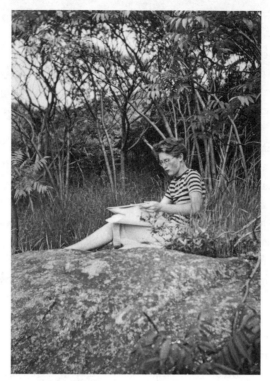

Nell in Gloucester, 1943.
Courtesy of Carolyn Harris.

roses "and larkspur & profusions of flowers running in bands & strands along long lawns sloping to the water's edge." At Halibut Point, in neighboring Rockport, she and Bob were mesmerized by the ceaseless action of the waves pounding against huge rocks, and also by a giant fish head with "huge teeth & great eyes." She wrote years later that this scenic vista was "a beginning and end of things: a dramatic spot." In hindsight, she seems to have been enlisting the visual drama to serve as a metaphor for the trajectory of her youthful marriage.

Lee Bell and Bob Bass introduced Nell to Larry Rivers, then a saxophone player and novice jazz drummer wondering if he had any talent as an artist.[47] When he showed her a pencil sketch he had made of a Coptic textile on the cover of an art magazine, she was blunt: to succeed, he would need to apply himself. Rivers lived across the street from Nell in the Penzone, a rooming house ("for derelicts," according to a disapproving friend) that charged four dollars a week. Al Kresch recalled that trumpeter Chet Baker and sax player

Gerry Mulligan would come to Rivers's jam sessions, held at a room on Times Square that rented for twenty-five dollars a night. To Edith Schloss, Rivers was "openly a street rat, out for himself, but brash, wise, funny."[48]

Through Rivers, Nell met eighteen-year-old Jane Freilicher, who had married a jazz musician a year earlier.[49] She knew Rivers from her husband's summer 1945 gig in Old Orchard Beach, Maine. To Jane, who had never seen a loft like Nell's, "her life as an artist seemed glamorous, courageous, and attractive."[50] Nell, Larry, Al, Jane, and their friends spent their nights at the Village Vanguard and other jazz clubs, and at the Irving Place Theatre and the Museum of Modern Art, watching French and Russian firms. Nell was reading Russian novelists at the time; in an eccentric approximation of Russian style, she bought herself a white fur toque at Saks Fifth Avenue, which she wore with red rubber boots. On many nights, her studio was ground zero for boisterous parties that continued until dawn. A snapshot shows a smiling Jane gamely lying on the floor in high-necked blouse and checked skirt while a man holding drumsticks (Eddie Aster, Larry's drummer roommate) pretends to play on her stomach. Nell, sprawling on the sofa, rests one foot on Jane's shin and grasps the trousered thigh of someone sitting next to her who is cut off by the edge of the frame.

Nell liked to work all night, opening her door to her friends around nine or ten o'clock while jazz records played. She would make an occasional sortie from her canvas to dance wildly or bang on the drums she had bought at a pawnshop, with Bell's guidance. Rudy Burckhardt later recalled how "Nell was kind of a leader and everybody was following her. She put her foot down and said, 'New Orleans jazz is dead. Dizzy Gillespie is the new king.'"[51] When Rivers used Nell's paints to decorate her drums, Edith recalled, "far from being annoyed, she liked it. 'You should go and study with Hofmann,' she told him."[52] On one occasion, a group of jazz musicians was so mesmerized by a recording of "Salt Peanuts" (which features scat singing of the title words by members of Gillespie's band)—and likely also so stoned—that they kept moving the arm of the record player back to hear the same few notes over and over. One of the musicians had brought a painting of his for Nell to critique. It was a landscape with dinosaurs and some puzzling spiky objects. Nell asked what they were. "Oh," he replied, "that is natural debris." From then onward, "natural debris" became a code phrase in her group.[53]

During this time, Nell "made no effort to closet her lesbian feeling," Rivers observed later, noting that no one ever referred to her as "Mrs. Bass." In his eyes, "being a lesbian and being married was so fantastic[;] it became a lighted gateway into the art, the jazz, the parties, the banter that went on in her

studio." According to him, in addition to the artists and writers he encountered at her parties, there were filmmakers, people in publishing and advertising, "an occasional heiress and the odd English nobleman."[54] The heiress was Jane Watrous, a descendant of the founder of the Parker Pen Company, who was a lover of Nell's in 1948–49. Decades later, Nell described her as "impossible," though that adjective would describe many of the objects of her intense crushes. The loft parties often continued for days, with friends and strangers staying overnight and carousing until they had no energy left. There was one shocking result of Nell's freewheeling, open-door policy during these years: at some point in the early forties, she was gang-raped in her studio by a group of young men. No details have surfaced; decades later, she mentioned this trauma in passing to an acquaintance who felt uncomfortable to be burdened with such information.[55] This may have been the mysterious "personal crisis" recalled by Edith that led Nell to remain "incommunicado for weeks."[56]

"The great jazz musician that we loved was Lester Young," Nell recalled. Then in his thirties, he was famous for his free-floating style on tenor saxophone, the epitome of cool. Young had made his name with the Count Basie band. After a three-year absence, he returned in late 1943. Close to the singer Billie Holiday, he made numerous recordings with her. Larry Rivers and his friends introduced Nell's group to saxophonist Charlie Parker and bebop. With its complex chord progressions and key changes, bebop moved too fast and too unpredictably to make it danceable, but its extreme virtuosity rewarded close listening. "We were there to hear the first notes that Charlie played at Carnegie Hall [in 1947]," Nell said. "We followed Billie Holiday and all those people in clubs for the price of a beer."[57]

In the 1940s, 52nd Street between Fifth and Sixth Avenues was a jazz mecca lined with clubs that featured all the great bebop players; Thelonious Monk memorialized the scene in "52nd Street Theme." Parker was in his early twenties when he moved to New York from Kansas City, Missouri, in 1942; a few years later, he joined up with bandleader Dizzy Gillespie on trumpet, Monk on piano, Charlie Christian on guitar, and Kenny Clarke on drums.[58] Jazz remained Nell's musical lodestar throughout her life, never augmented by rock-and-roll. Decades later, after watching the 1978 documentary *The Last Waltz*, memorializing the final concert of The Band, Nell wrote stiffly that they played with "great energy and skill," but she had not "investigated" this kind of music because she "never responded to Elvis and a number of the popular figures."[59]

* * *

In early 1944, Nell became the youngest member of American Abstract Artists.[60] At a period when popular figurative artists enshrined everyday American life as the prime subject of art, this group was dedicated to upholding a doctrine of abstract purity and rigor. As so often happens with zealous believers, there was a tendency to go overboard. Lee Krasner had given up her membership the previous year because of the group's rigid mindset: it not only denied membership to Alexander Calder but also refused to allow Hofmann to give a lecture.[61] Members bristled at the mere mention of Surrealism, because the Surrealists had heaped scorn on Mondrian and geometric art. When Pearl Fine, who also joined in 1944, proposed Jackson Pollock as a member, she was roundly criticized. The only style the group favored was Neo-Plasticism, developed by Mondrian. Intended as "a pure representation of the human mind," it limited painters to straight horizontal and vertical lines, squares and rectangles, and primary colors (red, yellow, and blue) plus black and white.

In other matters, however, American Abstract Artists was more broadminded. Fine's biographer points out that the group had several women members, including Nell, Irene Rice Pereira, Alice Trumbull Mason, Charmion von Wiegand, Gertrude Glass (married to painter Balcomb Greene), Suzy Frelinghuysen (spouse of George L. K. Morris, whom Nell remembered as "very elegant and erudite"), and Esphyr Slobodkina (married to Ilya Bolotowsky). "Not simply note takers and providers of refreshments at meetings," the women "helped articulate the organization's theoretical positions."[62] Twenty-two-year-old Nell would not have taken a leadership role, but the ethos and the organizational principles she imbibed would serve her well when she became a member of the Jane Street Gallery a few years later. She designed some of the organization's brochures and publications but eventually came to feel that it was rather "academic and stultifying."[63]

After Mondrian died, in February 1944, his studio was opened to the public. Nell, who had seen his solo show two years earlier, was enraptured: "The pure colors were still on the walls. . . . It seemed like a sort of cathedral, completely apart from anything I'd ever seen."[64] (The "pure colors" were rectangular cards, each one representing a color in Mondrian's chosen palette, which he tacked to the off-white walls.) Decades later, she recalled how "nothing was in his studio that didn't pertain to his art," including the furniture he built, "which was beautiful—square and all white."[65] Meanwhile, Nell was making a breakthrough in her own work. She had felt "liberated" by the activity of drawing and then painting her "funny-looking" *Composition* (also known as *The Duck* in the painted version). She used only primary colors

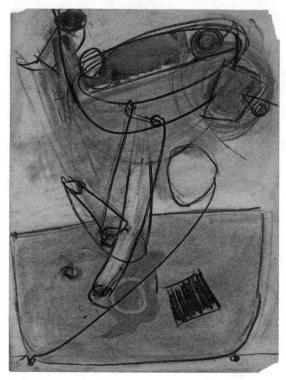

Composition, ca. 1943.
Charcoal on paper, 24 x 17-3/4 inches. The Metropolitan
Museum of Art, New York; purchase, Friends of the Department
gifts and matching funds from the National Endowment for
the Arts. ©The Metropolitan Museum of Art. Image source:
Art Resource, NY. ©Nell Blaine Trust.

"with a big white shape that looked almost like a cigarette" emerging from a
base that resembled a child's duck toy. "It was funny-looking," she said later,
but her friends admired it, "and suddenly I felt I was an artist."[66] Her new
confidence stemmed not only from the approbation of her friends but also
"from making contact with my own feelings, from knowing I could pull
them out at will."[67] She had broken away from the strictures of Neo-
Plasticism to create a vocabulary of knobby, eccentric shapes and outlines.
Henceforth, she would always believe in painting "as an extension of your
blood and body."

Nell's painting *Lester Leaps* (1944–45) is a tribute to "Lester Leaps In," a
song Young composed in 1939 for Count Basie's Kansas City Seven band. The
painting is made up of flat, puzzle-like shapes—variously fitted together or

Nell Blaine, *Lester Leaps*, 1944–45.
Oil on canvas, 24 x 13 inches. The Metropolitan
Museum of Art, New York; gift of Arthur W.
Cohen, 1978. Image ©The Metropolitan Museum
of Art. Image source: Art Resource, NY. ©Nell
Blaine Trust.

free floating—in gray, black, and bright primary colors.[68] It has the nervous
energy (though not the crowdedness) of a painting by fellow jazz lover Stuart
Davis, while remaining almost entirely abstract—*almost*, because the forms at
the upper right resemble a hand holding a drumstick. It's tempting to read the
lighter-colored shapes as stand-ins for the emphatic horn section in this piece.
Lester Leaps was reproduced in a 1947 *Harper's Junior Bazaar* article about
artists under thirty "who share a strikingly disciplined attitude." Nell was de-
scribed as believing that realism in painting was strictly about "order, rhythms,
growth and shapes rather than the actual appearance of things." The article
said that she "designs ceramics for a living"—this was a short-lived freelance
job, painting whimsical tiles for the J. Warner Prins Company—and lived in a
studio apartment "as trim and ascetic as her art."[69]

Decades later, she described her personality during these years as shy yet seemingly arrogant, "humbled by loss and rejections in love, by continued poverty and struggle...made as modest (almost) as a saint with a ramrod of selfishness remaining up my spine."[70] She was being too hard on herself. Nell was "the dynamic center of a circle," Edith Schloss Burckhardt recalled, "listened to, pleasing or irritating, but always in a dominant role."[71]

3

Jane Street

IN THE 1940S, art dealers interested in the abstract work the young down-town artists were making were virtually nonexistent. Dealers knew that collectors who wanted to buy modernist paintings were looking for famous Europeans. Other than participating in occasional competitions and juried shows, the avant-garde Americans were largely on their own. Founded in 1943, Jane Street Gallery (named for its location at 35 Jane Street, a former tailor's shop in lower Manhattan) was a new concept: a cooperative, with the artist members doing all the work of painting the walls, hanging the art, publicizing it, and "sitting" the space when it was open to the public.[1]

Hyde Solomon, Nell's downstairs neighbor on 21st Street, invited her to join the group in 1944. Together with Al Kresch and Lee Bell (who joined slightly later), they formed the group's nucleus of fiercely dogmatic abstract painters. "We were so excited, we really thought that was the gospel," Nell said later.[2] A writer described her single-minded way of talking about "the more or less absolute and unbending realities" in "terms closer to religion than anything else."[3] Most of the earlier Jane Street members, unpersuaded by the new doctrine, were gradually eased out.[4] Taking their place was a raft of new painters, including Ulla Matthíasdóttir, Judith Rothschild, Sol Bloom, Sterling Poindexter, Frank Bacher, Ida Fischer, Frances Eckstein, and (in the gallery's last days) Larry Rivers.

Matthíasdóttir, who had come to New York from her native Iceland in 1942, after studying in Paris, had a distinctive, radically simplified figurative style; her real subject was "the geometry of everyday life."[5] She imbued her vividly colored landscapes of restful scenes with an almost supernaturally alert quality, illuminated by the clear, bright light of her homeland. Little is known about Bloom (described in a listing of gallery members as a furniture designer) or Poindexter, an Abstract Expressionist from Texas. Bacher translated the Purist aesthetic into bold graphic compositions.[6] During Rothschild's Jane Street years, cut short in 1947 when she moved to California with her husband, she painted Cubist-influenced abstractions, the most

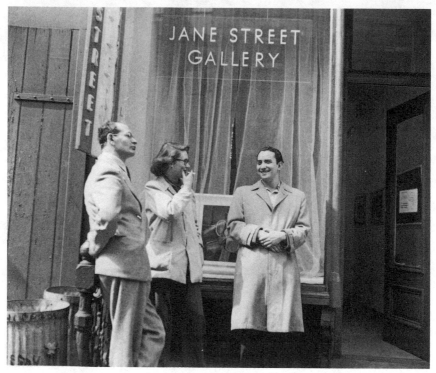

Jane Street Gallery members Hyde Solomon, Nell, and Al Kresch, 1947.
Photo: Robert Bass. Courtesy of Carolyn Harris.

successful of which are composed of flat, irregular shapes in unexpected color combinations.[7]

Fischer, whom Nell described as "ebullient and vigorous," prone to exaggeration but "a great storyteller,"[8] had retired early from supervising music instruction at Washington Irving High School. On a round-the-world trip, she became fascinated with Chinese brush painting; later, she studied with Hofmann. In addition to her paintings, she made three-dimensional mosaic collages fashioned out of shards of broken cups, glitter, tinted plaster, and other objects.[9] Eckstein, a retired secretary, was Fischer's life partner; unlike the others, she was self-taught and worked in what Nell called "a lyric primitive" style.[10] Up-and-coming art critic Clement Greenberg predictably dismissed her paintings as "nice but irrelevant flower pieces."[11] In their fifties, decades older than the other members, the two women were prized for their wisdom, their "Old World culture," and their food offerings. The "fabulous meals" Nell recalled eating at the Fischer-Eckstein home were five-course affairs that lasted for hours. Eckstein, who was as reserved as Fischer was talkative, made the desserts.[12]

Nell, the gallery's secretary (and subsequently coordinator—people some-times referred to the "Blaine Street" Gallery), would recall this period as "an exciting time," with lively openings and coverage from local media and national art magazines. The entire membership would visit an artist's studio to determine whether he or she was worthy of joining the group. Nell later admitted that they could be "rather harsh," rejecting "gifted people," but "we wanted to keep the group small, at approximately ten members."[13] Each artist paid about eight dollars, "which seemed a lot of money to us," into a general fund for rent, printing of invitations, advertisements, and other costs. The gallery took only a 10 percent cut of sales, far less than commercial dealers. A patron system was eventually instituted; a sixty-dollar annual donation entitled the sponsor to choose a painting from a portfolio of work by all the members.[14] Nearly every week, the artists would gather for a meeting. "But we weren't good at business, any of us," Nell said. "And we all had to learn to use the hammer and nails."[15] The result of this manual labor was a pristine space with white walls and gray floors.

Each member participated in annual or biannual exhibitions. Shows fol-lowed one another according to a brisk schedule, with only a few days' down-time. During the first few months, critics were slow to respond, but people who lived and worked in the area stopped by frequently to look and ask ques-tions. In an era when the people who attended art openings were usually in evening dress, an observer described the crowd at one of Nell's openings as "young men with their collars open, long-haired girls in flat heels, a couple of smartly dressed middle-aged women, and two or three soldiers and sailors."[16]

Nell was so excited about a sketch she made in Hofmann's class that when she came home, she told Bob, "I have to paint this right now!" So she used the first large surface she found: an eight-foot-tall theater poster she found lying on the street. Shown in a 1944 American Abstract Artists group exhibition, *Great White Creature*—a rhythmic composition of outlined black-and-white shapes, with a few touches of color—was favorably reviewed Clement Greenberg in *The Nation*. Peggy Guggenheim had rejected the painting for the 1943 Spring Salon of Younger Artists at Art of This Century, claiming that it was "too clean."[17] But the distinguished jurors had accepted it,[18] and Greenberg and dealer Howard Putzel argued for its merits. In 1945, Nell's work met with more favor from the doyenne of new art, whom she found "not an easy person to be around." Her painting *Blue Pieces* was included in The Women, a summer exhibition of abstract and surrealist work by thirty mostly young and unknown women artists at Art of This Century.[19]

Influenced by the rhythmically scattered shapes in Jean Arp's collages, Nell's painting is a vertical dance of irregular blue, gray, and small red forms anchored by a black handlebar-mustache shape at the bottom. "I felt like I had become a painter, like from one day to the next," she said later. For the first time, she was using "real colors" and was "really in touch with my feelings, putting them down directly."[20]

Having fallen under Mondrian's spell, Nell wrote that when looking at his 1943 painting *Broadway Boogie Woogie*, "the eye responds in physical reflexes to the vibrating color transitions."[21] In this late work, crisscrossing bars of yellow interrupted by small rectangles of red, white, and blue reflect the stop-and-go dynamism of the city. Mondrian was a big jazz fan; by eliminating melody and replacing it with "dynamic rhythm," this new music struck him as the equivalent of his painting.[22] For many artists of the period, rhythm was king. Hans Hofmann had written that it was "the highest quality" in art, and Jean Hélion had praised Seurat and Poussin for the rhythm of elements within their paintings and the way they directed the attention of viewers.[23] Nell would take these influences to heart throughout her life; especially in her postpolio landscapes, her brushwork charged trees, flowers, and even distant mountains with a continuous rhythmic current.

The Jane Streeters sponsored a fund-raising jazz session at the Village Vanguard on a Sunday afternoon in June 1945, with tickets priced at $1.20. Hearing that Dizzy Gillespie and Charlie Parker were going to play there one night, Nell and Al handed out flyers for their event to the queue of jazz fans. Waiting at the door after the concert, Nell walked up to Parker and gave him a flyer, assuring him that this was an invitation to listen, not to play. "She had that kind of nerve," Al recalled.[24] The group was also involved in other types of performance. Jane Street artists designed the sets and costumes for the Provincetown Playhouse production of *If Five Years Pass*, Federico García Lorca's 1931 play about young lovers, and mounted a concurrent exhibit of his drawings and manuscripts.[25] During this period, the gallery was a Village institution, assured of having its events listed in *The New Yorker* and *Cue* magazine, the city arts and entertainment guide. Nell later said that part of the gallery's mission was to show visitors "that the abstract artist is very sincere and is not trying to perpetuate a hoax."[26]

In November, Nell's first solo Jane Street show elicited a tiny rave review in *ARTnews*, which noted that she was a twenty-three-year-old native of Richmond, Virginia, and praised her "combination of simplicity precision and vitality." The writer, painter Renée Arb, declared that "Mondrian would

have admired…her compositions."[27] Nell was the youngest member of the group, a fact noted by a writer for the newspaper *PM*, who came to the opening and described her as "a thin, bobbed-hair girl with horn-rimmed glasses."[28] To this observer, Nell's fifteen paintings in the show looked like "crossword puzzles." Nell explained that the art was "concrete…as concrete as a leaf." She was tossing out a term associated with Theo van Doesburg, author of a 1930 manifesto stating that art should make no reference to objects in the world, or to "sensuality or sentimentality." But by comparing her own work to the concreteness of a leaf—nature always serving as her touchstone, even in an urban setting— she meant that an idea can have as much *reality* as something in the world.

Together with Rothschild and Fischer, Nell tried to steer the *PM* writer away from her preconceptions about art, including the then-current notion in left-wing circles that it should engage with social issues. The Jane Streeters' emphasis on a "pure" art involved a total rejection of the literal-minded Social Realism that had dominated American art in the 1930s. Nell puzzlingly announced that painting "is social in itself" and tried to explain the connection she saw between the Jane Street artists' work and jazz. Fischer, probably aware of the writer's bafflement, handed her a glass of sherry and exclaimed that the young people were "insane with life." Clearly, she thought this was terrific.

The following year, in a published statement, Nell professed her delight in "giving the effect of a decorative pattern," despite the effort it took "to make one form grow out of another with a natural flow, with twisting and turning complexities." Her "strongest initial impressions" when conceiving a painting were "from nature itself." It was extremely difficult to incorporate those "intervals, measures, and quantities" into her composition. The negative words she used to describe the process of translating nature to abstraction ("frustrating," "dissatisfied," "unequivocable [*sic*] demands") suggest that this work went against the grain of her deepest artistic impulses.[29] But her belief in the credo of the Jane Street group kept her from recognizing the problem. The Nell of 1946 would have been amazed at her admission, a dozen years later, that she could scarcely see a difference between artists who felt as she did and the Impressionists. "For me," her future self would say, "the word 'pretty' is not a bad word."[30]

In 1947, Clement Greenberg lauded Nell as "the most developed" of the Jane Street artists, though this pat on the head was a digression in a sentence noting that none of them were "anywhere near fulfillment as yet."[31] He also believed their notion of art was "too narrow and too sectarian." By now, the Jane Street storefront had been sold, and the group had temporarily decamped to Gallery

Neuf. This was the first of a series of moves that subsequently landed them at a shabby street-level room at 41 Perry Street in spring 1948. This space required the artists to engage in another massive carpentry, painting, and wiring project. In the autumn, they moved to 760 Madison Avenue, hoping that this uptown location, closer to collectors' homes and galleries, would result in more exposure. At first, it did. A reporter and photographer from the *New York World-Telegram* dropped by to gather material for a feature story.[32] In the published article, Lee Bell ("handsome, soft-spoken") and Ulla Matthíasdóttir ("slim, Icelandic") were pictured with their three-year-old daughter, Temma ("a kid with a cute grin"). Nell ("a pretty young woman") was reported as being exultant at having sold three works at her current solo show. After Solomon explained how the cooperative gallery worked, Nell added, "We like hanging our own paintings." She would always be insistent about supervising the hanging of her work, even after she had moved on to major galleries and had to issue orders from her wheelchair.

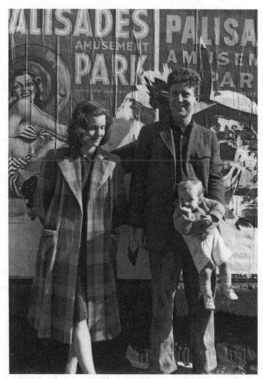

Louisa Matthíasdóttir, Leland Bell, and daughter Temma, 1946.
Courtesy of Carolyn Harris.

Jane Street exhibitions continued to be well reviewed. In *ARTnews*, Elaine de Kooning noted Nell's "new sense of activity" in her 1948 solo show;[33] the following year, Larry Rivers's first show received high praise from Greenberg, who wrote in *The Nation* that the work "has a plenitude and sensuousness all its own."[34] Yet there were few sales. This dispiriting situation must have played a role in the closure of the gallery in 1949. Nell later said the artists had come to feel that the energy it took to run the place took too much time away from their own work. They also felt boxed in by trying to uphold the utopian aspect of Mondrian's philosophy. His spiritual view of art was based on a blend of the mysticism of theosophy and the rigor of Dutch Calvinism. His belief in purity was upheld (or inspired) by a serendipitous Dutch linguistic quirk: *schoon* means both "clean" and "beautiful." But the Jane Street artists were part of a far less homogeneous society, at a vastly different historical moment. Even Hélion, working in France in the 1930s, and newly influenced by Jean Arp and Alexander Calder, had begun to allow curved shapes and a greater range of colors into his paintings. After his experiences in a Nazi forced labor camp in 1940–42, he renounced abstraction to paint figures in an idiosyncratic style.[35] Nell, who saw the new work at a gallery in New York, called this shift "a deep, soul-searching change" and said she was strongly influenced by it.[36]

Also contributing to her stylistic shift was the Bonnard exhibition at the Museum of Modern Art in 1948, the year after the artist's death. As a young man, Pierre Bonnard was a member of Les Nabis (the Prophets), a group that included his friend Édouard Vuillard. Working in various media, including posters and textiles, these artists claimed the right to present the world in personal ways that melded the Impressionists' interest in nature with the flat patterning of Japanese prints and the sinuous line of Art Nouveau. In Vuillard's interiors, figures and settings often seem to be cut from the same patterned cloth. Admired by Matisse, Bonnard is best known for his late paintings of intimate domestic scenes at his house in Le Cannet in the South of France. Many of them feature his wife, Marthe, who often floats in a bathtub or busies herself with a household task. There is a dreaminess about these pictures, in which the image of Marthe (or a cat), bathed in a golden light, merges with the walls and furniture of the house. "Bonnard has the most highly developed tactile intimacy of any painter I know," Nell wrote. "He has…a special kind of reality…which one can partake of more leisurely" than that of other modernist painters.[37]

She would later draw on elements of their styles in her own interiors and landscapes, but her early figurative paintings have a sketchy look, a should-I-really-be-doing-this? quality that would take several years to coalesce into a

personal style. Yet however much Nell was influenced by Bonnard and Vuillard, the Impressionists' capture of fugitive light effects, and the Fauves' wild colors and brushwork, she was firmly of her time—with "the translation of power, confidence, and energy into paint" that was a legacy of "the physical agitation" of Abstract Expressionism.[38]

Nell knew Willem de Kooning ("brilliant, charming, and a beautiful man"[39]) and other painters who were taking the expressionist route to abstraction.[40] "We liked them personally and were stimulated by them," she said later, "but felt, in our arrogant way, that we knew what structure was and that they were going up the garden path."[41] As Nell once remarked, she "always had the instinct not to be fashionable."[42] It is noteworthy that the Jane Streeters were taking their cues from European art while the Abstract Expressionists were bent on creating a style with no ties to the Old Country. Kresch maintained that the Jane Street group "were using the abstract as an armature...onto which to build a painting and [the Abstract Expressionists] were using it as the be-all and end-all of painting."[43]

While Nell would later abandon the exacting standards of abstraction upheld by the Jane Street group, she did not regret her "affairs" with Mondrian, Léger, Arp, and Hélion, because "structure liberates and is never a bind." She compared an understanding of structure to "having more notes on a bigger keyboard," so that an artist can express her painterly impulse "with rich inventive facets and wonderful twists surprises & rhythms."[44] Color was one of those facets. Nell was enthralled by "the brutal intensity of Léger's color," with its "sharp brilliance unlike any other modern." In her eyes, Mondrian's intense color was "qualified by a lightness and an elegant refinement."[45]

As a result of Nell's new visibility, painter Ad Reinhardt, who published a cartoon tree in *PM* illustrating the state of the art world in 1946, gave her a leaf with her name on it on the most abstract bough, along with Josef Albers and ten other artists.[46] Two years earlier, she had been thrilled to be asked by Howard Putzel to join his new 67 Gallery, along with Jackson Pollock, Adolph Gottlieb, Hofmann, and others. As she recalled, "I had just gone to him cold and taken one painting"—a five-foot-high rectangle with red, blue, and gray shapes on a white ground—"and he said to me, 'If you have other paintings like this you're the hope of America.'"[47] But Putzel died before her first show was to open. She also took a couple of her paintings to Dorothy Miller, curator of collections at the Museum of Modern Art. Miller "wasn't terribly warm," Nell said later, advising the young artist to try Hilla Rebay's Museum of Non-Objective Painting. Although her friend Lee Bell was a guard there (and Robert De Niro worked at the coat check), Nell thought the atmosphere was

Nell Blaine with *Open and Enclosed* (1945).
Photo: Robert Bass. Courtesy of Carolyn Harris.

"claustrophobic and other-worldly," and it seems that she did not bother to try her luck at the museum.[48] During these years, she was too caught up in her work and the thrills of her New York life to dwell on setbacks. "I was very cocky," she recalled, "confident I was a genius—I never doubted it for a minute!"[49]

Nell later dropped hints about wild evenings in the late 1940s. Decades later, when she saw John Schlesinger's film *Sunday, Bloody Sunday*—in which Glenda Jackson plays a woman having an affair with a male doctor while both of them are also openly involved with a younger man—she was reminded of this period in her life.[50] Reveling in new freedoms, artists experimented with sex as a party game, in much the same spirit as they enjoyed dressing up. At one of Nell's parties, someone gave Larry Rivers a blow job on the sofa. Then the lights went out and people groped each other on the floor; when the lights came on, everyone got up and danced.[51] Photographs show Nell at her fabled costume parties, dressed as a whorehouse madam (floral headpiece, bare shoulders) or a pirate (T-shirt, drawing of a bone tacked to one pants

leg). Bill Cannastra, a bisexual Harvard Law School student who was a friend of Nell's (and of Jack Kerouac's, who based a character on him), crashed one of her costume parties dressed as a ghoul. Cannastra was "extremely quiet and terribly sweet," she said later, but when drunk, he became "a wild man with a death wish."[52] He had brought his 78 rpm opera records—made of fragile shellac—dumped them on the floor, and danced on them in his silver-painted bare feet. Beer from a keg he had opened poured onto the record shards. Cannastra stuck his head in the oven to flirt with death, and for a finale jumped on the hood of a car outside. When they summered in more bucolic environments, the artists reveled in their freedom from middle-class norms. A snapshot taken by Rivers by a lake in Wellfleet, Massachusetts, shows several nude men and women (whom Nell had photographed posing on a dead tree) trying to pull off her clothes.

Nell's marriage ended in 1948, the year she paid her first visits to a therapist, perhaps seeking answers to her sexual identity.[53] During the forties and fifties she was intimate with many men and women—for one night or a few months, or off and on for an extended period of time. At some point near the end of her marriage she had a miscarriage;[54] whether the child was Bob's is not clear. A list of her lovers that Nell compiled years later includes Larry Rivers, Jane Watrous's unnamed boyfriend ("short in stature, muscular, nutty!"), designer Ward Bennett,[55] and Gene Smithberg,[56] who accompanied her to Provincetown in the summers of 1948 and 1949. Decades later, she wrote to her cousin Charlotte that she "almost married" Smithberg.[57] Another Provincetown fling was a painter who assisted Hofmann ("guy in boat...very attractive"). She identified some lovers with just a first name ("Cyril," "Gloria B.," "Leonore," "Eddie S.") or a brief description ("musician, young one," "Italian writer now pretty well known").[58]

Nell singled out Watrous, with whom she was involved for "2-1/2 years of switches"—a reference to concurrent relationships with two male friends of Jane's—and Smithberg ("2-1/2 years") as "important" relationships, along with her husband, Bob. A page of her diary refers tantalizingly to "the wild episode with Jane Watrous, myself, Alvin and Eliot Stein (then about 17 years old)—1948."[59] She was in a high-keyed, experimental mode during these years, flinging herself into affairs that often, it seems, ended badly, while trying to figure out what she really wanted. Her new lover was Midi Garth, a modern dancer for whom Nell was designing costumes and programs. A mutual friend described sitting with Midi and Nell at their kitchen table, "telling jokes, laughing, gossiping, sipping beer or tea."[60] Midi would prove to be a loyal friend throughout Nell's life, despite many storms along the way.

4

Paris, Poets, and Poverty

NELL STEPPED UP HER FREELANCE WORK—through Clement Greenberg's brother,[1] she got a temporary day job as art director of the United Jewish Appeal—to save $1,000 for a trip to Europe. She was anxious to trade the frantic New York scene for the opportunity to learn more about the past and present masters of art. Determined to save every penny, she would not even allow herself to buy a cold drink on a hot day. In an early version of crowdsourcing, she also raised money by throwing a costume party with a one-dollar admission charge. At night, she designed layouts for an astrology magazine with fellow artist Friedel Dzubas, whose wife would bring coffee to keep the two of them awake. Decades later, she would tell an interviewer that freelance design work taught her "discipline.... There were some good rules about being exact and not sloppy." Commercial design techniques came so easily to her that she "had to fight against practicing this approach" in her painting.[2]

In a photo taken on the dock in Hoboken, New Jersey, in the spring of 1950, Midi, dancer Eleanor Goff,[3] and another friend keep Nell company. She sniffs a bouquet, with her arm around Midi. Nell had told Edith Burckhardt that she didn't want to learn how to conjugate the verb *aimer* (to love), because "I want to remain faithful."[4] She was about to set sail on the SS *Volendam*, a decades-old ocean liner that had seen service as a troop ship during World War II. Thrilled to be a passenger on this majestic vessel, she didn't find sleeping in a hammock—apparently the only bed available—to be a hardship. Decades later, she recalled how she "trembled with excitement" to see New York Harbor. Unlike others on the passenger list, who specified an exact period of time they intended to remain abroad, Nell's entry reads "3–6 months." She was going to play it by ear. The ocean crossing was like "a fabulous dream." She marveled at "phosphorescent seas off the bow," made new friends, and had a black male lover.[5]

In Paris, Nell stayed in a cheap apartment Larry Rivers had been renting.[6] He helped her find a Montparnasse studio where (as she learned later) Ezra Pound had lived in the early 1920s. There was a garden "with wonderful light,"

Nell, Midi Garth, Eleanor Goff, and Constance Smith at the Hoboken, New Jersey, dock, 1950.
Photo: Norman Wasserman. Courtesy of Carolyn Harris.

and the rent was the equivalent of just five dollars a month. But there were major inconveniences. Nell could work in the studio only in the afternoon—sculptor Harold Cousins occupied it in the morning—and she was not allowed to turn on the electric light. Determined to maximize her use of the space, she would paint until it was pitch dark. By September, the unheated room was freezing, but Nell was informed that the furnace would not be switched on until November. So she worked bundled up in a scarf, two pairs of long pants, and three sweaters, "dream[ing] of Arles, Avignon and Corsica," where she planned to go in two months' time.[7]

When Nell first arrived in Paris, she was "almost hysterical," as she wrote to Jane Freilicher, from "the shock of...the strange language, people and color patterns." She felt "as helpless as a child on her first day in kindergarten."[8] At one point, she kept bicycling around and around the Place de la Concorde, stuck in heavy traffic and afraid to break some foreign traffic rule. Yet her new environment was having a marked effect on her art. When her ship landed, she immediately felt as though she had stepped into landscapes painted by the Impressionists. "Theirs seemed a natural way of painting," she wrote later, "and I was always trying to find the natural and honest way."[9] Temporarily putting aside her strict adherence to abstraction, she spent hours

sitting on the banks of the Seine sketching what she saw. It helped that this landscape was completely different from the one she knew in Richmond. "I realized that I had been depriving myself of some wonderful sensuous pleasure with painting," she said later.[10] Making ink drawings was "like opening a window. Suddenly a lot of sunlight came in. So I decided to let myself go and become a kind of hedonist."[11] Drawing would always be her first response to a new place, a way of examining its structure; she once said that she thought of black and white as if they were colors, allowing her to "approach nature with confidence."[12] The legacy of her years with Hofmann and her abstract work was an instinctive feel for structure that would underpin even her most riotous landscape images.

Nell wrote to Jane that Chartres Cathedral was "the finest single work of art I've seen—overwhelming."[13] A few years later, claiming to have visited a cathedral "almost every day" while she was in Europe, she mused about the fact that the medieval period in which they were built—commonly disparaged as the Dark Ages—was "the one time in society when life was in accord with the artist."[14] The Louvre and the Musée d'Orsay—home of Impressionist and Post-Impressionist paintings by Monet, Degas, Renoir, Pissarro, and others—were major sources of joy and amazement for Nell. She later singled out canvases by Delacroix, Courbet, Watteau, and Poussin as her favorites. "I found all of it overwhelming," she said later.[15] But she was not one of the legion of artists who set up an easel to copy works in museums, because, she said, "I could never work in public with people around me." Instead, she reported at length in her notebook on the contents of museums she visited, freely criticizing works that failed to meet her standards ("shadows too imitative" in an illustration by Tiepolo) and capturing details in vivid phrases (to her, the faces of figures by John Brown looked like "nervous lions"). It was typical of Nell's idiosyncratic selectivity that she would take time to scrutinize portraits by a minor eighteenth-century Scottish artist in a city full of masterworks.

Dick Brewer,[16] a painter friend who was visiting Paris, provided an earful of New York art gossip, including the lowdown on Jean Hélion's "more and more realistic" new work and the sad fact that he had not sold any paintings for two years.[17] Assuring her that even famous artists in Paris were willing to receive uninvited guests, Brewer gave her their addresses. At the open house Hélion held every Saturday, bringing out his paintings for those who dropped by, Nell discovered that his uncompromising abstract style was becoming more lyrical—another confirmation of her own evolving state of mind. She found him "extremely articulate and friendly," and she admired his large studio, "like a church with a great balcony." Despite her youthful rejection of

the Baptist Church, Christian references would always be part of her vocabulary; in later years, she would mark the death of friends with a double-barred cross in her diary.

Léger's large, light-filled studio was just a block from Nell's. After looking at his recent figurative works—this was the year he painted his monumental image of builders on a scaffolding, *Les constructeurs*—she was "most impressed by his organization and the rhythm he would get with a cascade of form, one into the other." Now that she was increasingly tempted to paint figures and landscapes, she told herself that her artistic hero had actually never thought of himself primarily as an abstract artist. Watching Léger teach a class of amateurs (mostly American GIs) was less inspiring; he was too "shy and disinterested."

At first, Nell usually hung out with Larry. "This boy is a dynamo," she wrote to a mutual friend.[18] A photograph shows them posing jauntily with a wine bottle in a biplane cutout at the Place Clichy street fair. She sketched him asleep—they were intimate for a while. He sketched her in a bulky coat. But as the weeks went by, the "nervous tension Larry generates" began to irritate her.[19] In any case, he was too flighty to be relied on for steady companionship. Reading between the lines of a letter in which Nell mentioned her annoyance with him—she rarely spelled out highly personal matters in correspondence— he seems to have reverted to his earlier hard drug habit, in the company of a visiting jazz musician.

Nell and Larry Rivers at Place Clichy fair, Paris, 1950.
Courtesy of Carolyn Harris.

Nell was lonely. She wrote to Jane begging her to visit "if only a month or two."[20] Most of her time was spent alone in the studio, "painting on one of seven or eight pictures"—some, abstract; others, images of people and places. *Still Life*, a painting from this period, reveals her artistic indecisiveness, interspersing curving open forms and solid black areas in a crowded, unresolved composition. When she wasn't working, she felt adrift. Accustomed to going out with a group of friends, she now ate by herself most nights at the Beaux-Arts student restaurant, where dinners cost sixty francs. That was the equivalent of little more than a quarter, she noted—a good thing, because art supplies were so expensive in Paris. In August, she took day trips to Versailles and other nearby sights on a bicycle, but the onslaught of rainy weather in autumn put a stop to these excursions.

Not being able to speak the language was a barrier to most forms of nighttime entertainment. Much as she loved movies, trying to follow the French dialogue gave her a headache. Feeling "starved for music," she saw a performance of modernist composer Darius Milhaud's ponderous, four-hour opera *Bolívar*, about the Venezuelan military and political leader Simón Bolívar. For her, it was "an exhibition more than an opera," with "wonderfully exciting" sets by Léger. They included a simulation of an earthquake in the Andes, with scenery that appeared to blow up. About to set off with Larry to a performance of Mussorgsky's opera *Boris Godunov*, she regretted that it would be sung in French.[21] At least dance needed no translation. When American Ballet Theatre came to Paris, bringing a whiff of Americana in the form of Agnes de Mille's *Rodeo*, Nell faithfully recorded details of the final night's program in her notebook.

She did meet a few people in Paris, including "an Indo-Chinese bore," an equally dull German engineer, and a "knock-out Swedish beauty" who was dating Rivers's musician friend. She had a brief affair with a man, but her major romance was with a German woman, Ali Augsberger, to whom she was intensely attracted—"enough to suffer" when the affair was over.[22] But Ali also got on Nell's nerves, by constantly talking about her father and insisting on taking photos to show him. In November, the two women visited Florence and Rome. (Perhaps at the urging of Augsberger, Nell ditched her earlier plan of traveling to southern France.) The Eternal City struck Nell as "not so lovable" as Paris. She disliked the "sickness for collecting and not selecting" that made museum visits "exhausting" and the "awful, monumental power" of ancient ruins, heightened by their "melodramatic lighting."[23] Nonetheless, she dutifully applied her tiny stippling technique to a detailed drawing of the Roman Forum on the Palatine Hill. The Palazzo Vecchio, the fortresslike

town hall of Florence, also elicited a critical review of its exterior. "Something's wrong with it," Nell was overheard muttering.[24] The room she rented that winter in Rome was damp and cold, heated with a tiny wood-burning stove. Fiesole, a nearby village, was more to her liking, with its ancient walls and gardens, and houses "built up and down the hills in rhythmic layers." Omitting any reference to her companion other than a vague reference to "us," she scribbled hasty mentions of towns visited on postcards to Jane, regretting that after "all this time, I haven't got a postcard style."

Nell reserved her innermost feelings for her diary. In a long undated entry made in Florence, she excoriated herself for her nervousness and timidity with people she met. Mentioning no names, she reviewed an affair she had had years earlier with "another sick person" when she herself was "lonely and disturbed." Feeling rejected by her lover's aloofness, Nell had unsuccessfully tried to make the woman jealous by confiding in her friends and coming on to them. The affair ended, and the friends now viewed Nell with suspicion, or so she believed. "I am a hypocrite in their eyes," she wrote. "And what a price to pay." If only she could be "casual in the beginning, casual and fond in the end."

With her intense personality, passionate attachments, and deep feelings of guilt, that would never be possible. A dream she jotted down from her European trip involved intimate simultaneous encounters with three people, each one named only with an initial, while blood streamed from her mouth and nose. With the ruthlessness of dream logic, this scene took place on North Avenue—a major thoroughfare in Richmond, Nell's hometown. In the dream, she felt guilty about Midi, her lover in New York, who was not present ("I ought to tell her I'm back"), and she had a "terrible fear" of being seen by her mother ("who sits in 2nd floor window like a mannequin").[25]

Nell sailed home on the RMS *Queen Elizabeth* in December, playing the drums with the ship's band. She arrived in New York with the equivalent of one dollar in her purse. Customs officials snatched up her copy of D. H. Lawrence's novel *Kangaroo* for scrutiny, based on the scandalous reputation of the author.[26] They took so long paging through it that she left her luggage to be reclaimed later. Unable to afford a taxi, she called Midi to pick her up from the dock, then took her up on her offer to share her room on Third Avenue—presumably because a subletter was still in Nell's loft.[27]

Born Mildred Gluck in 1920—Nell would refer to her as "a product of a broken home, an unloved bourgeous [sic] bastard child"[28]—Midi was a modern dancer and choreographer who coped with a slight deafness. She lived at the frayed edge of poverty. Someone who loaned her an apartment one summer discovered that Midi lacked enough money to buy a stamp or

make a phone call. In later years, Nell would send her money to pay for necessities and occasionally give her a painting.[29] She also served as "artistic advisor" for Midi's company in 1951, 1954, and 1956, when they performed at the Henry Street Playhouse and the 92nd Street YM-YWHA Dance Center.

As a performer and choreographer, Midi initially received critical plaudits. In a review of a program she presented in 1958, *New York Times* dance critic John Martin described her "almost peasant beauty of face and manner,"[30] an earthiness Nell would capture in drawings of her lover, nude or wearing a leotard and tights. Known for her small, precise gestures and radically pared-down movement, she choreographed solo and group works to a wide range of music, from Vivaldi to the contemporary composer Alan Hovhaness.[31] After attending her spring 1958 recital, at which the house was full and the audience enthusiastic, poet Denise Levertov called Midi "a *great* artist, at her best."[32] In the 1960s, critical reception of her work soured: one reviewer called her choreography "slow of pace, self-conscious and calculated;"[33] another chided her for "tentativeness;"[34] and Clive Barnes, chief dance critic of the *New York Times*, pronounced one of her concerts "sublimely boring."[35] Although Midi and Nell were no longer a couple by then, Nell rushed to her friend's defense, writing to the *Times* to denounce Barnes, provide a list of dance world figures who admired Midi's work, praise her "delicate but strong lyricism," and declare that she "has given her life to dance."

Despite her loyalty in professional matters—Nell would also write a Guggenheim Fellowship recommendation for Midi—she often found her overbearing personality hard to take. "You never get a sentence out of your mouth before her excited opinion presents itself immodestly," she wrote when the relationship had nearly run its course. "She is more aggressive than most men." To some extent, this was a clash between two cultures, Nell's middle-class southern WASP upbringing, in which women clothed their true feelings in pleasantries and elaborate courtesies, and Midi's origins in a struggling Jewish immigrant community, where take-charge bluntness was a survival strategy. According to Nell, Midi would heap scorn on "you Americans," who indulged in claims of being neurotic—a cultural archetype in postwar intellectual circles at a time when Freudian analysis was widespread.

Nell had a foot in those circles through her friendships with a group of poets later known as the New York School. Frank O'Hara's arrival in New York in autumn 1951 gave the group its charismatic leader. At twenty-five, a wiry, unassuming piano virtuoso and Surrealist-influenced poet with a Harvard degree, he radiated the easy sociability that soon made him a beloved figure in the downtown scene. While working at his first job, selling postcards

at the Museum of Modern Art, he began writing the poems that made him famous, the ones that crystallized moments out of the flow of everyday life in New York. He met poet James Schuyler at a party given by John Myers, codirector of the Tibor de Nagy Gallery, to celebrate Larry's first show. Nell was present, too, arguing with Willem de Kooning about whether artists were shooting themselves in the foot by taking on commercial art jobs.

Not that she had any choice; without her freelance graphic design work, she could not pay the rent. Nell worked on brochures with painter Elizabeth (Lib) Collins, a fellow student at the Hofmann School. Design, layout, type, and paste-up were Nell's department; Lib drew the cartoons. Still-life painter Alvin Ross—conveniently, her downstairs neighbor—was her partner in a layout and typography service for businesses that they kept afloat from 1951 to 1955. "I would get the job and do the layout and do the sketch, and he would do the finish part," she recalled. Ross was gay, but Nell and Jane Watrous once got it into their heads to head downstairs, totally naked, and knock on his door. "You could hear this gasp going through the place as these guys got off the laps of one another," she reminisced, hooting at the memory.[36] Nell would remark later that her nocturnal painting practice caused her to sleep through her jobs, but her diary entries show that she expended a great deal of time, energy, and worry on her graphic design work.

Nell later recalled meeting O'Hara at a party at the 14th Street apartment John Ashbery was subletting.[37] She was closest to him during the early fifties, admiring his brilliance and "insatiable appetite for life."[38] When he died, in 1966, she reflected that "a whole chunk of my vital past went with you"—the era when he and their mutual artist and poet friends "were full of excitement drive and overflowing with creative juices and ideas."[39] They went to movies and plays as a group and met at each other's apartments for drinks and conversation. In the spring, she played word games with them while they drove to East Hampton or Southampton to scout out a house to rent for the summer.[40] The poets "had electric feelings going between them, both intellectually and emotionally," she said later, "and they were terribly free in their lives and terribly interesting." Years after O'Hara's death, she wrote, "I never knew how much I loved him until then."[41] Yet she mused that he had been "unkind...more than once—the way bright sassy homosexual males are so often hostile to women."[42]

Together with their fellow poet John Ashbery, O'Hara and Schuyler were captivated by the art of their time; during the 1950s, they published reviews and articles in art magazines. Schuyler worked at the Modern, as a curator for circulating exhibitions. Nell would remember seeing him often. "His 2 sides

Nell Blaine, *Frank III*, 1952.
India ink and graphite on paper, 12 x 19 inches. Courtesy of
Tibor de Nagy Gallery. ©Nell Blaine Trust.

seem in conflict—the warm and the angry," she wrote after his death in 1991,
perhaps unaware of his struggle with mental illness. Although she liked
Schuyler and his poetry "very much," they were never close: "I found him shy
or he made me shy."[43] The fourth member of this group was Kenneth Koch, a
Columbia University graduate student who lived in Jane Freilicher's building.
He was not formally involved in the art world, but his poetry shared with the
others an openness to elements of pop culture—a radical move deeply dis-
trusted by the poetry establishment. Like O'Hara and Schuyler, though with
a more playful style, Koch was drawn to writing about ordinary things, closely
observed, and the pleasures of living in the moment. Nell admired "the good
natured pleasures he takes in what he creates," though she wished he could rid
himself of a habit of laughing self-consciously at his own jokes.[44]

According to poet and playwright Arnold Weinstein—who was Larry
Rivers's roommate on 12th Street—Nell's loft was the cradle of the New York
School of poetry: "That was the place where everybody met."[45] In 1951, when

her previous building was about to be demolished to make room for a parking lot, she had moved across the street to 153 West 21st Street, where Midi joined her.[46] Bebop records still played at her boisterous parties, campy bantering was the norm, and the guests—artists, writers, people in publishing and advertising—were often invited to settle in for marathon games of poker. Entertainment also included a roulette wheel Nell had purchased at a five-and-ten-cent store.[47]

The poets' openness to sensory experience helped ease her out of the rigid belief that abstraction was the only valid kind of painting. As a naïve twenty-year-old, Nell had entrusted her art education to someone she viewed as a supreme master, whose guidance she followed unquestioningly. (It was not until years after she left the Hofmann School that she realized how "liberating" his precepts actually were.) Then, as a member of the Jane Street group, she had upheld the banner of "pure" art with the maniacal intensity of a follower of a political fringe movement. Now, as part of a stimulating circle of creative people her age—several of them gay—who fully accepted her and enjoyed her wit and energy, she was finally free to be herself.

In the early fifties, she usually hung out with Koch, O'Hara, and Ashbery several times a week. As she wrote later, "There were so many parties, jazz sessions, gang movie going and so much gab....We moved in a pack....For awhile, Jane, John, Larry, myself, Kenneth [and] Frank were kind of a six-some."[48] What they shared, she said, was "the same sense of humor...and crazy habits, and...a great respect for each other's art."[49] Ashbery, who kept having dreams about Nell, found her "funny and amusing."[50] She remembered him as particularly wistful, compared to her other friends. In a photograph of him at one of her costume parties, he is dressed as a Pierrot figure—traditionally, a sad clown—his face set in a glum expression. Yet he was also capable of writing "an amazing triple pun" on the cast of a woman who had broken her arm.[51]

Others who joined them on occasion included Al Kresch, Edith and Rudy Burckhardt, and poet and dance critic Edwin Denby. A lighthearted spirit prevailed. "We had a lot of almost too private jokes," Nell said later. "At a poetry reading of John's, you would hear a lot of giggling."[52] Once, when she was eating lunch with Jane Freilicher on the roof of her building—where Koch also lived—he playfully locked them out while wearing the rubber ape mask he liked to use to scare passersby. There were frequent late-night group excursions to watch movies (often with smuggled-in alcohol or pot), hear Judy Garland or other singers, go dancing, or attend readings or lectures. Sometimes, the poets accompanied Nell to sketching sessions at different

John Ashbery and Nell Blaine with Barbara Epstein, Seymour Krim, and others at Nell's Halloween party, 1949.

Photo: Robert Bass. Courtesy of Carolyn Harris.

artists' studios. One weekend in 1954, Nell, Ashbery, Jane, and Joe Hazan (whom Jane would later marry) were guests at the Cornwall, Connecticut, home of Elinor Poindexter, an art collector about to open a gallery Nell would join.[53]

All this togetherness did have its limits: Nell was aware that the gay male members of the group (Koch was heterosexual) pursued a separate after-hours life after everyone else went home. But this was perfectly natural. Years later, Nell wrote to another poet friend about her surprise "that some of my sophisticated writer friends are so intolerant of the gay life or skeptical of the potential of it."[54] She named no names. The old gang's friendship endured; at Poets and Painters, an event in December 1990 at the 92nd Street Y with Ashbery, Koch, Freilicher, and Rivers, Nell was in the audience. "I thought Kenneth was so lively," she wrote, "and I loved it when he included my name"— evidently in one of his poems.[55]

Her friendships with the poets led to artistic collaborations and crosscurrents. In 1951 or 1952, O'Hara posed for a painting and charcoal sketches by Nell, who was the first in their group to paint his portrait.[56] One of her sketches shows him looking touchingly vulnerable—naked to the waist, with a cluster of dots standing in for chest hair. Schuyler would praise her pictures

in *ARTnews*, writing in one review that her figurative work suggested "Léger as Mondrian might have preferred him to paint."[57] She returned the favor, writing what she admitted was a "gushing" letter praising him for "vividly" evoking "the colors and shapes" of the paintings.[58]

For the second production of Ashbery's one-act play *The Heroes*,[59] Nell designed and painted the set—which included seven-foot-high gates of Troy on fire and a four-foot-high Trojan horse pull toy. The play is a comedy in which Theseus, Ulysses, and Circe visit the beach house where Achilles and Patroclus are living and "fall into awkward, intimate, and funny conversations about themselves and the past."[60] Also on the bill was James Merrill's "The Bait," with a set by Al Kresch, and Barbara Guest's "The Lady's Choice," designed by Jane Freilicher.[61] After the performance, all but one panel of Nell's sets disappeared, as did her preliminary sketches and paintings.[62] But she remembered the collaboration as an "exhilarating experience because the painters and poets gave each other freedom and the respect to feel their way." Thirty-three years later, Ashbery would write an evocative and deeply felt introduction to a published portfolio of her drawings.[63]

Nell's abstract work had been included in Talent 1950, a landmark show at the Kootz Gallery, selected by Greenberg and art historian Meyer Schapiro, that included paintings by Jane Freilicher, Helen Frankenthaler, Grace Hartigan, and Joan Mitchell. But now she was struggling to heed the lesson of freedom she had learned in Paris. She had refined her Purist style to the point where she felt extremely confident. Pursuing a new direction meant abandoning her comforting certainties. She later wrote that the years from 1949 to 1953 marked "a period of deep change away from dogmas of modern art toward a deeper & quieter understanding of my true nature."[64] Her style swung wildly during the early part of this period, from an awkward attempt at a domestic scene (*Sketching the Model* [1949], based on the informal sketching sessions she held at her studio) to the dense and fascinating *Chinese Landscape* (ca. 1949–50, plate 2). This imaginary terrain is rich in bright color, texture—built up with small clustered brushstrokes—and an overall sense of great forces of nature at work. But making such major changes in her work was so wrenching that it gave her stomachaches.

Nell was not a member of the Club—the artists' intellectual center, founded in 1948 in a loft at 39 East 8th Street, with panel discussions on Fridays—but she did attend a talk about Surrealism by Max Ernst, on November 9, 1951. More than half the Club's membership intersected with American Abstract Artists, which prompted barbed remarks from the audience. Although she

had no interest in Surrealism, Nell was unhappy about the schism between those who turned their backs on European art and the illustrious tradition she admired. "I felt that Ernst was an authentic and interesting artist," she said years later. "He talked about the common experience of artists in Europe, how they helped each other and worked together, and he said he didn't feel this in New York."[65] She understood that Americans had "such an inferiority complex" that they needed to break free from European domination. "But I never wanted to break from the past." Her cluttered painting *Public Square* (1951) reflects the influence of her European trip in its architectural details—it was based on her drawing of the Piazza della Repubblica in Florence—but demonstrates that she was still searching for a viable way to orchestrate a painting of people and objects in an environment.

In 1952, Nell's hometown paper featured her on the Women's Page, as a Richmonder with a "quadruple artistic career": painter, commercial artist, art teacher, and student.[66] She told the interviewer that she spent eight hours a day on her painting when she had no freelance assignments and tried to avoid doing illustration work because it conflicted with her art.[67] Her time abroad had softened her previous modernist dogmatism, she said, giving her a new appreciation for Old Master painting. Referring obliquely to dealers' lack of interest in her new work, she said, "The abstract things I was doing about six years ago are much more popular with galleries now."

Nell had joined the Tibor de Nagy Gallery, thanks to a nudge from Larry, who had begun showing there, and a recommendation from Clement Greenberg.[68] In 1953, she had her first solo exhibition, of paintings from her trip to France and Italy.[69] The gallery was just three years old, founded by Tibor de Nagy, a Hungarian émigré banker whose art collection was a casualty of World War II, and John Bernard Myers, an editor and puppeteer from upstate New York. The founders' eclectic approach attracted talented young artists working in figurative as well as abstract styles—including Jane Freilicher and Grace Hartigan—and the poets in their circle. Nell contributed nine color and black-and-white woodblock prints made between 1947 and 1952 to a limited edition of Kenneth Koch's poetry published in 1953 by the gallery, which bravely invested its limited resources in such specialized books.[70] This was one of many labor-of-love projects she would undertake over the years for poets she admired, as we shall see.

Nell's freelance work included a stint as an art teacher at a school in Queens, which ate up a big chunk of time, what with the commute and the time spent in "endless cleaning afterwards."[71] Casting about for a new way to earn money,

she began taking courses at The New School—which often hired her to design posters, at four or five dollars apiece, "barely cover[ing] about ¼ of my time."[72] Her goal was to have a credential that would qualify her to teach at an art school or college. Nothing came of this plan, but Nell benefited in other ways: studying Proust (along with her fellow painter Joan Mitchell) in a course taught by French literature expert Wallace Fowlie, and art history with Meyer Schapiro. In a class taught by Surrealist painter Kurt Seligmann, guest speakers included Harry Holtzman, a painter who was one of the founders of American Abstract Artists and an expert on the work of Mondrian.[73] Nell also audited (as ticket taker) W. H. Auden's class "Meaning and Technique in Poetry." Auden struck her as extremely shy when not standing in front of a class. She would watch him pace up and down after taking the stairs because he found the elevator too claustrophobic.[74]

In 1954, publisher Jason Epstein had asked Nell to design covers for Anchor Books. This "quality paperback" imprint, launched by Doubleday the previous year, reflected Epstein's goal of publishing affordable editions of serious books, as opposed to the twenty-five-cent crime, mystery, and Wild West novels that ruled the paperback racks. The new editions would be distinguished by better-quality paper and well-designed covers. Epstein told Nell he wanted a painter "to bring a fresh eye" to the job.[75] But it turned out to be as exasperating as most of her other commercial work.[76] After her cover for the fifth book in the series—*Studies in Classic American Literature: D. H. Lawrence*—was approved, her color choices were changed to accommodate a press run of covers in different colors, and elements of her design were altered in other ways. Offered a full-time position at the press, she declined; the job went to writer and illustrator Edward Gorey, now best known for his illustrations for the PBS *Mystery* series.

In a psychiatric studies class at the New School, Nell had met Edwin Fancher and his friend Dan Wolf, two of the founders of *The Village Voice*,[77] which debuted in October 1955. The office was an apartment above a bakeshop on Greenwich Avenue—a noisy location because of the constant stream of men calling up to prisoners at the Women's House of Detention across the street. Hired as the "design and production" staff member—in her recollection, someone else had proved too inexperienced—Nell established the weekly's original logo and layout. The job was supposed to be part-time, but, as Nell wrote to a friend, it "turned out to be full & overtime." Exhausted after working "night & day" to launch the paper, she was determined to "seek an out from so much drudgery."[78] Florence Ettenberg Janovic was the office manager, tasked with rounding up ads from local businesses so that the shoestring

publication could pay the printer. She remembers Nell as "lovely and very gracious with her time," explaining "how to set up an ad, where the headline and illustration should be."[79] Fancher, who was fond of Nell and thought highly of her painting, recalled that Wolf didn't like her design work ("He said it was too feminine") and that she lasted only a few weeks at the paper.[80] Janovic believes she was there much longer. "Dan Wolf may have been a great editor, but I don't remember him being in any way visually sensitive," she wrote. "No wonder he didn't like Nell's designs."[81] It's not clear whether she was still at the office when Midi launched her campaign of continually asking Fancher when the paper was going to review her next concert.[82]

Larry Rivers would recall how Nell "rushed from revelation to revelation, a tireless spokesperson for all her enthusiasms."[83] Now, finally plunging whole-heartedly into landscape and still-life painting, she enjoyed her contrarian stance. Abstract Expressionism was the style of the moment, but she was determined to go her own way. It helped that she saw herself as maintaining a key element of the best abstract painting. "I never thought of abstraction as divorced from nature," she wrote later. "Vital abstractions conveyed…a sense of breathing and an essence of rhythm as in growing things."[84] Beginning with tightly packed, mosaic-like compositions, she gradually began enlarging the forms and applying paint in a more sensuous manner.

A postcard from writer Seymour Krim cheered her on. He had seen one of her "new-style" landscapes at a friend's home and found it "so alive and exciting to look at…What an adventure for the eye!"[85] Reviewers were more guarded. In *Arts & Architecture*, James Fitzsimmons noted that Nell had a "strong, systematic" structural sense "and sees things comprehensively—like an aerial photographer." He praised the "rhythmic" quality of her more recent work, in her first Tibor de Nagy show, but warned that the "'floral' exuberance…could easily become prettiness."[86] The *New York Times* review described her as a "refreshing and pungent colorist" and noted the way her "conspicuously sound draftsmanship" kept her "nervous pointillism" in check.[87] The following year, her Tibor de Nagy show elicited a tepid reaction from painter and critic Sidney Tillim, who was not keen on what he saw as her Kandinsky-like borrowings; he suggested that she needed time for "search and discovery."[88] To a friend, Nell railed against the impossibility of selling pictures "without involved political maneuverings, gall and thick-skinned pushing."[89]

As she tried to develop a personal way of using the structural elements of abstraction to make paintings of real things, Nell went through several phases.

Influenced by Hélion's figurative work of the late forties, her painting *Street Encounter* (1950, plate 3) adapts his cartoonlike style to portray a scene in which a man makes a mechanical adjustment on his car amid a busy scaffolding of geometric forms representing aspects of the urban environment. This approach proved to be a dead end. Another blind alley she pursued during these years was her *Runners* series, paintings of athletes in motion. Figure painting would never be her strong point, and she virtually abandoned it in later decades.

By the midfifties, Nell would establish a more personal manner of painting, in which the contents of her studio or a landscape view were perfectly recognizable but charged with the rhythmic energy of visible brushstrokes in vibrant colors. As she said later, "I think you look at things differently after having the abstract experience. It forces you always to look for rhythms." Nell had come to realize that the impetus for her paintings was the "fleeting vibration…given off by a natural object."[90] Coincidentally—she could not have known this at the time—Bonnard wrote in 1946 that in his paintings, "everything sparkles and the whole painting vibrates."[91] Vibration would increasingly be a key element in her work, the visual hum she saw in nature that animated her brushstrokes and use of color. In *Midi and Brook* (1955)—painted while the women spent the summer in a cabin in the hamlet of Jamaica, Vermont[92]—Nell evoked the landscape with an agitated pattern of browns and greens, punctuated by the solid forms of tree trunks. Slumped over in a private reverie, Midi sits on a blanket beside the rushing water. Her bright turquoise shorts are the focal point of the painting, yet her nearly featureless face and the soft curves of her arms and legs blend in with the outdoor scene, as if she were as much a part of nature as the trees or the brook.

On January 1, 1955, Nell walked into her studio and said a New Year's prayer: "God make me a better painter (really meaning 'great')." Then she looked up at the holes in the ceiling and castigated herself for her "bourgeois desires for freshly plastered walls."[93] In her mind, artistic achievement was irreconcilable with the middle-class standard of living she had known as a child. Two days later, she was back at her commercial design work. The following night, after delivering several completed jobs, she read E. M. Forster's novel *Howards End* until 3:00 a.m., "guiltily chewing nails and enjoying the book immensely." Midi was visiting a friend, and Nell was happy to be temporarily free of her lover's overbearing presence.

Although she worried she had disgraced herself after forgetting to attend a meeting of American Abstract Artists—her sense of guilt kicking in once

again—she was "weary of crowds & lack of privacy & forcing the chatter."[94] After coming down with a stomach bug, a typical result of a bout of furiously concentrated work, she let herself be nursed by Midi, who had returned and was pleased to be needed by Nell. On January 7, still under the weather, she wrestled with the conflicts that consumed her days. "Which is more pressuring," she asked herself, "the need for bread & clothes & plumbing, or the need for the sense of spiritual (or internal) freedom which comes from painting, or the need for love [and] affection (<u>either</u> returning it or giving it)."[95] It was a question for which she had no answer.

5

A Taste of Success

IN 1956, NELL was one of twenty-one painters working in abstract or figurative styles who were singled out by *ARTnews* editor Thomas Hess as having "reached maturity" during the previous decade.[1] He had chosen work by these artists—most of whom were students of Hans Hofmann—for a group show at the Stable Gallery the previous December. In Hess's view, Hofmann had given his students an "escape hatch" that allowed them to depict real-life subjects while retaining aspects of abstract painting. Along with their allegiance to modernism, the artists had "a connoisseur's affection for...the past."[2]

The three reproductions of Nell's work accompanying Hess's essay spanned the years 1945 ([*Great*] *White Creature*, which Hess compared to the work of Léger) to 1954 (*Interior with Blue Wall*, which Hess called "summertime painting from nature"[3]). *From Watteau*, from 1953 ("calligraphic figure painting—with an old master motif"), was also illustrated in the article. Although pleased to be included in this survey, Nell pointed out that she and her painter friends—Leland Bell, Larry Rivers, Robert De Niro, Hyde Solomon, and Wolf Kahn, also singled out by Hess—did not feel influenced by or connected to any of the "older" painters he mentioned.[4] She added that she "benefited from Hofmann's teaching but not his pictures."[5]

In an *Arts* magazine review of the Stable Gallery exhibition, Leo Steinberg subjected Nell's painting *Studio Window* (also known as *Dark Window*, 1955[6]) to a tortuous analysis; he found it to reveal "intense inner strain" and "a sharp conflict of directions" that "treats us to a double inhibition of our motor impulse." The good news was that he thought her work was among the five "most real and rewarding in the show."[7] Another reviewer took a completely different tack, aligning Nell with a group of artists, including Joan Mitchell, whom he viewed as Abstract Impressionists, "rely[ing] more on optical unity as the dominant expression in their work."[8]

Nell also rated an article in *The Village Voice*. Her interviewer was puzzled that her voice gave no clue to her origins. "I know," she said. "I sound like Brooklyn."[9] Part of Nell's deliberate distancing from her roots involved losing

her southern accent; she told one interviewer that this happened when she married Bob Bass. Someone who later worked for her thought she sounded like "a little bit of Jewish New York and Brooklyn."[10] Another person who knew her in later years described her "melodic, lyrical voice" with "a kind of staccato, almost Brooklyn accent."[11] The accent comes though clearly in a panel discussion among painters recorded in 1979.[12] Another panelist, Jane Wilson, was an Iowan who had lived in New York for thirty years, yet her voice bears no trace of her adopted city.

In another sign of Nell's increasing stature, she had joined the new Poindexter Gallery on 57th Street, where she would have eight well-reviewed solo shows during the next two decades. Her first show there opened on April 24 with twenty-eight oil paintings and watercolors (including window views, still lifes, and Vermont landscapes), and paintings on ceramic tiles.[13] In the press release, her work was praised as "a fresh concept in nature painting [with] a new fluidity and freedom in response to the outside world... disciplined by the grasp of form which...has gradually evolved from a period of terse, pure abstractions." The *New York Times* critic singled out her "pictorial hedonism" and her ability to convey "the pulsating life of trees and flowers." He added, "The wonder is that so much sweet color escapes being cloying."[14] In *ARTnews,* Fairfield Porter fancifully suggested that her rhythmic brushstrokes allowed her to "turn the air and the wind into something substantial."[15]

Nell's work was also on view elsewhere. Her ink drawing *Forest* was among the 150 works chosen from among 5,000 entries for Recent Drawings U.S.A. at the Museum of Modern Art.[16] Her theater designs were part of a group exhibition at the Tibor de Nagy Gallery. The most long-lasting good news was her introduction, by her onetime flame interior designer Ward Bennett, to Arthur W. Cohen. A former Hofmann student, now a partner in the Carl Neckwear Company, he would become her most dedicated collector, visiting her studio on a regular basis to make his selections, which eventually numbered well over one hundred works.

In Richmond, Nell was featured in a local-girl-makes-good newspaper article that quoted her on the high quality of contemporary art made by women.[17] The accompanying photo showed her in a sleeveless top and shorts, setting up the glass palette she always used. "Oil painting satisfies me most as the broadest and most sensuous medium," she told the writer, adding that she also favored brush drawings with ink "for direct expressions from nature." The article included a reproduction of a drawing of a Vermont landscape that aptly illustrated the lively and luxuriant aspects of her style.

Nell Blaine, *Bryant Park* [n.d.].
Ink on paper, 11.16 x 14 inches. Weatherspoon Art Museum, The University of North Carolina at Greensboro; bequest of Arthur W. Cohen, 1992. Image courtesy of Weatherspoon Art Museum. ©Nell Blaine Trust.

Although Nell would claim that she was now able to support herself on sales of her paintings, she still needed to fill in with freelance work—most recently, teaching for the Adult Art Education program of the Great Neck Public Schools. Other artists employed by the program included Louise Nevelson and Larry Rivers, neither of whom was particularly interested in giving instruction to amateurs. Nevelson was paid forty dollars a week to teach an afternoon parent-child class and a two-hour evening sculpture workshop, in which she spent the first hour "refusing to answer questions or look at her students' efforts."[18] Rivers would recall "high ceilings, bright lights, nude models," and a retired candy manufacturer who tried to paint scenes from the Bible "with a messianic mission to forge ahead of Grandma Moses."[19] Nell occasionally also taught private pupils. One day, after setting up a still life for a student—coconut pieces in a green bowl with beets and turnips on a gray cloth—she reflected that it irked her to be spending so much time and her limited energy on supervising someone when she

yearned to paint the arrangement herself.[20] Even when the lesson went well, she fretted that teaching "breaks my continuity" and throws the studio into disarray.[21]

On February 26, 1957, Nell applied to Yaddo, the venerable artists' colony in Saratoga Springs, New York. Since 1926, Yaddo had been a productive refuge for artists, writers, and composers,[22] who worked from 10:00 a.m. to 4:00 p.m. in seclusion, according to the rules of the colony. All meals were provided, with a packed lunch delivered at noon. Hundreds of thousands of coniferous and deciduous trees, including a pine grove Nell favored, grew on the four-hundred-acre estate. The grounds also contained a rose garden with marble statuary, a rock garden with a fountain, and four lakes (which poet Elizabeth Bishop later called "awful scummy ponds"), in addition to the fifty-five-room turreted Victorian mansion where most guests stayed. There were also three smaller houses and studio cabins.

As "sponsors"—i.e., references—Nell listed Thomas Hess and artists Hyde Solomon and Elaine de Kooning. Elaine was apparently unlocatable by the admissions committee,[23] so for the third required reference, they used a letter artist Karl Knaths had sent on her behalf in 1951, when Nell had unsuccessfully applied for the first time. Solomon wrote that he was "a great admirer" of Nell's work. Responding to a question about whether the applicant was able "to work well and live harmoniously with others," he assured director Elizabeth Ames that Nell was "a mature person who gets along very well with people."[24] Hess lavished praise on her as "one of the outstanding painters of her generation in creativity...and originality of style."[25] Knaths, who had written about Nell at a more tentative stage of her work, attested to her "wholesome" personality and awareness of progressive art, calling her "one of the most promising of the young women painters."[26]

In late March, Nell received a letter welcoming her to Yaddo for the period May 16 to June 26. In a tribute to Ames after her death in 1977, Nell wrote that the director asked her to stay longer on this first visit, "and that in itself cheered me on a great deal." Nell loved just about everything about her residency: the food, the chance to hang out with interesting people—she had an affair with a painter she referred to only as "Henry N."[27]—and the amount of work she was able to accomplish. One of her paintings from this period, *Imaginary View of Mexico* (1957, plate 5), anticipated a south-of-the-border trip she would take that summer. Soon, she would stop trying to invent a landscape in this clotted, quasi-abstract way and start trusting herself to paint what she was actually seeing.

At Yaddo, poet Barbara Guest cemented what she called her "cautiously growing friendship" with Nell, describing the way she traipsed in and out of her studio "with a sort of useful freedom," radiating "pure joy."[28] For some reason, Nell was drawn to the dog cemetery at the retreat, the subject of an ink drawing she made and gave to Guest. The poet saw an eerie power in it, reflecting a "slightly sinister" aspect of the grounds. Although Guest felt that Nell treated her "as if emotionally I were rather delicate," this approach vanished during poker games, which "brought out Nell's tough side." Visiting art critic Hilton Kramer, who had hoped to spend an evening discussing art, was shocked to find a group of poker players, with Nell at the head of the table, shuffling cards. "Hilton, take a seat," she directed, flashing what Guest called "her special grin." He declined to join them.

After her stay at Yaddo, Nell traveled to Mexico City and then drove to Oaxaca with her former lover Gene Smithberg and his wife, Lorraine. Nell rented a house with a garden on the outskirts of town. Denise Levertov

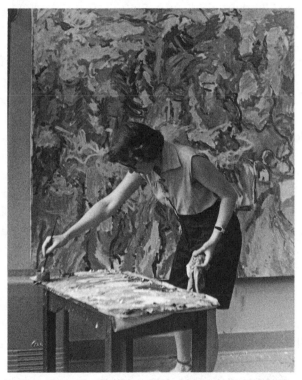

Nell working on *Imaginary View of Mexico* in her Yaddo studio, May 1957.
Photo: Hyde Solomon. Courtesy of Dilys Evans.

(whom Nell had met several years earlier through Al Kresch[29]) was then living in Oaxaca with her husband and young son. The two women apparently went to a sketch class together.[30] Years later, Nell wrote to Levertov that she remembered the trip "in a romantic haze....My own vulnerability surfaces as well as my loneliness then compared to your warm family life of that time."[31]

Still, the isolation was good for her painting. While she worked—at night, illuminated by a stack of kerosene lamps in the absence of electricity—the forms she conjured grew larger, her paint application more lavish and sensuous. She mused that her interest in both landscape and still lifes was like "everyone's need for outdoor and indoor sports." It struck her that in the still lifes, "more sweetness seems to come out and an intimist attitude toward the subject which I try to make clear and simplified."[32]

The trip was not without its dangers, in a region where the indigenous population could be hostile to tourists. One day, after joining another woman for a drive to the mountains in a Jeep, she was painting *Landscape near Oaxaca* when gunshots rang out and two men approached. It's not clear how she managed to escape. "Fortunately," she said later, "I had almost finished the painting."[33] It depicts the face of a mountain, evoked in squiggles and dashes of pale and dark green and brown that suggest the ruggedness of the terrain but make the rocks and vegetation look weightless, as if they might suddenly blow away. On the left side of the painting, a glimpse of an ethereal distant mountain range is reminiscent of the misty views in Chinese paintings.

Before leaving Mexico, Nell visited San Cristóbal de las Casas in the southern state of Chiapas, where she shopped for fabrics in the marketplace.[34] Roaming nearby villages, she noted that the men's outfits in some tribes were more "glamorous" than the women's, while the women in other tribes outshone the men. She was intrigued by the way the women would follow behind the men, all of them moving "like ballet dancers."[35] A red-painted half-gourd she carried back to New York and gave to a delighted twelve-year-old Temma Bell bore Nell's initials on the bottom ("so I would remember she gave that to me," Temma said).[36]

Clay animal sculptures from Mexico became part of the ambiance of Nell's studio, along with paintings by other artists and more than two dozen potted plants. Nell disliked what she called the "pseudo simplicity" of midcentury design, Scorning "polished woods & self-conscious craftsmanship," she chose to live with objects reflecting "personal imagination and a sense of abundance," as Edith Burckhardt observed. All were "display[ed] so that you too can see the beauty she saw first."[37] Nell wrote in her diary this summer that

"fullness & overflow"—qualities she saw even in Mondrian—were the hallmarks of "true purity."[38]

She won a trifecta of residencies this year. In September, upon her return from Mexico, she stayed at the fifty-year-old MacDowell Colony. This was her third attempt to be accepted for a stay at the retreat in Peterborough, New Hampshire. Her 1952 and 1953 applications were rejected, despite glowing accounts of her work from all her references. Tibor de Nagy director John Myers wrote that Nell's inclusion in the gallery's 1951 group show (Nine Painters) led to her work being "again and again…singled out for praise" by people knowledgeable about avant-garde art.[39] Hans Hofmann lauded not only her "great talent" but also her "great sincerity toward her work."[40] In a brief, scrawled note, Karl Knaths updated his earlier, more qualified assessment of Nell, calling her "an accomplished painter."[41] George L. K. Morris, a founding member and former president of American Abstract Artists, remarked on Nell's "unusual sense of quality" and assured the admissions committee that she was "a thoroughly nice person." Theresa Pollak—who knew the financial and family-disapproval hurdles Nell had had to jump—praised her "stamina" as well as the promising direction her work had taken in recent years, with its greater "freedom and warmth." Significantly, Pollak added that the experience of associating with "sympathetic fellow artists" at MacDowell would give Nell "a certain warmth and assurance that she needs."[42]

In 1957, Nell's references again offered high praise. Solomon affirmed that he had "the highest regard for her ability."[43] Hess added to his earlier observations his sense that her work had not received sufficient attention, "because of her reticence, and the poetic quality" of her paintings. Now that he had come to know her personally, he was also able to praise her "warm personality."[44] Elaine de Kooning wrote that Nell's work was "painting of the highest order" and added that she knew no one who had "worked more courteously and more wholeheartedly" on behalf of other artists.[45]

Nell had initially asked to arrive in mid-May to complete paintings for her autumn show at the Poindexter Gallery; after she was accepted at Yaddo for that period, she was able to have her MacDowell arrival date shifted to mid-October. (As a result, her Poindexter show was postponed until the following year.) More welcome news came in May, when she learned that she would receive a fellowship covering her month-long stay at MacDowell.[46] As was true of Yaddo, most of the people at this 450-acre retreat were promising writers. During her visit, Nell befriended poets Jane Mayhall[47] and May Swenson,[48] whose work was frequently a lyrical celebration of lesbian love.

Swenson had published her first book of poetry, *Another Animal*, in 1954. After hearing her read at MacDowell, Nell appreciated her affinity for nature and developed a crush. Nell liked to work in the woods at MacDowell; an ink drawing (*Woods*) reflects her growing ability to create a rhythmically exuberant yet recognizable landscape. While sketching, she would sometimes hear the striding poet's footfalls, which gave her a pang. After returning home from MacDowell, she mailed Swenson a color slide she took of the poet rubbing a horse's nose. Although Nell's feelings for her were unrequited, they remained friends. At Swenson's death in 1989, Nell would write that the late poems were "a little obsessed with sexuality perhaps," but that she was "a great person and poet."[49]

She returned to Yaddo in December, when she was allotted the Pine Tree Studio—a cabin nestled among tall trees—where Carson McCullers had finished writing *The Member of the Wedding* a dozen years earlier.[50] Nell loved the beauty of the campus in winter despite the two small stoves she had to "fill and coax."[51] *Pine Tree Studio*, a large, horizontal-format painting, shows an awkward lineup of furnishings, including the cumbersome heater.[52] Nell was still in the process of defining a representational style, and this picture may have served mostly as an exploratory, documentary piece. She wrote to Swenson that she liked Yaddo's undemanding, casual environment: "It doesn't say, get up there and paint *Guernica*." Nell added wistfully that on this visit, with only five other people in residence, she became "a little goofy from sheer lonliness [*sic*]."[53] But the wit and silliness of another (unnamed) artist helped her cope with dinners she thought were overly formal. It was a simpatico group, including Barbara Guest, poetry editor and publisher Donald Allen, and poet Jean Garrigue, who would become a good friend.

Nell was featured in a US Information Service press release this year as "one of the newer generation of American artists," accompanied by a photo of her painting a landscape "in her summer studio in northeastern United States."[54] The five-page bulletin included an unattributed quote from a review ("conspicuously sound draftsmanship") and reported that she had had eight "one-man" shows, "chiefly in prominent New York galleries." She was also credited with exhibitions "in leading galleries in England, Denmark, Paris, Rome, Munich, Tokyo, Munich and Honolulu."[55] In addition to the houseplants that became subjects of paintings, her work was "nourished" by her leisure activities—reading, visiting galleries, traveling, and theater- and movie-going. She liked "almost every kind of music"—and couldn't resist adding that she had played the drums in a nightclub in Paris.

Evidently responding to a question from the USIS interviewer, Nell noted that women artists had come to the fore in the mid-twentieth century, with "so many producing works of vigor and high caliber." Most interesting were her remarks about "the woman painter," who "should not be in competition with male artists," because she has "an inherently different slant." And what was that? Speaking quite obviously for herself, Nell said, "Perhaps her emphasis is on joie de vivre, a luxuriant quality." In another midfifties interview, she claimed that women's art had a particular approach, "the way things are seen and felt."[56] Still, it's one thing for an artist to make a distinction of this kind and quite another when a critic treats "woman artist" as a special category. Dore Ashton gave Nell's spring 1958 show at Poindexter a positive review, but she remarked on the "delicacy" of her watercolors and pastels, and the only artist she trotted out for a comparison with the flower paintings was Berthe Morisot.[57]

As a sign of her standing in the art world, a *Life* magazine article, "Women Artists in Ascendance," profiled Nell along with Helen Frankenthaler, Grace Hartigan, Joan Mitchell, and Jane Wilson.[58] All had "won acclaim not as notable women artists but as notable artists who happen to be women." An accompanying photograph shows Nell sitting in a seemingly careless way on the floor of her studio, staring down at a drawing. The caption, titled "Warmth and light," describes her as a lover of nature and "the light around things" who earned her living "doing layout work and teaching painting." Unfortunately, Nell is the only woman in the group who doesn't look at the camera, which makes her seem remote and self-involved, especially as contrasted with the femininity of Frankenthaler's demure upward glance, the elegance of Wilson's lounging pose, or the forthrightness of Hartigan's gaze. Perhaps Nell literally did not see eye to eye with the photographer, Gordon Parks.

Nell spent the summer of 1958 in Gloucester, renting a studio at West Wharf, a building that jutted into the water near the end of Rocky Neck. The long-established art colony on this peninsula shared its space with the fishing industry; boats docked at the harbor were both picturesque subjects for a canvas and a lynchpin of the local economy. Nell's sixty-foot-long studio—which she would later call "my largest and best studio ever"—had fifteen windows and a skylight; the porch extended over the harbor.[59] It was in this space that Rudy Burckhardt photographed her for the *ARTnews* feature "X Paints a Picture," which had previously honored such luminaries as Josef Albers and Hans Hofmann. Lawrence Campbell had met Nell years earlier when he was an art student studying on the GI Bill, sharing a studio with Larry Rivers. As a

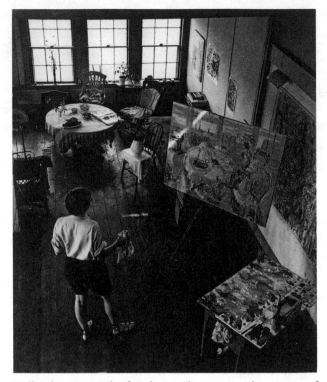

Nell in her West Wharf studio in Gloucester, with a version of
Harbor and Green Cloth.
Photo: Rudy Burckhardt. ©2018 Estate of Rudy Burckhardt/Artists
Rights Society (ARS), New York.

member of the evening sketch group that convened at Nell's 21st Street studio,
he was mesmerized by the way that "with a single bound, she attacked some
drums which she beat with ferocious energy." Now a writer for *ARTnews*,
Campbell thought of her as "a very formidable person…enormously ener-
getic…capable of doing anything."[60] When he proposed to profile her for
this series, editor Thomas Hess gave the plan his blessing.

Campbell spent days in Gloucester observing the progress of Nell's work
on *Harbor and Green Cloth I*.[61] His timing wasn't great; she was recovering
from pneumonia and the supreme annoyance of two weeks of being fogged
in.[62] But she was not going to pass up this opportunity. Campbell watched as
she "put a white pitcher [of flowers] on a white cloth on a blue chair"[63]—part
of her painstaking setup, which took nearly an hour. On the walls, in addition
to her own work, magazine reproductions of paintings by Bonnard, Vuillard,
Rouault, Monet, and other artists formed a kind of wallpaper. Among the

bric-a-brac of the studio—including books of poetry and notebooks—Campbell noticed an array of unused stretched canvases in different sizes. True to her abstract beginnings, Nell found that just looking at these empty rectangles gave her ideas for paintings. She "loves her materials and the rituals of beginning," he wrote.

He watched her work "very fast, rocking back and forth, first on one foot, then on another, brush poised, then striking and darting." After one hour, he began to see forms appear among the calligraphic brushstrokes. After three hours, she took a quick break and critiqued her work for Campbell's benefit: The forms were "too soft," the painting "simply a pleasing calligraphy." (Normally, she preferred not to analyze her output while she was working.) By now, the fog had lifted. As she continued painting, boats took shape on the canvas beyond the windows, and so did a glimpse of two boys wearing orange life jackets, an image she soon wiped out.[64]

The next day was sunny. Nell finished the picture and painted a second version that she felt was less lyrical: *Harbor and Green Cloth II* (1958, plate 6). In this canvas, she attempted to convey "more power" and a clearer sense of the relationships between objects. This sunlit view of her studio almost seems to vibrate with energy. In another, much smaller, painting from this summer, *Wharf Studio, Gloucester,*[65] she zoomed in more closely to focus on a tabletop

Nell in Gloucester, 1958.
Courtesy of Dilys Evans.

view with pink lilies in a glass and a plate of abstracted fruit and vegetables. Colorful, ribbonlike brushstrokes convey the cheerful disorder on a wicker sofa, and the top edge of the canvas reveals a glimpse of the water through the windows. A pastel drawing, *Gloucester Harbor, Dusk* (1958, plate 7), is another example of this transitional period of her style. Horizontal patterning evokes a restless sea; kaleidoscopic shards of color conjure a distant view of boats crowding the harbor. Nell told Campbell that abstraction had gone "underground" in her painting; no longer the subject of her work, it had become a means to "always look for rhythms, whether you're painting trees, a landscape, a flower, or whatever."

Later, Nell would look back on the summer of 1958 as one of three periods when she worked hardest on her painting. (The others were her stay at Yaddo in 1957 and her sojourn in Greece [see chapter 6].) "Something about Gloucester connects with my childhood, with those trips into the backwoods of Virginia," she mused many years later. "There's a wildness to the scene."[66] "Nell Blaine Paints a Picture" was published in the May 1959 issue of the magazine. That year, the Whitney Museum of American Art purchased *Harbor and Green Cloth II.*[67] In a note she sent to the museum, Nell wrote that she "tried to push further" in this version, "attack[ing] the subject with more boldness and with a different feeling about the changing atmosphere." She aimed to create "an expansive and almost joyous feeling…as *naturally* as possible."[68]

All the signs pointed to Nell's ability to secure a place in the pantheon of significant young New York artists as a figurative painter—at the very moment when her Abstract Expressionist peers were at the height of their fame.

6

Stricken

ARISTODEMOS KALDIS, an eccentric Greek American painter with a fierce allegiance to his homeland, had whetted Nell's appetite to visit a country where the brilliant light was ideal for painting. She saved small amounts of money from her freelance jobs, encouraged by news that government-run studios in Greece rented for as little as fifty cents a day. An article in a Richmond newspaper that announced the trip also noted Nell's inclusion in a "controversial" local exhibition of contemporary work. Dora Blaine, not one to mince words, told the reporter, "I liked her work better before she went to school." She was pleased that her daughter was "swinging back to realism now."[1]

In early February, after what James Schuyler described as a "cheery blow-out" Saturday night party,[2] Midi and a large crowd of friends saw Nell off at the dock.[3] She was about to set sail on the SS *Cristoforo Colombo* for Italy, the first leg of her journey.[4] The crossing was "really rough," she wrote to Denise Levertov.[5] Passengers were afraid to go to sleep for fear of being tossed onto the floor of their cabin. Traveling tourist class, Nell would sneak up to first class to visit clients of her designer friend Ward Bennett, who had paid in advance for a painting of hers, temporarily easing her financial worries.

Naples, where she slept with "a boy in hotel,"[6] reminded her of Mexico City, with "the same great Art Nouveau buildings." Ravello, a popular tourist destination on the Amalfi coast, was "too too, but very sweet." Her foreign adventure continued with a leisurely two-week cruise down the Nile. The double-decker river steamer reminded her of a "wonderful old Mississippi steamboat,"[7] with a band and other entertainment. It stopped at ports from Luxor to Aswan to allow passengers to explore the ancient ruins. Unfortunately, no one else on the boat spoke English. A photograph shows her with an elegant fellow passenger—a middle-aged woman in a trouser suit—walking on the beach in Dendera, on the west bank of the Nile. Nell, bundled up in jacket, scarf, and billowing skirt, looks away from the camera with an odd, bemused expression.

Nell with Olga von Flotow, a fellow boat passenger, in Dendera, Egypt, 1959.
Courtesy of Carolyn Harris.

After a brief detour to Istanbul, Nell arrived in Delphi in mid-March 1959.[8] The city on the southwest slope of Mount Parnassus was the sacred center of the ancient Greek world, containing the temple of Apollo, the god of many good things (including light, music, truth, and healing). He spoke through an oracle, the sibyl (most famously painted by Michelangelo as a plump matron in colorful robes, at the Sistine Chapel in Rome), whom the ancient Greeks consulted before all major undertakings. In hindsight, it's a pity she was not available to give advice to Nell.

From her studio high above Delphi, she had a dazzling view of the entire valley and the Gulf of Corinth. She marveled that the mountains were still snow-covered while poppies bloomed in the fields. But she had not counted on such unwelcoming accommodations. Only two other artists were working in the large, unfurnished building that housed the School of Fine Arts studios, and the stone floors made sounds echo ominously, "like a prison." Bundled up

in a coat and gloves, she could see her breath in the unheated space—an un-welcome throwback to her first New York studio. Looking for some local crafts to brighten the room, she bought brightly colored fabrics from a hand-some shopkeeper whom she befriended.[9] He was a "terrific dancer"—a tidbit she would pass on to a gay friend planning a trip to Delphi. Nell wrote to May Swenson about the great views from her studio. She was fascinated by the flying patterns of "a white eagle with black wings and a russet [bird] about the size of a hawk…the ace of all flyers" that looked "as thin as paper."[10] She added that she was running out of money and might have to return to the United States earlier than she had planned.

On May 1—after a brief visit to Michael Bank and his wife,[11] a young American couple who lived in Philothei, a suburb of Athens—Nell took the ferry to Mykonos. Since the 1930s, the rocky, thirty-three-square-mile island near Delos had been known in bohemian circles for its tolerance of freewheel-ing lifestyles. By the late fifties, peasants living in whitewashed huts were in-creasingly coming into contact with artists, writers, and wealthy Europeans charmed by picturesque views of fishing boats, winding pathways, and clus-ters of old windmills. A postcard with a black-and-white photograph of Petros, a local fisherman, with his pet seagull standing on the large sack he carried on his back would become Nell's "favorite Mykonos card."

Alone in a Mykonos studio as her thirty-seventh birthday neared, Nell brooded about her hopes for "a new beginning…a marker in my life." She chastised herself for the desire for power over people that led her to criticize her friends, and for her wild rages against anyone who condescended to her—especially men.[12] Dissecting her troubled relationship with Midi, she blamed her lover's irritating aggressiveness and lack of self-awareness on her desper-ately unhappy childhood.[13]

As usual, despite her unsettled thoughts, her outgoing, social self soon as-serted itself. Before her allotted weeks at the studio were up, she befriended a weaver, Vienoula Kousathana, who rented her a room above her shop and a garden shack that became Nell's studio. Friends from New York came to visit, including Arthur Cohen (who bought some of her work) and poet James Merrill, stopping at Mykonos on an around-the-world tour with his compan-ion David Jackson. A fellow Virginian, painter Cy Twombly, arrived in August and worked on *Delian Odes*, a group of drawings that were partially destroyed by local children who wandered into his hotel room.[14] Marshall Reeves Clements, a twenty-nine-year-old former ballet dancer, was another young ex-southerner attracted to the island's easygoing charms.[15] Always keen on introducing kindred spirits to one another, Nell brought her blue-eyed,

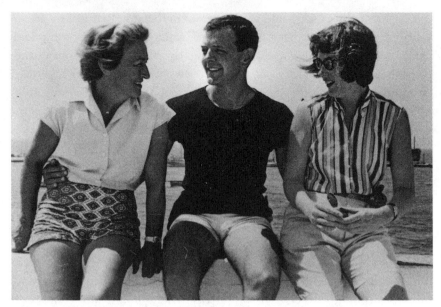

Nell with friends Flora Kriezi and Marshall Clements on Mykonos, 1959.
Courtesy of Dilys Evans.

blond friend to meet Robert Dunn, a fellow American who ran a hotel bar
where she took her meals in exchange for a painting.[16]

Clements and Dunn became a couple. They lived in Stupa House, the
sixteenth-century building Dunn was renting on the west coast of the island.
In exchange for a painting, they let Nell use a spacious, thick-walled room as
a studio and kindly agreed to her request for total silence and privacy. Now
she had a sweeping view through arched windows of the island of Delos, a
patio and porch, and free meals. As she said later, "I really never had it so
good." Beguiled by the crystalline Mediterranean light, Nell mingled violet,
green, and blue brushstrokes in rhythmic patterns evoking the optical effect
of sun on water, hills, and white-walled buildings. Aware that the drama in-
herent in the Greek landscape was all too easy to turn into kitsch on a canvas,
she painted scenes that anchor the dazzle of a distant view in the everyday
clutter of her living and working space. In *Interior at Stupa*, she captured the
look of "her favorite flaring sunset hour," with a Matisse-influenced evocation
of sensual pleasure.[17] The room glows in brushstrokes of purple, turquoise,
red, and yellow; the view through the windows abstracts the fracturing action
of light on boats in the ocean.

Her solo exhibition at the Poindexter Gallery in March and April 1960
would be composed almost entirely of paintings made on this trip, selling for

$150 to $1,000.[18] In his *ARTnews* review of this "very beautiful show," Lawrence Campbell singled out the way "the shapes of color fuse into an image more successfully than before."[19] The *Arts* magazine reviewer remarked on Nell's use of softer colors (mostly pale greens and blues) for the local landscape and the way figures and objects appear to be "momentary events" investigated by a brush that quickly "darts off...toward another discovery."[20]

Nell would later recall that the whitewashed architecture "looked like fairyland" in the moonlight, that the sunsets had "such high keyed colors," and that she could not paint outdoors "because the light was blinding."[21] Sketching outdoors was another matter. On a visit to the island of Santorini—damaged by a 7.7 magnitude earthquake three years earlier—she drew an intricately detailed hilltop view, *Churches at Santorini*. Yet after several months of living on Mykonos, Nell mused that despite painting in such an exotic environment, "I might as well be in Gloucester, Virginia, New York, Maine, etc.... because whatever is at hand seems always magical, difficult and mysterious."[22] With this casual statement, she unwittingly summed up the sensibility that infused her paintings, no matter how often she returned to the same

Nell Blaine, *Churches at Santorini*, 1959.

Ink on paper, 19-7/8 x 27-1/2 inches. Hirshhorn Museum and Sculpture Garden, Smithsonian Institution, Washington, DC. Gift of Joseph H. Hirshhorn, 1966. Photo: Lee Stalsworth, Hirshhorn Museum and Sculpture Garden, Smithsonian Institution. ©Nell Blaine Trust.

landscape view. Meanwhile, news of her critical acclaim in New York had reached the island via the illustrated article about her work in *ARTnews*.[23] Dunn helpfully parked a copy of the issue on the bar, prompting tourists to make appointments to visit Nell's studio.[24] She wrote to Denise Levertov that her return to New York was delayed because she was waiting for a Greek shipping millionaire to return from a trip and buy one of her paintings, as he had promised.[25]

In early September, Jane Freilicher greeted Nell's rapturous letter from Greece with mock envy. "There must be a few unpleasant things you can come up with," she joked.[26]

Oddly enough, there were. For some reason, Nell was feeling terribly tired, too exhausted to paint. Hoping to snap out of it, she rented a boat to a small island. When the boat docked, she jumped off—and collapsed on the shore. Shrugging off this show of weakness ("I thought, I'm really just getting old"), she returned to her studio. By now, this malady, whatever it was, had affected her mental state. The subject of her most recent painting—the last one she would make on Mykonos—was unlike any she had attempted before. Based on a magazine photograph (why had she cut it out?), her watercolor showed an athlete carrying one of his exhausted fellows after a race.

Feeling stiff and cold, and plagued by a severe backache, Nell was now hardly able to walk. Clements called a local doctor, who diagnosed the flu. A second doctor agreed. But Nell showed no signs of recovery. Frantic to get another opinion, Clements found a German tourist who was a doctor. His examination determined that she had polio, a disease with potentially crippling outcomes that were virtually unknown in Greece, where primitive sanitation gave most people immunity to the virus in infancy.[27] The polio virus enters the body through the mouth. How she caught the disease—perhaps by drinking polluted well water or from swimming in the sea—and whether her immune system might have been compromised after her bout of pneumonia the previous summer, she would never know.[28] However, there was a reason she was particularly vulnerable to the virus. The inactivated polio vaccine (IPV) required a sequence of three doses (the second one, a month or two after the first; the third, at least six months after the second). Nell did not bother to get the final one. As a result, she had only partial immunity.

Three years earlier, twenty-seven-year-old Tanaquil Le Clercq, a beautiful and gifted dancer with the New York City Ballet, had made a seemingly snap decision to forgo the polio shots administered to the company before a European tour. In Copenhagen, where friends noticed that she looked unusually thin and tired, she became severely ill after a performance. The next

day, she was paralyzed. Although she eventually regained upper-body strength, Le Clercq spent the rest of her life in a wheelchair.[29] Her brilliant career—more than thirty roles had been created for her uniquely charismatic style—was tragically cut short. In an eerie coincidence, a decade earlier she had danced the role of a polio victim in *Resurgence*, a ballet choreographed for a March of Dimes fund-raiser by company director, George Balanchine (whom she married in 1952); he danced the role of the specter of polio.[30] The charity, named for its solicitation of dimes from children, was founded by President Franklin D. Roosevelt—who had contracted polio at age thirty-nine—to find a cure for the disease and provide care for those already stricken by it.[31]

On September 22, with the clock ticking on Nell's life, Dunn got in touch with the American Embassy in Athens. Nell's friend Michael Bank, who was the vice-consul, picked up the call. He was working as a visa officer; assisting Americans with emergencies was not one of his duties. "But I was in the office when the call came in," he recalled, "an American citizen gravely ill in Mykonos who needed to be evacuated immediately. They feared she would not be able to last the eight to ten hour boat trip to Athens," the location of Evangelismos Hospital. He contacted the Greek Air Force, "but they were very wary and refused to send one of their helicopters." What to do? "I put on my thinking cap. We were friendly with Captain Scull, the naval attaché, so I called over there and explained that Nell was not only an American citizen but a personal friend. Was there any way he could send a seaplane to evacuate her? He readily agreed."[32]

Lying on a stretcher at the dock, Nell—who had still not been told of the seriousness of her illness—watched the plane repeatedly try and fail to land because the waves were too choppy. The sequence of events diverges here. Bank believes that the seaplane eventually rescued her; another version has Dunn and Clements, huddled in a phone booth, hiring a helicopter (an unlikely scenario, Bank said, considering the dearth of civil aviation in Greece at that time).[33] According to this version of the story, when the helicopter arrived, the pilot refused to let her board because no Greek doctor had signed off on an evacuation document. Frantic with grief, Flora Kriezi, another friend of Nell's, burst into tears and demanded that he take her. The pilot relented, and Dunn got into the helicopter with her. Whichever aircraft she wound up flying in, she arrived in Athens in a perilous state. Her blood, depleted of oxygen, gave her skin the deathly blue cast of cyanosis. She was hallucinating, close to death.

Evangelismos Hospital had a staff doctor who was familiar with polio and—even more crucially—the only iron lung in Athens. This device, which kept a polio patient alive by simulating normal breathing, was a seven-foot-long, seven-hundred-pound steel drum that encased the patient's entire body from the neck down. A motor lowered the air pressure, forcing the patient's chest to expand—letting air flow into the lungs—and then raised the pressure to produce an exhalation. Unlike normal respiration, the machine "breathed" according to a rate set by a doctor.[34]

A few days later, after a tracheotomy that cleared her lungs and allowed a breathing tube to be inserted, Nell was moved to the US military hospital, where a newer iron lung model had been dispatched from Tripoli. She remained in it for seventeen days while Dunn and Clements took turns by her bedside, reading to her and writing letters to her art world friends. Decades later, when Dunn was dying, Nell called to tell him that he had given her "the gift of life." She would never forget his gesture of putting a flower on her iron lung.[35] Meanwhile, someone at the hospital sent her mother a shockingly bleak telegram: "Condition worse. Her recovery is questionable. Prognosis poor."[36]

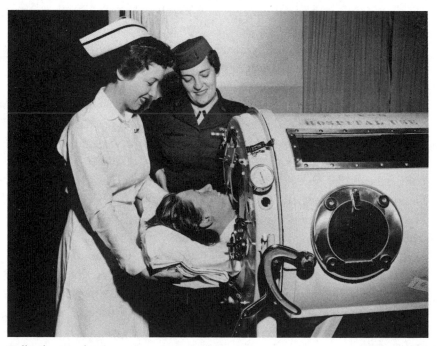

Nell in her iron lung, 1959.

Photo: Irving Kaufman. Courtesy of Carolyn Harris.

Nell was almost completely paralyzed below her neck, with the exception of her left hand, which she could move slightly, and the fingers of her right hand. She was unable to swallow and in constant danger of choking. In two weeks, her weight had dropped from about 137 pounds to a skeletal 90 pounds, and she had lost control of her bodily functions. "There was like a hole where my stomach was," she recalled later. "The pain was so great I felt like I was burning alive."[37] (Pain medication could not be administered for fear of interfering with her labored breathing.) She hallucinated a hatchet chopping her leg and a bird pecking at her. "I was convinced that two nurses had abducted me for some macabre medical reason," she said.[38] Another nightmarish vision featured a black box with the paintings she had done in Greece repeatedly sinking into the sea.[39]

Yet, in a merciful form of compensation, Nell also experienced "a strange euphoria," which she attributed to the intercessions of friends. People she had met in Greece visited her at the hospital. They apparently opted to forgo wearing the mask the hospital required—to shield them from Nell's still-contagious disease—so that they could talk and read to her. When she was at her worst, a doctor from Boston whose name she never learned stayed up all night to oversee her care.

During these weeks, flowers—a get-well gift that had a special resonance for this passionate lover of blossoms—and "tons of mail" arrived from her friends at home. Jane Freilicher mailed a money order to Athens "for some little extra you may need," masking her shock and concern with hopes that "the old Blaine guts, stamina and perseverance" would save the day.[40] Denise Levertov claimed to know someone who had polio and "made a wonderful recovery, one would never know."[41] Frank O'Hara sent an upbeat telegram from the "CFM Rooting Society" in care of Dunn.[42] Edith Burckhardt wrote a heartfelt note, telling Nell, "New York isn't the same without you."[43] Composer Stefan Wolpe mailed her a "lucky stone." When the news reached Tom Hess, vacationing on a yacht in the Aegean Sea, he let Nell know that he had gotten in touch with "a very nice group of distinguished Greeks" whom he hoped would facilitate her return to the United States.[44]

Seven people—technicians, nurses, and a doctor—accompanied Nell on a US Military Air Transport plane, a "flying hospital" with a small iron lung bolted to the floor. In Wiesbaden, Germany, she spent three days in a full-size iron lung. Barbara Fussiner, Michael Bank's sister—who had known Nell in New York—was living in England at the time, and she traveled to the hospital to visit Nell. "I remember being so struck with her wish to go on painting," Fussiner recalled. "The only things she asked me to buy were art postcards.

There were mirrors in the iron lung that allowed her to see them."[45] As soon as she was sufficiently stabilized to travel across the ocean, Nell was flown to McGuire Air Force Base in New Jersey. Able to breathe on her own only for forty seconds, Nell had to be calmed down before the transfer from the hospital's iron lung to the one on the plane.[46]

On October 14, the plane touched down after an eighteen-hour flight. A group of Nell's friends was waiting in the rain to greet her as she was hoisted down to the tarmac, encased in the iron lung. She was immediately admitted to Mount Sinai Hospital in New York, where she would spend eight months in the Jack Martin Polio Respirator Center—nearly as long as her time in Greece—as the oldest person in the ward. At first, doctors were not certain whether she would live. She had bulbar spinal polio, the most severe form of the disease, which affects muscles controlled by the spinal nerves as well as the cranial nerves responsible for breathing, swallowing, and speech. Gradually Nell regained her breathing ability, beginning with five minutes a day; eventually half her diaphragm was restored. For the rest of her life, the loss of the other half would sometimes leave her breathless. "If I hadn't had a strong heart and a strong stomach, I would have died," she said later. "Because everything else was nearly gone."[47]

The day after Nell was admitted to Mount Sinai, her mother told a Richmond newspaper that she was waiting for the doctors to tell her when it was "wise" to visit. Dora Blaine told the local press that Nell's recovery was likely to be "rather long and drawn out," but "she has an indomitable spirit and that's going to help."[48] Worried friends of Nell's kept sending letters inquiring if there was anything they could do. Referring to her departure from Greece, William Kienbusch joked that Queen Frederica "never got that kind of sendoff."[49] With her note, Elaine de Kooning enclosed a talisman: a tiny painting of a bull.[50] Pauline Hanson assured Nell that "the good Catholics here are praying you into a fine recovery. And I...pray my pagan prayers."[51] Nell's devoted collector, Arthur Cohen, would either buy a painting or just send her money every month during her hospital stay.

As soon as she was allowed guests, her friends rushed to the hospital. Midi took the bus uptown every day to check on her. Jane arrived with comfortable cotton outfits and assured her that she was looking stronger. Edwin Denby brought her fancy canned goods. Rudy Burckhardt fixed up a rotating cylinder with the text of Jack Kerouac's On the Road so that Nell could read it in the iron lung. Dan Flavin—later famous for his light sculptures, but a painter at the time—came to the hospital to visit his twin brother, David, who had a severe case of polio, and struck up conversations with Nell.[52] (She could talk

only during the moments when air was expelled from her lungs by the machine, which made for somewhat stilted communication.)

Although some hospital staff did not look kindly on the constant stream of visitors crowding the L-shaped ward, Dr. Avron Y. Sweet "was determined not to deprive us," Nell said later. The Respirator Center director was "tough but just and a very caring and skilled doctor."[53] His innovations included insisting that the patients be fully dressed; he told family and friends to bring brightly colored clothing, Dr. Sweet had the ward painted in "beautiful primary colors"—a gesture that was particularly cheering to Nell. He even allowed patients to smoke, going so far as to have an engineer rig up a device that would hold the cigarette. At appropriate intervals, "he forced us out of bed whether we felt like it or not," she recalled fondly.[54] Nell also praised the other doctors on the ward, because they "consider the whole patient, not just the disease."

Dilys Evans, a twenty-two-year-old English nurse, began working at Mount Sinai in late January 1959. As a teenager, she had wanted to become an artist. Her father's response was "Girls get married; boys go to college." So she devised a roundabout plan to get to art school, inspired by a newspaper ad offering nurses free passage to America. Confident that her high marks in biology would stand her in good stead, she completed her training at Dudley Road Hospital in Birmingham in August 1957. The following July, Dilys successfully applied to a program that provided guaranteed employment at Mount Sinai. Meanwhile, after rejecting a doctor's proposal of marriage, Dilys had become engaged to a lawyer. As she recalled years later, "My friends said, 'He's a big deal and he's handsome.'" But the spark was missing. Feeling "bored out of my mind," she broke with him before she came to New York. After her shift at the hospital was over, she took night courses at the Art Students League—which led to her transfer to the polio unit to care for Nell.

When Dilys first stepped into the polio ward, she was taken aback by the deafening whoosh-whoosh of ten iron lungs running simultaneously. "You won't hear anything in another minute," the head nurse assured her, explaining that her brain would quickly adapt to the decibel level. Spotting Nell's head sticking out of an iron lung, she moved closer to her patient. "Oh boy, are we going to get on," Nell said. "You're gorgeous." Dilys recalled that Nell was "smiling the whole time, looking forward to my taking care of her."[55] Still believing that she would be entirely cured, she was in a good humor, cracking jokes despite her incarceration in a metal tube.

"When I could see she was beginning to move her legs," Dilys said, "I opened one of the portholes," breaking the vacuum seal. "Nell was talking about May Swenson, de Kooning, the Village—she's babbling. Then she said, 'I'm getting a little tired.' I said, 'You've been breathing on your own for fifteen minutes.' And she screamed with joy. 'We're going to get along, girlfriend!' she said."

On October 30, Denise Levertov visited Nell and learned that she could be removed from the iron lung for increasingly long periods. She was able to move her left hand and arm, and the fingers of her right hand. Levertov was obviously willing herself to understand that "little though it seems," this news was significant. "She is extraordinarily courageous—full of humor & spirit," the poet wrote to a friend. "What a future to face. But I think she believes in her recovery."[56] Finally, it was time to swap the iron lung for a shell respirator, a metal dome that fits over the chest and abdomen. The next step was moving Nell to a wheelchair, with a positive-pressure respirator—often used in firefighting—supplying a flow of oxygen. "As soon as she got all those muscles back, we got her transferred into a regular [hospital] unit," Dilys said. "She was bright and funny and could put up with all sorts of things."

But one thing made Nell furious: despite her progress, she was told that she would never paint again. That prognosis was simply unacceptable; painting was her life. "Look," she said, "if I can move my hand, I can paint!" Seeing long faces around her, she insisted, "If I can't paint, I will write."[57] Enraged, she dismissed a social worker who suggested that she learn basket weaving. Weeks after she entered the hospital, Nell used her left hand, which shook violently, to try to draw with a Magic Marker. Her right hand was useless, leading her to yell and curse with frustration. With Dilys's urging, Dr. Sweet talked her into undergoing an operation that would transplant muscles from another finger to her right thumb. This allowed her to hold a pen and pencil. Then, as she said later, the doctors on the ward "realized I needed privacy and rigged me up a private studio with curtains."[58] After a late November visit, Levertov reported that Nell had been drawing with her left hand and was "just" able to hold a pencil in her right hand.[59] A drawing of flowers in a vase was her first postpolio work. Clotted webs of lines scribbled with a marker captured more than a hint of Nell's rhythmic facility. With a ballpoint pen, in shaky script, she wrote: "For Dilys N Blaine."

Because of the atrophied muscles in her right arm, Nell would have to train herself to produce oil paintings using her left hand. She was still unable to write with it, but she could scribble, which gave her the hope that she could eventually paint with this hand. "It took another year to begin to be a little

Nell Blaine, untitled drawing of flowers, 1960. Inscription:
"For Dilys N Blaine."
Black marker on paper. Courtesy of Dilys Evans.

adept at that," Dilys said: another year of daily, punishing work. It took two
years before Nell was satisfied with her left-handed paintings. Meanwhile, she
kept up a brave front, assuring an interviewer that she would "become ambi-
dextrous in time and will invent gadgets to help me....If I'm not able to do
large paintings, why then I'll do small ones."[60]

In December, her friends rallied again, donating their work to a benefit
exhibition at the Poindexter Gallery, organized by Hess, Elinor Poindexter,
and Leslie Katz, publisher of *Arts* magazine. Pieces were contributed by sev-
enty-nine artists, including Willem and Elaine de Kooning, Larry Rivers,
Helen Frankenthaler, Hans Hofmann, Jane Wilson, Hyde Solomon, Robert
Motherwell, Saul Steinberg, Robert Rauschenberg (his piece was titled *Well
Nell*), Lawrence Campbell, former Jane Streeter Frances Eckstein, sculptors
Ibram Lassaw and Richard Stankiewicz, and Nell's close friends Jane Freilicher,
Robert De Niro, Louisa Matthíasdóttir, Leland Bell, and Al Kresch. Priced at
fifty to six hundred dollars apiece, the works sold briskly, raising enough

money to support Nell for the next two years. In *ARTnews*, Hess wrote that her "freshness of touch and insight has brought a sense of youth, gaiety and summer to the often lugubrious New York School."[61]

It was customary to send recovering polio patients to Goldwater Hospital on Roosevelt Island. This institution was advanced for its time, with a caring staff, windowed wards, solariums, and a terrace that allowed patients to get fresh air. Desperate to live on her own, Nell refused to go there, unwilling to be shunted away from the life she knew. But crucial aspects of that life had changed forever; she would now require the constant assistance of helpers to enable her get out of bed, use the toilet, wash, dress, and move about in the world.

Chuck Close, a painter best known for his large-scale portraits, had to make similar huge adjustments when he was suddenly incapacitated by a spinal stroke in 1988, at the peak of his career. His work was already selling at high prices in a hot art market, enabling him to afford a specially equipped van, expensive alterations to his studio, and the salaries of helpers. Nell's paintings sold at modest prices; making enough money to live on and support her own helpers would be a never-ending struggle. Bob Bass, her former husband, kindly offered to marry her again and look after her, but she knew that was not the solution.[62] Girded by her childhood experience in overcoming disability, she would summon the courage and "natural optimism that somehow horrible things will turn out all right" to retrain herself to paint at the highest possible level.[63]

Nell's walk-up apartment on 21st Street had served her well, but it was no longer practical for someone in a wheelchair. According to Dilys, a young woman working as an orderly at the hospital overheard two of Nell's friends—Leslie Katz and Judge Mary Conway Kohler—discussing her situation. "My boyfriend is house painting in a building on the Upper West Side that has a view," the woman said. Katz and Kohler liked what they saw and signed the lease. Al Kresch's recollection is that his wife and Midi Garth were the ones who found the new apartment, on the eighth floor of a building with an elevator on Riverside Drive. There were three bedrooms and bathrooms, a spacious living room, and a kitchen. A ramp was built for Nell's wheelchair on the 93rd Street entrance of the building.[64] Ward Bennett, her interior designer friend, modified the kitchen and the living room; with its view of the Hudson River, it would become her studio. Nell would move in during the summer of 1960.

"I was with her for a little bit longer until the end of my stay came up," Dilys said, referring to the expiration of her visa. Before her departure, on February 3, 1960, Nell presided over a going-away party at the 21st Street

apartment. The guests were poets and artists, including Edwin Denby, May Sarton, Jane Mayhall, Robert De Niro, Hyde Solomon, and Jane Freilicher. When Dilys arrived, she walked under a banner that proclaimed "Bon voyage Dilys come home soon." Fifty-seven years later, she recalled her awe at seeing the room "jam packed, full of [leading] artists. I walked in, and there was this huge cheer. There was dancing. Nell said, 'Do you want to dance?' I took the brakes and one of the pedals off her wheelchair and I danced her around. Everyone was clapping and dancing." Nell already anticipated Dilys's return. "When you come back you'll work for me," she said. "We'll go to Paris, Rome. My artist friends are there." Dilys assured her, "It's a deal."

During the eight months Dilys was in England, Nell missed her terribly. On a copy of the flyer for her spring Poindexter Gallery show, she scribbled a note to Dilys about the birthday presents she'd sent, adding that she had been "out of the respirator about week & ½ no more machines!"[65] In a letter urging her to return, Nell enclosed a check to pay for the trip. Dilys was equally keen to rejoin the woman who was so much fun to be with and who had introduced her to notable people in the arts. "We have so many peaceful quiet moments ahead looking at photographs, reminiscing, learning about each other," Nell wrote to her. "And so I can't wait.... These days I cannot contain myself and my longing—Oh love!! Life begins the fourth of October"—the date Dilys's boat would dock. "Keep that boat sailing on & on."

Back in New York at last,[66] Dilys began helping Nell learn how to walk in leg braces by gripping parallel bars attached to the long, narrow corridor in the apartment. Temma Bell recalled her parents discussing whether it made sense for Nell to continue with these exercises. She ultimately decided that the immense effort needed to try to retrain herself to walk was draining energy she needed for her painting. Resigned to spending the rest of her life in a wheelchair, she focused on adapting her physical limitations to her art. She was now able to paint watercolors with her right hand, but she had to use her stronger left arm for oil painting.

"Obviously, I had to...simplify my style," Nell told an interviewer. "But as a painter friend of mine said, 'You were too complicated before.'"[67] While some commentators prefer the earlier work, the postpolio paintings display a new brilliance and freedom. They reflect Nell's joy at rediscovering the nuances of color and light and the infinite variety of the natural world—sensual delights charged with a new awareness of the fragility of life. Years later, she explained that the joyfulness of her work stemmed from being able to "caress [the world] in the act of painting." Unsaid was her new inability to caress it literally, unless it came to her in the form of cut flowers. It was not that she

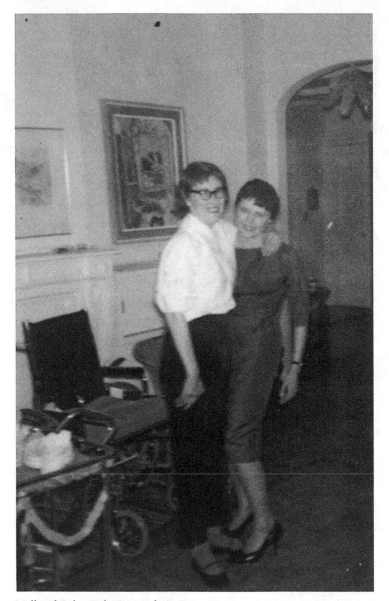

Nell and Dilys at the Riverside Drive apartment.
Courtesy of Dilys Evans.

was blind to malign forces in the world, but rather that she needed "to be one with nature…to be one with what you love."[68] It was this psychic embrace that made life worth living.

"One night," Dilys recalled, "I'm putting [Nell] in bed, taking the foot leads off the chair, standing her up—we stood knee to knee—before she landed on

the bed. It was a particularly wonderful evening with her poet friends, but we were both tired. She started saying, 'Wasn't it funny,' and the next thing I knew, she had her arm around my neck, pulled me down, and kissed me. I said, 'Wow what was that all about?' She said, 'Give me a five'— a high five. This was kind of shocking at first. [But] in the weeks that followed, I fell in love. That was beginning of my fulltime living with Nell. She and I were lovers. I couldn't imagine I was a lesbian; I had thought, 'that's disgusting.' But it was the most incredible thing."

7

Love and Work

COMFORTABLY SETTLED in her spacious apartment on Riverside Drive, Nell was drawn to the view from the front window. It overlooks the arc of building façades curving around Riverside Park, with its promenade and gardens, and the temple-like Soldiers and Sailors Monument fronting the Hudson River. A watercolor, *Hudson and Ice* (1960, plate 9), marked her triumphant return to making art. Flashes of green and orange—deftly abstracting the optical effect of the setting sun on the river—interrupt the choppy horizontal bands of variegated blues. The sky takes on the colors of a bruise. Together, water and sky almost palpably evoke the frigid atmosphere of a dying day in winter. This panorama would remain a source of pleasure throughout Nell's life. Always attuned to the quality of light, she observed that "winter and spring on the Hudson...bring wild sunsets and iridescent ice floes."[1] Contributing to that wildness was "the crazy light" that tinted the tree trunks orange and pink, and painted the buildings "a brilliant, illuminated salmon, when they had been very drab before." Describing this effect to an interviewer, Nell exclaimed, "And at that moment I go mad."[2]

Word of Nell's recovery reached Richard Ellman, James Joyce's biographer, who wrote to tell her that he and his wife "have always admired your work greatly and so we were pleased that you were able to paint once more."[3] According to another fan of her work, Nell was initially "worried that her left hand could not tap into her creative force and express what she wanted on canvas."[4] But she gradually regained her painting skill during the early sixties, with the serendipitous difference of increased spontaneity—at least partly due to her intense gratitude at once again being able to live in the moment.[5] In *Summer Time, Saratoga* (1961), a faceless woman (Dilys) sits on a blanket in a wooded setting indicated by foliage and ground cover in shades of green, yellow, and pink. Like *Midi and Brook* of 1955 (plate 4), this painting showed Nell's lover in a pastoral setting. But the forms are much looser, revealing Nell's ongoing struggle to regain control over her brush. Years later, she recognized

that no longer being able to rely on her right-handed facility allowed her to develop a broader, less technically virtuosic way of painting with her left hand. Her right hand now proved capable of coaxing extraordinary beauty from the watercolor medium. *Trees at Saratoga* (1961, plate 10) evokes the shimmering quality of midsummer light on the landscape with a flickering medley of dark and pale green leaves, anchored by ghostly brown tree trunks and one that is magically cloaked in sunlit violet.

Nell was in the throes of a heightened passion for painting. She wrote that "some little aspect of a subject," like "the kind of light that falls on a leaf," would lead her to set up her easel: "I feel a direct connection with the city, with plants, and everything around me."[6] Yet this connection was tempered by a new set of circumstances. Painting outdoors, once a carefree act, now involved time-consuming navigation and placement of her wheelchair and the apparatus necessary to hold her paints. Still lifes of flowers arranged in her apartment allowed her to paint directly from nature when an outdoor excursion was not practical. While northern light is the painter's ideal—because it is a cool, indirect illumination, not subject to shifts in brightness during the day—the window facing the park was a sunnier southern exposure. This was not a problem for Nell, who usually worked on still lifes at night and in the small hours of the morning, illuminating the canvas with a combination of full-spectrum "daylight" bulbs and incandescent lights. Night was always her best time for the state of "aloneness" she required, an abandonment to the rapture she felt when fully engaged with a picture. "I must be in a state of readiness to enter nature," she wrote, describing this as a "secret domain" in which her eyes, breath, and blood were "opened to pleasure." To warm up, she reverted to her jazz practice: "Often I am 'drumming' while I get rhythm in the brush.... Suddenly everything is quiet and I know what to do!"[7] Throughout her life, rhythm was Nell's governing element, whether in the process of painting or in organizing her life. She would feel nervous whenever there was "a break in rhythm," often caused by the presence of other people when she needed to work.

A physical therapy practice called "standing transfer" allowed Dilys to "waltz" Nell from her wheelchair to a car and back to the wheelchair by supporting part of her weight while helping her pivot into the seat. But before the Americans with Disabilities Act of 1990 mandated specific changes in public places—from curb cuts to wider bathroom stalls—wheelchair users had few rights. They were often unable to navigate streets,[8] ride in taxis (public transportation being out of the question), or enter public restrooms. Taxis would

often roar past a disabled person; even if one stopped, the driver might have clutter on the front seat that he would not remove to accommodate a passenger. For Nell, attending a friend's gallery opening or a party had suddenly become a laborious and costly expedition. She was sometimes obliged to write an apologetic letter explaining that she couldn't get there unless "a friend happens to be free and also interested as vitally as I am."[9] In later years, when she acquired a secondhand Cadillac, a male helper she hired usually served as the driver, but if a meal was involved, she had to foot his bill. One year, Nell traveled to an art jurying event in the city by ambulette—a paratransit vehicle—which proved a frightening experience. The speeding driver ran over curbs while turning, making it hard for her to stay upright. Also, as one of her doctors explained, unlike some people with polio, "she had full sensation" in her legs; if she was placed in an uncomfortable position, she would be in pain. Restaurants posed problems of their own. When the front door happened to be wide enough for her chair—hardly a given—Nell often encountered waiters who refused to look at her. Even going to the movies was rendered more difficult in a wheelchair. She had to sit adjacent to the front row, in the aisle—where people were liable to step on her feet. Yet despite all these difficulties, Nell was determined to resume a semblance of her active life.

An early personal triumph was her arrival at the February 1961 opening of her solo show at the Philadelphia Art Alliance during a raging blizzard. Three months later, she was one of several notable painters in the Creative Process exhibition at The New School; the others included Josef Albers, Elaine de Kooning, Arshile Gorky, and Jack Tworkov.[10]

In October, a *Cosmopolitan* magazine article about women artists "who have recently achieved great success" featured Nell along with painters Joan Brown, Elaine de Kooning, Helen Frankenthaler, Grace Hartigan, Sonia Gechtoff, Ethel Magafan, and Ethel Schwabacher and sculptors Lee Bontecou and Louise Nevelson.[11] The paragraph about Nell, illustrated with her photo and a reproduction of her painting *Friends at Mykonos*, led with a mention of her polio attack and the generosity of artists who offered their work for sale to raise money for her. However irritating it may have been to have her disability highlighted in this manner, Nell was always keenly aware of the power of positive publicity. As if to counter any doubts about her current state of mind, her quote is upbeat. "I feel a kind of hedonism," she said, "the pleasure of connecting with the outside." Once again, she looks away from the camera. But this time, she is smiling.

In September 1962, Nell received a welcome boost to her finances: a benefit exhibition and sale of her work at Yaddo (a rare instance when the colony

was opened to the public). In addition to eleven pictures from her time in Greece, the show included a sampling of landscapes, interiors, portraits, and still lifes—nine of which were painted this year. In a heartening sign of renewed interest in her work, Chase Manhattan Bank purchased two of her landscapes of Nyack, New York. Nell described the Yaddo opening as mostly "full of elegant (above 40) ladies (in old lace)...a world apart."[12] Her cheeks ached from smiling at her benefactors, she wrote to May Swenson, who had purchased a watercolor, *The Pink Field*. Afterward, Midi, Jane Freilicher, and Leslie Katz joined Nell and Dilys at a bar for more relaxed festivities. Midi would always be one of Nell's most loyal friends, but the two women were no longer intimate.

Despite the outpouring of affection that greeted Nell's comeback, it would take some time for her postpolio work to be valued as the equal of her work of the 1950s. Her solo show at the Bliss Gallery in Richmond that fall included several recent works, but the earlier pictures commanded considerably higher prices.[13] Still, she was keen to have her work seen wherever possible. A group exhibition called Art as Gaiety opened at the Terrain Gallery in New York in early November, with Nell among the sixteen artists. Her quote in the brochure—she "didn't know of any paintings that come off without [gaiety], even if the subject, as in Goya, doesn't seem gay"—suggests that she was struggling to make an authoritative statement about the show.[14] Toward the end of the year, Dora Blaine swooped down on Nell and Dilys for a week, providing another opportunity for positive thinking. "She came laden like S. Claus," Nell wrote to a friend, "each package wrapped more ingeniously than the other. All was old fashioned & cozy & friends joined us to devour a huge bird." But her visit made it impossible to do any work: "No peace when she is around—all is chatter-boxing!"[15]

Nell's return to visibility in the art world continued in August 1963, when the Zabriskie Gallery gave her and the late painter Jan Müller[16] a two-person show. The following month, twenty-five of Nell's paintings were shown at the prestigious Knoedler Gallery,[17] along with work by her friends Louisa Matthíasdóttir, Leland Bell, and Hyde Solomon. The catalogue contained a pretentious screed by Leslie Katz, who selected all the work (Nell had recommended the artists). Katz excoriated current styles in art—without naming them—in order to praise the integrity of the artists in the show, who accepted "adult challenges" and "reckon[ed] with difficult challenges of beauty."[18] The exhibition had an ulterior motive: it was a shot across the bow to the Sidney Janis Gallery (across the street from Knoedler), which had held a groundbreaking show of "New Realists"—including Pop artists—the previous autumn.

The renown of the Knoedler Gallery brought out an army of critics, nearly all of whom responded positively to Nell's work. *ARTnews* reviewer Lawrence Campbell praised the "explosions of controlled and synthesized color experience" that gave Nell's paintings their "freshness and vitality."[19] In the *New York Post*, Irving Sandler pronounced the new work "fresh looking and beautiful";[20] in the *New York Herald Tribune*, John Gruen remarked on how each interior and landscape was "gorgeously put together."[21] *Arts* magazine writer Martica Sawin noted that "the quality of the illumination gives one a very specific sense of time and season, and...the suggestion of imminent change, even an accompanying nostalgia."[22] The *New York Mirror* called Nell "freedom's child personified, highly Cezannesque yet with an arresting idiom all her own."[23] An anonymous writer at *Newsweek*, who seemed to know Nell personally, praised her work as "a triumph of loving attention to reality, by an artist whose constant laughter covers an intensity that is more than a match for the random absurdity of misfortune."[24] But the *New York Times* reviewer choose to view her as "the more feminine" of the two women painters in the show, an artist who "chooses less forbidding subject matter, focusing her entirely affectionate attention on flowers and interiors."[25] This was a limited and patronizing view of her work that she would have to combat for the rest of her life.

Marshall Clements, Nell's friend on Mykonos, was now working at the Phoenix Book Shop in Greenwich Village. Robert Wilson, another friend of Nell's, was the proprietor. Born in 1922, he served in the army during the war after earning a degree in English and American literature from Johns Hopkins University. He was the unhappy manager of a cuckoo clock factory when Clements introduced him to the shop, which he bought in April 1962, bolstered by his interest in "the four authors whom I had collected in a serious manner: Mencken, Hemmingway [*sic*], Stein and Marianne Moore."[26] Like Nell, he was close to many of the downtown poets and was a stamp collector.[27] In late 1963, she offered him a drawing in exchange for her "pillaging" of his duplicates and mentioned her forthcoming departure for Yaddo. She had written in her application that her goal was to be able to complete work for her fall solo show at the Poindexter Gallery, and she hoped vacancies remained for May and June. Instead, she was accepted for January and February.

Unlike her earlier stays at Yaddo, this one was hedged with practical difficulties. From October to December, she had a protracted exchange of letters with Elizabeth Ames, the colony's director, about selecting an appropriate studio and preparing it to accommodate her wheelchair. Although no family

members or friends were allowed at Yaddo, an exception was made for Dilys, who was needed to tend to Nell, and who was planning to do some painting of her own. Ames suggested that the women could use three rooms on the first floor of West House, including a bedroom with "pretty good northern light" and an en suite bathroom.[28] An added ramp would make it possible for Nell to move from the porch adjoining one of the bedrooms to the road. Dilys could prepare Nell's breakfast in the "old" West House kitchen, and a staff member would deliver dinner in a covered basket at 6:20 p.m. Able-bodied guests ate those meals together in the dining room, but in the midsixties, it was not navigable for a wheelchair user. (Lunch was traditionally delivered to each studio so as not to interrupt the working day.) Fortunately, there would be no problem getting to the library, where Yaddo residents gathered in the evenings during the winter months.

Nell replied with detailed information about her special needs, including a tiny sketch of herself in her wheelchair with measurements of each side. She also requested that Dilys sleep with her rather than occupying an adjacent bedroom. Nell's explanation sounds plausible: she sometimes needed to be turned on her side in the middle of the night, or have the covers shifted, to keep the pressure off her "bad toes." Also, if she had to call out to Dilys in another room, it would be hard for them both to get back to sleep. When they "experimented" with putting their beds close together the previous summer in Gloucester, she wrote, "to my delight," Dilys would usually awaken with "no memory of having done anything but sleep soundly."[29] However important this issue may have been, explaining it was a strategic method of ensuring her nighttime intimacy with her lover. Freeing up the second bedroom also gave Nell a large studio and avoided the need for her to breathe paint fumes as she slept.

On November 7, Nell wrote that her image of Yaddo was keeping her "from flying apart." Arriving in early January 1964, when the colony was buried under a foot of snow, she began working on still lifes and landscapes. Towering fir trees on the property may have reminded her of the tall pines on the Virginia coast that so impressed her childhood self. The paths were cleared quickly, and Dilys later recalled having little trouble pushing Nell up a couple of steps to a building. ("Everybody was always saying, 'Can I help?'")

Nell's painting *Studio in the Afternoon* captures the rumpled, casual feel of everyday life at Yaddo. As her friend Howard Griffin observed, her paintings of rooms with a window view have "the feeling of a certain snug, contained, affable atmosphere."[30] Dilys, wearing a brightly colored outfit, reads on a sofa bed covered with a red spread next to an easel holding a portrait of herself.

Nell Blaine, *Fir Tree (Yaddo)*, 1964.
Ink on paper, 22 x 15 inches. Weatherspoon Art Museum,
The University of North Carolina at Greensboro; gift of
Arthur W. Cohen, 1983. Image courtesy of Weatherspoon
Art Museum. ©Nell Blaine Trust.

For some reason, both her "real" face and her painted one are featureless; Nell
had also left the faces blank when painting Midi and Dilys years earlier, but
they were small figures in large landscapes. Here, Nell may have used this
device to create a more generalized image that would preserve her lover's pri-
vacy. Dilys's kicked-off shoe lies on an expanse of blue carpet; towels dry on a
table next to the radiator, under the window. In contrast to the brightly lit
matter-of-factness of the interior, the outdoor view—bathed in the light of an
unseen moon—is of snow-laden fir trees and eerie blue and purple snowdrifts.
Nell would always paint snow in this manner, perhaps because she had never
outgrown the novelty of seeing it for the first time in her early twenties.

In late February, Nell wrote to Wilson, expressing her pleasure at
"escap[ing] 2 months in hectic New York City" and revealing that her "new
vice is ping-pong." Composer Ned Rorem and poets Galway Kinnell[31] and
Jean Garrigue were among the other paddle-wielding players at Yaddo that

winter. Nell was still at the snowbound colony in early March when Rorem wrote in his diary about "smiling Nell Blaine who gives me drawing lessons *a la Redon*, and sympathetic Dilys Evans who admonishes us, in a Welsh accent, not to smoke."[32] He tried his hand at a still life on this visit and was critiqued by Nell. "She told me to have more fun, to think bigger," he recalled. "She said I was too concerned with detail in the flower and not enough with the canvas I was going to cover."[33] Before he left Yaddo, Rorem presented Nell with a score he had dedicated to her. On her return to New York, there was more good news. She had won an award from the Longview Foundation,[34] and the director of the Worcester Art Museum chose a painting she completed toward the end of her stay at Yaddo for the permanent collection.[35] But a new problem loomed.

Although Dilys had received a visa extension from the Immigration Department on September 15, 1961, she learned in early 1962 that she would be deported unless she voluntarily left the United States, because she had remained in the country "for a longer time than permitted." She was ineligible for an immigrant visa because, as an exchange visitor, she was subject to the two-year foreign residence requirement of the Immigration and Nationality Act. Happily, the women had a guardian angel: Judge Mary Kohler, a strong-minded, devout Catholic who had taken on Dilys's cause as a personal crusade. The following spring, her behind-the-scenes work resulted in an extraordinary

Nell with Jean Garrigue and Ned Rorem at Yaddo, winter 1964.
Courtesy of Dilys Evans.

bill (HR 9054 "for the relief of Dilys Evans") that was making its way through Congress. It stipulated that Evans be granted permanent residence in the United States, because her departure "would impose extreme and undue hardship on her paralytic patient, Miss Nell Blaine, due to the difficulty of finding an adequate replacement nurse capable of performing the special and complex services Miss Blaine requires."

The report accompanying the bill stated that Dilys "not only assists Miss Blaine to function physically in her daily effort to overcome severe handicaps, but also helps her to earn her livelihood and to maintain her career as a prominent painter." Tasks that Dilys performed were listed as "arranging her pigments on the palette, set[ting] up the easel, canvas, and subject, show[ing] the paintings, act[ing] as Miss Blaine's agent in arranging for exhibits, and other aspects of carrying on her career." The crucial element of Dilys's assistance was emphasized: "It is no exaggeration to state that without this specialized assistance and encouragement, Miss Blaine would not continue her struggle to resume a useful life and to fulfill the promise of her notable talent." Should Dilys be obliged to return to England before Nell "has had an opportunity to replace her," she would have to consider leaving the country with Dilys, "thereby run[ing] additional risks to her delicate health because of possible vulnerability of lung infection and other problems of poor health and wheel chair [*sic*] confinement in the cold climate of the British Isles." Congressman Leonard Farbstein appended a letter "earnestly request[ing] that Miss Evans be permitted to remain in this country."[36]

The House of Representatives passed the bill on May 15, 1962, but it stalled in the Senate. By early 1964, with no resolution in sight, the women were planning to leave for Europe in mid-April. Grants from the American Federation of Arts, the Art Students League, and the Ingram Merrill Foundation would finance the trip.[37] In July, Nell's doctor wrote a "to whom it may concern" letter attesting to her "good condition." Nell had always been an enthusiastic traveler, and disability was not going to keep her from a new adventure.

8

Travel and Turmoil

BOB DUNN, Nell's friend in Mykonos, who was now working for a New York travel agency, arranged the women's passage on the *Queen Mary*. Before they sailed, Dilys visited the ship with a tape measure, dodging other people's bon voyage parties, to make sure the cabins were the right size. They would be boarding with twenty-two pieces of luggage. Among them were a large trunk and the bulky items Nell required, including a special toilet seat and a lap-board for her typewriter. They would soon regret traveling with such a burden, which became even greater with the addition of paintings made en route and Nell's collections of heavy items like shell fossils. In a postcard to Edith Burckhardt—who had divorced her husband and was living in Rome—Nell inquired if she had seen any houses in the city with cheap rent and views "and no steps and lovely first-floor bathrooms."[1]

On April 15, 1964, Jane Freilicher drove Nell and Dilys to the dock, where Dunn was waiting to escort them through the boarding process. From the ship, Nell sent Elizabeth Ames a letter thanking her for an "inspiring" stay at Yaddo, which was both "fruitful and stabilizing."[2] She noted happily that the rocking motion of the ship didn't affect her. But she hadn't bargained on eating three meals a day at a table where a retired dentist who was a John Birch supporter spewed nonstop right-wing views. Most of her shipmates in "cabin class"—the level between first and tourist class—struck her as little different from the close-minded people she knew back in Richmond. So she was especially grateful to be alerted by Galway Kinnell that poet Robert Bly, traveling tourist class, would be on board. A photograph shows her smiling in her wheelchair next to the looming figure of Bly, seated at a table with Dilys and Bly's wife, Carol. "When we spoke with Bly," Nell wrote to Ames, "within two minutes fresh air cleared the mind."[3]

After the ship docked in London, the women made their way to the plush Rubens Hotel, down the street from Buckingham Palace—a far cry from the humble apartment where Nell had stayed in Paris on her first European trip. She wrote that she could "feel the glamor" of living so close to the queen and

Nell on her way to Europe, April 1964.
Courtesy of Dilys Evans.

"kept expecting to see a furtive figure slip out incognito into the corner pub."[4] Days of rain did not get in the way of sightseeing; Dilys had pushed her to the Tate museum and back in a downpour that stopped while they looked at the paintings by J. M. W. Turner and Pierre Bonnard ("which stole my heart completely") and started up again just when they were ready to head back to the hotel.[5] One morning, a blast of music from the Queen's Guard band served as their alarm clock. Nell believed this serenade to be a hopeful sign, since she heard that the band did not play in bad weather.

The next stop was Burton Bradstock in West Dorset, where poet Howard Griffin—a well-heeled American friend of Nell's, who had been secretary to W. H. Auden before settling in England[6]—invited the women to stay at Darby House, his country home. Situated in a valley a half mile from the English Channel, the village was an unspoiled realm of thatched cottages and a parish church with carvings dating to the fourteenth century. Every other weekend, Griffin came down from London to take Nell and Dilys on a drive. An excursion to Stonehenge was a highlight of her time in the English

countryside; she later recalled falling under the spell of the ancient monument's "mystic persuasive power." In her view, Brancusi was the only modern sculptor whose work evoked the same quality. Nell did not get as much painting done as she had hoped, but the weather was fine and the countryside "divine," with "plenty of flowers, ducks, sea gulls…big rolling spaces…many Saxon remains and a terrific coastline."[7] Yet it was the smaller-scale sights, especially Griffin's garden, that she chose to paint. *Dorset Garden*—loosely rendered clusters of iris and narcissus pushing up against the picture plane, with abstracted farmhouses in the distance—was one of the first of her long series of garden views.[8] In a drawing, *Dorset Garden with Blackbirds*, two birds in a small clearing are surrounded by an exuberant all-over pattern of stalks, leaves, and flowers.

News from Manhattan was slow to reach the village. Months later, when Nell heard about the Harlem Riots in July,[9] she wrote to Robert Wilson that the city had become "a dangerous cesspool." In contrast, life in Dorset was "very calming & nourishing," and she felt "rested physically and mentally."[10] Nell had taken up bird watching, delighted at the detail afforded by binoculars. Her new hobby gave her a pop-flavored segue—"birds" as slang for "women"—to some trivia on her mind: Didn't Wilson say that Capucine (the model turned actress who starred in *The Pink Panther*) was a drag queen?[11]

After returning to London in September, Nell and Dilys moved on to Paris in early October. Thanks to scouting work by Kinnell—armed with a piece of string as long as the width of Nell's wheelchair—they stayed in a charming hotel a block from the famous Café de Flore, former hangout of French intellectuals. Nell wrote to Elizabeth Ames that Dilys was pushing her "mile after mile" along the streets of Saint-Germain-des-Prés.[12] At a museum, Nell would point at a painting and tell Dilys to walk toward it and think about it. Then she would quiz her: "OK, you're on." Dilys, who was learning to paint, appreciated this unique tutorial in art, with an emphasis on Léger. For Nell, the "high point" of the trip, as she wrote to Lee Bell,[13] was a visit to Hélion's studio, where he showed her "lots of fine pictures." He also took a lively interest in the lithe young Englishwoman. "I think I love you," the artist announced to Dilys. "Take off your blouse."[14] Nell quickly set him straight: "She's taken!" Dilys remembered thinking, "I guess Paris has officially begun!" This impression was confirmed when she was offered a glass of wine—in the morning. Just before they left, Hélion gave Dilys three watercolors. On October 28, the day they were to leave for Madrid, the women woke up late and were frantic to get to the airport. Taxis whizzed by. One finally pulled over, and they hurriedly got in. Dilys happened to look back as the taxi drove

down the street and saw a familiar object on the sidewalk: the special toilet apparatus. "Bon voyage, cheri!" sang the unflappable Nell.[15]

In Madrid, they stayed at the centrally located Hotel Nacional, near the Prado. Apart from the museum, which they visited every other day, this leg of the journey was "a nightmare," Nell wrote to a friend. When the women dined with Kinnell and his wife in a restaurant, "a sweet old man fell dead after serving us & Dilys tried desperately to save him." It was, she noted wryly, "one of our few gala nights out."[16] Toledo struck her as particularly stimulating. The highlight of her visit to the city was El Greco's *The Burial of the Count of Orgaz*, in the Iglesia de Santo Tomé, which she admired for its "great scale & authority." Struggling to make out the details of other works in dimly lighted churches, she rejoiced to find this majestic painting clearly visible.

After a fortnight in Lisbon, the women flew to the island of St. Lucia, where a small house was under construction on the 450-acre banana plantation owned by Nell's dealer, Elinor Poindexter, and her husband, a commodities broker. [17] Largely covered by forests on rugged hillsides, St. Lucia is part of the archipelago of Eastern Caribbean islands, stretching from the Virgin Islands in the north to Trinidad in the south. The biodiversity is staggering; decades later, the island still had 151 species of trees.[18] But in the early 1960s, before the rise of tourism, St. Lucia was a poor country with an economy almost entirely dependent on agriculture.

Airplane travel always presented myriad problems to Nell, what with a paucity of ramps for entry and exit, tiny restrooms, and callous or uncomprehending personnel. But she and Dilys hadn't anticipated the challenges they would face during the eleven months they spent on the island. They had no car, and the house, perched on a hillside overlooking the Anse Galet Valley, was thirteen miles from the nearest town. There was no water or electricity, and scorpions, tarantulas, and deadly fer-de-lance vipers lurked on the path down to the sea. The women were in constant danger of contracting bilharzia, an infection caused by a flatworm that lives in subtropical water. For many weeks, their lives were disrupted by noisy, quarrelsome workmen working on the house and constructing a road on the mountain. In late July 1965, Nell wrote to her friend Bob Wilson about being "harassed again (4 weeks of it) with the construction of hurricane doors, drain repairs and floors being sanded, stained, & varnished." Dilys had to remove everything, including paintings and supplies, from the rooms where the floor work was in progress. As a result, Nell wrote, "painting is always being interrupted in the most frustrating & uncontrollable ways.... We will become professional injustice collectors before long."[19] In September, she sarcastically described the tortuous

pace of road building, "pebble by pebble crushed for our personal pleasure [from] 7 AM to 4 PM in our ear."[20]

Nell kept up a lively correspondence with Wilson, partly about stamps and the books she had bought from his shop. In this letter, she offered qualified praise for Frank O'Hara's *Lunch Poems* "immediate, fun, clear, bouncy and unpretentious if unambitious." She was less enthusiastic about a book of poetry by James Merrill (probably *Water Street*, 1962), calling it "slight," but wished she liked it better because Merrill was a kind acquaintance, and she had received two life-saving grants from the Ingram Merrill Foundation, which he established in the midfifties. Among her requests from the bookshop were the latest novel (*Landlocked*) in Doris Lessing's *Children of Violence* series, new editions of Gertrude Stein's experimental novel *The Making of Americans* and Henry Roth's *Call It Sleep*, and Kinnell's second book of poems (*Flower Herding on Mount Monadnock*).

During the summer and early fall months, Nell and Dilys waited until the afternoon, when the heavy blanket of hot air lifted slightly, to garden, read, or paint outdoors. "We rush to work before the light fails," Nell wrote. Her new subject was the Font des Serpents, "a mysterious mountain." Crowded with coconut palms and banana trees, it was visible at the far end of the valley below their house. The other end of the valley offered an alternative vista: "a wedge of sea, a postcard view featuring great multicolored sunsets over the Caribbean."[21] Painting outdoors was difficult. Nell once explained to an interviewer that the fact that light comes from many directions posed a technical challenge. To keep the light from shifting on her work, small pieces of cloth and paper needed to be attached to the umbrella she always used to shield herself from the sun's rays; staring for hours at the white canvas had once given her sunstroke. Despite her concentrated focus, interruptions of various kinds, especially people talking, were liable to shatter the intense privacy she needed to commune with nature. Yet, she added, "things that happen in and around nature … like birds and snakes [could be] very stimulating."[22]

Gardening took on a new aspect on St. Lucia, where seeds that were supposed to take four weeks to germinate, according to the packet, would spring up in a few days, and papayas, mangoes, and avocados were ripe for the picking. Nell's passion for birding reasserted itself, what with exotic species to observe and describe in fulsome detail to correspondents who cared about such things. "The strident, dissonant voice" of the St. Lucia grackle was the sound she associated with the island, along with the nightly syncopated chorus of tree frogs and locusts.

Intrigued by the shells people in Dorset used to line their flower beds, Nell began making a shell collection on the island. Some came from children whom she paid a penny or two for a handful. She purchased several varieties of conch and other large shells from a local fisherman and filled a notebook with drawings of their intricate whorls and frilled edges. His prices were high, but she was "charmed by his handsome smile and stories."[23] A snapshot Nell mailed to May Swenson shows her at a long table with dozens of shells neatly lined up in shallow boxes. Swenson had sent her a poem, probably "On Handling Some Small Shells from the Windward Islands," written the previous June. Apologizing for taking so long to send a letter, citing the energy-sapping tropical weather, Nell thanked her profusely. "Whenever I study my shells more thoughtfully," she wrote, "a line [from the poem] pops into my mind—especially when we find a wonderful fragment which reveals the inner spiraling which is so complex."[24] (The poem contains the lines "The curve and continuous / spiral intrinsic, their / role eternal inversion, / the closed, undulant scroll."[25])

Nell told Swenson that when she had read her poem to Moses Henry, the islander who managed the estate, he asked if she could make a copy for a friend of his. She had become aware of the extent of ignorance and illiteracy among the population when Lennards Lamontagne—the young teenager Nell employed to do yard work, help around the house, and push her in her wheelchair—told her he had never heard of Africa. She befriended him, taught him to read and write, and paid for him to attend mechanics school. One day, Lennards came to Nell with a story he wanted to tell her. "Everybody on the island know you," he said. "They all talk. They say she very rich lady in all the world, because she has so much money she don't ever have to walk again."[26] When Lennards turned fifteen, Nell and Dilys threw a party for him. He seems to have held her in high regard: a houseguest offered $100 for the birthday card Nell had made for him, but he refused to sell it. His mother, Marie Lamontagne, who worked as the women's cook-housekeeper, was not so amiable. Some of her outbursts at the women seemed to come out of the blue. Once, when she grew angry over what they considered a trifle, it was right after Nell (for unknown reasons) had bought her a Bible; she wondered half-seriously if a leader of the Obeah folk religion had "put a hex on her."[27]

To relieve their sense of isolation, Nell and Dilys hosted a number of houseguests, including Arthur Cohen, Nell's major collector. In a postcard inviting Galway Kinnell to visit, Nell mentioned that other friends of hers (painter Lib Collins and her husband, Pete) had enjoyed their stay, which included a ten-minute walk down a "charming" road to a "peaceful" beach

where "nobody goes…except us and a stray kid."[28] She asked Kinnell to bring linseed oil, refined turpentine, and a tube of paint—items she had used up after months on the island. After he left, she wrote that his visit seemed to have been "a whirlwind affair of sightseeing, shell looking, talk & poker."[29] His short poem "In the Anse Galet Valley," published in his collection *Body Rags* (1965), commemorates his stay with an evocation of the landscape at nightfall.[30]

Left to their own devices, the women amused themselves with a battery-operated phonograph and records. Radio offerings—mostly French rock and roll—were not to their taste. "We miss vulgar things like TV, movies & the modern museum," Nell wrote, "(not Pop and Op tho)."[31] At Christmas, always an important holiday for Nell, she and Dilys decorated a flamboya tree. Marie kindly corralled twenty local children to come and sing carols in English. "But we liked it best," Nell told an interviewer, "when they lapsed into songs of their native French patois and danced."[32]

Soon after the workmen left the house, the rainy season started, causing landslides and washed-out roads. She was alarmed to see what appeared to be black heads and bodies churned by the rushing waters of the flooded river; to her relief, they turned out to be coconuts. "Tons of earth & rocks broke loose from our cliff behind the house and then water poured over the gutter & onto the back porch," she wrote to Kinnell.[33] Rain gouged "tiny river beds" in the garden. Helpers with brooms worked for several hours to clear the living room of "small tidal waves" of water.

Unable to venture out to explore the terrain, Nell wound up painting the same view over and over. Yet, as she said later, her responses to changing atmospheric conditions gave each image a different quality. The tropical setting reinforced Nell's interest in allowing light to act "as a springboard for color." When people asked how she could paint "anything as lush as the tropics," she threw their question back at them: "How can you not paint them when you're there?"[34]

Tropical scenes had caught the fancy of several Western artists of note in the nineteenth century, for a variety of reasons. Paul Gauguin spent most of the 1890s in Tahiti, intent on escaping the intrigues of Paris. In his paintings, the landscape elements serve mostly as a vivid frame for Symbolist images of local women. Matisse visited Tahiti in 1930, sketching, swimming, and exploring the landscape in his pith helmet. His *Lagoon* cutouts from the early 1940s display the brilliant colors of the island; a few years later, he made two huge screenprinted hangings—*Oceania, the Sky* and *Oceania, the Sea*—that evoke his memories of tropical birds, coral, and undersea creatures. In 1952–53,

near the end of his life, he again recalled the island paradise with an abstracted image of a ship and a banana tree in *Memory of Oceania*.

Winslow Homer, who wintered in the Bahamas, Cuba, Bermuda, and coastal Florida during the 1880s and 1890s, used watercolor to evoke the atmospheric effects of bright, undiffused sunlight on calm seas and water roiled by turbulent storms. Martin Johnson Heade, who traveled to Brazil in 1863, followed by trips to Nicaragua, Colombia, Panama, and Jamaica, painted exquisitely detailed close-ups of tropical birds and flowers in landscape settings. Among contemporary artists, Peter Doig, a Scot (b. 1959) who grew up in Trinidad and returned decades later, is noted for capturing the stark white light of the tropics in seemingly serene figurative paintings that have an undertone of disquiet.

Unlike those artists, Nell—specifically drawn to the rhythms of nature— focused on lush, jostling swaths of vegetation. Even when a landscape was essentially large-scaled and dramatic, she would usually focus on a corner of it—probably due to both her nearsightedness and to her inability to wander freely around the steep terrain. In her painting *Anse Galet Valley*, a scrutiny of different leaf shapes is the main event, not the view of distant hills. Similarly, in *Garden and Font des Serpents, St. Lucia* (1965, plate 12), clustered green forms within a garden nearly crowd out the sloping hills and volcano. What she lacked in exploratory range she made up for in sheer intensity. Nell's physical limitations led her to imbue the natural features of St. Lucia that were available to her with a heightened sensitivity to color and pattern—whether these sights were as small as a speckled fish on a plate or as immense as a cedar tree rising above a tangle of exotic plants.

Despite Nell's closeness to Lennards, Marie, and the shell seller, she was uncomfortably aware of the hostility of some local people to white tourists. A former resident of the island living in England sent a threatening letter: "Americans, Anse Galet Valley, my spies are surrounding you. The day of your death is in my dairy [sic]." The terrified women kept a machete under their bed.[35] Another ongoing concern was Nell's relationship with her New York landlord, who threatened legal action because of the long duration of this trip. (She was required to live in the apartment at least six months of every year.) The upshot was that she was given a deadline of October 31 to resume her tenancy. In early August, Nell wrote to Kinnell that their homesickness "gets worse as getting a ship home gets harder."[36] What with the increasing heat, the bugs, the "unreliable workmen," and a recent outburst from Marie, Nell joked that she was ready to take "a private plane or a battleship—anything

at this point." A month later, after Dilys's visa application was filed, the consulate in Barbados announced that she might not be able to return legally to the United States until November 1966—more than a year later. This prospect led the women to consider traveling to Canada and applying for a visa from there.[37] By now, they were extremely anxious to return to their life in New York. Dilys, Nell wrote, was "quite low in spirits."

The consular issue was soon resolved, and the women were free to return home. But leaving the island was not a simple matter; ship officials would claim that their vessel could not accommodate Nell's wheelchair, probably as a way of sidestepping any responsibility for a would-be passenger with polio. In October, Dilys finally wrote a "to whom it may concern" letter explaining that she was a registered nurse and polio therapist, and that the wheelchair was "a new model equipped with two strong brakes," able to pass through a twenty-four-inch-wide doorway.

Nell's Poindexter Gallery show in April 1966 included eighteen still-life and landscape paintings completed in St. Lucia and a quartet of Dorset canvases, plus watercolors and drawings. There was also a quirky portrait of Dilys leaning on the back of a chair. The critics were enthusiastic. In the *New York Herald Tribune*, John Gruen wrote that the landscapes "have an exuberance that never fails to communicate Miss Blaine's love for nature at its most restless and colorful." He perceived that "she managed to make a virtue of pictorial density, breathing air into heavy jungle foliage and drenching whole mountainsides with brilliant color."[38] In *ARTnews*, John Ashbery noted that "different 'families' of colors are distributed over the surface like groups of solo instruments in an orchestra. But colors which seem to echo each other often differ vastly in intensity and saturation, resulting in an exciting counterpoint."[39] Good notices aside, costs associated with framing, advertising, catalogue printing, and postage came to $3,000, most of which Nell had to pay. Only half joking, she vowed to mail out postcards for her next show and send out her pictures "naked" (with no frames).

In July, Nell was one of Frank O'Hara's many grieving friends who learned of his death at age forty; in a freak accident, he was struck by a taxi on Fire Island. She managed to get to his funeral in the Springs, on Long Island. Recalling her feelings for O'Hara, Nell asked Robert Wilson to send her his books of poetry.[40] She would contribute a city rooftop lithograph to *In Memory of My Feelings*, the memorial volume published by the Museum of Modern Art.

A far more painful shock had already occurred. After Nell's aide left in early May, she fretted that "not one person" wanted the job, despite the

eighty-five-dollar weekly salary. On May 22, she wrote to a friend that Dilys, who now had to perform the aide's duties, had pulled a muscle in her back, "but still stoicly [*sic*] works on. So we cut down on going out and cooking."[41] Unbeknownst to Nell, Dilys had fallen in love with another woman. A few days later, she suddenly moved out. Nell was inconsolable, writing obsessively in her diary for months afterward. It was "a period of nightmare."[42]

9

Embracing Sensation

MIDI TRIED TO CONSOLE NELL during a weeklong stay at Arthur Cohen's summer home in the East Hampton neighborhood of the Springs, famous for its population of artists. But nothing could relieve the pain of losing Dilys. In early October, Nell wrote forlornly to May Swenson, "It has taken me until now to realize that Dilys & I are really kaput—a dreary fact I could not accept."[1] Later that month, weeks after she collected her last box of belongings, Dilys visited Nell. Her initial pleasure at seeing her former lover soured when Dilys wanted to take the painting of a Greek woman Nell had given her and pressed her for money. Nell was shocked at how "hard, ambitious (career-wise)" Dilys had become. The rupture had made her question her judgment; now she asked herself whether what she saw in Dilys was in fact a new development.[2] When she made out her Christmas gift list, she wrote "cancel!" next to the *ARTnews* subscription she had planned to give her. The following April, Nell would return Dilys's stamp album.

In January 1967, Midi filled in for an aide who didn't show up and helped Nell unpack the shells she had gathered on St. Lucia, which she finally felt able to do "without too many painful emotions re D."[3] But two days later, suffering from menstrual cramps and feeling depressed, she confided to her diary her "anger & resentment & old wonderment" about Dilys's behavior.[4] She had "believed in her and would have done anything for her." The next day, the pain resurfaced: "It awakens me in the morning and seizes me before I'm strong and myself."[5] She would return to this theme six months later, accusing Dilys of "hav[ing] her eye on American citizenship, nice apt [apartment] and a better and easier life. She cared for me but the glamour of my life played a large part in the attraction."[6] In an effort to sort out her feelings about her lover, Nell was seeing Dr. Herbert Peyser, a psychiatrist affiliated with Mount Sinai Medical Center, which had saved her life seven years earlier.[7]

Carolyn Harris was a young painter who had fled her hometown of Raleigh, North Carolina, for the freedom and opportunities of Manhattan. She studied

at New York University and supported herself with editing and proofreading, and a job in the collections department of the Museum of Modern Art. In 1961, she decided to try living in gay-friendly San Francisco. Among her friends was Nell's friend Dick Brewer; as Carolyn wrote later, they liked to complain to each other about "the cultural backwater he thought we were stuck in." Back in New York in December 1965, Carolyn returned to work at the Modern. Brewer came to visit the following summer and wangled an invitation to dinner at Nell's apartment on July 19, 1966, for the two of them. As Carolyn later recalled, Nell's attendant Mattie "rose to the occasion and produced an exotic stew, a stifado."[8] Nell said that Mattie was "totally unreliable, but in the plus column sassy and always ready for a good time." It was clear to Carolyn that "the dependent one lived at her mercy." More visits followed, with Carolyn bringing samples of her work as well as loaves of home-baked bread and an Osmiroid fountain pen. By early 1967, she had moved in. Now, she wrote, "our lives were entwined."

Carolyn Harris, 1960s.
Courtesy of Carolyn Harris.

Like Nell, Carolyn—who was born in 1937—had found her vocation early in life "with the first intoxicating whiff of a new box of Crayolas." Other youthful interests included movies and architecture: a child who lived next door helped her lay out floor plans in the yard, marked with bundles of pine needles. Carolyn grew up in the port city of Wilmington, North Carolina, the eldest of three daughters whose father called them by nicknames. Hers was "Butch" or "Sport." When she was ten years old, the family moved to Raleigh, where the high school offered daily classes in painting and art history. At the Women's College of the University of North Carolina, Carolyn fell in love with an English major, Bertha Harris, who was possibly related to her. Bertha was known as the campus troublemaker, but one Sunday, when she had a medical emergency and the campus doctor was playing golf, it was Carolyn who fell afoul of the administration. Without consulting anyone, she took Bertha to the emergency room of the town's largest hospital and demanded that she be admitted. Carolyn remained on the outs with the university, allowed to be on campus only in the daytime. There was a showdown with the dean, but her father supported her with the present of a car, "a beautiful green Packard." Clarence Lee Harris would soon know what it was like to be in the crosshairs of controversy. On February 1, 1960, four African American students from North Carolina Agricultural and Technical College sat at the lunch counter of the Woolworth's in Greensboro, where he was the manager. Told to leave by a waitress—the counter was understood to be "whites only"—they refused to leave their seats. Nearly six months later, after continuing sit-ins in the store and similar actions in cities across the country, Harris finally asked four of the store's black employees to change into their street clothes and order lunch, effectively desegregating the counter.[9]

The two women left for New York the day after graduation, in June 1959. Bertha Harris became a novelist who would later coauthor (with Dr. Emily L. Sisley) *The Joy of Lesbian Sex*.[10] By the fall of 1961, they had parted ways, and Carolyn had grown weary of "hopelessly grimy" New York. She took a bus to Oakland, California, and began to frequent the "low-lit underground watering holes" of lesbian culture in San Francisco. She would remember "gay bars…wild as the frontier when the music got louder and the bartender herself stomped from one end of the bar to the other, dodging beer glasses and ashtrays." With her new lover, Alice Jeung, Carolyn fell under the dreamy spell of sinsemilla, the seedless flowering tops of the marijuana plant. (Years later, when Jeung came to dinner one night, Nell deemed her "most pleasant."[11]) Eventually, Carolyn got a part-time night job at the bookstore at the San Francisco Museum of Art, which left her weekdays free for painting

or exploring the many scenic spots of the Bay Area with Jeung. Back then, before the onslaught of mass tourism, it was possible to feel that Yosemite was your own private place. Deciding to leave this comfortable life was wrenching, but Carolyn felt that her work—"a mostly mystical, exhausted mode"— was not going in a good direction. It was time to return to a more demanding metropolis.

In New York, Nell's influence helped shift Carolyn's focus to landscapes that drew on her strengths as a colorist, but the relationship involved tremendous sacrifices. "Nell wished I were anything in the world but a painter," Carolyn said many years later. "So I always had a studio outside this apartment, whether I could afford it or not, and also to store [my] paintings."[12] Her painting always had to take a backseat to her lover's celebrated work. Nell even told her that she could not exhibit in New York.[13] On the face of it, this proscription makes no sense. Nell surely had sufficient faith in the strength of her own work, and Carolyn developed a distinctive style of her own, building up her evocative landscapes from broad juxtaposed strokes of color.

But Nell was unable or unwilling to abandon her ferociously competitive spirit. It was the same impulse that let her to exult over every poker game victory, even against inexperienced players. After a game in which she roundly beat a friend's college-age son, his mother assumed that Nell would probably return her winnings, since her opponent was a teenager. "Believe me, she did not!" Mary Weissblum recalled, laughing. "She was just salivating over her success."[14] Aware of Nell's attitude, Marshall Clements, who owned several paintings by Carolyn, made a habit of taking them down and replacing them with Nell's—which he also collected—when the women came to visit.[15]

Years later, Carolyn wrote, "It was of the utmost necessity that [Nell's] career stay in full gear, at the expense of my ever-nascent one, because it was her reputation, regular exhibition and sales that paid the bills." Fortunately, Carolyn added, "I played very well out of town"—during Nell's lifetime, she was in numerous solo and group shows in Gloucester, Boston, and other cities—"and did not venture to shine my light too brightly."

Apart from personal dramas, the weather served as a reliable barometer of Nell's moods. When the sun came out on April 25, 1967, it was a red-letter day: "My energy is back!" Her high continued the next day, with news that Carolyn was returning from her first trip to Europe ("a little Grand Tour of my own devising"). She had visited Spain, Italy, Belgium, France, and England, living as cheaply as possible, much as Nell had done years earlier. The following week, Nell, who had missed Carolyn terribly, sketched her asleep. Around

this time, she made a list titled "Portrait of C," which included what she believed to be her new love's favorite foods (oranges, spareribs, lemons, collard greens, strawberry shortcake, sweet potato pie, pecan pie), bird (Cedar Waxwing), flowers (peonies, California poppy), film directors (Vittorio De Sica, Fred Zinnemann, Jean Renoir, Georges Franju[16]), actors (Greta Garbo, Gary Cooper, John Garfield, Stanley Baker[17]), countries (Spain, Belgium), and clothing ("the touch of cashmere," cardigan sweaters, a fifteen-year-old-shirt).

In June, the women spent a few weeks at Arthur Cohen's summer home. Willem de Kooning was building his studio next door, and Nell and Carolyn had to put up with daily construction noise. One night, Nell's aide apparently overheard the women's lovemaking; the next morning she was full of "revulsion and reproach," vowing to leave them as soon as they were back in the city.

Throughout her wheelchair-bound life, Nell hired and trained a long parade of aides—the women who helped her with intimate tasks she was unable to accomplish on her own as well as doing light cooking and cleaning. Her requirements were structured around the time she needed for painting as well as the protracted assistance involved in getting her up in the morning and putting her to bed. The aide needed to work for five and a half hours during the day, generally from 11:00 a.m. to 4:30 p.m.; after a brief break, her work would resume in the evening, with dinner "started at 7:00 to be ready at approx 8:30 or 8:45"[18] and dishes washed about forty-five minutes later, after Nell and Carolyn had eaten. Nell would place a newspaper ad and brace herself to interview applicants who might seem ideal at the outset but who would soon prove unreliable, mentally disturbed, or unable to lift her.

Daureen—Nell usually did not mention the last names of her helpers in her diary—had arrived in November 1966. "She is a dear person, lovely & tender," Nell wrote. "I marvel at a whole new horizon. I pray all goes well."[19] On Thanksgiving, Daureen cooked a turkey and two pies. But by mid-January 1967, something was amiss: "Daureen off after dinner to trouble?"[20] In Nell's moody lithograph portrait of the young woman, one hand props up her heart-shaped face, framed by cascading long hair; her strikingly large eyes look vacant. Her turbulent personal life involved a transvestite lover with breast cancer who would not see a doctor. One day in early June, Daureen failed to show up as promised. She exited Nell's life on June 16, in a whirlwind of loud accusations and destruction, smashing treasured dishes and damaging Nell's mother's silver wedding pitcher.

Despite all the stress involved, Nell was heavily dependent on her aides. When Hazel, who had been spelling Daureen, failed to appear one morning, Nell was unable to get up, even with Carolyn's help, and had to call Marshall

Clements, who lived nearby. At one point during the Daureen period, Nell received a long and wise letter about the adjustments she needed to make in her relationships with friends and personal aides, now that she was no longer able to do everything herself.[21] Referring to the aides, the letter writer remarked that it was "painful for your friends to see you being taken advantage of…afraid to kick these people out." Nell needed to make a detailed list of her routine needs for a week, to establish exactly what they were. Then she should hire two people and tell them what to do and when to do it. If Daureen, who was supposed to care for Nell at night and on weekends, could not stay up until 2:00 a.m., or wake up then to get Nell ready for bed, she was not fulfilling her end of the bargain: "It is bad for morale if one person does more of the giving than the other." When an aide would try to sidestep a needed task, the writer chided, Nell was in the habit of "giv[ing] way constantly— partly because of your liberal tendencies & partly for fear these people will leave you in the lurch." Surely Nell would never make "liberal" excuses for sloppy paintings. The letter ended on a positive note: if her helpers abandoned her, "this is where your friends come in. Friends are not just people whom you shower with gratitude. They want to give too."

Helen, another assistant Nell hired, quarreled with her about the injustice, as she saw it, of a black woman working for a white one: "I am an aristocrat!" She was also annoyed to be sent to buy groceries. In mid-February 1967, when Helen's father was dying in Jamaica, Nell gave her time off and loaned her $155 for the airfare. Three months later, Helen left in a huff, saying, "How do you think I feel taking orders from a woman in a wheelchair?"[22] Nell wrote in her diary that she felt "a sense of failure in being unable to reach" Helen, despite her unending hostility, adding, "I hate to give up!" Another helper, Lucille, was "sweet" but afraid of lifting Nell, who wrote in frustration that "the business of dressing [which had to be done while she was in bed] & toilet is so tiring and time consuming that I have little energy left for my work."[23] In a letter to Judge Kohler, Nell bluntly described her "schedule of 21 hours eating sleeping and lifting," which left "3 hours for picture making. No time to defecate."[24]

Jane Andrews ("very nice") was one of the twelve people who answered Nell's July 5, 1968, ad in the *New York Times*, headlined "Housekeeper-Cook-Personal Aid." The ad read: "Artist in wheelchair needs intelligent, responsible help. 5 days. Live in. Cheerful apartment Riverside Drive. Two in household. Interesting opportunity for flexible, healthy woman, able to travel. Height 5.5 ft–5.10 ft. $85.00–$90.00. References. Permanent. RI 9-0678 after 2." Jane lost her balance several times when she tried to lift Nell, who realized

that the woman was "trying hard, but my fatigue and her inexperience makes it rough."[25]

In early 1969, Nell trained Dorothy Forbes, who "seem[ed] very obliging and capable and pleasant."[26] She apparently did not work out.[27] Nor did Madge, or Alice, who seemed noisy at first, was elevated to "sweetie" status a couple of days later ("a bit slow but nice"), but was fired a month after she arrived. ("She was sad. Me too.")[28] In April, Nell complained to her diary that the majority of the women she hired "have been neurotic: unreliable and dishonest (with stories, lies)." Her trust was rekindled when a new helper, Rachel, made a delicious meal of roast beef with Yorkshire pudding and a butter cake. Nell wrote excitedly to a friend that this woman was "a really lovely person, full of sympathy and very intelligent and really helpful."[29] She even wrote a naïve sort of poetry. But Rachel, like Jane, was unwell. She may have been the aide who had to quit due to a flare-up of severe asthma caused by dust in the apartment and Carolyn's Yorkshire terrier.

And so it went. Laura, "so very sweet and sympathetic," had trouble learning how to perform the "assisted stand" Nell required to get out of bed every morning. "The nervous strain for both of us is terrific," she wrote.[30] Three days later, Laura finally managed this, while Nell was "shaking inside and living in dread." Grateful for small miracles, Nell gave her a ten-dollar raise. By May 1972, a sadder and wiser Nell had changed the wording of her ad. No description or location of her apartment was given, and no indication of the number of people in residence. "Healthy" replaced "intelligent" in the list of desired attributes, and the wage was "$100 to start." Nell added that the person needed to be "free to travel summers."[31] Ten months later, she vented to her diary about an "older lady . . . rather slowly paced . . . but a cheerful well intentioned person. I hope she can learn all the finicky details so we can have a bit of freedom—one day!"[32] That day was further postponed by the arrival, in April 1974, of "beautiful" Lurline, whose inefficiency, grumpiness, and noisy "puttering" got on Nell's nerves when she painted. One day, she got a call from someone claiming to be a relative of Lurline's, who told an unlikely tale of a medical emergency. Eventually, Nell conceded that she "must consider this awful truth. [Lurline] takes me for a sucker."[33]

Beginning in 1969, Nell had been experiencing new ailments of her own: fits of coughing in damp weather, pain in an arm, swollen feet, bladder infections. Her lifelong habit of painting through the night and collapsing with exhaustion in the morning was likely undermining her health. Instructing a new aide was a painful procedure that sometimes led to muscle pain in Nell's arm, shoulder, and neck. "So many push ups are required for me to do while

they struggle to learn…the various holds & positions needed to transfer me," she wrote in her diary. "It is incredibly wearing on all 3 of us."[34] These problems put even more strain on her relationships with the aides. In addition to the time and energy involved, finding the money to pay them was another constant struggle. A letter Nell wrote to the Department of Social Services about her application for a new mattress and wheelchair also contained a lament about having to support the aides despite working with "1/5 of my normal energy and no show for two years!"[35]

Relief from the endless parade of unsuitable aides finally came in the person of Jestina Forrester, a plump, middle-aged woman from Grenada with a beguiling smile. She arrived in 1976 and remained loyal, in her own fashion, for the remaining two decades of Nell's life. Her well-padded physique pleased Nell, whose postpolio body was extremely sensitive, because it had no sharp angles to hurt her while she was lifted to her chair. "We like Jestina a lot in terms of her kindness, gentleness, goodheartedness but wish for other capabilities," Nell wrote to a relative.[36] Several years later, Nell summed up her helper as "an island 'cutie'—a bit country & a bit Brooklyn." Jestina was "at times warm[,] at times simply self-oriented"[37]—a personality actually not so different from her own. Always keen on celebrations, Nell made a point of marking Jestina's birthday in style—one year, with pink champagne, key lime pie, and various small gifts (including a "potholder woven to resemble a slice of watermelon"—a cluelessly insensitive choice). Jestina typically rose to the occasion on Nell's birthday, always a key date on the Blaine calendar. One year, her present consisted of bath towels and—as Nell wrote—"knowing my childish humor…a joke hat that lights up & blinks in diff. colors!"[38] Nell thought Jestina had a special gift for arranging flowers and credited her assistance in the titles of paintings like *Jestina's Best Bouquet*. In 1994, *Jestina's Reds* was the title of a limited edition of Nell's flower lithographs published by the Metropolitan Opera Guild and exhibited at the opera house. When Nell bought a summer home in Gloucester, Massachusetts, Jestina was allotted a small garden of her own, where she grew tomatoes and beans as well as flowers.

Carolyn, who cooked a wide range of international dishes—Spanish paellas, Italian cacciuccos (fish stews), Moroccan tagines—assigned Jestina the work of chopping, mincing, and stirring. To Carolyn's frustration, Jestina's reading level did not enable her to follow a recipe, so it was not possible to ask for a particular dish in *The New York Times Cookbook* "and then go off blissfully to paint or help Nell in the studio." The dishes Jestina was able to make on her own were limited to the ones she had cooked all her life. When she was not cooking or helping Nell, she often sat with her elbows on the kitchen

counter, head in hands, acting out her boredom. She also managed to avoid most of the housekeeping part of her job.

According to Carolyn, Jestina had "a good heart that would every now and then erupt with symptoms of resentment." She was subject to illness, and she had a way of being uncooperative at moments when this behavior caused maximum stress. One year, her two-week spring vacation stretched into five, after which illness kept her away for another week. Meanwhile, Nell and Carolyn—who was due to travel to North Carolina for a show of her work—were left helplessly fuming. Another year, days before the women were to set off for their home in Gloucester, Massachusetts, Jestina threatened to refuse to accompany them, which would have greatly delayed their trip while they interviewed, hired, and trained a new helper. Nell, whose heart was pounding when she heard the news, figured that this was "an extortion (as usual) for higher wages."[39] The upshot was mounting tension between Nell and Carolyn before Jestina finally agreed to travel with them. Once, when Jestina's pregnant granddaughter was overdue, Nell and Carolyn waited until July to leave New York. Yet the summer when Jestina ran a 104-degree temperature right before they were ready to drive north, they simply left without her.

In 1987, when the minimum wage was $3.35, Nell paid Jestina $7.68 an hour for 27.5 hours a week; her benefits included paid sick days and two weeks of vacation. Occasional treats also came with the job. One year, Nell took Jestina and her daughter to see the Broadway musical *Barnum* (about the nineteenth-century showman P. T. Barnum) and for a meal at Sardi's afterward, an expensive outing. When Jestina was off duty, Nell felt bereft and missed her help. She empathized with Jestina's arduous subway commute to Brooklyn, which sometimes took as long as two hours. But she was not always on the side of the angels. One winter day, she was annoyed that she had to hurry through dinner and rush to the bathroom because Jestina wanted to leave early, even though "the snow wasn't very deep."[40] She thought Jestina was "terribly sensitive," though it's hard to imagine anyone who would take kindly to being teased about taking a large helping of food when she said she was dieting.[41] It was not surprising that Jestina was irritated at Nell's habit of peremptorily calling out from the studio ("Where are my scissors?"). Carolyn suggested that Nell adopt a friendlier tone: "Can you come help me?"[42]

In the spring of 1987, Jestina sparked a crisis by announcing that she was leaving because—as Nell reported in her diary—she felt that Carolyn treated her like a child. Ironically, Nell had railed against Jestina in her diary ten years earlier as a "permanent child" who was "always looking for help instead of ways to be helpful."[43] Only after Nell's "tears and pleading" did Jestina agree

to stay. For her part, Nell may not have fully comprehended the feelings of injustice caused by a history of racial oppression. Jestina's mother, brother, nephews, nieces, and cousins still lived in her native Grenada, part of the British Commonwealth. Three years after she began working for Nell, the Grenada Revolution overthrew the Caribbean island's despotic ruler; in 1983, a coup by Cuban-trained military led to widespread violence, followed by the invasion of US troops. Jestina was surely aware of these events—as well as, no doubt, media reports about the crack cocaine epidemic and galloping homicide and fetal death rates among African Americans. Ironically, Nell and Carolyn were themselves members of a minority that Jestina regarded with prejudice. Because they were, as Nell liked to joke, "a couple of lezzies," the couple felt they were "on a faultline" in terms of Jestina's willingness to ignore, or at least not to make a fuss about, their relationship.

Carolyn's own role—lover, studio assistant, cook, and sometime attendant—was not an easy one. Her time in her own studio was circumscribed by Nell's needs. Because the attendant went home at 6:00 p.m., Carolyn had to return to the apartment, and when the attendant took her two-week vacation, Carolyn had to be "on duty" full-time. When no helper was available, Carolyn had to help Nell in and out of bed, on and off the toilet, in and out of her wheelchair. A friend of both women said that Carolyn "really sacrificed her career" for her lover. "It was always about Nell, and Carolyn somehow allowed that to happen.... Nell was a queen, the focus of everyone's attention, always."[44] Another friend said, "I think they loved each other, but [Nell] treated Carolyn like a servant in my presence. I found it very stressful that she would give her orders in the evening about what wasn't on the table. I'm sure Carolyn fought back, but there was some amount of built-up resentment and anger and misery."[45] Over the years, Nell's diary documented her frequent blowups with her lover. From her perspective, the problem was a lack of warmth and understanding: "Upsetting words with Carolyn. She was extremely critical and I thought, cold."[46] Weeks later, when Carolyn gave her "a lovely watch" for her birthday, all was temporarily well again. A similar battle erupted the following summer. "C. absolutely hates me sometimes," she wrote. "The hatred is violent and icy and shockingly intense. I react violently when I receive this ugly coldness."[47]

Nell often tried to analyze their quarrels. "Is the anger in ratio to the caring?" she asked herself.[48] She realized that arguments flared when both women were tired. Sometimes she credited her lover's hard work, as in a drawing titled "Carolyn worn out"—a woman lying on her back on the floor below a row of blank canvases, presumably ones she had stretched for Nell's use.[49]

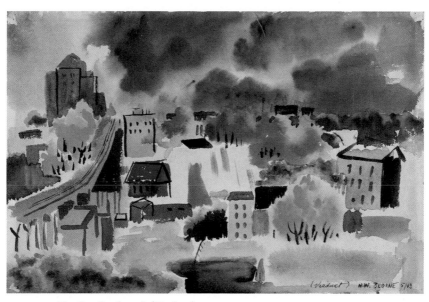

PLATE 1. *The Gay Patchwork (Viaduct)*, 1943.

Watercolor on paper, 13-3/4 × 20 inches. Virginia Museum of Fine Arts, Richmond; gift from the Springfield Group of Fire Insurance Companies. Photo: Travis Fullerton. Image ©Virginia Museum of Fine Arts. ©Nell Blaine Trust.

PLATE 2. *Chinese Landscape*, ca. 1949–50. Oil on canvas, 44 × 36 inches. Photo courtesy of Tibor de Nagy Gallery, New York. ©Nell Blaine Trust.

PLATE 3. *Street Encounter*, 1950. Oil on canvas, 41 × 63 inches. Photo courtesy of Tibor de Nagy Gallery, New York. ©Nell Blaine Trust.

PLATE 4. *Midi and Brook*, 1955. Oil on canvas, 25 × 30 inches. Photo courtesy of Tibor de Nagy Gallery, New York. ©Nell Blaine Trust.

PLATE 5. *Imaginary View of Mexico*, 1957. Oil on canvas, 70 × 68 inches. Photo courtesy of Tibor de Nagy Gallery, New York. ©Nell Blaine Trust.

PLATE 6. *Harbor and Green Cloth II*, 1958. Oil on linen, 50 × 65-1/4 inches. Whitney Museum of American Art, New York; purchase, with funds from the Neysa McMein Purchase Award; 58.48. ©Nell Blaine Trust.

PLATE 7. *Gloucester Harbor, Dusk*, 1958. Pastel on paper, 22 × 30 inches. Photo courtesy of Tibor de Nagy Gallery, New York. ©Nell Blaine Trust.

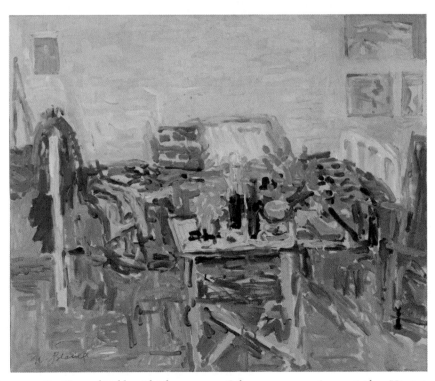

PLATE 8. *Cot and Table with Flowers*, 1959. Oil on canvas, 30-1/2 × 35 inches. Virginia Museum of Fine Arts, Richmond; gift of Martha Davenport in Celebration of the 60th Anniversary of The Council. Photo: Travis Fullerton. Image ©Virginia Museum of Fine Arts. ©Nell Blaine Trust.

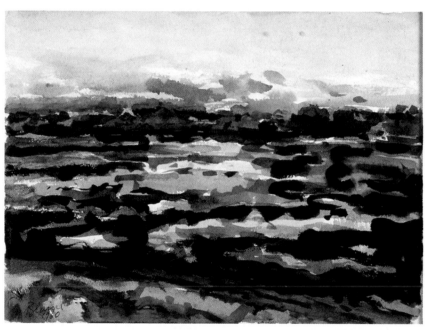

PLATE 9. *Hudson and Ice*, 1960. Watercolor on paper, 9 × 12 inches. Photo courtesy of Tibor de Nagy Gallery, New York. ©Nell Blaine Trust.

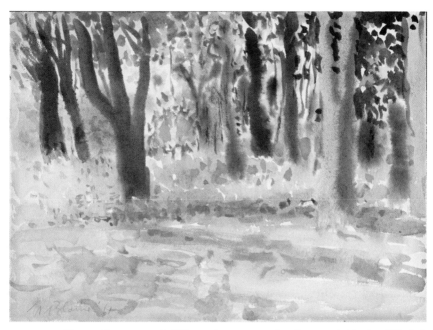

PLATE 10. *Trees at Saratoga*, 1961. Watercolor on paper, 8-7/8 × 11-15/16 inches. Virginia Museum of Fine Arts, Richmond; gift of Martha Davenport in Celebration of the 60th Anniversary of The Council. Photo: Travis Fullerton. Image ©Virginia Museum of Fine Arts. ©Nell Blaine Trust.

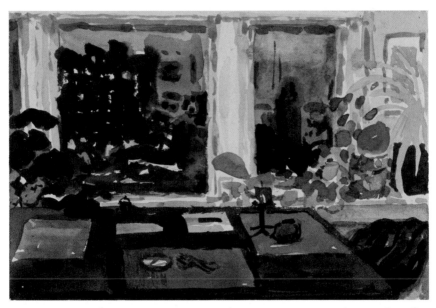

PLATE II. *View of an Interior*, 1963. Watercolor on cream paper, 6-3/4 × 9-7/8 inches. Courtesy of the Pennsylvania Academy of the Fine Arts, Philadelphia; gift of Edna Andrade; 1986.51. ©Nell Blaine Trust.

PLATE 12. *Garden and Font des Serpents, St. Lucia*, 1965. Oil on canvas, 20 × 24 inches. Photo courtesy of Tibor de Nagy Gallery, New York. ©Nell Blaine Trust.

PLATE 13. *Rooftops, Rain*, 1967. Oil on canvas, 20-1/8 × 26-1/8 inches. Hirshhorn Museum and Sculpture Garden, Smithsonian Institution, Washington, DC; gift of Arthur W. Cohen, New York, 1976. ©Nell Blaine Trust.

PLATE 14. *Interior with View of Quaker Hill*, 1968. Watercolor on paper. Frances Lehman Loeb Art Center, Vassar College, Poughkeepsie, New York; gift from the Roland F. Pease Collection, 1997.11.5. ©Nell Blaine Trust.

PLATE 15. *Riverside Drive and Park*, 1970. Oil on canvas, 28 × 30 inches. Photo courtesy of Tibor de Nagy Gallery, New York. ©Nell Blaine Trust.

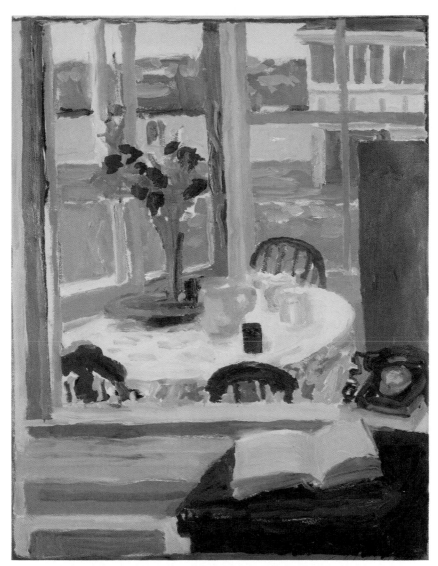

PLATE 16. *Summer Interior by Gloucester Harbor I,* 1971. Oil on paper, 24-1/4 × 18-3/4 inches. Virginia Museum of Fine Arts, Richmond; Adolph D. and Wilkins C. Williams Fund. Photo: Katherine Wetzel. Image ©Virginia Museum of Fine Arts. ©Nell Blaine Trust.

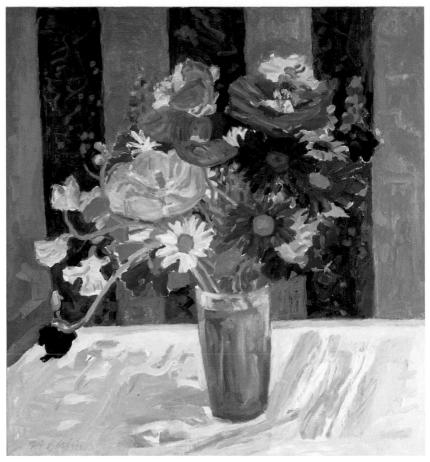

PLATE 17. *Fiesta Bouquet*, 1971. Oil on canvas, 30 × 28 inches. Virginia Museum of Fine Arts, Richmond; gift of Norah and Norman Stone. Photo: Katherine Wetzel. Image ©Virginia Museum of Fine Arts. ©Nell Blaine Trust.

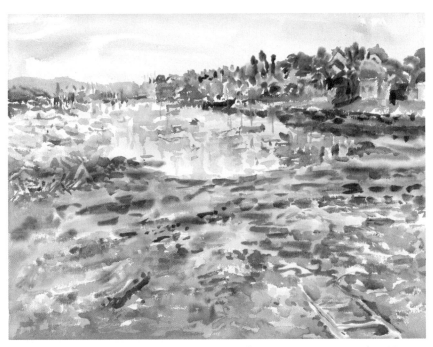

PLATE 18. *Low Tide, Smith Cove*, 1971. Watercolor on paper, 21 × 27 inches. Virginia Museum of Fine Arts, Richmond; gift of Norah and Norman Stone. Photo: Katherine Wetzel. Image ©Virginia Museum of Fine Arts. ©Nell Blaine Trust.

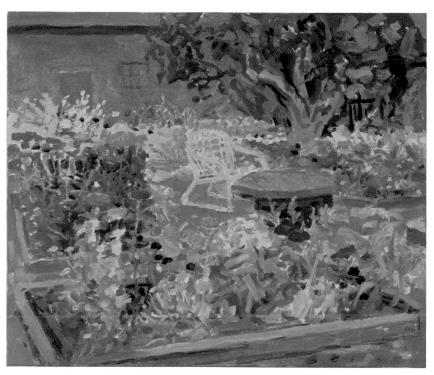

PLATE 19. *The Cut-Flower Garden*, 1972. Oil on canvas, 24 × 28 inches. Virginia Museum of Fine Arts, Richmond; gift of Mr. Arthur W. Cohen. Photo: Katherine Wetzel. Image ©Virginia Museum of Fine Arts. ©Nell Blaine Trust.

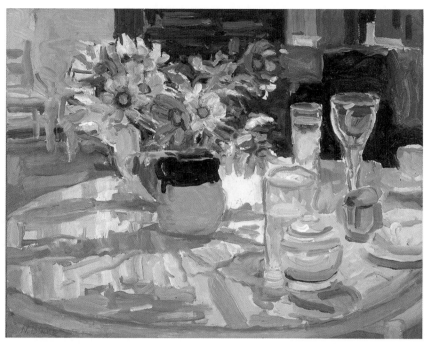

PLATE 20. *Cosmos in Night Interior*, 1976. Photo courtesy of Tibor de Nagy Gallery, New York. ©Nell Blaine Trust.

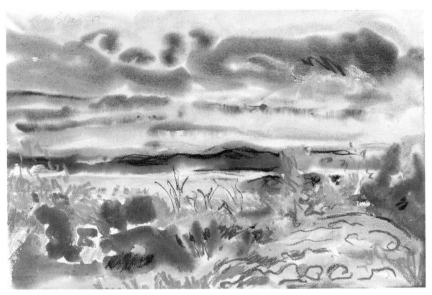

PLATE 21. *October Landscape*, 1977. Watercolor and pastel on paper, 16-7/8 × 25-11/16 inches. Virginia Museum of Fine Arts, Richmond; gift of Beatrice B. Dunn. Photo: Travis Fullerton. Image ©Virginia Museum of Fine Arts. ©Nell Blaine Trust.

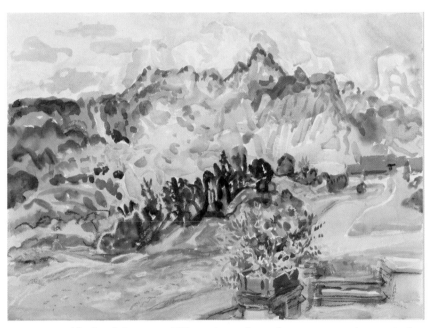

PLATE 22. *Acherkogel One*, 1978. Watercolor and pastel on paper, 21-3/8 × 29 inches. Sheldon Museum of Art, Nebraska Art Association, Trustees' Purchase in memory of Mrs. Dorothy Holland, N-554-1980. Photo ©Sheldon Museum of Art. ©Nell Blaine Trust.

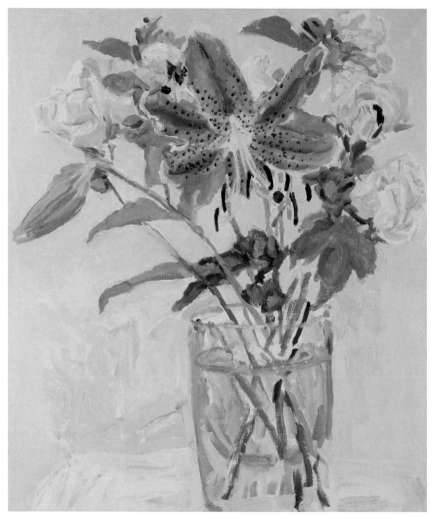

PLATE 23. *Rubrum Lily*, 1980. Oil on canvas. Cape Ann Museum, Gloucester, Massachusetts; gift of Arthur W. Cohen, 1990. ©Nell Blaine Trust.

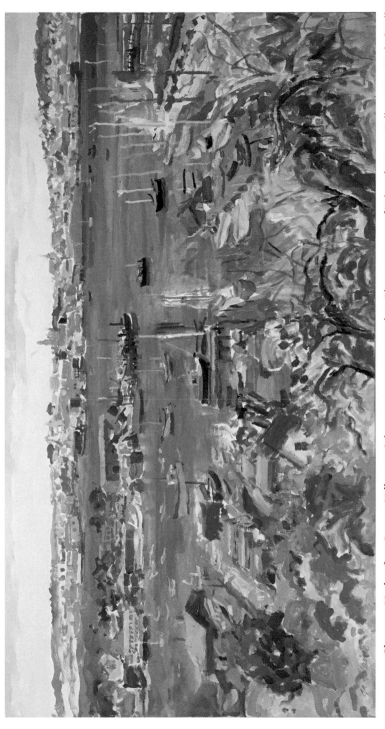

PLATE 24. *Gloucester Harbor from Banner Hill*, 1986. Oil on canvas, 24 × 46 inches. Photo courtesy of Tibor de Nagy Gallery, New York. ©Nell Blaine Trust.

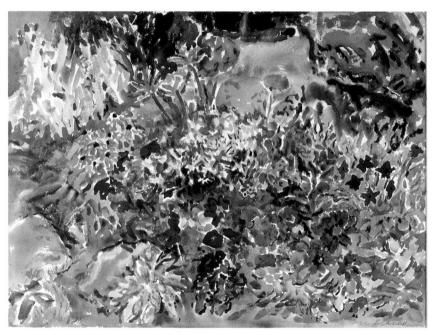

PLATE 25. *Platform Garden*, 1988. Watercolor on paper, 18 × 24 inches. Photo courtesy of Tibor de Nagy Gallery, New York. ©Nell Blaine Trust.

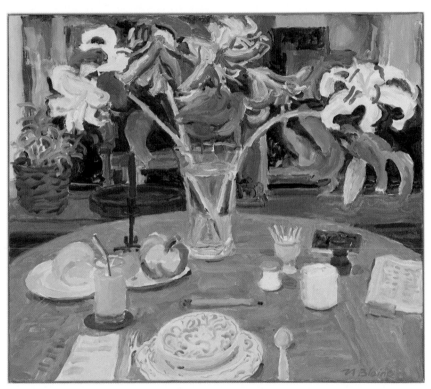

PLATE 26. *White Lilies, Pink Cloth*, 1990. Oil on canvas, 24 × 27 inches. Photo courtesy of Tibor de Nagy Gallery, New York. ©Nell Blaine Trust.

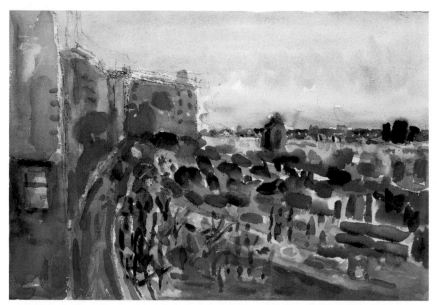

PLATE 27. *Blue Sunset*, 1996. Watercolor and pastel, 14 × 20 inches. Photo courtesy of Tibor de Nagy Gallery, New York. ©Nell Blaine Trust.

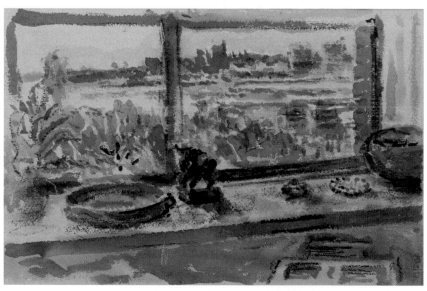

PLATE 28. *Winter View, Black Peke*, 1996. Watercolor and india ink on paper, 12 × 16 inches. Photo: Robert Gebbia. Jack Blanton Collection. ©Nell Blaine Trust.

But despite Nell's fondness for self-scrutiny and awareness of what she called "my terrible insecurity,"[50] she seems never to have recognized the lingering expectations raised by her mother's smothering love. Although she hoped to escape its embrace by moving to New York, it had marked her for life. Nell's fierce will to succeed and triumph over her illness also blinded her to Carolyn's selflessness as an aspiring artist who—unlike Dilys—had not trained as a nurse. While Nell realized that most of her money went to the aides, with little to spare for Carolyn, she felt that her lover failed to realize that her food and her share of the rent were paid for. Still, she was painfully aware of the inequity and hoped to be able to raise more money somehow. It probably helped somewhat that the two of them had a similar approach to painting; the quarrels were not about aesthetic matters.

Three Friends at Table II (1968)—Nell's largest postpolio painting to date—is a moody group portrait of Carolyn with Marshall Clements and Flora Kriezi. Now living in a one-bedroom apartment on Riverside Drive, they had married so that Kriezi would not have to return to Greece. It was a platonic union.[51] Clements was a kind man who tended to see the good in others. Years later, he told Nell that *Landscape with Traveler*, Barry Gifford's fictionalized book about his life as a gay man, consisted mostly of Clements's letters.[52] His unwillingness to confront this unauthorized use of his personal details struck Nell as a sign that he was "afraid of . . . committing himself."[53] After a stint at the Phoenix Book Shop in Greenwich Village, owned by Nell's friend Robert Wilson, Clements worked as an office manager at Mount Sinai Medical School. He was a polymath, an opera buff fluent in several languages, an enthusiastic host of dinner parties, and an accomplished musician on recorder, guitar, piano, and a harpsichord he built himself.[54] In *Three Friends*, the windows reveal only nighttime blackness. The table holds the remnants of the end of a meal—a teapot, cups, a snuffed-out candle, an orange—and, next to Carolyn, an effusive bouquet of tulips and other flowers that contrasts with her long-suffering expression. Kriezi, who seems to be still finishing her dinner, stares down at her plate; Clements leans on the table, propping up his head, and looks out with an unfocused gaze. Sitting for Nell could be exhausting, especially when the hour grew late.

A perceptive article by James Schuyler heralded Nell's spring 1968 Poindexter Gallery show. *Rooftops, Rain* (1967, plate 13) is a glorious work that manages to be both abstract (the colorful shapes of buildings, the green and blue blurs of puddles) and immediately recognizable as a specific locale. Writing about this painting, Schuyler identified Nell's approach to painting landscapes and cityscapes: she does not create a specific mood or monumentalize

her subject; rather, her work "is something made out of what happened to be there, which is always enough."[55]

In the summer, Nell and Carolyn traveled to the country homes of friends—to Vermont, where Nell painted watercolors of the mountains and the poppies in the garden, and to Patterson (in Putnam County, New York), where a kitten she dubbed Hecate Raquel Hachenbush wandered over and became a permanent member of the household. Visiting this home, owned by Riverside Drive neighbors, involved the addition of a ramp and a special toilet.[56] Despite "torrents of rain" in July, Nell and Carolyn—who was working on still lifes—both had a productive summer. In landscape paintings (plate 14), Nell continued her theme of through-the-window views, begun in Mykonos. A tabletop grouping in the foreground and an open door lead the eye to a blurry green panorama of lawn, foliage, and distant hills. Her paintings of windows with a landscape view owe a debt to Pierre Bonnard's canvases with still lifes on dining tables near windows (and sometimes an open door), which include *The Dining Room in the Country* (1913) and *Table in front of the Window* (1934–35). But unlike the French master, who worked only from drawings and notes, Nell needed the direct stimulus of the scenes she painted.

At other times, Nell worked outdoors. She could be especially interested (as she told an interviewer) "in the way the tops of the trees met the sky, or the way the light came in through the trees."[57] Explaining that she looked for rhythms in nature, she delighted in the challenge of bringing a fresh approach to a clichéd view. The result was *Summer Afternoon*. The greens and yellows of the trees form a sort of tapestry—reminiscent of Bonnard's manner of merging near and far views into flat, patterned screens—across most of the background of the scene. Nell's favorite time to paint landscape was "the moment of the dying of the light." She believed she was "physically more alert" to her surroundings as a result of "the excitement that the color takes on...a blast of color coming over and saturating everything." Because the late-afternoon light emphasizes some details and obscures others, it creates a special drama— "as if everything is unfolded suddenly...each tree seems to have more life in it and there is some flaring up of its own inner self." It was typical of Nell's intense identification with nature to talk about a tree as if it had a soul, or a self. She once wrote that her response to nature involved "becoming as much as possible what is before me." She was not just painting a scene; she was somehow *becoming* it.[58]

Privately, Nell mused about the dilemma of feeling part of the avant-garde while staying true to the way she wanted to paint. In a diary entry titled

"Bucking the Tide and going with it," she reviewed her shift from the certainty she felt in the 1940s as part of the Jane Street group to "a deeper and quieter understanding of my true nature" in the early fifties, as she abandoned her dogmatic stance. Now, she decided that it was OK to be called a hedonist. Abandoning herself to the pleasures of color and "pure paint" gave her an "embracing sensation...expansive, sensuous, excited & abandoned" that she likened to lovemaking.[59] "To give pleasure sensuously rates high for me!" she wrote to May Swenson in January 1969, apropos her poetry.[60] In a burst of libidinous silliness, Nell covered a few diary pages with titles for an imaginary first book, including *Copulating without Fear of Noise*, *The Case of the Missing Pussy*, *In the Shower with Tom & Dick*, and *Mary Takes a Bath*. She illustrated *Fun in a Wheelchair* ("a real runaway best seller!") with a partially scribbled-out sketch of two figures smooching in the chair.[61]

Switching to a serious vein—and perhaps prompted by having been asked to write an autobiography focusing on the art scene of the 1940s[62]—she listed her fantasy book's dedicatees. They included Theresa Pollak, her college art teacher ("high regard for quality"), Wörden Day ("giving me a love of exploration & adventure & a taste for the exotic"), Hans Hofmann ("immense love of art and vitality & eye for color & for his unerring...intelligence"), and Karl Knaths ("unpretentiousness...both in his person and in his art"). Knaths died the following month; Nell sent his widow, Helen, a loving tribute, calling him "one of the best painters of our country" and telling her that every time she met him, he "filled [her] with pleasure and a sort of inner security."[63]

Nell's mother was another dedicatee of the fantasy book, "for her sense of honesty as she saw it and her high regard for hard work."[64] She would always have complicated feelings about Dora.[65] In 1967, after a visit from her, Nell wrote to a friend that her mother was "really very sweet if in another world—so provincial and waspish in her ideas."[66] The following year, when Nell called her after apparently failing to write for a while, Dora wrote that she had "to pray hard...to be relaxed and get to sleep" while "fearing for your welfare or your paintings, [w]ith all this rioting and vandalism about." She was pleased that Nell had received "the china" and "the towels," and enclosed "a small check...as a congratulatory expression [for the upcoming Poindexter Gallery show] to be used as you please, (flowers, stamps, a little momento [*sic*] of the occasion, or what have you!!)." Forgiving or overlooking Nell's youthful transgressions, Dora wrote that her daughter had "always been <u>so</u> thoughtful."[67]

Dora had a stroke on December 29, 1970. In early January, Nell wrote to an acquaintance that after emerging from a coma, still unable to speak, her mother seemed to be improving—news related by cousin Charlotte, who visited

Dora Blaine in Gloucester, 1954.
Courtesy of Carolyn Harris.

Dora in her nursing home in Richmond.[68] Anguished at not feeling able to travel to visit her mother—she told one friend that "the doctor & relations urged me not to," until her mother's condition either improved or was fatal[69]—Nell continued to hope that she would recover. But Dora died of a cerebral hemorrhage on January 31. Nell flew down with Carolyn and Marshall, whose financial assistance made this trip possible, for the February 2 funeral. "It hit me harder than I imagined," she wrote afterward to a friend who was among the mourners. Oddly, she apologized for being "so weepy," attributing her tears to "not having slept much for days."[70] In her diary, Nell reiterated her backhanded praise of Dora as "one of the most honest & absolutely truthful [people] I have ever known, under the circumstances of her naivety and innocence."[71] A diary page on which she jotted a reminder to give her mother's stole to a woman who had worked for her also recorded "a nightmarish dream." It ended with a bloody scene of a body ("I think it was a woman's") stabbed with two huge staves.[72] It is impossible to know if this dream was evidence of guilty feelings about her mother's death, but theirs had been a remarkably close bond despite Nell's youthful rebellion and the lifelong gap

between her mother's conventional views and her own. In the catalogue for her 1972 show at the Poindexter Gallery, below the listing for *Bouquet with Parrot Tulips II*, a line reads: "Dedicated to my mother, Dora G. Blaine (1887–1971)." Dora's death brought an unexpected gift: despite her modest income ($180 a month from Social Security and her department store pension), she had saved the small sums of money Nell had sent faithfully over the years and bequeathed them to her. In her own gesture of gratitude, Nell signed over the $500 life insurance policy she received from her mother to Midi Garth.

A longtime acquaintance, Daisy Aldan, came to Nell early in 1969 with a request to illustrate *Breakthrough*, a book of her own poetry. Unimpressed by the quality of this work, Nell asked May Swenson for her opinion, as a "real" poet.[73] Also in play were her feelings about Aldan as a collaborator, years after she had mishandled a big project that was deeply meaningful to Nell. The résumé she had sent with her 1957 Yaddo application included a line stating that she was editing a drawing anthology "to be published soon under the tentative title '25 Painters and 25 Poets.'" Nell had gathered a large group of drawings by artists she admired—including Willem and Elaine de Kooning, Helen Frankenthaler, Robert Motherwell, Grace Hartigan, Philip Guston, Fairfield Porter, and her old buddies Jane Freilicher, Albert Kresch, Robert De Niro, Leland Bell, Louisa Matthíasdóttir, and Larry Rivers. She enlisted John Ashbery, Frank O'Hara, and Kenneth Koch to select poetry by poets they mutually respected. The project—which she typically conceived as a beautifully printed book—was hugely time-consuming, and she finally realized that it would use up all the time she had for painting.

Aldan agreed to take over.[74] But she did not share Nell's conscientious approach and high aesthetic standards, and she carelessly or ruthlessly failed to acknowledge Nell's extensive work in the book, finally published in 1959. (Appended to the list of contributors, she is credited only "for [acquiring] the drawing by Joan Mitchell.") A drawing by Nell of chairs and a table appears on the cover—poet Robert Duncan and his lover, the artist Jess (Burgess Collins), praised it highly[75]—but only fourteen of the many drawings she collected are included, and the book was cheaply printed. Titling it *A New Folder*, Aldan claimed it as the fifth in the *Folder* series of poet-painter collaborations issued between 1953 and 1956 by Tiber Press,[76] but it has little in common with the earlier volumes, printed on high-quality paper, with silkscreened covers and interior images.

A New Folder has been saluted as a risk-taking precursor to the anthology *The New American Poetry* (1960). But the literary selections—which include

Beat writers and others not associated with the New York School—not only failed to honor Nell's vision for the book but also lack a unifying sensibility.[77] It turned out that Aldan had not sent proofs to the poets or even bothered to let them know which poems she would be including. Nell later claimed that Aldan did not send her a copy until December 1959, when she was in the polio ward at Mount Sinai Hospital. But in a letter sent before her trip to Greece, she thanked the poet for "the handsome book and great inscription."[78]

In the late sixties, Nell had a somewhat more satisfying collaboration with another poet. She had written to Galway Kinnell in December 1968 to propose a Christmas card that would be printed with a drawing of hers and a brief poem of his. According to Robert Wilson, the idea was that "collectors would buy this item for $7 or so."[79] After recouping her printing costs, she would split the proceeds with Kinnell. The card—with a delicate ink drawing of wildflowers in a glass and a magical twelve-line poem about the power of love "in the dying world"—was printed in December 1969. But the profit motive had vanished: a statement on the back of the card explains that the three hundred copies were printed "for the poet and painter's personal use."

Writing in the January 1970 issue of *Art Now: New York*, Nell declared that her "true subject" was "the life of the forms as revealed by light."[80] She noted that light "can be mysterious or it can dazzle" and explained that she felt free to depart from the exact appearance of light and shadow, although they helped her in structuring the picture. The following year, in the guise of a "letter to a fledgling artist," Nell would offer a justification of her current approach to painting. "Good artists," she wrote, "reach intuitive levels of freedom & awareness" by feeling "free inside and exuberant and strong."[81]

Nell's show at the Poindexter Gallery—which had moved to a more spacious location on West 84th Street—opened on September 19 with more than three dozen images of Vermont and upstate New York landscapes, views from her window, portraits, and still lifes. In *ARTnews*, Lawrence Campbell wrote, "All the work is beautiful, some of it more beautiful."[82] He observed that her paintings of the same scene under similar lighting conditions could look quite different and giddily compared her brushstrokes to "rain flams"—a double-stroke pattern—"on a snare drum." In *Art International*, Gerrit Henry tied himself into knots trying to praise Nell's "generous, lyrical" landscapes while indicating that he understood how out of fashion her work was, now that having "stunning ideas about beauty" was "suspect." Nell wrote to a friend that she "got a big laugh" from the review.[83] A rapturous article by James R. Mellow in the *New York Times* compared "the element of risk" in her

work to the (much-discussed) risk involved in abstract painting.[84] Success, he wrote, hinged on remaining focused on her perception of light, color, atmosphere, and details of the scene, as well as on her emotional response. Mellow noted the way Nell's work "precedes from a sense of experiences shared with its audience, the poetry of place…the pleasures of recollection." He acknowledged that the viewer's appreciation of such aspects depended on not being wedded to "the dogmas of the modernist movement," with its emphasis on confrontation and shock value. Nell's approach to painting was fated to remain at odds with the fickle taste of the art world.

That fall, her work was also in Fifties Revisited, a group show at Tibor de Nagy Gallery, and in a traveling exhibition, Painterly Realism, sponsored by the American Federation of Arts. Speaking to a reporter from a hometown paper, she deplored some of the work in the latter show as "gimmick-oriented" and "almost pornographic," devoid of "all signs of lyrical tenderness." She also criticized Op art and the lack of "spiritual refreshment" in Pop art: "It's dangerously easy to dehumanize with a preoccupation on technique."[85] It was probably her rejection of Pop art that had prompted her distaste for the beguiling cutout sculpture Alex Katz made of Frank O'Hara in 1960.

By October, her financial situation had grown so dire that she had to drop her hospitalization coverage and lacked enough cash to pay her helper's wages for the week. So she wrote to Arthur Cohen, to ask him to send the $700 he had not yet paid for a painting of hers. Nell explained that she still owed about $840 for expenses related to the Poindexter show[86] and was thinking about trying to get unemployment benefits despite having been rejected twice. A more delicate matter she raised had to do with Cohen's decision to disperse some of his art holdings, possibly as the result of his marriage that spring to gallery owner Virginia Zabriskie. Nell was so unhappy about this that she accused him of lacking the "passion" to exhibit a "complete show" of her work. His habit of passing on Zabriskie's remarks about her paintings would also get on her nerves.[87]

When Cohen publicly described a certain large painting of hers from the late 1950s as her best effort, Nell's hackles rose again. *Every* period of her work had its "best" examples, she wrote, and in any case, *Stupa House Interior* (1959), the Whitney's *Harbor and Green Cloth II* (1958), and other pictures were as good as or better than the large piece. She even dared lump Cohen with "[a] number of people who do not know enough about painting"—the ones who praised her earlier work more highly than her current output. Although Nell did not spell it out, she was fighting for the value of her post-polio paintings, the ones she had worked so hard to be able to execute at a

level that satisfied her exacting standards. "I remember...the birth pains so vividly and especially on these later ones," she wrote. "The cost is [greater] and I rate them higher."[88] To Nell's rather self-centered dismay, Cohen once admitted to her that "he care[d] for people more than art." Yet he continued to buy Nell's work; his Blaine collection eventually numbered nearly 150 pieces. Her portrait of Cohen, *Man with Suspenders*, shows him as a stocky seated man with a hint of a smile playing on his closed lips.

Despite her financial worries, on an autumn day in 1970, Nell was "full of delight and joy" when she returned from a drive with poet Jane Mayhall to Bear Mountain, a peak that overlooks the Hudson River, north of the city.[89] She was greeted by an outburst from Carolyn, who said she hated living in New York—a nonnegotiable issue as far as Nell was concerned. It seems not to have occurred to her that she was extolling the scenery of Rockland County to someone left behind, who also would have enjoyed the drive. In Nell's mind, it was simply a question of her own elation being quashed by pointless negativity.

Carolyn wanted the two of them to move to San Francisco. Nell mentioned this in a letter to a friend, adding that she would "if it were easier," without further explanation. Easier for whom? Nell told an interviewer this year that she would "feel cut off" if she left Manhattan, yet she equivocated: "My friends are here and I feel nourished here, but the quality of city life is deteriorating."[90] Six years later, the cold war between Nell and Carolyn would show no signs of abating. Nell worried that "Carolyn's resentment is so ever present. She no longer seems like a real friend. There is little kindness. Everything she does is tainted with oppressive resentment and hostility. My resentment grows and hampers me from improving a worsening situation. Am I to have a repeat of the Dilys leave-taking?"[91] Fortunately, that never happened. As Nell wrote, "Somehow we rise from these ashes periodically after rest with energy again and we are friends once more."[92]

In the spring of 1971, Nell wrote to C. Douglas Dillon, president of the Metropolitan Museum of Art, to complain about lack of access for wheelchair users. She explained that she had to wait an hour to be able to get to the painting collection. The guards needed to be trained to advise wheelchair visitors of the best way to see the collection. And the red carpets were not only hard to ride over in her chair but "aesthetically distracting."[93] On a mission to right the wrongs of the world, Nell also drafted a letter (unsent) to President Nixon, demanding that he spare the life of William Calley, charged with murdering twenty-two unarmed South Vietnamese civilians in the 1968

My Lai Massacre, so as not to "further brutalize the image of our U.S. gov't. throughout the world." She found it "shocking that the army that ordered civilian deaths as policy would kill its own instrument of obedience."[94]

In late June, Carolyn and Nell left for a rented cottage in Gloucester. Carolyn, sent on ahead to check it out, was discouraged to find "a dank little house." But the "workaday atmosphere" and "natural beauties" of the town grew on her. The house turned out to be ideal—after three ramps were installed inside and the tiny bathroom was retrofitted with a new commode. Nell, writing to a relative, called Driftwood Cottage "darling" and was thrilled with the harborside location, which offered a "great and colorful variety of boats."[95] To another correspondent, she wrote, "The air is fresh, the water goes slosh, slosh against our house, gulls scream, motorboats… cruise by in a steady flow of water traffic almost like Venice. Best of all it is cool and pleasant and the dreary aspects of New York are behind us for a while."[96] During the two months she spent in Gloucester, Nell painted "water, sky, clouds, ships—the elements—as expansively & naturally as I possibly could."[97] In *Summer Interior by Gloucester Harbor I* (1971, plate 16) a windowed corner of a room with a bright bouquet on the dining table also provides a view of a neighboring house and boats in the harbor. She simplified this image to create a cheerful blue-and-green cover illustration for Robert Wilson's book *Modern Book Collecting: A Guide for the Beginner Who Is Buying First Editions for the First Time*.[98] Nell had already provided an ink drawing of the same view for the cover of one of his bookstore catalogues.[99]

It had been seventeen years since Nell last visited Gloucester with a woman friend. They had seen an amateur production of a play in dialect about the early settlers, a performance that lodged in her memory, outlasting the impact of many sophisticated plays. Nell and her friend had struck up an acquaintance with one of the actors, who worked in the local art supply store. Years later, she could still recall his bass voice saying "aye-aye" with "a real flat A sound." The women had listened to his anecdotes, eaten his home-cooked meals, and ridden in his station wagon while he pointed out highlights of the local terrain: Dogtown, the uninhabited 3,000-acre center of the Cape Ann peninsula; Lanesville and Pigeon Cove, coastal communities to the north; and Halibut Point, across Gloucester Harbor from Rocky Neck.

Now, Nell was disappointed to see that urban renewal had caused the razing of many old warehouses and "interesting houses which made a fine cubist effect and rhythm on the shore."[100] A highway cutting along the waterfront compounded the loss of "quaintness… rich colors, interesting irregularities."[101] In July, an afternoon of drawing at Loblolly Cove exhausted

Carolyn, who had to carry an easel, portfolio, and drawing board and push Nell in her chair, laden with two bags of equipment. "We need a burro with brains," Nell concluded.[102] One day, after a group of friends had descended on the women, requiring Carolyn to serve as host, she lashed out at Nell with "terrible fury." As usual, Nell claimed to be shocked, despite observing that "those gruesome scenes" occurred "always when I'm having a good time too— with other people."[103]

In early August, on the porch of a friend's house, she painted *Low Tide, Smith Cove* (plate 18), a large watercolor featuring "very delicate boats in sunset glow."[104] The staccato pattern of stubby brushstrokes edging the cove contrasts with the pale, calm water and ghostly vessels. On the day Nell decided to tackle a large oil painting of this scene, the weather had shifted; a strong wind blew the plastic cover she left on the unfinished canvas into the paint, smearing "all the passionate accents."[105] Painting out of doors inevitably brought interruptions, or worries that they might occur, but Nell found this practice "as exciting as walking [on] a tightrope."[106]

Back in New York that fall, Nell wrote a letter criticizing the prospectus of a new publication, *News from the Art World,* for demonizing *ARTnews*—recently purchased by the Washington Post Company—as somehow nefariously controlled by *Newsweek*, another *Post* subsidiary.[107] She hoped that the new magazine would be dedicated to quality, "which would be a miracle in these superficial times," and would offer articles on subjects like "How the Modern & other museums neglect quality to favor newsworthiness." An exhibition that avoided these issues was the Hopper exhibition at the Whitney Museum, recipient of the artist's estate after the death of his wife, Josephine. Reviewing the show in her diary, Nell missed "the great mysterious oils" but enjoyed Hopper's early paintings of Paris ("a lovely light & air & simplification"), some of his etchings and watercolors, and several views of Gloucester.[108]

November brought a new source of irritation: the sound of a sewer pipe or water main on Riverside Drive being blasted at odd intervals during the day and night. It felt like the building was being dynamited, and Nell looked up warily at the ceiling, wondering if it was fated to collapse. Her spirits rose, as usual, at Christmas. A few years earlier, she had written to a friend that she would get caught up in the celebration "as if it were a life and death marathon."[109] Marshall Clements and Midi came for a tree-decorating celebration on December 24. Nell always took a childlike delight in her presents. This year, Clements brought her Frank O'Hara's *Collected Poems*, which gave her "floods of memories both painful and pleasant" when she began to read them. After nurturing a hopeless passion for her straight friend Jane Freilicher, Nell

was moved to read of O'Hara's love for her.[110] Midi's gifts included a knitted hat and a scarf; Carolyn's offering was John Russell's *Édouard Vuillard, 1868–1940* and the newly published *Flannery O'Connor: The Complete Stories*; and Lurline gave Nell underwear. Midi returned the next day for Christmas dinner, cooked by Carolyn: ham with apple jelly sauce, mashed yams with lime, broccoli, and "eggs in the snow" (*oeufs à la neige*). Everyone, Nell reported, had thirds. On New Year's Eve, Arthur Cohen arrived with more presents: an address book with floral illustrations published by the Met and two OTB superfecta tickets (which didn't win but brought "a moment of excitement"[111]). He also bought one of Nell's drawings.

The following spring, Nell's Jazz and Painting exhibition (work from the 1940s) at Keene State College in New Hampshire gave her the opportunity to write about the influence on her work of this musical form, "with its wonderful spontaneity, vigor and inventiveness."[112] But she noted sadly that her early paintings had suffered water damage in the 1950s, some had been lost, and even "ordinary" handling had worn the paint off some of her pictures. Nell's work was also in a group show—Six Figurative Painters, at the Kansas City Art Institute[113]—that included her old friends Lee Bell and Ulla Matthíasdóttir.

Denise Levertov came to visit in early April. She always gave Nell "a warm & affectionate feeling," but she failed to respond to Nell's paintings, "which could have been blank canvases for all the attention or appreciation they received."[114] It seems odd that she would be so blind to the appeal of Nell's still lifes. In "The Tulips," a poem about a bouquet she had received that withered, Levertov evoked the changing colors, the shape of the petals, and the "small sound" they made as they fell. She had written years earlier that although she admired Nell's work "very much," the work sometimes fell prey to "too much facility."[115] But that was before the ravages of polio led to a new way of working.

In the summer of 1972, Nell published an article, "The Act of Painting," that presented an intimate, emotional view of her art practice. As she explained, her initial "state of joy" when she began a painting would become increasingly fraught. Switching to the image of a swimmer panicking that the distant shore was receding rather than advancing, Nell wrote that she would force herself to keep going and not drown, finally reaching the shore, "as in a dream."[116]

Constant money problems dogged Nell during the 1970s. A letter she wrote in May 1971 spelled out her difficult position: although she was "supposed" to earn about $24,000 annually just to pay the salaries of her aides, "I don't make it, so I have help trouble and little mobility. Help is very expensive. My day person, 5 days, 8 hrs is getting $125 a wk. & is due raises regularly. I must have

night & weekend help too!"[117] She awaited various payments, including a $2,500 grant from the Creative Artists Public Service Program (CAPS), for expenses relating to her upcoming Poindexter Gallery exhibition, but would still be $71.75 short of what she owed ($4,218.25), and it wasn't clear where she would find the money. The following year, Nell figured that her "basic" monthly expenses for the summer—not including tips, medical supplies, and art supplies more costly than the $260 she budgeted—came to $4,290.[118] Yet when a charge card she had not requested arrived in the mail, she wrote to the bank to cancel it, fearful that it represented "a dangerous invitation to theft and indiscriminate use by others."[119]

During the summer of 1972, Nell and Carolyn spent three months in Woodside, California ("a foreign country!"[120]), as guests of art collectors Norman and Karen Stone, whom she met through Judge Kohler. "This is an extraordinary place," Nell wrote. "Very luxurious with many gardens—animals, great variety of trees and birds.... I have a separate studio in the woods which is very grand."[121] Norman Stone later recalled that when Kohler told him and his wife about Nell's situation, they felt compassion for her, but they were relieved that "her personal maintenance was not what we would be responsible for," because of Carolyn's presence.[122] He was also intrigued that Nell would paint images of the property, which was tended to by five gardeners.

The first paintings she completed were of bouquets of poppies, the quintessential California flower, and other blooms. Nell was thrilled by the garden: "They said they had every flower known to grow in California in that area."[123] A wooded area near the house also delighted her. Nell's watercolors and sketches became the basis of several oil paintings, including *The Cut-Flower Garden* (plate 19) and two versions of *Shaded Garden with Live Oaks*. Another painting of the grounds, *Pasture*, was one of several purchased by the Stones and later donated to the Virginia Museum of Fine Arts. In mid-August, Nell recorded her frustration with the bright sunlight that made it hard to see colors on the canvas and with her need "to fight my handicap (lack of strength & movement & general weakness)."[124] Yet she managed to embark on a series of new paintings, beginning with one she sketched in miniature in her diary, with a typically detailed description ("upper right a piece of the apple tree...").

For Carolyn, however, this sojourn was not a happy one; she told Nell that she felt like a prisoner in the house. Inga, the latest helper—who had been recommended by Elaine de Kooning—was shirking her work, annoying them with her constant chatter, and proclaiming a lack of sympathy for the elderly and infirm. A day trip to San Francisco, with shopping at Ghirardelli Square

and dinner on Fisherman's Wharf, was a welcome interlude. Nell was enraptured by the "spectacular" fog "ris[ing] up in long dramatic banks like mountains over the city[,] creating wild changes in form and strangely beautiful light."[125]

Her huge Poindexter Gallery show—fifty-seven oil paintings, watercolors, and drawings done in Gloucester, California, and New York, plus decorated ceramic tiles and two sketchbooks—opened on November 28. A review by the *New York Times*'s chief art critic praised the "freshness" of her paintings despite her debt to Matisse, and the "verve and sensitivity" of her ink and wash drawings. In *ARTnews*, Lawrence Campbell, always a strong supporter of her work, wrote, "Although the subjects are familiar, Blaine keeps seeing them in a new way."[126] An even larger show of Nell's work—a retrospective of seventy-four works, from 1956 to 1972—would open in January at the University of Connecticut.

Nineteen seventy-three began in a minor key for Nell, saddened by the death of Jean Garrigue in late December, at fifty-eight, of Hodgkin's disease. Nell admired her writing and was charmed by her warmth and unpretentiousness ("only art & friendship mattered").[127] Noted for her lyricism and technical brilliance, Garrigue—the name Gertrude Louise Garrigus adopted when she moved to New York from the Midwest—had led an unsettled life. She had affairs with several noted male writers, including the poet Delmore Schwartz, and an unhappy liaison with novelist Josephine Herbst. Garrigue was "a superior person," Nell wrote, "one of the nicest I've ever known." During the summer of 1958, Garrigue had visited her West Wharf studio. In "Tide at Gloucester," the poet evoked the sensation of living on the water ("you wake…to its breathing") and experiencing "the high C's and F's of the gulls." Although she was never an intimate friend, Nell believed that they "both love[d] beauty in a similar way."[128]

A month later, she studiously listed her savings bonds' serial numbers (eight of them, totaling $1,475) in her diary before having Carolyn put them in a safe deposit box. Nell was a compulsive list maker, whatever the subject: letters received and written; money earned or paid out; mail-ordered books, clothing, and household items; subscriptions; presents purchased and received; birthday and Christmas cards sent. She squirreled away each item inside a separate box drawn on the page, as if tucking it into a desk drawer. These actions had a psychological basis. As she wrote in her diary, she took refuge in "security and routine to quiet those off the track worries and wobbles."[129]

In early March, Nell painted a still life of anemones and candytuft in a blue vase, working all night "until I collapsed" in a typical ecstatic burst of activity that gave her joy and self-confidence while threatening her health.[130] It was only gradually, in the act of painting, that she began to see "complex relationships, exciting shapes interlocking & moving endlessly." Attaining this state of enhanced awareness involved a physical sensation "of weights and measurements," a sensuous "thickness" in her mouth and body that she found difficult to describe, worried that it might be perceived as a state of sexual arousal.[131] She sometimes felt as though some force impelled her to begin "hurling myself at my canvas, rushing to transfer this condition before it's over."[132] It is telling that she used the word "hurling"—an action that could take place only in her mind. Five days later, she pulled another all-nighter to paint a bouquet of yellow tulips. "Tulips and anemones excite me...almost any flower does," Nell wrote to a friend, describing her "contact with the mysteries of nature in the middle of New York."[133] She added that she and Carolyn hoped to live in the country in their own place—a wish that would come true a few years later.

In May, Nell served on a panel about women in art at Sarah Lawrence College, part of the new women's studies program on campus. As usual, she criticized her performance. "Too nervous" to say what she really thought, she had worried about "stepping on some of those earnest toes" of fellow panelists whom she felt lacked a sense of humor.[134] The following month, she replied to a letter from a college student who wondered how hard it was to be a woman artist. Nell pointed out that the career was hard for men as well and few made it to the top rank. Being a woman, she wrote, was neither "a great asset nor a hindrance."[135] Even after achieving a degree of recognition, she experienced rejection and neglect because of her unfashionable style and "some lack of aggressive confidence." This failing led her to remain silent during conversations with "aggressive or chauvinistic male artists." But whenever she encountered sexism—or racism—her hackles rose. Countering negative remarks made her stronger: "Now it's harder to knock me down." Nell credited women's lib for changing attitudes among both men and women; interestingly, she saw "more similarity between males & females than many imagine"—a view perhaps influenced by her bisexuality. Once again, Nell credited her difficult childhood with giving her the courage to fight back.

By now, Nell had made her peace with Dilys, whom she had invited to dinner in 1970 "as an experiment—partly to smooth over bad feelings of years standing & partly to see (hopefully) that I didn't care about her anymore." It was still painful to hear about Dilys's new lover ("I didn't want to hear that they

were too happy together!"), but Nell rationalized that she had more in common—well, mostly—with Carolyn. In June 1973, Dilys stayed overnight and brought her paintings to be critiqued. On the earlier visit, they had struck Nell as amateurish and derivative of her own, yet she felt that some—here is her generous side coming out—were imbued with a "lovely quality of affection."[136] Now, Nell noted that Dilys's work had "improved."[137] (About to become assistant art director at *Cricket*, a new children's magazine, she subsequently founded a company to promote and exhibit children's book illustration as a fine art form.) In 1975, when Nell moved into her new vacation home in Gloucester, Dilys and her lover, Trina, brought housewarming presents that included champagne, filet mignon, and an artichoke pie with Nell's and Carolyn's initials and a heart worked into the crust. Nell sketched this bounty on a diary page.[138] Two years later, a condolence letter Nell sent after the death of Dilys's father—whom Nell described as "a sweet charming man"—offered "heartfelt sympathy" and "my love to you both," an embrace that included Trina.[139]

In a period notable for the development of minimalism and explorations in new media, Nell remained unalterably opposed to all recent trends in art. A visit to the Museum of Modern Art in June 1973 reinforced her dislike of work by several artists, including Donald Judd, Anthony Caro, Frank Stella ("black death!"), and "the perpetrator of a glass or plastic cube."[140] Around this time, she railed against "relevance in art," which, she believed, led either to "emptiness" or to "cynical, cool satires which are the ultimate in decadence." Bolstering her argument with quotes from Degas and Picasso about their indifference to seeking a personal style, she wrote, "In order to create a meaningful and moving art, one must not seek either success, style, relevance or 'experiment.'"[141] The museum did offer compensations: work by Mondrian and Matisse. In a diary entry reflecting her intense excitement at seeing these paintings, she gushed that the French artist embodied "all pure beauty all soul all expansiveness all positive, complete!"[142] Nell had told an interviewer, "What you don't get from religion, you can get from Matisse." It was this "nourishing quality, a spiritual quality," that she wanted to achieve in her own paintings.[143] Always acutely sensitive to aspects of vision, Nell had begun to realize how her painter's eye functioned when her work was going well: "As I paint, I see more ... exciting shapes interlocking & moving endlessly, yet in a coming together.... Strange how sensuous it is."[144]

That summer, a nine-week sojourn in Lyme, Connecticut, at the home of Elinor Poindexter and her husband[145] yielded a bountiful harvest of twelve oil

paintings, eight watercolors, and twenty drawings. As she did each year, Nell listed each of them in the back of her diary, with dates, dimensions, and stars marking the ones she thought were best. *First Lyme Landscape* was one of these. A swath of bristling tall grasses in the foreground gives way to a low-lying distant landscape, with two leafy trees—generalized in a style akin to Milton Avery's—anchoring the view.

In October, when Vice President Spiro Agnew resigned in disgrace, Nell wrote, "Agnew out, hoo-ray!" in her diary. But she worried that his resignation might have been a "'ploy' of the Republicans" and felt that there was too much corruption "to even...want to know about."[146] The following month, Nell returned to Richmond for the opening of the exhibition Jack Beal/Nell Blaine at the Virginia Museum of Fine Arts.[147] The show included a sampler of her paintings of the various places she had lived in or visited over the past eight years: Riverside Drive, Gloucester, Dorset, St. Lucia, and upstate New York. The round of social events included a Virginia Commonwealth University alumni dinner at a country club ("very snazzy place") that caused her some embarrassment because she could not remember the names of some of her fellow students when signing their copies of the museum catalogue. But her heart warmed to see the "sweet people" who had come on her behalf, and she called the evening "a really dazzling experience." A dinner at a collector's home prompted her observation that some of the Art Nouveau and Art

Nell with Jack Beal at the opening of Jack Beal/Nell Blaine, Virginia Museum of Fine Arts, November 19, 1973.
©Virginia Museum of Fine Arts.

Deco furniture was "less pretentious and more involving" than most of the art by Warhol, Twombly, Stella, Lee Bontecou, and others.[148]

Jack Beal, the other Richmond-born painter in the show, was then living in upstate New York, but he was in town for the opening. A writer for one of the local papers engaged the two artists in a dialogue that mostly highlighted their different approaches. The rival paper interviewed Nell by herself, describing her as "a friendly, soft-spoken woman with a puckish grin and matching sense of humor" and eliciting details of her early life in New York as well as her current painting practice. Nell spoke about her nocturnal habits ("I paint until I can't hold my arm up") and emphasized her enjoyment of spontaneity, "though you go through all kinds of things to get to that point."[149] A high point of her four-day visit to Richmond was the time spent with her seventy-four-year-old former art teacher Theresa Pollak; Nell told her that she seemed to be "the youngest, most lively person, the most sparkling of all those in view."[150] The low points ranged from a long wait and unexpected steps at the airport to a hotel with a bathroom that was too small to navigate. Staying in a hotel added even more time to Nell's normal four-hour morning and evening routines, making it hard to show up on time for her various appointments. She returned to New York feeling exhausted.

But she always had energy for Christmas, throwing herself into shopping (by mail), wrapping, sending cards and packages, and overseeing the removal of studio items to provide space for a dining table and a tree. One year, she flirted with the idea of designing a women's lib Christmas card featuring famous historical and mythical women, including Cleopatra, Carmen, Emily and Charlotte Brontë, Queen Elizabeth I, and Golda Meir. Carolyn, who hated making such a fuss about the holiday (in letters to a friend, she preceded "Christmas" with "bloody"), was obliged to play along and shoulder the burden of holiday preparations. Five people—Midi, Howard Griffin, Jane Mayhall, Leslie Katz, and Griffin's friend Bill Stewart—arrived for Christmas dinner, with a turkey cooked by Carolyn. Afterward, it took her three and a half hours to clean up. On December 26, Nell wrote that the two of them felt "like overused rubber bands. Flaccid, limp, grey, palid [*sic*], putrid, pale, poorly—OLD."[151] Much as she loved the holiday season, Nell realized that guests often depleted her energy and got in the way of her work.

Nell wrote to Arthur Cohen in early 1974 to apologize for her tactlessness, apparently in complaining about his intent to sell some of her works to the Virginia Museum of Fine Arts.[152] Another storm blew up later in January, when she spoke to Cohen on the phone about applying for a Guggenheim

Fellowship and Carolyn, lurking nearby, said, "She'll never get it." This segued into an argument about whether Robert De Niro had received one. Parsing this exchange, she wrote in her diary, seemingly without irony, that Carolyn "<u>must</u> be a frustrated artist."[153] Although she blamed Carolyn for "always seem[ing] to want to put me down," Nell would later admit—to herself, at least—that the root cause of their arguments was her own "terrible insecurity…plus a feeling of not being loved enough."[154]

In March, Carolyn left for a month-long trip to Mexico, leaving Lurline—who was somehow still in Nell's employ—in charge of her care, earning a larger weekly wage to make up for the additional work. When Carolyn returned, Nell admired her tan. "Exciting," she wrote in her diary.[155] Absence had done its good work.

Gloucester

IN THE SUMMER OF 1974, the Parrish Museum in Southampton, New York, held a retrospective exhibition of Nell's work from the midfifties onward.[1] A reviewer praised "the kind of keen, direct observation of nature" that had always been a hallmark of her work. Even the ink drawings demonstrated her "interest in light [and] the intensity and spontaneity of her vision." *Landscape near Connecticut River*, a recent work, "has every bit as much energy as the early drawings."[2]

Nell and Carolyn returned to Gloucester that summer, renting three units—for living, painting, and the aide's use—in West Wharf, on the Rocky Neck peninsula favored by artists.[3] Inspired by the movement of light on the waves and the drama of the setting sun, Nell enjoyed being right on the water. "I have a feeling of sea & sky & freedom & art!" she wrote. "And I need that 'anything goes' feeling for my painting."[4] She was "eagerly absorbing the panorama of ships & water and especially the marvelous light and cloud changes."[5]

Carolyn helped her locate a small shed near the dock at Marine Railways, the shipyard on Rocky Point, where she could get as close as possible to the water.[6] "The fishermen going about their business…did not bother her," Carolyn told an interviewer. "If anything, they gave her the eye."[7] In *Summer, Marine Railways, Gloucester*, one of Nell's watercolors of this view, the water laps the lower edge of the paper; the two boats in the foreground loom large. Other vantage points were also possible. Moody grays in her watercolor *Rackcliffe [sic] and Wiley Streets* subtly convey the atmosphere of a drizzly day on the western side of the Rocky Neck peninsula, with a view of the opposite shore.[8] A drive with a local friend yielded a bouquet of wildflowers, smooth stones "in marvelous colors," and—a memorable sight for an artist in thrall to luminosity—whitecapped dark green water in bright light.

This year, the women were in time for the three-day St. Peter's Fiesta in late June, which honors the patron saint of fishermen. Nell, whose diary faithfully records the foods eaten at all celebratory moments—a sensual pleasure unhampered by her disability[9]—gorged on Italian sausage with peppers and

Nell at Marine Railways in Gloucester, 1974.
Photo: Carolyn Harris. Courtesy of Carolyn Harris.

onions on a roll, orange soda, french fries, and Italian ice cream. She watched the Ferris wheel spin, listened to the amateur band, and reveled in the fireworks. Another annual event, the Beaux Arts Ball hosted by the Rocky Neck art colony, had a "Roman orgy" theme this year. Nell, an enthusiastic participant in costume events during her early years in New York, bemoaned her "rather primitive" attempt at classical dress (a getup incorporating shields, a mask, and fur, which got caught in her chair), but her group of friends won a magnum of sangria and she had a great time.[10]

The high point of this trip was a visit to a house for sale on Ledge Road that Mary Shore, a Gloucester friend, had told her about. "Swept off my seat!" Nell wrote in her diary, her twist on *swept off my feet*. "I love it."[11] A former carriage house surrounded by trees, it was perched on a hilltop directly east of the artist colony on Rocky Neck peninsula, with a view of the harbor and Ten Pound Island. Nell liked that it was "panoramic yet <u>private</u>."[12] (A couple of years later, she was dismayed to see people, often with dogs, walking on the two-acre property, apparently considering it to be public land.)

She happily inhaled the scents of the junipers and pines, and the wild bluebells. More good news: the front door was nearly level with the front lawn.

Inside, the living room struck her as "livable, quiet, peaceful!" Nell would tell an interviewer that Gloucester had something in common with the backwoods of Virginia: "a wildness."[13] In addition to the water view, the property offered an ideal combination of trees, always important to Nell, and "crazy rocks"—the area is famous for its granite outcroppings. There was also a convenient grocery store just down the hill. Other enticing features included the "adorable" small cottage and a garage that would be outfitted with a skylight and converted to a studio for Carolyn. A week later, Nell saw the house again in the company of friends and felt just as keen about it. To rationalize the purchase, she leaned on her dealer's assertion that real estate was a good investment. She also figured that having a permanent base in Gloucester would obviate the "exhausting business" of finding a new place every summer and losing two months from her painting in packing and unpacking. Little did she realize that transporting her and Carolyn's goods would only grow more complicated.

After listing questions for the owner of the house (could she keep the fire screen? the built-in chest? the fridge?) and gathering bids for work that needed to be done, Nell made a successful offer. Negotiations, she wrote in late August, had "dragged on like a long poker game."[14] She made a $4,000 down payment from her mother's legacy[15] and cobbled together another $7,000 from her savings and checking accounts, loans ($1,000 from Carolyn, $2,000 from Elinor Poindexter), and a US savings bond, leaving her with a $25,000 mortgage. She figured that repairs, including heating and wiring, would cost an additional $10,500, a small portion of which she hoped would come from her collector Arthur Cohen, who had visited the couple that summer.[16] Nell was happily unaware that the cost of remodeling would balloon to about three times the estimate by autumn 1975. Hoping to prove her financial worthiness, she sent copies of her catalogues and reviews to Cape Ann Savings Bank along with her mortgage loan application.[17] The annual cost of mortgage payments, insurance, and property tax would be about $1,500 more than she usually paid to rent a cottage in Gloucester. For now, whenever she worried that she had taken on too much, "the calm I felt from the quiet of the place and the beauty on every hand" would ease her fears.[18]

In a burst of filial sentiment, she had named the house Eudora Cottage after her mother. "I wanted to thank her this way," Nell wrote to a relative, alluding to the legacy. The word "cottage" created some confusion, however, because of the small cottage on the property, where her aide stayed. (A buzzer enabled Nell to call her from the house.) The following spring, sketches of the Gloucester house filled pages of her diary ostensibly devoted to other matters.

Aware that structural changes would need to be made for her wheelchair, Nell asked Karen and Norman Stone for a loan.[19] Otherwise, she wrote, "I'd sit with Carolyn in one room for working & everything."[20] For Nell's fifty-fifth birthday in July, Carolyn chose the perfect present: a book about do-it-yourself house building and repairs. Furnishings would be simple but attractive: reproductions of Shaker originals and a few pieces from her mother. Charmed by a friend's demonstration of break-resistant Corelle Livingware (she "slamm[ed] a dish on the floor as hard as she could!"[21]), Nell decided it would be just the thing for her new household.

She hired a New York architect, David Mahon, to reconfigure the house to accommodate her needs. One of his additions was a "trail of light" that enabled her to illuminate her path throughout the house. Local builder Geoffrey Richon, whom she met when she bought the house, did the actual work. A key project was to raise the roof, letting in more of the "beautiful Gloucester light" she adored and giving the sixty-foot-long second-floor studio a sweeping view of the rock garden and harbor. The southern exposure was somewhat unfortunate; by noon the sun's rays would become too blinding to allow her to paint. Her bedroom window looked out on trees that would soon be outfitted with a special squirrel- and jay-resistant bird feeder. "We worked together and argued with each other," Richon recalled. "People were afraid of her; she was tough." But Nell was considerate of those who helped her, he said, and "very appreciative" of his help in picking her up and moving her in and out of cars. She complimented him on his strength—the praise a young man wants to hear. He was intrigued by the dynamic between her and the people in her household, contrasting Carolyn's "almost worshipful subservience with an edge" with Jestina's bursts of outspoken rage.

Richon installed an elevator, which Nell enjoyed showing off to visitors, to get her up to the second floor. He also built a first-floor deck with a garden view. For Nell, gardening now meant planning the shape of gardens, choosing individual plants, and doing a little potting and deadheading.[22] She wrote that it helped her "connect more deeply with the feeling of growth—the reality of putting down roots."[23] Even just watching Carolyn and Jestina cut flowers pleased her: "I feel like I am doing it myself," she told an interviewer. Nell once said that she considered her garden as her "third studio." Painting it was like "recording a kind of documentary of the things I love to live with."[24]

She designed a fan-shaped raised garden, envisioning it as a mingling of calla lilies with pink, yellow, red, and orange flowers—a medley of cosmos, marigolds, phlox, and coneflowers (rudbeckia). In this "platform garden," the space in the middle would be reserved for her wheelchair. Among the first of

many paintings that reflected her view of the garden from the platform was *Ledge, Early Autumn* (1975), which includes a thin ribbon of water and faraway coastline. The masses of flowering plants in *Platform Garden* (1988) barely cede their space to a small patch of grass and a couple of rocks. In another artist's hands, this jumble of color might seem excessive, but Nell locates a rhythmic dance of petals and leaves that gives the composition its airy feel.

There were actually several gardens on the property. Nell designed each one with a detailed drawing-cum-diagram, including copious notes and instructions for Martin Ray, a professional gardener in Gloucester who worked with her from 1981 onward. The "box garden" was to be devoted mainly to Shasta daisies, fronted by "very bright large" petunias ("purple, red, deep pink—no white") and bordered by zinnias in different heights. Shades of purple would dominate in a garden created around the Japanese maple tree—a complicated scheme involving foxgloves, harebells, begonias, and bellflowers ("I want campanula badly!"), and the wild bluebells and violets already on the property.

The "septic tank garden," designed around that fixture, would be a riot of tulips, cosmos, "huge iris," impatiens, strawflowers, marguerite daisies, phlox, and other blooms. Nell wanted the rocky "spoon garden," which she named for its shape (like the "tongue garden") to have "more life & <u>hardy</u>, <u>low perennials</u>!" She dreamed of planting a rock garden, an anemone garden, a euphorbia garden, a California poppy garden, and an iris garden in which she would make room for more of her beloved Shastas. The "cut-flower garden" was intended to furnish her still-life paintings. An eleven-foot-long vegetable garden would also contain strawberry plants, herbs, asters, anemones, lilies, and poppies. In front of the house, facing the road, Nell proposed a shade-tolerant mixture of foxgloves or coleus with red and white impatiens.

In her first letter of instructions for Ray, she fretted about the "delicately established frail survivors" of the existing garden—the delphinium and "very marvelous" Shastas and lilies—and a lost limb the white pine had suffered in a winter ice storm. She also enclosed an ad for generic mail-order lily bulbs.[25] Ray initially wondered whether he would be able to produce "the landscape vision of a chair-bound New York artist drawn to gaudy mass mailings."[26] Her taste for "exuberant gardens" clashed with what he viewed as "the quiet splendor of coastal New England." Influenced by Japanese naturalism, he appreciated the subtleties of earth tones, with color limited to "occasional bursts." Ray explained to Nell that popular plants in Gloucester included gray-green lichens and low-bush blueberries, offering "tiny white confetti flowers" in spring and "an autumn pageant of clarets and golds."

Nell approved these choices but wanted more color. "Craving luxuriant blooms to paint," Ray said, "she envisioned drifts of petunias through the hedges, reds, purples, bicolors, spiced with fiery marigolds, cosmos, cannas, dahlias, zinnias. To her eye they were not impositions but complements to the spare terrain." He learned early on that Nell's golden rule about planting was "Don't stint!" Abundance was her eternal goal: "more big dahlias," "more begonias," "more paprika marigolds." Her ideas were closely related to her views about painting. She wanted her garden to be "part wild, part cultivated," with a combination of "bare areas" and "busy areas." Noting that some of the trees needed to be removed "to let the best trees show," she linked this goal to the "air and clarity" required in painting. Nell did not believe in theories about color relationships, telling Ray that "any color can work with any other color," and that color choice was a matter of "what it does to you" and "the needs of the composition." The close looking required in painting flowers had even made her reconsider her notion that hydrangeas and petunias were garden clichés.

As time went on, Nell increased her trust in Ray, who she felt shared her openness to change, dislike of rigidity, and desire to "honor the land." Yet her tone always remained a cross between pep talks about her aesthetic preferences ("Fluidity is important to me"; "I like sharp edges") and recurring anxiety about her garden's health ("Did you <u>mulch</u> against winter burns & freezes?"). She wrote that she considered herself an "amateur-beginner-gardener," despite having been involved with gardens "off & on since childhood."[27] Nell had grown up among people who cared deeply about their suburban plots, favored by the temperate Richmond climate that encouraged plant growth. Her parents, as she now described them, were "excellent gardeners": her mother tended roses, jonquils, hyacinths, and other flowers, and her father grew "gigantic" dahlias.[28] On a visit to her hometown, she marveled anew at the beauty of the residential areas, with houses set among a "forest of young trees"; in her eyes, the residents were "all expert horticulturists."[29]

During her long working relationship with Ray, she expressed her gratitude in gestures of what he viewed as "impersonal kindness." She wrote a recommendation for his wife, Kay, a painter, to take up a residency at the Vermont Studio Center and enabled the Rays to spend ten days at the Poindexters' house in St. Lucia ("completely staffed, quite a treat," he recalled).[30] Of course, Nell was also capable of lashing out when something seemed amiss. In the summer of 1987, she wrote to Martin to complain that his bill, now that he was working with a helper, reflected a higher hourly rate he had not previ-

ously mentioned to her. This was especially annoying because she had sold him a painting of hers at the wholesale price, $3,600, paid $300 for the framing, and—laying it on a bit thick—"also paid someone to wrap it up."[31]

At one of Nell's New York openings, Geoffrey Richon noticed a photo of her in the catalogue: sitting in her wheelchair at Lane's Cove, a favorite spot of his, she was working on a painting. He asked if she could send him the photograph. Months passed; he kept reminding her, and she kept promising to send it. One day, a crate arrived at his office. To his surprise, inside was the matted and framed photograph . . . and the painting. The photo, taken by Carolyn, was not originally intended for publication. Although Nell allowed a photographer for *Countryside* magazine to show her working on a watercolor in her wheelchair, she was adamant about not presenting herself as a disabled artist. "She didn't want it to be part of her artistic legacy," one of her assistants said. "She wanted to be known as a free person."[32]

Yet her disability naturally made her output dependent on others. In Gloucester, "I have to get up bright and early to paint early in the morning," she said, "and that means Carolyn has to do the job. I can't ask Jestina to get up at four in the morning to get me up." A closer view of the harbor than she could see from her "platform garden" was possible only if Carolyn managed to push her up a steep incline toward the ledge for which Ledge Road was named. On a summer day in 1977, Nell was thrilled at her first experience of the "exciting" vista with its "huge boulders, grasses and varied trees: hornbeam, maple, apple, birch...and the water of course."[33]

There was much scenic beauty on Cape Ann, but, as an acquaintance recalled, "mobilization even for a day trip required the efforts of a household staff of three and a gargantuan powder-blue Cadillac."[34] These excursions were tiring for Nell, because of the extra lifts involved and the experience of rolling over rough terrain. "However," she wrote after one trip, "it was worth losing a day [of painting at the cottage] considering the image I have retained of the really lovely landscape view."[35] Another day, when a road closure in neighboring Rockport made it impossible for her to paint a particular scene, her frustration melted away when she returned to Loblolly Cove, with its "beautiful light on the water & shore" that she captured in two watercolors. Nell declared that Halibut Point—at the northern tip of Rockport—was her favorite spot, with "the grandeur of those gigantic boulders jutting out into an endless curvature of ocean."[36] Yet, especially for someone who required a high level of control, working outdoors could be extremely frustrating. The first time she tried painting in oil, the glare of the setting sun was blinding, her

hand became stiff from the early November cold, and the wind blew her hat onto her palette.[37]

In her many paintings of Gloucester, Nell avoided the postcard fidelity to nature favored by many local artists, replacing it with an effervescent quality that captured light on water and gardens rife with blooms. Returning constantly to familiar scenes, she had to try to see them freshly every time; she attributed her ability to do this to her "probing state of mind." As she told an interviewer, "Always discovering new things in nature is what I left abstraction for."[38] It was also a matter of emphasizing different elements of her style, adjusted to the medium and to her physical abilities. In 1958, Nell used pastels to evoke *Gloucester Harbor, Dusk*, a tour de force of scattered glimmerings on the water and on a crowded array of boats. Painted twenty-two years later, her watercolor *View of Tarr and Wonson's*—the name of a historic paint-factory building on Horton Street on Rocky Neck[39]—simplifies the coastal scene to a swath of choppy water and a trio of rocky outcroppings situated between her vantage point and the distant building. ("I like the movement of water," she once said. "It's as if it were already made of paint."[40]) Of course, she was not working in a vacuum. Nell papered her studio walls with reproductions of paintings by Bonnard, Vuillard, Monet, Rouault, and other artists she admired, and she was also aware of the significant role played by Gloucester in American painting.[41]

A local artist, Fitz Henry Lane,[42] put the town on the artistic map in the nineteenth century with nautical scenes distinguished by an aura of stillness and the luminous quality of sea and sky. Nell may have drawn some inspiration from his sensitivity to atmospheric effects. Among the notable modern artists who had painted local scenes were Winslow Homer, Childe Hassam, John Henry Twachtman, Maurice Prendergast, John Sloan, Stuart Davis, Edward Hopper, Marsden Hartley, and Milton Avery.[43] Their styles were completely different, but they were mostly, in one way or another, loners. Nell may have been the most gregarious of the lot.

Homer, best known for his marine paintings, is usually identified with coastal scenes in Maine. But before moving there, he spent two summers in Gloucester. In 1873, he stayed in a hotel, but in 1880, he got closer to the action by joining the lighthouse keeper on Ten Pound Island. He developed his signature watercolor technique on these trips in works that often showed children—playing, daydreaming, picking berries—on the rocky coast. Hassam was also a summer visitor, beginning in the mid-1890s, painting detailed, sunlit scenes of the harbor. Twachtman, a celebrated landscape painter who died of a brain aneurysm in Gloucester in 1902, spent the last three summers

of his life working in a studio on Wonson Cove that extended into the water. His delicately hued *Gloucester Harbor* (ca. 1900) offers a panoramic view of houses, a fragile-looking pier, sailboats, and fishing craft. Prendergast, who occasionally summered in the area, was in his fifties when he painted his own version of *Gloucester Harbor* (1918–23), a group of rather listless figures gathered at the water's edge.

John Sloan came to Gloucester in the summer of 1914, a forty-two-year-old desperately in need of a holiday.[44] He and his wife, Dolly, rented a small red cottage on East Main Street with another couple. The following summer, they were joined by Stuart Davis, his mother, Helen (a sculptor), and his father, Edward Wyatt (a photographer and art editor). While the paint color of the cottage was coincidental, its inhabitants shared the progressive, socialist, antiwar outlook of *The Masses*, the magazine that had brought them together. For Sloan, Gloucester offered an enticing variability of natural light and inspiring views—the same combination Nell would find compelling. Using a new brand of premixed paint that came in a range of hues (a novelty at the time), he produced ninety paintings in two months.[45] In *Glare on the Bay* (ca. 1914), he attempted to capture the dazzle of sun on water, an effect that Nell, with her lighter touch, would also pursue.

In 1919, irritated by the increasing number of artists populating Gloucester during the summer, Sloan decamped for Santa Fe. Davis remained loyal to Gloucester until 1934.[46] When he came to town—long before he developed his famous jazz- and Cubist-influenced style—he was attracted to Gloucester's "brilliant light [and] topographical severity" and to the visual appeal of "the Gloucester schooner."[47] During the 1920s and '30s, he filled sketchbooks with drawings. They ranged from multiple views of boats and the harbor (including one that incorporated his car's windshield) to images of Johnson's Auto Park. While much of this production may seem remote from the Davis we know, more than 70 percent of his works from the last decades of his life were based on his Cape Ann compositions.[48] And there were hints of the freedom to come. His harborside painting *Gloucester* (1919) has a rhythmic intensity and coloristic freedom that come close to Nell's own style.

Edward Hopper—one of the few contemporary American artists whose work Nell liked—painted in Gloucester during five summers, beginning in 1912 and continuing in the 1920s. Unlike other visiting artists, he turned his back on the sea; what interested him were the Victorian houses. His watercolor *The Mansard Roof* (1923), with its army of cupolas and billowing awnings, served as the springboard for his subsequent career.

Marsden Hartley first visited Cape Ann in 1920, when he met Davis and sculptor Elie Nadelman, but he dismissed it as "a cesspool of American vulgarity and cheapness."[49] He did not begin painting the Dogtown landscape until he returned in the summer of 1931 as a rootless fifty-four-year old artist, recovering from a serious attack of bronchitis and ready to give Gloucester another try. It served as both rest cure and creative impetus. "I had remembered the rocks and the name Dogtown—that's a great name," he wrote later."[50] Because it was so deserted, there was "a sense of eeriness." At first, he stayed in a boardinghouse at 1 Eastern Point Road, steps from Rocky Neck Avenue, site of a long-established art colony that he studiously ignored. Then he moved into the colony itself, befriending a kindred soul, painter Helen Stein.[51]

Undeterred by the four-mile distance between his lodgings and Dogtown, Hartley threw his energy into daily sketching sessions at the massive boulders until the onset of punishingly cold weather in early December. To him, they "looked like a cross between Easter Island and Stonehenge."[52] Aware of the identification of rocky landscapes with hermit monks in Renaissance art, he believed the stones embodied an "almost metaphysical" aspect.[53] His drawings became the basis of small paintings pulsing with the stored energy of clustered rocks. Returning to Dogtown in 1934, he was upset to see the primeval quality of the landscape ruined by mottoes carved into the boulders at the behest of the new owner of the land.[54] Hartley managed to overlook this desecration to paint a new Dogtown series as well as an odd and fascinating group of still lifes of fish and fishing implements that had washed up onshore. They are elements in a composition that also includes miniature seaside views—the kind of paintings he despised as tourists' art.

Milton Avery had a personal connection to the Cape Ann landscape: another summer visitor, Sally Michel. In 1924, he was impressed that she would go out at six thirty in the morning to sketch; two years later, they eloped. Avery had first come to the area in 1920, when he was working in an American Impressionist style. In the late twenties, he abandoned plein air painting for quick pencil sketches of views that he would paint in his studio. During the next few years, he focused mostly on everyday aspects of life in Gloucester, like the gas pump and station lettering in *Colonial Gas* (1934). Writer James Mellow, who grew up in Gloucester in the 1920s and '30s, remembered the town in those years as "a tough, workaday place…with busy wharves and salty, roustabout saloons."[55] It was also inexpensive; Sally Avery recalled that rent for a small house was $30 a month, and $150 would see the couple through for the entire summer.[56] With no money to spare, there was no drinking; a nighttime get-together would feature tea and crackers.[57]

After a nine-year absence, during which the Averys traveled to Vermont and Quebec, Milton began to simplify his style and brighten his colors. Returning to images of the coastline, he produced works like *Sunlit Rocks and Sea* (1945), a watercolor in which the sea is a swath of blue and the rocks are mere squiggles, with the white of the paper indicating the sun's dazzle. Nell embodied something of Avery's lightness and freedom in her watercolors. Fittingly, the two painters would show together posthumously in two group exhibitions.[58] But the seeming effortlessness of her watercolors was an illusion. A photograph taken in the early 1990s shows her left hand supporting her right arm above the wrist—she used her weakened right hand for watercolors—as she made a stroke on the paper.

At the end of every season, she would invite a few people, one at a time, for what was inevitably a late dinner. As soon as she arrived, a neighbor recalled, Nell would invite her to come upstairs. "Then she would want to show you her recent work. There was never a chair in her studio. One never sat down in her presence! And then, much, much later…Carolyn would serve a wonderful meal."[59] An artist friend described the formality of these showings: Carolyn would bring in one piece at a time, hang it on the wall, and then take it off and bring in the next piece.[60] This ritual did not encourage candid

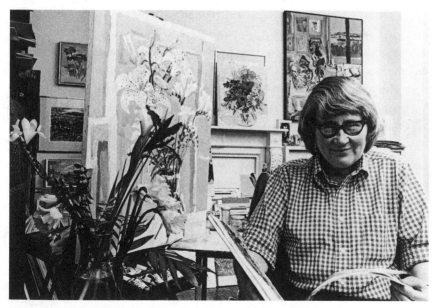

Nell in her studio, 1978.
Courtesy of Carolyn Harris.

remarks. But Nell made her own annual assessments of her work in her diaries, adding stars to her detailed lists of her oil and watercolor painting production to denote the ones she thought were the best. These records also included the books she had read. One year, she was delighted to discover that May Sarton's semiautobiographical novel *Mrs. Stevens Hears the Mermaids Singing*, about an elderly poet looking back on her life, was set in Folly Cove, a scenic spot on the border between Gloucester and Rockport.

For all of its charms, the house—with its mortgage, property tax, upkeep, and renovations—represented a huge drain on Nell's finances. There were also problems on the other end: unpleasant surprises at the Riverside Drive apartment when the women returned after months away. Returning after the first summer at the house, Nell and Carolyn found that water pipes had broken, mold was growing, and much artwork was damaged. Some paintings were stuck together, beyond rescue.

Dick Brewer visited Nell and Carolyn in New York in October 1974, prompting Nell's portrait of him in her diary as "a southern gentleman, very polite."[61] She regarded him as a faithful friend with a "sweet & generous nature," though she felt that his art was marred by "personal obsessions" she did not specify. Noting his perpetual dissatisfaction and the expression of "profound sadness" she sometimes glimpsed on his face, Nell concluded that he "cheat[ed] himself of pleasure." Although she had realized "at long last how difficult life is for everyone," she believed that her life was different, because she periodically had "moments even longer periods of exaulted [*sic*] joy, of pleasure, of marvelous satisfaction." She mused that her current positive state of mind may have been the result of her conversation with Brewer. Then again—in line with the usual impetus for her positive thoughts—the weather was "superb" that day.[62]

One day that fall, Nell worked for thirteen hours straight on a book jacket design, probably for *Love's Aspects: The World's Great Love Poems*,[63] a collection selected by Jean Garrigue that was published by Doubleday in 1975. The poets ranged from Sappho and Shakespeare to Sylvia Plath and Robert Graves. Nell chose for the cover her painting of a bouquet on a table with a red checked cloth. Emerging from her euphoric stupor of overwork, she fervently hoped that Jean would have liked it.[64] Nell was beginning to have problems with fatigue; painting all night, always a health-endangering practice, had become a perilous endurance test.

On November 1, at literally the eleventh hour, Carolyn brought her and Nell's applications for National Endowment for the Arts grants to the post office to meet the deadline. Nell's application would be successful; she had

also received a Guggenheim Fellowship this year, her second try for this prestigious award, which she had hoped to receive in the mid-1950s.[65] In mid-November, Clements returned from a trip to Greece, where he had encountered several people he and Nell had known in 1959. One was Lena Tscouchlou, who came from a wealthy family. A "heavy and peasantlike" bohemian, in Nell's fond recollection, Tscouchlou had worked with the filmmaker Michael Cacoyannis, best known for *Zorba the Greek* (1964). Another acquaintance was the "rather lovely" Iris Malanidis. The mention of the women's names stirred "vague memories...that were buried," Nell wrote, tantalizingly, in her diary.[66] Coincidentally, Vienoula Kousathana—the weaver who had rented Nell a room on Mykonos—came to visit two days later with members of her family. Nell felt as though the fifteen-year gap from their last meeting had vanished. While she chatted with the visitors, Kousathana's grandchildren were handed over to Carolyn. Why didn't Nell realize that expecting her lover to act as a babysitter was asking for trouble? The following day, she noted in her diary that Carolyn was "distressed again—hysteria and anger from her frustration."[67]

Nell's first task in 1975 was jurying the annual exhibition of Audubon Artists.[68] The combination of only two hours of sleep, freezing weather (while she waited for a taxi), bad food at lunch, and unsympathetic organizers proved toxic—not to mention the "depressingly run of the mill potboilers" she had to choose from.[69] Reading W. H. Auden's posthumously published book of last poems, *Thank You, Fog*, a few days later put her in a better mood. She was fascinated by his ability to be "witty about dying." Ever since she first read his work in the early 1940s, it had given her pleasure.[70] Her equilibrium was shattered all too soon by the yelling of the young man who lived in the apartment next door, irate at Carolyn's complaints about being kept awake by the noise he made at night. Nell promised herself to complain to the landlady but couldn't help criticizing her lover for being "so frantic, it wears everyone out, her most of all."[71] A fog of negativity hung over their relationship for the next few days, because of their lack of sufficient time for their work and Carolyn's lack of freedom. Nell wistfully wrote that what they needed was "a 24 hour live-in saint."[72] Until news reports were published, the women were unaware of a serious event in the basement of the building in February, the fatal shooting of former *Life* magazine photographer and art scholar Frank Horch. The only thing Carolyn heard was the side emergency door slamming when the murderer made his getaway.[73]

In early June, Nell stayed up all night to make a poster for Midi's forthcoming dance concert. She performed with "great dignity and presence &

refinement of an unique order," Nell wrote, lamenting that her concentration was distracted by a difficult entry up two flights of steps and the lack of the dedicated space for her chair that had been promised. "It's nerve-wracking to be carried up or down steps," Nell wrote in her diary. "However[,] by far the worst is going down afterwards!" She was so frightened that she made two men carry her down in her chair, despite realizing how hard it was on them.[74]

The following month, she placed a new ad for household help in the *New York Times*. For the first time, she called herself a "well known artist"; all caps emphasized the "PERMANENT" nature of employment. In Gloucester, the employee would have her "own cottage," now that an outbuilding on the property was being revamped. The new wage was $125. On July 13, Nell spent five hours interviewing candidates for the position.[75] She figured that the employee would need to work from 10:30 a.m. to 3:30 p.m. two days a week, to allow Carolyn time to paint. On other days, the aide would be on call from 11:30 a.m. to 4:30 p.m., and from 7:00 p.m. to 10:00 p.m. Every other Friday and Monday, she would need to put Nell to bed and get her up the next day.

After hiring Marion, the new aide, Nell explained that in the morning, she needed half an hour in the bathroom while the helper made the bed and tidied the room. Dinner had to be started at 7:00 p.m. and ready at 8:30 or 8:45, but if Nell was still painting then, dinner should be served at 9:00 p.m. The meal would take about forty-five minutes. Washing up after dinner was to proceed as quietly as possible. Despite the rigor of this schedule, Nell realized that she had to request some flexibility, since she was "not an office or a machine."[76] Although Nell had a "pathological revulsion" to bookkeeping,[77] she applied herself dutifully to calculations of Marion's pay. A more pleasant job was working on specifications and sketches for adjustments needed in a house to be occupied by a wheelchair user. Would it be easy to install four drawers under the kitchen counter? How high would the heating pipes be?

Nell was shocked to read of Fairfield Porter's death of a heart attack on September 18. He was sixty-eight. In her view, Porter was "a bright man, interesting, but...somewhat cold." Jane Freilicher had told her that Porter liked her work, and Nell thought his paintings "very fine indeed," but she was "not one who looked up to him as an influence or as a mentor."[78] Although both painted the world they saw around them, had homes in picturesque areas, and were close to the New York poetry world, their work is quite different. An astute art critic whose reviews were elegantly articulated meditations on form as the conduit of feeling, Porter did not come into his own as a painter until his early forties. Beneath his taciturn exterior, he held strong views and battled emotional crises. He painted his family—although bisexual, like Nell, he

remained married to his wife, Anne, with whom he had five children—as well as views from the windows of his homes on Great Spruce Head Island in Maine and in Southampton, New York. Porter's ability to flood his canvases with an almost miraculous yet completely plausible light was one of his great strengths. In contrast to Nell's vivacious landscapes, Porter's are meditative; large swaths of color convey the seasonal look of trees and grasses; flowers are incidental to his evocation of nature's moods. *Lizzie at the Table* (1958) is an exception, with its exquisitely observed floral still life as one of the meticulously painted scattered objects surveyed by Porter's baby daughter. Unlike Nell, who usually orchestrated her still lifes and then felt free to make adjustments on the canvas, Porter liked to paint whatever was in front of him, which often—in a house full of children—was a table or room in disarray.

In October, Nell learned that Howard Griffin was dead at sixty, a suicide in his farmhouse in Haderlehn, a hamlet in Austria surrounded by steep mountains. He had flown to Germany in February after learning that his German lover, Ulli, had been run over by a car, only to discover to his shock that the accident was fatal. After Griffin took an overdose of pills that sent him to the hospital, Nell sent a card begging him not to give up on life. He recovered, but his yearning for death was overpowering. Days before he took his life, he poured brandy on the grave of his mentor W. H. Auden, who had died two years earlier.[79]

Griffin's death haunted Nell, whose mind swirled with questions about his last hours and worries about his friend Bill Stewart, who had returned from a trip to find Griffin dead on the bathroom floor. She mused about his "awful ugly obsession with sex—out of his pathetic loneliness," his drug taking and unraveling mental state, and Ulli's "ugly" art and "unpleasant imagination…alien to me."[80] Stewart later told Carolyn that, to avoid repercussions from the police, he and Griffin's kindly neighbor, Therese Schöpf, had trundled a wheelbarrow from her house, filled it with the author's large stash of pornography, and burned it in Schöpf's oven.[81] The "gentle, friendly" man whose company Nell had enjoyed in Dorset had given her no inkling of his darker side. "He was very brilliant but lonely," she wrote to a relative. "I knew little of his private life until after his death."[82] Nell agreed with another acquaintance of his who described Griffin as "an introverted man who blushed easily out of a sandpapered-fine sensitivity toward life."[83] Although he had purchased several of her paintings, she thought of him mostly as a frequent correspondent who liked to send her his poems. He wrote a perceptive essay about her paintings of the Greek landscape, in which he noted that by ignoring

the more dramatic views, she "maintain[ed] her privilege of detachment." Griffin aptly described the landscape she was constantly drawn to as "the half world of outdoors-in or indoors-out."[84]

Nell wrote to Hilton Kramer, chief art critic at the *New York Times*, in hopes of coaxing him to write an obituary for Griffin. In an effort to cozy up to Kramer, who was born in Gloucester, she mentioned that her cottage was up the hill from the Yankee General Store and looked out on Ten Pound Island, site of a historic lighthouse. Citing Griffin's journals about literary life in the 1940s and '50s, his poetry books, and his art writing, she argued that he was "a more important writer than he was given credit for," who "described the world as a visual artist might." But Kramer did not act on her suggestion.

While Griffin's large trust fund became the property of distant family members, Nell inherited his property. At first, it was a white elephant. For many months to come, she was burdened with the need to arrange the appraisal and dispersal of his books, art holdings (in her view, "some good contemporary works and a few old works"), and household goods in New York, England, and Austria. She also had to sort through his manuscripts and deal with lawyers and banks. Nell wrote to a relative that the paperwork "reminds me unhappily, of my days at N.Y. Life Insurance Co. in 1943."[85]

Carolyn spent three days cleaning out Griffin's Manhattan apartment, which yielded a sad miscellany, including a broken desk, tennis shoes, and three small curled-up watercolors of Ulli. The women sent a foam mattress and small bookcase to Midi, whose continuing poverty was always uppermost in Nell's mind. She kept the manuscripts of Griffin's "Dialogues with Auden" from the 1940s—some of which had been published in *Partisan Review*, *The Hudson Review*, and other journals—and his poetry, with the intention of publishing them. Ownership of the Auden conversation transcriptions was initially more of a burden than a privilege.[86] An acquaintance of his who believed that his own remarks had found their way into these notebooks asked Nell if he could read them. She told him they were impossible to decipher; when he persisted, she said that they were out of reach, in a warehouse.[87] The poetry was another matter: in 1976, she designed a limited edition of *Howard Griffin: Four Poems*, accompanied by two of her etchings.[88] Five years later, she finally oversaw the publication of the "Dialogues" as *Conversations with Auden*, with her own brief preface.[89] In hopes of documenting Griffin's life, including his illnesses—it's noteworthy that Nell, so accustomed to ill health, would dwell on them—she wrote to a close friend of his, asking for more information, and looked for a writer who could assemble a book of Griffin's

letters and portions of the more than forty volumes of journals that documented his friendships with Auden, Christopher Isherwood, and other poets and painters. This project was never realized.

Darby House, Griffin's cottage in Dorset, would yield Victorian oil lamps and chairs (some of which Nell hoped to sell to pay for the shipping costs), as well as more than twenty cartons of books, eighteenth- and nineteenth-century Japanese prints, and paintings, mostly by British artists.[90] Learning that British historian Hugh Trevor-Roper had wanted to purchase the house, she wrote to him to suggest that the sale be completed as soon as possible. Speed was necessary because there were tax liens on the property. Briskly providing the facts of her paralysis, Nell described herself as "an open and honest person" and "a poor artist with no income other than the irregular sale of my paintings."[91] There was also an apartment in Berlin, and she had no idea whether Griffin leased it under his name or Ulli's.

According to Griffin's Austrian lawyer, the farmhouse in the Alps also contained many books and paintings. At Nell's request, Robert Wilson and Martica Sawin, an art historian, agreed to sort through these items the following summer. Nell decided that she wanted to keep Griffin's art supplies, art books, "ordinary but interesting books," journals, personal papers, and fur hat.[92] In an essay written for the W. H. Auden Society newsletter, Wilson described driving up "a steep and winding road with many hairpin turns" in bad weather and feeling as though he were in a gothic novel.[93] At the house, he was dismayed to discover from Sawin (who had arrived earlier) that there was no heat and the stove didn't work. It also turned out that Griffin had stolen the only books of any value from Yaddo, the New York Public Library, the British Museum, and other institutions. But the journey was redeemed by Wilson's discovery of correspondence from leading authors and the draft of *The Ascent of F6*, a play (long considered lost) that Auden had written with Isherwood in the 1930s.

Some larger objects in the farmhouse were earmarked for the Gloucester cottage; an old refectory table, shipped in parts, would be repurposed as a dinner table for eight. Nell hoped that Sawin could transport a number of smaller items. A compulsive list maker, she itemized her selections: "set of blue & white handpainted dishes...consisting of 12 dinner plates, 6 salad plates, 2 soup bowls, 1 platter, 12¾ wide oval..." The good news was that the house itself was in reasonable shape, except for mouse infestations and some damp spots. Carolyn had already visited, to check on the layout of the house and the width of doorways. Nell was happy to learn that taxes would cost her less than a hundred dollars annually.

* * *

Anticipating the opening of her Poindexter Gallery show in April 1976, Nell wrote to the editor-at-large of *ARTnews* to suggest that the time was right for "a special article."[94] But she failed to offer a news peg for the piece, other than the four-year gap since her last exhibition in New York. *ARTnews* did come through with a review in the summer issue that praised her paintings for being "so pleasurable to look at" and "so seemingly spontaneous" that it took a while to see how much artfulness was involved.[95]

In July, while pondering what seemed to be a new low in her relationship with Carolyn, caused by frustrations with the aides, Nell poured out an effusive tribute to the view from her Riverside Drive apartment at dawn. She saw the pale blue river "cutting like a strong light...through dark rich green trees," the "pale oyster gray" monument "jutting upwards into a long mass of gray blue clouds," the sun creating "coppery orange sparkles like fire" on nearby buildings, and "shards of coppery brilliance jumping wildly off the Jersey shore."[96] Two days later, Nell continued in this vein, playfully asking herself why the river landscape seemed to resemble paintings. "All the clouds are brushstrokes," she wrote, "all yearn to be painted by me!"[97]

11

Keeping On

AUSTRIA, 9 Rm Farmhouse, Tirol nr Oetz. Sweeping views. Lge Terr, 5BRs, studio, library, tiled bth, lavatory, gar. furn'd, center htg, 2½ thick walls upper $80s.

IN EARLY 1979, Nell wrote this ad for the classified section of the *New York Times*. The previous August, she had spent a month in Austria with Carolyn, Jestina, and her current assistant—David Acker, a young painter—to inspect the spacious nine-room farmhouse. Griffin had modernized it with oil heat (though only three of the five bedrooms were heated, and the stove ran on bottled gas), tile floors, bookshelves, and other furnishings. "Comfortable without being slick" was Nell's verdict. She was thrilled that Karalpe—Griffin's name for the house—contained a studio with northern light. The trip had been preceded by an anxious letter to Robert Wilson about her problems with the lawyer in Austria who "tends to minimize the value of the books" and her worries about whether a local art appraiser could also serve as buyer without being judged self-serving by the Austrian authorities.[1] But once Nell spied nearby Haderlehn, a hamlet with a sprinkling of houses, a farm, and a chapel, she was in heaven.

"Pinch me—it's so beautiful!" she wrote to her cousin Charlotte. "I can't believe that this house...the most exquisite spot in the world? is mine!" The views were "incredible"; the food, "lovely"; the air, "splendid."[2] To an artist friend, Nell described the trip as "a fantasy experience realized," fancifully likening the haystacks to "little priests in rows" and marveling about how "everything is cared for."[3] Months later, after she had returned to New York, Nell wrote to May Swenson—who she hoped would rent the house—that it was "a fantastic spot with incredible vistas.... Walking distance, tho' steepish, to villages [Sautens and Ötz]...very beautiful & very <u>healthy</u>....The best air & pure mountain stream-spring water."[4]

Perched on a small plateau, the house overlooked the valley and the two facing mountains, Tschirgant, with its massed contours, and Acherkogel, which rises to a sharp peak. Nell, Carolyn, and David each staked out a spot

Nell's house in Haderlehn, Austria.
Courtesy of Carolyn Harris.

on the spacious terraces and worked on watercolors. "The beauty of the mountains and their mysterious power compels me to study and paint them again and again," Nell wrote.[5] The eastern terrace facing Acherkogel would become her favorite spot for painting; the mountain caught the rosy glow of the late afternoon sun, and its peak gave it a distinctive character (plate 22). Nell wrote to Theresa Pollak that she "always had a thing for mountains."[6] Up until now, she had never really satisfied her urge to paint them, although she had sketched views of Mt. Parnassus when she was in Delphi.

Nell returned with Carolyn, Jestina, and David on August 1, 1979, for a much longer visit. Although the disabled-travelers office at Lufthansa was alerted to ensure that a jetport would be available at their destination, Nell was shocked to see steps rolled up on the tarmac at the Zürich airport. Acker managed to carry her down. Then they spotted a parked ambulance "with two women in white who were laughing."[7] After these irritations, it was a relief to set out by rented car for Haderlehn. Nell happily noted "pink clouds piled up[,] straight poles of tall pine trunks striping [a] luxurious view."[8]

Later that month, she kept trying to make a drawing that met her standards for "organic" composition and overall effect. "It often takes about 40 drawings for a perfect alignment with one's forces to pull it off," she mused.[9] A week later, after an early morning snowfall, Acherkogel "looked almost black with great white drawing all over it[,] a startling & wonderful sight. It

Nell in Austria, 1979.
Courtesy of Carolyn Harris.

made all the heights more massive and sculptural" and "was <u>all</u> much more mysterious."[10] She took photos to document this view and started painting. John Ashbery would liken her landscapes to "a more benign and sensuous" version of the German Expressionism of Oskar Kokoschka—a painter who had captivated her since the 1940s. He noted that she did not use traditional perspective to create a feeling of depth in her mountain paintings, but rather "varying intensities of colors."[11] Her nearsightedness may have been an impetus for this, as well as her coloristic sensibility.

Arthur Cohen arrived unexpectedly in early September, prompting a trip to town for beer and snacks at the Posthotel restaurant and to the supermarket to stock up. Carolyn, feeling put upon, lashed out at Arthur and David. Nell lamented her outbursts while worriedly listing expenditures for hotels, food, restaurant meals, art supplies, gifts, gas, heating oil, paint, and lumber. It seemed to her that the cost of living in Austria was double what it was in the United States.[12] After leaving Karalpe, the group was bound for Verona, Innsbruck, Munich, and Zürich before heading home.

As usual, the travel time estimates she was given were way off. Instead of two and a half hours, it took six and a half to get to Verona and another three and a half hours to find a hotel. While the time differences would be annoying to anyone, Nell had special problems with lengthy drives because of her need to find usable toilet facilities en route. But the city elicited her charmed

remarks: "endlessly interesting streets buildings antique shops...views of the city from the bridge spectacular! Glowing colors of terra cotta roofs and warm walls—painted ochre, gold."[13] She was equally passionate about Giotto's fresco cycle at the Scrovegni Chapel in Padua and Andrea Mantegna's frescoes at the Church of the Eremitani. ("Such sureness! I love him!")[14] A day of aesthetic rapture was followed by a day of petty squabbling: Carolyn, exhausted with the effort of pushing the wheelchair, argued with Nell about her shopping habits, repeating her complaints in a way that, Nell thought, went "way beyond crankiness toward madness."[15] After their next major quarrel, she wrote that it threatened her "joy in living." She claimed that she had perceived Carolyn's "sourish" temperament when they met, "but I didn't heed the warnings because I was in desperate need."[16]

The long transatlantic flight home was a misery for Nell, largely due to the layout of the restroom, where Carolyn had to struggle to keep her on the seat and she was obliged to assume a jackknifed position. Her right hand was sore from trying to hold on, her spine was bruised by the back of the toilet, and her arm, neck, shoulder, and back muscles were strained with the effort. "Minor alterations for the handicapped," she wrote—including a sloping, lightly upholstered area behind the toilet and flat areas on either side to use for push-ups—would have made a huge difference.

Nell's dealer, Elinor Poindexter, had loaned her money against future sales during difficult times, and Nell considered her a good friend, though Poindexter's self-effacing manner and vagueness sometimes irritated her. Yet any dealer's patience would have been tried by Nell's many demands—among them, that she be given the name, address, and phone number of each of her collectors, freely borrow her sold work for exhibitions, and retain reproduction rights. She also insisted on choosing the paintings for her shows and determining how each work should be hung. So important were these issues that when spelling them out in a letter to the gallery she added, "Selling is secondary."

Nell's spring 1976 exhibition had marked her last connection with the gallery. Later that year, Poindexter sold her building and retired from public art dealing; soon thereafter, she was mugged and broke her hip, though she continued to sell work privately from her Fifth Avenue apartment. Flattered to be approached by three galleries, Nell chose Fischbach, where she would have eight solo shows. After her twenty-two-year relationship with the Poindexter Gallery, she was pleased that Elinor would be allowed to continue as her "private dealer." It must have been equally satisfying to see her prices raised by

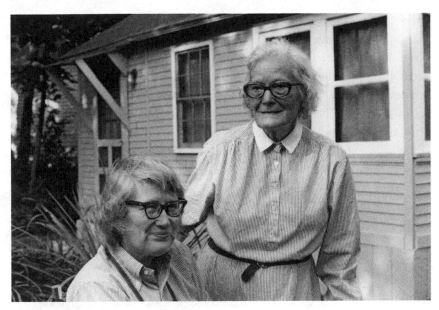

Nell and Elinor Poindexter in Gloucester, 1981.
Photo: Carolyn Harris. Courtesy of Carolyn Harris.

Fischbach director Aladar Marberger, whose intensity dazzled Nell.[17] He told her that he wanted "the [art] stars," and that her approach to painting was "the coming thing." She also admired gallery owner Marilyn Fischbach ("an elegant woman of means brought up as aristocrat in Europe but fortunately...very natural, down to earth").[18] The gallery struck her as "very grand," with its two large rooms. Jane Freilicher's show there in January 1979—three months before her own debut—led Nell to write to a relative that she was "getting some cold toes (not the whole foot!) after seeing the huge space again plus the white floors! And Jane's show was full of very large & lovely works. A hard act to follow!"[19]

In April, after experiencing her usual preshow "terrible anxiety and doubts," Nell was pleased with the ambiance and sales at her Fischbach opening.[20] Later that month, she appeared on a panel, "Is There Still Life in Still Life?" with fellow artists Jane Wilson, Ruth Miller, Gabriel Laderman, and William Bailey. Nell explained that she painted all night because "the light is more constant." Along with her own work, she graciously showed slides of two paintings by Carolyn but falsely claimed—why?—that her lover "has chosen not to exhibit."[21] The Fischbach exhibition marked Nell's initial public showing of the Austrian landscapes, touted in the press release as "the first series of mountain subjects since 1957 when the artist worked in Oaxaca,

Mexico." Also included were paintings of Gloucester, *New York Rooftops in Snow*—painted from a neighbor's north-facing apartment—and portraits of Carolyn and helper David. A glowing review in *ARTnews* affirmed that in Nell's hands, "familiar motifs" became "breathtaking compositions" with a "sense of complete spontaneity... which can only be achieved by an artist totally in control of her means."[22] In *Art in America*, Gerrit Henry, who wrote that he was tempted to compare Nell's interiors to Bonnard's, saluted her "gift for painterly improvisation." The "unevenness" he found in this show was, he claimed, part of her adventurous approach.[23] Most impressively, in *New York* magazine, John Ashbery called the new work "more vigorous and wildly chromatic than ever before." Nell's use of bright colors produced the impression that she "had simply brought to our attention colors in nature we never noticed were there."[24]

Back in Gloucester in October, Nell brooded on her financial problems, asking Marberger to send the $2,310.27 she was owed—which, she wrote, would cover only "3 weeks of partial expenses."[25] Inflation had caused painting supply prices to escalate: eight to thirteen dollars for a tube of paint; ten to fifteen dollars for a small oil-paint brush; fifty dollars for a watercolor brush.[26] Yet, despite the cost involved, she decided to travel to Richmond in November to give a talk at the Virginia Museum of Fine Arts and receive the first Governor's Award for the Arts.[27] Broke after eleven weeks in Austria, she wondered if her cousin Charlotte knew "any kind & wealthy business person who might like to buy a watercolor or drawing for 460 or 500 [dollars], or someone who'd like to subsidize my trip." She explained that even a short trip like this one, with airfare paid by the award sponsor, would cost her many times the amount she would have paid in her prepolio years, because she was responsible for three hotel bills and three people's meals. Somewhat flummoxed at the prospect of attending a black tie ceremony with no appropriate garment in her closet, she joked: "A little black humor perhaps will substitute?"[28]

In early December, negotiating with a potential buyer, Nell agreed to reduce the price of the house in Austria by $5,000 to $113,000. She asked for $20,000 of the deposit by December 24 and another $28,000 by February 1, 1980, so that the sale could close soon afterward. After the transaction fell through, Nell changed the wording of her ad to read: "AUSTRIA — ALPINE IDYLL / TIROL Lovely 9 rm farmhouse furnished. Sweeping views large terraces. 5 bedrooms, library, studio swimming nearby reasonable monthly rent." Sadly, no buyer came forward. Desperate to realize some money from the house, Nell initially sought to rent it for "June, July & probably August"

for $300 monthly plus utilities to someone she felt would take proper care of the books and artwork.[29] When a friend who was going to rent the house suddenly canceled after Nell had paid the local plumber the equivalent of ninety dollars to turn on the heat and water, it was another financial blow. For the few renters who did make the journey, the alpine scenery was inspiring. Denise Levertov spent restful weeks at Karalpe in the autumn of 1988, writing several poems. One was "Two Mountains," in which she mused on the gulf between the human and natural worlds.

During Christmas week, Nell's quarrel with Jestina and a mysterious dustup with her patron Arthur Cohen caused her "extreme pain," as she noted in her diary. She reviewed her twenty-year history with him—during which he was often the first person to see her new work, frequently purchasing it on the spot—and decided to put her thoughts in a letter, since it was impossible to talk to him ("maybe he only talks openly to his shrink").[30]

Jane Freilicher's New Year's Day party offered a welcome respite from real estate concerns and other worries. The guests included Kenneth Koch, John Ashbery, Larry Rivers, Barbara Guest, Irving Sandler, Paul Georges, Alex Katz, and Temma Bell and her husband and baby. For Nell, the infant was "the star of the whole affair a pink cheeked image of exquisite innocence and fair beauty." She was grateful for the opportunity to see old friends, at a time when she felt increasingly isolated from the art world. A few days later, Nell and Carolyn went to the Whitney for its over-the-top fiftieth anniversary party ("probably 3,000 people and some passing out and falling on the floor").[31]

The Graham Gallery was showing work by thirty prominent women artists, including Nell, in conjunction with the publication of Eleanor Munro's book *Originals: American Women Artists*. Munro, who called her biographical method "psychoesthetics," was particularly interested in the way childhood memories related to the artists' work. Nell seemed pleased with the way her interview appeared in the book, calling it "very frank" in a letter to her cousin Charlotte.[32] Another relative was "amazed to read of [Nell's] early trials and tribulations." She added, "Few people in this world would have had the inner resources that you drew upon in your determined efforts to succeed. But you did have a certain sweetness in your character and an ability to make and hold friends."[33]

In March, Nell fretted that the crowded state of her workroom was affecting her pleasure in painting. It wasn't until five years later that she finally sent some of her works to a storage company. But she was happy that two of her

early paintings—*Dark Window*, also known as *Studio Window* (1955), and *Harbor and Green Cloth II* (1958)—were chosen for a major show at the Hirshhorn Museum, The Fifties: Aspects of Painting in New York.[34] It was another feather in her cap to be included in "a nice article about some great artists & their gardens" in the June issue of *Architectural Digest*.[35] Back in Gloucester in the summer, she discovered that the weeds had taken over the garden, but the "thrilling color" of the iris was a welcome sight. A neighbor took Nell and Carolyn to nurseries in nearby Ipswich and Essex, where Nell snapped up columbines, "petunias in crazy colors," marigolds, impatiens, lilies, iris, and other plants. "I'm smitten like Monet with a fever to create a gorgeous landscape," she wrote.[36]

Nell remained true to the practice Lawrence Campbell had observed in 1958, when he quoted her as "put[ting] down every color I have" on her glass palette. (He counted thirty-eight, not including white and black.) Nell's artist friend Celia Eldridge recalled that the palette contained "twenty, thirty, forty colors all laid out and mixed in different hues, different intensities," an array that "inspire[s] you to use them, because they're so gorgeous," like a cosmetics counter with a range of lipstick colors. She added that having all these pre-mixed colors to choose from "allows you to be spontaneous" while also suggesting a course of action, "because there's already a wonderful green and you [can decide] where to put it."[37] Color choices are "all within the retina," Nell once said, "and what it does to you, how you feel."[38] She told *American Artist* magazine that "the whole canvas must be broken up by color so that there are intervals of color, like intervals in music."[39]

She had been working with an apprentice, a young woman who was too abashed to show Nell her work and apparently felt conflicted about whether she wanted to be an artist. Carolyn wrote to Celia that the young woman was being taught to "handle the wrapping, filing, 'gophering' and other chores" that would otherwise fall to herself.[40] Nell spent hours discussing art with her—hours that she could have devoted to her own work—so she was especially annoyed when the woman quit. It turned out that she had expected to be able to watch Nell paint, which she never allowed. Carolyn would always shoo away the rubberneckers who edged closer to the easel when Nell painted outdoors.

The annual visit to Gloucester was memorable mostly for a massive summer heat wave (the house had no air-conditioning) and a mysterious illness that laid Carolyn low, finally diagnosed as whooping cough. A friend recalled Carolyn saying that packing for the trip back to New York would leave her so exhausted, she would be falling asleep at the wheel. This year, a

late November downpour made the drive especially hazardous for the last fifty miles, with sheets of rain "sloshing and thrashing" the car so forcefully that Nell thought the windshield would collapse inward. Weeks later, a sooty gale blew through the Riverside Drive apartment when the building owner replaced six of the old windows with a double-paned brand that didn't close properly, and then refused to fix them.

But autumn had brought another, more welcome gust of fresh air, the October special issue of *ARTnews*: *Women's Liberation, Women Artists and Art History*, which featured Linda Nochlin's groundbreaking essay "Why Have There Been No Great Women Artists?" Nell was pleased that a photo of herself and a color reproduction of one of her paintings were part of the package. Despite her own success, when asked by an *ARTnews* writer whether she saw gains for women in art, Nell was skeptical. While collectors and galleries were paying more attention, women artists were still undervalued in terms of the prices for their work. Yet Nell was somewhat equivocal about the women's movement. A decade earlier, she had told an interviewer, "I never thought of myself as having to struggle against men to succeed. Maybe I identified more with men than women, I don't know.... I don't think it would have been any different for me if I'd have been a man."[41]

Nell told *ARTnews* that what the art world cared about was "aggression, because it conveys power" and "novelty." As a result, artists who worked in quieter or more decorative styles were overlooked. If Chardin were a woman and alive today, Nell said—giving the magazine a catchy subhead for the article—"she wouldn't be able to make a good living."[42] Aggression and novelty were themes Nell had discussed in 1972, in a publication called *Women and Art*.[43] She wrote presciently that the world appeared to be "splintering into militant pockets, each with a heightened sense of its own grievances." Artists were making "quick gestures...in a hurry either to make a quick buck or a quick impression." While deploring machismo, Nell cautioned that "concepts of male and female are extremely complex."

In a 1970 interview, she had also railed against artists who "depend on accidents to make [a piece] happen," including the composer John Cage. Her antagonistic stance was likely connected to her essentially traditional approach to the arts. She had always been an earnest disciple of certain modern masters, whereas Cage—informed by his teacher Arnold Schönberg that he had no feel for harmony—was obliged to find a new way to compose music. In Nell's case, a degree of envy and resentment might have been involved as well, since she had to work extremely hard, often under difficult conditions, to produce a single painting. Having lost her interest in theory-based practice when she

abandoned abstract painting, Nell was also hostile to conceptual art. Her work, she said, was about "letting myself go where my passion leads me."[44]

Nell believed that if she did not have a show in New York every other year, she would be forgotten. Preparing for her exhibitions was always stressful. "Preshow paralysis," she wrote, "is a paralysis of will which I become infected [with] each time."[45] Marberger instructed Jim Touchton, a young painter who worked part-time at the gallery, in the protocol Nell insisted on: "When her paintings come in, keep all the [protective] cardboard corners the same way." If a painting was showed to a client before the opening of an exhibition, it had to be wrapped up afterward, not simply placed on one of the sliding storage racks. "She was very demanding," Touchton recalled. "She had to be there for the hanging of every show."[46]

Once, when gallery partner Larry DiCarlo was doing this painstaking job, Nell kept insisting that a painting was hung crookedly. "We'd wheel up to the painting," Touchton said, "and she'd look at the top"—where the level tool showed that the painting was actually level with the floor—"and she'd refuse to accept it." (It's possible that her old eye coordination problems may have led her to this conclusion.) Exasperated, DiCarlo threw down his hammer and walked out of the room. Another version of this story has him tossing the hammer at Nell's lap, which he denies having done. For DiCarlo, who had to hang fifty or sixty paintings in a couple of hours, Nell's need to "be in control of every detail" was frustrating.[47] "It wasn't as if her paintings were precision-ist work," he said, suggesting that the way "the flowers always tended to lean" may have made Nell think the paintings were out of plumb. "Quite honestly," he added, "I don't think artists are able to be objective enough about their own work to be able to hang the best show." But he did credit Nell's habit of "fussing over her catalogues" as contributing to their importance as documents.

Even in Gloucester, Nell's perfectionist side never let up. Jean Kaiser, director of the Stage Coach Gallery, exhibited a group of Nell's recent paintings, watercolors, and drawings in the autumn of 1977.[48] According to local bookstore owner Greg Gibson, "Jean was a forceful and dynamic personality, as was Nell." Because Nell insisted on supervising the hanging of her show, "the job of an afternoon took several days." He recalled the sparks that flew. "The two of them together—it was difficult, it was exciting, and somehow they both survived."[49]

After the hammer-throwing incident, whenever Nell called the Fischbach Gallery, she always asked to speak to Touchton or Beverly Zagor, the other partner, who "was always so calming to Nell," DiCarlo said. Touchton had a

special relationship with Nell. He grew up in Georgia, and she seems to have reverted to her southern accent when she was with him. When he asked to purchase her painting *Cosmos in Night Interior* (1976), she dropped the price for him and said, "I think you can work off some equity."[50] (She knew that he owned a Pontiac Grand Prix.) "I remember once picking her up out of her wheelchair and sitting her in the car," he recalled. "She had this funny little grin; she'd look up with her eyes and twist her lip up. 'I think you're on my foot,' she said. "She had these tiny little slippers and [my foot] was on the edge of her shoe." Nell told him that she appreciated the way he would "flop down next to the wheelchair" at her openings, so that she did not have to strain her neck looking upward. She came to his Fischbach openings, too. He was a partner in Bassett Coffee & Tea Company during these years, so she always greeted him with a stuffed basset hound toy.

The April 4 opening of Nell's 1981 Fischbach show was "a smashing success" in her estimation, with "quite a number of sales that day, including the largest oil: *Acherkogel from Haderlehn*...What a thrill!"[51] "If there was ever an artist you wanted to sell, it was Nell Blaine," DiCarlo said, "because she really needed the sales for her living." Yet, understandably, Nell "didn't want to be treated like she had a handicap." His clients were shocked to learn she had polio: "You didn't know that from the work...the paintings were so much about joy and happiness." In accordance with her dislike of being pigeonholed, she also "wanted to make sure nobody knew" she was gay. The exhibition was critically well received. A reviewer for *Art/World* compared her "subtle and delicate handling of greens" to fifteenth-century Italian fresco painters, and the white space (of the primed canvas) around objects to a method used by Matisse.[52] Like the French master, Nell employed this technique to heighten the sense of a light-filled image.

Nell's cousin Charlotte was one of her most faithful correspondents, despite the gulf of cultural awareness, politics, and temperament that separated the two women.[53] For the most part, Nell would report on her daily activities, discuss health issues, and thank Charlotte for her periodic gifts of food, clothing, and cash. But in early April, a few days after John Hinckley Jr.'s attempted assassination of President Ronald Reagan, Nell's letter to her cousin ventured into different territory. While professing sympathy for the president ("a charming man a great sport & a touching figure"), she disparaged the way "great monies from social...programs" were earmarked for "weapons buildups," and strongly supported the banning of handguns. ("The gun lobby people are idiots.")[54]

The televised British royal wedding in July elicited an oddly mixed response from Nell, who was usually keen on celebrations of all kinds. She saw it as "a delicate salute to the virgin brood mare and to holy wedlock, to childbearing and to the very young," Although she praised the "orderly, touching yet oddly satisfying" ceremony, she also found it "disturbing," for unstated reasons.[55] Could she have somehow foreseen the unsuitability of this union? Meanwhile, she had acquired a miniature Ping-Pong set, which she once called "my best therapy," as well as a new studio assistant, "a bouncy 28 year old gal who is robust and a talented painter as well." Nell found this curly-haired "softik" (i.e., zaftig) woman especially attractive and hoped to be able to paint her "if she'll sit quietly!"[56] Another addition to the household was a light blue 1973 Cadillac with just 17,000 miles, from the estate of the mother of one of Nell's neighbors. It would be driven on long and short jaunts by a succession of male helpers.

While jurying a show at the National Academy of Art in January 1982—"a most exhausting experience"—Nell was pleased to be spending the day alongside her old pal Jane Freilicher and fellow painters Paul Georges and Paul Cadmus. A picture by Carolyn was accepted for the show, as was a piece by David, Nell's assistant. (Rejected by the committee, his painting was the one she chose as her "rescue" piece—a perk granted to each of the jurors.) The following month, Contemporary American Realism since 1960—work by more than a hundred living painters and sculptors—traveled from the Pennsylvania Academy of the Fine Arts to the Virginia Museum of Fine Arts. Nell's work was shown alongside paintings by Alex Katz, Chuck Close, Janet Fish, Andrew Wyeth, and other major artists. But a group show, even one of this magnitude, was not sufficient reason to endure the long journey to Richmond.

In the spring, preparing for a show of her work at the Reynolds/Minor Gallery in Richmond,[57] Nell was caught up in the aftermath of the murder of a friend, Beatrice Gazzolo. A solitary seventy-seven-year-old artist and teacher,[58] Gazzolo was attacked in her apartment on West 21st Street in late December and died a few days later in a hospital. In a diary notation, Nell wrote that she "spent 6 weeks day & night on B's affairs" and paid more than $690 for the costs associated with this sad project.[59]

On April 23, Nell wrote to her friend Celia Eldridge, who was housesitting during the Gloucester winters. The letter contained a litany of problems with money and with Jestina's unreliability and poor health, and detailed information about various household issues. Presumably in an effort to brighten the

tone, Nell offered the temporary use of the Riverside Drive apartment in exchange for utilities payments and mail forwarding. Celia had been renting another house on Cape Ann, whose owner had died. At Ledge Road, she was initially offered the choice of paying $225 monthly rent or doing chores; money was tight, so she chose the latter. Little did she realize that "chores"—described in a constant stream of letters—would range from sanding and painting window frames to moving a woodpile, lifting the mulch from "baby suculents [*sic*]," oiling a wood table, and heating the kettle to a boil "once a week or so." Even so, Nell wrote in 1986, "it weighs heavily on me that you don't pay rent.... I feel you owe me in any sense of fair play to pay me at least $100 a month" in addition to utilities.[60] Noting her need to earn "over $1,500 a week to pay Jestina, Carolyn & rent & taxes & food," she explained that she would normally rent the house for $375 a month in its cluttered state, or for $600 if it did not contain her and Carolyn's possessions. She fretted that her $600 monthly apartment rent in New York would "go up to $900 in the near future," that the car cost $200 a month to park, and that art storage, art supplies, pay for her studio assistant, and raises for her helpers were all a drain on her resources. It was clear that what Nell really wanted was a tenant able to pay a substantial monthly rent (even though winter was the least inviting time of year in Gloucester), adept at fixing things, and willing to comply with a constant stream of directives about how to care for the house. Such a person surely would not have been easy to find.[61]

The many letters traveling northward over the years from 210 Riverside Drive to 3 Ledge Road were filled with complaints about bills ("you didn't tell me whether the gas was paid") and assorted decrees and entreaties ("if door lock breaks you replace"; "<u>please</u> keep [garden] stakes in place"). There were some absurdly detailed instructions (to ensure its functionality, the suction cup that held the bird feeder was to be rubbed "about 20 times"). These missives contained urgent requests, inquiries about whether local tradespeople had completed the repairs they had promised to make, and chidings ("you didn't answer regarding rain fall [*sic*] & holly bushes!!!"). To avoid turning on the water in the "little cottage" for a visitor and potentially freezing the pipes, Celia was to supply this person with buckets of water from the house. To suit another visitor with an allergy, she was to borrow a vacuum and remove all the cat hair. Nell's insistence that the post office forward utility bills to her in New York—even though Celia needed to submit them to a government agency for payment via the Low Income Home Energy Assistance Program—meant that payments were needlessly delayed. (Nell never seemed to realize that she was not the only one trying to manage with limited funds.) When

AT&T erroneously announced a temporary suspension of service, Nell suggested that her (blameless) housesitter might have ordered it. Other issues arose from Nell's constant worries about the state of the garden. Although she would sometimes report on art world doings in New York or ask a question about Celia's own art, her letters were mostly peremptory, leavened only by an apology for "the mess we left," a hope that her housesitter was keeping warm, or occasional invitations to a party or opening.

A quirk not revealed in the letters was Nell's insistence that the positions of the furniture and other items be marked with masking tape. Anyone who spent the winter in the house would be sternly rebuked for moving so much as a pencil. Celia, who made diagrams of the contents of the house as insurance against leaving any trace of her presence, was extraordinarily patient with all the demands. "I did everything," she said. "I was actually good at it. And when I left, my feeling was, you could eat off the floor." A slender, soft-spoken woman with a keen insight into people's motivations, she said she understood Nell's need to control her environment and realized that for someone whose energy is limited, it is of the utmost importance to know where things are. But she was also well aware that "a lot of things ended up getting done in the winter: 'There's a gas leak? Well, Celia is coming. She'll take care of it.'"

In May 1982, she accidentally dropped a sheet of glass in Nell's "personal" upstairs sink—designed to allow her wheelchair to scoot under it—damaging the enamel. Nell's response to the polite letter of apology she received was a furious diatribe. The sink and counter were her "pride & joy and one of the few things I found really pleasurable that turned out right and looked right."[62] She was irate that her housesitter had "bothered" her with this issue; now it was now her "problem to solve." Nell did not want any "hassles" when she arrived at the house. Worried about a potential "disaster," she demanded that Celia "toughen up" and make sure that the plumber installed the new sink properly. "Many workmen take advantage of women," Nell wrote, "esp. civilized ones."

Another haranguing letter arrived the following week. Not only did the new Formica on the sink counter need to be the same height, but it also had to be a "lemony yellow" with no pattern or speckles.[63] Nell complained about her high level of stress, unaware that the receipt of her letter coincided with news that a friend of Celia's had been in a terrible accident. A month later, however, Nell sent an apologetic letter again suggesting a visit to the New York apartment. A few words of gratitude occasionally found their way into this correspondence. In one letter, Nell thanked her housesitter for "the fresh

floor paint jobs very neat & welcoming & also for a great rehabilitation of the steps. So much improved. Very charming to me.... Did you use the studio? It looked as I'd left it!"[64]

Taking stock, as usual, at the beginning of a new year, Nell chided herself in early 1983 for the way her ambitions "leap ahead," while her accomplishments "lag behind." She believed that her failure to accomplish her goals was partly due to diminished energy during the past year. Nell sometimes wondered whether her physical problems were linked to insufficient oxygen from lack of exercise and too much time spent indoors.

The previous summer, she was distressed at not being able to get "the bounce and vigor I want" in a watercolor, blaming the problem on "health worries and too many people around to help."[65] Now, she told herself that "more realistic expectations wouldn't necessarily diminish zest for work."[66] Falling into her old habit of self-flagellation, she berated herself for eating too many eggs and sweets, calling herself a "repository of human frailty." Concerned about having less money to pay for her aides and needing to ask for favors, she realized that her mood was partly driven by worries about her upcoming show at the Fischbach Gallery. "After all these shows, I should be more relaxed," she wrote to a friend, "but it doesn't improve."[67] An apologetic letter she wrote to her gardener for late payment of his invoice indicates that another problem was the slow-paying habits of collectors who had bought her work.[68]

In the spring, Nell was anxious to find a replacement for David Acker, who had left for less physically strenuous work as a typesetter at *The Nation*. It was hard to get a young person living in downtown New York to commit to riding the deteriorating, crime-ridden subway system to 96th Street. The director of the graduate program at the Parsons School of Design (where Lee Bell was teaching) recommended a second-year student, Peter Dickison, a young painter who had already done some work for Nell. "She was like, 'Here's this deal,'" he recalled. "'You've got to help me move [to Gloucester in June], and we come back to New York in November.'" That schedule would not mesh with his studies, but he decided to go anyway. "I had the feeling that I might be ready for the next thing," he said. Although he never completed his master's degree, he has no regrets. "I made a lifelong friend," he said, "and she was willing to teach not just about painting but about music, film, literature. The first year was a long series of her saying, 'You know'—the book or the film or the play or whatever—and I was always saying, 'I've never heard of that.' She would say, 'No, really?' Then she'd tell me about it."

Nell received a gift in return: Peter's calm and thoughtful way of managing her physical and temperamental issues. Her Gloucester neighbor Mary Weissblum described him as "a quiet, almost saintly fellow" who "never, ever said a word of complaint about anything [Nell] demanded from him."[69] As the driver of the Cadillac—its huge passenger-side door was a big help in getting Nell into the car—he perfected a "very smooth" and mindful way of driving, so as not to jar her.[70] Because the muscles of her diaphragm were weak, she had trouble staying upright on a fast or bumpy drive. In the studio, Peter realized that she was "very demanding and a control freak" when she directed him to cut pieces of masking tape off the roll in a certain way. Even the lettering for the cardboard wrappers of her paintings had to be done to her specifications: "I want my label to be black letters, just so high, flush left..." He understood that he was dealing with someone with enormous drive who felt stymied at being unable to do many things herself. Then he had an epiphany: "I'm acting as an extension of her physical body—she wants my hands to do what she wants to do—and if I can accept that, it's going to go easier, almost like a little game, and it might be fun to see her get pleasure out of it."

Nell's visit to the Whitney Museum Biennial in mid-May 1983 elicited her scorn for the "big au courant expressionists," whose work she dismissed as "undigested without much form and not sustaining." Yet she singled out the work of "the subway artist" (Jean-Michel Basquiat) as "outstanding—inspired and fresh."[71] A few days later, the *New York Times* published an article about master lithographs the Internal Revenue Service claimed were sold solely as a tax shelter.[72] Nell worried—needlessly, it would seem—that her own prints might be viewed similarly and belatedly drafted a letter to Elinor Poindexter itemizing the reasons her work would not fall into this category.[73]

After making her first etchings in 1946 while studying with Stanley William Hayter at Atelier 17, Nell returned to the medium in the late sixties. In the 1980s, she employed others to do the printing because the chemicals involved affected her breathing. "Drawing on the plates is the part I love," she wrote, "and seeing the sometimes magical results."[74] Working on a lithograph—which involves drawing with a greasy crayon rather than etching lines on a metal plate—brought out her sensuous side, a "feeling that my hand is physically responding to the process and the texture."[75] In 1967, her black crayon lithograph of rooftops had been included in the commemorative book *In Memory of My Feelings* (published by the Museum of Modern Art); now, Nell employed her brightly colored style for evocative lithographed landscape views and still lifes.

The events of this year's stay in Gloucester included Nell's sixtieth birthday celebration (with a "delicious meal" whipped up by Carolyn), a record heat wave that made painting difficult—she finally gave in and bought an air conditioner—and her rescue of a bird stalked by neighborhood cats. (She took it to the vet and then left it with the local Audubon Society.)[76] In October, a visit to the 159th annual Topsfield Fair—a nostalgic extravaganza of horse racing, pony and oxen pulling, fiddler and banjo contests, a flower show, and displays of livestock and produce—rated a special mention in Nell's diary. She watched children dance to a country music band, drew the "dainty elegant" black-and-white Dutch rabbits, and chowed down on Italian sausages, clam chowder, and cannoli. She also approvingly noted the appearance of a Greenpeace booth. Although she sometimes made rather cutting remarks in her diary about the people she knew in Gloucester, when a seventy-one-year-old gay acquaintance committed suicide in early November, Nell mourned. Hard of hearing and impoverished, Paul Oakley lived with his cats in a harborview home on which the bank had foreclosed. As was her custom, she drew a double-barred cross next to her diary entry about his death.

Because the terms of their apartment lease allowed Nell and Carolyn to be absent from New York for no more than six months a year, they usually spent June to November in Gloucester. Autumn was Nell's favorite time to paint: the view was more spacious when the leaves had fallen. The coloration of nature at this time of year was a special delight. In a letter to a friend, she described how "the color is…changing fast but still exciting—prussian waters, mauve & gold foliage streaks of violet in long clouds or cerulean blush to the skies."[77] Yet, although the house was built for year-round living, Nell never considered moving there permanently. "You gotta stay in New York," she told one of her helpers. "Or people will forget about you so fast."[78] As an interviewer aptly noted, "In the push-pull of Nell Blaine's life, New York may be the push but Gloucester is the pull."[79]

Complex preparations preceded the journeys to and from Gloucester, which necessitated the rental of a fourteen-foot truck that would be loaded with the women's possessions and painting materials. Mary Weissblum recalled helping the women unpack: "This obsessive-compulsive business about saving things—it was just fantastic, what they chose to take out of their refrigerator in New York and bring up here. [Even] four peas in a plastic container."[80] Weissblum was a treasured friend. In her diary, Nell recorded her joy at being met by Mary at Logan Airport after the trip to Austria in 1979: "a welcome sight—a shining countenance—silvery & glowing and gentle as usual…a very special person." It was wonderful to see that "food

[was] in the house and good vibrations! Flowers were on the table...lovely Dahlias."[81]

This year, because Jestina understandably insisted on celebrating Thanksgiving with her family, the return journey was scheduled the day before the holiday. But Nell was reluctant to stop painting—"as the fall progressed, she was really livin' it," Peter Dickison said, "so happy and productive." Finally, there were just about four days left. "Suddenly we're packing everything up; lots of stuff had to happen very fast," he recalled. Wrapping canvases and other materials was an activity Nell called "at best an ordeal."[82] As the driver of the U-Haul, Peter would have liked to leave while there was still daylight. But it wasn't possible to finish loading the truck before 6:00 p.m., which meant getting into Manhattan at midnight. First, Jestina's things were unloaded, to hand on to her relatives. Then all of Nell and Carolyn's possessions had to be carted up in the elevator to the eighth floor of their building. By the time Peter drove to his apartment in Brooklyn, it was 5:00 a.m., and the truck still needed to be returned to the rental location. This crazy routine never varied during the three years he worked for Nell.

Meanwhile, Nell's autumn show at Fischbach had opened. It received a thoughtful review from Gerrit Henry in *Art in America*. He took pains to explain how her work differed from that of other landscape painters, partly because her brushstroke was "not gesture but pure color." In his view, she managed to combine aspects of French and American twentieth-century painting with "a vision undimmed by the passing of time and unafraid of the parade of fashion."[83] Her paintings were selling well, at $20,000 to $40,000 (for the larger ones)—a respectable price level at the time. "Aladar was sort of like a racehorse when he was working...all business," Peter said. "But when I'd see him with Nell, there was a real warmth. He knew her history and he got her as a person."

Nineteen eighty-four began with the rejection of Nell's bid for a Tiffany Foundation grant. Her recent history of grants, vital to her costly living situation, had been mostly positive. A $10,000 Ingram Merrill Foundation grant in 1976 marked her fourth and final award from this generous institution.[84] But from now on, her recognition would be mostly in the form of honors that came with no monetary award.

Agreeing with Lee Bell, who called with New Year's greetings and to talk about various perceived injustices, Nell was annoyed to read an article damning the artist Balthus—whose paintings of young girls show them in erotically charged poses—"on of all things <u>moral</u> grounds." Believing him to be "one of

our best" artists, she added, "Yes he is a strange one but painting can not be judged thus."[85] Nell would forcefully reject the notion that good art is made by "good" people. "Many marvelous artists of the past committed criminal acts," she wrote, "and had as many character flaws as plumbers or lawyers—or any other professional."[86]

A weary and aged-looking Rudy Burckhardt—whose lifelong friend Edwin Denby had recently committed suicide—and his second wife, Yvonne Jacquette, came to visit; he gave Nell a major painting, earning her gratitude. Deep snow and freezing temperatures kept her indoors in January. Carolyn was Nell's emissary to a book launch party for John Myers's autobiography, which Nell faulted for its inaccuracies and typos. But she couldn't stay away from the opening of American Women Artists at the Sidney Janis Gallery, a large group show that included her painting *Landscape near Connecticut River* as well as work by several friends. When she accidentally called Miriam Schapiro "Mimi," as if confusing her with Mimi Gross, both women were upset. "I go out so seldom and insecurity is heightened by this," Nell wrote in her diary.[87] She also made her way to the award-judging session for the annual exhibition of the National Academy of Art. Carolyn won the major landscape prize, which worried Nell because of their relationship, though she believed the picture to be "obviously the best."

In May, a note ("please don't disconnect"[88]) with a bill payment to the New England Telephone Company that was apparently just a few days late typified the financial pressure she was under, which may have been one cause of her constant feeling of tiredness. A visit from an interviewer for a project about disabled artists elicited Nell's praise ("probably the bravest person I've ever met"); she was amazed that the woman, who had cerebral palsy, managed to take the subway with her walker.[89] Two weeks later, Nell confessed feelings of unworthiness, "a lifelong condition promoted by parents and abetted by a self weakened by physical problems."[90] She returned to this issue the following summer, ascribing these feelings—which, at their most acute, involved "many tears regressions and withdrawals…neurotic moods"—to times when she was not painting. Whenever she was deeply involved in a picture, she mused, her "inner strength lying partly dormant returns — tho' I'd never say it is constant."[91]

In July, Nell's senses were stimulated by the mountain scenery on the five-hour drive to the new Vermont Studio Center, a converted mill in the Green Mountain village of Johnson. Invited as a visiting artist, she put in a long day of "crits" in artists' studios and gave a slide lecture about her work. For the umpteenth time on her travels, she needed to be repeatedly hauled up many

steps and found the bathroom impossible to enter in her wheelchair. The following month, at the Gloucester Historical Society, James Mellow introduced her as "one of the greatest American artists," which made her blush. Nell believed that giving talks was necessary to address misconceptions about the art of decades past, and to earn money—now desperately needed for her planned trip to Austria. Yet shifting from painter to expounder involved a wrenching adjustment of her "inner focus."

Responding to a tedious questionnaire about her working methods (with the same set of flat-footed queries about each of six paintings) involved another trying detour from her work. To a question about the relative importance of the angle at which a still life is painted, Nell wrote, "Everything is important." What special techniques did she use to make her subjects look vital? "None. I try to approach every painting freshly, almost as if I never painted before." Did she have favorite still-life subjects? "I love to paint flowers, for many reasons. Even cut flowers are not dead. I like to celebrate their brief lives, their moment of glory." Asked to suggest a project for students that would employ her methods, she rebelled. Nell discouraged imitation. Her advice was simply not to be afraid of pure color, to realize that "the things around you daily are your truest subjects," and "to pay absolute attention to whatever you're going to paint." It was important to feel "true <u>physical</u> empathy as well as a spiritual attitude" and to "keep this feeling alive throughout!"

The return to Austria was the big event of the summer. Carolyn had been taking intensive advanced German language classes on Saturday mornings, and Nell asked Peter to bone up on his German so that he could shop for groceries in the village and request the engraved stamps she liked at the local post office. At first, Nell wasn't sure she could afford the trip, estimating that paying three salaries (Carolyn's, Jestina's, and Peter's) plus her New York rent, Gloucester mortgage, car storage, and car rental while abroad would cost "at least" $17,000 to $20,000.[92] To raise the money, she sold her Fairfield Porter painting, which first required expensive restoration.

Nell also had to ensure her housesitter's cooperation, claiming that she wouldn't leave on her trip abroad in early August if Celia could not stay in the house then, "as the place is too vulnerable & will have our additional things in it & garden care."[93] The latter included "additional watering, flower cutting, weeding, etc." Celia came through for them, putting up with Nell's insistence on reading about "how the tomatoes grow, the petunias, the anemones," but the rental arrangement was on its last legs. Later that year, an army of skunks took up residence in the crawl space, giving the house a terrible smell even after all the windows were left open—a major inconvenience in a New

England winter. When Celia went shopping for food, she said, people would sniff at her and wrinkle their nose. "So after that, I didn't come back." Nell wrote to her gardener, Martin Ray, that the rodents and skunks were "a terrible agony" for her housesitter, but she failed to offer the same sympathy to Celia herself. (The skunks proved hard to dislodge; ten years later, Nell told Ray that they were still "a serious problem.")

As usual with Nell's travel arrangements, there were problems with the flight to Zürich. Departure was postponed for six hours, a painful situation for Nell, who was unable to use the toilet during this time. She had already battled the airline's policy against allowing disabled passengers to remain in a wheelchair while boarding the plane; previously, she had been inserted into what she called a "Nazi torture device"—a steel contraption with straps that dug into her body, which was especially tender due to muscular atrophy. Victorious, Nell wheeled down the gangway. Peter picked her up—with one hand under her knees and the other on her back—and placed her in her seat. He piloted Nell, Carolyn, Jestina, and the luggage (some items were shipped ahead) in a rental car. The scenery along the main highway from Zürich to the Ötztal Valley reminded him of *The Sound of Music*.[94] Near Landeck, the travelers passed a *Trachtenkapelle*—a marching band dressed in traditional costumes—which Nell found "really lovely visually and musically."[95] Then, as they drove through the mountains, in heavy rain and mist, the windshield wipers stopped—a nerve-wracking interlude.

After she settled in, Nell was charmed anew by the Tyrolean scenery. She had told an interviewer that although she was not conventionally religious, "you feel nearer to God there."[96] She never tired of the view, because it was constantly changing with the weather and the quality of light. An excursion to the village of Umhausen introduced her to "a lovely old church with a tall needle sharp spire and an incredible graveyard around it. Each grave had a tiny chock-a-block garden with dazzlingly bright flowers all blooming freshly." She also admired the "lovely designs" of the iron crosses.[97] Christian symbols always retained their appeal.

On another sunny day, a drive along "rather precarious" narrow mountain roads yielded views of "lovely woods with thick moss under pines." En route to Silz, Nell gazed at apple orchards, homes with "dazzling" flowers in "beautiful orderly gardens," and "scattered clumps of haystacks" she yearned to paint.[98] In a letter to a friend, she described the elevated position of the house, "with crazy clouds below us and the earth & sky interchangeable—we are literally up in the clouds which are whirling mists ever shifting & disolving

[*sic*] & dreamlike.... The tinkle of sheep bells and cows mooing are our main sound track."[99] The only drawback was the increased stress the altitude placed on her breathing and energy.

After rushing out to paint a watercolor of the "crazy skies" before a major storm in early September, Nell moved indoors and nervously watched a long series of lightning blasts around the house. A few days later, she completed her first oil painting, a view of the heavy snowfall on Acherkogel. Bundled up in two sweaters, jacket, blanket, leggings, and hat, with scarves on her head, neck, and ankles, and newspapers lining the wheelchair pedals, she was still painfully cold. Her hands and feet felt frozen. "I kept painting every minute," she wrote, "looking hard simultaneously at one [peak] with that light and that snow on the upper reaches. My struggle was intense physically and otherwise."[100] The following day, her aching body and exhaustion told of the effort she had made. Self-critical as always, despite her pleasure at "beginning again" and her sense that the painting "has something," she felt that it was "not enough to lift me very high."[101]

A ten-day sojourn in Italy—with stops in several towns—involved the usual logistical problems. In one hotel, she could barely squeeze into the elevator and had to go outside to enter the dining room. Beds were never firm enough or the right height to allow her to rise easily. A Jolly Hotel was "not so Jolly" because her wheelchair did not fit in the elevator. Although she had paid in advance, Peter managed to extract a refund from the hotel owners. Another hotel had steps at the entrance, but the treads were long enough to allow him and Carolyn to lift on either side of the chair. Having forgotten to pack her watercolor palette, Nell was reduced to squeezing out a few colors on a piece of Masonite in order to paint a view of the beach at Malcesine, on the eastern shore of Lake Garda. Poor light and interruptions from passersby bedeviled her further. Perhaps to counterbalance the disruptions of travel, she stuck with familiar food in Italy: a banana split in Malcesine and pizza as her standard meal. In Austria, she reveled in the rich pleasures of schnitzel, ice cream, and strudel. Always keen on dessert—a part of the meal Carolyn could live without—Nell would ask Peter to join her in ordering something sweet "to share the experience," as he intuitively understood his role.[102] She believed her craving was inherited from her chocolate-loving mother.

Nell especially enjoyed Ravenna. She had long dreamed of seeing the Basilica of San Vitale—a monument of Byzantine art, with mosaics of Jesus, the apostles and evangelists, and Emperor Justinian and Empress Theodora, as well as flowers, stars, birds, and animals. It proved to be "different than my imagination—wonderful but awesome and hard to absorb and hard to see . . . a

bit overpowering." Conversely, she was pleased to see the "human scale" of the Mausoleum of Galla Placidia, which contains the remains of the daughter of Emperor Theodosius I and her family.[103]

Back in Austria, an unexpected fire drill—with firemen Nell thought resembled Nazis—blocked the way from her house and made her an hour late for a visit to an architect and his family, who lived in a former monastery. By the time she arrived—at night, in the rain—her hosts had given up, and the house was dark. One hour does not sound like a tragic lateness, but Nell was always beating herself up over failures to adhere to the good manners she learned as a child. On October 16, she worriedly totted up the amount of money she had left: $1,670. But she managed a broad smile in a photograph showing her in a Tyrolean jacket and plumed hat with a couple of antique medals pinned to her chest.

Summing up her reading for the year, Nell remarked in her diary that the Jane Bowles biography *A Little Original Sin*[104] was "the most heartrending book I have ever read," with the exception of the *Diary of Anne Frank* ("equally sad but in a different way of course"). In the late 1940s, she had met Bowles—like Nell, a bisexual woman mostly involved with women. Edwin Denby told her he had thought of fixing her up with Bowles but decided not to, because "two geniuses shouldn't be together." Nell had been fascinated by Bowles's play *In the Summer House*—about a toxic relationship between a mother and her teenage daughter, a subject she knew well—which had a short Broadway run in 1953–54. After the performance, she and Midi ran into Bowles on the street. Nell thought she was "charming...not pretty perhaps but appealing and attractive—and I wanted to know her better." Musing that her closeness to Midi at the time kept her from pursuing Bowles, Nell wrote that her own "impetuous headstrong and crazy" behavior was similar to the author's, "with many of the same fears and hopes. But thank god my inferiority feelings were not quite so self-destructive and I did not fall in love with a homosexual man"—Jane was married to composer and writer Paul Bowles. "But then, perhaps he was also her life?"[105]

In early 1985, Carolyn lost her studio—a curt notice had been slipped under the door while the women were in Austria—and was having trouble finding another space at a time of rising rents and scarce availability. During the 1970s, she had tried to make do with a windowless room ten blocks from the apartment; now, she was hard put to find a studio that did not involve a long subway ride, ambient noise, or high cost. As she wrote to a friend, $1,200 was the going monthly rate for a studio apartment with a tiny kitchen and

bath on the Upper West Side.[106] Meanwhile, Nell's finances were at a low ebb, after the previous year's trip to Europe. Consumed with the need to produce for her next Fischbach show, she was feeling especially pressured—as an artist whose paintings were necessarily small-sized—to fill the large rooms of the gallery's new space.

That winter, she painted the snowy view from the window: *Snow, Hudson and Park*. Along with her passion for vivid colors in nature, Nell was attracted to the challenge of painting snow landscapes—a permanent novelty to some-one reared in the American South. In 1964, during her winter stay at Yaddo, she had painted *Snowscape with Fir and Birch*. Although lacking the formal suavity of her later work, it shows that she was already figuring out how to portray the ghostly, unearthly quality of snow-covered ground. *November Snow* (1987) reveals the Gloucester house landscape in its covered-up state, with just a few plants poking through and draping their long violet shadows over the whiteness. (Carolyn's evocative photograph of snow-covered houses, taken that month, became the cover of the women's New Year's card.) In Austria, Nell had further opportunities to paint snow blanketing the valley and dusting the mountain tops, as seen in *Snow, Acherkogel* (1978) and other works.

On March 30, 1985, when Nell's Fischbach Gallery show opened, she was delighted that the worries plaguing her during the hanging of her work had dissipated. Catalogue essayist Jed Perl wrote that she was able to "extract the maximum lyric intensity" from her subject matter."[107] Nell felt that skillful lighting and "the large, lovely rooms" enhanced her work, as did "the most affectionate and warmest group of friends a person could have"—the ones who came to the opening.[108] Despite coping with the onset of AIDS (unbe-knownst to Nell), Aladar Marberger treated more than two dozen of her friends and collectors to a restaurant meal that was marred only by a "sassy" waitress. There were ten sales on the first day of the show—including three to Ronald Reagan's doctor,[109] seven to Sharon Rockefeller, wife of US Senator Jay Rockefeller—and five more a few days later.[110] By late April, Nell was thrilled to report to a friend that thirty-five works had sold and several more were "reserves" held for buyers still making up their minds. A reviewer for *Art/World* wrote that the paintings "sell like cotton candy" because "they are full of bright clear colors, loosely and quickly painted, that give the pictures a remarkable freshness and spontaneity."[111] Before the show opened, Arthur Cohen had swung by the apartment and purchased four of her paintings, all of which she thought were among her best. His generosity helped relieve her financial anxieties, though she worried that the gallery would be "furious"

with her for the private sale.[112] Other collectors—like the two southern women in long mink coats who made gushing remarks about her paintings—occasionally came to her studio, but she resented giving up her time when no sales resulted.[113]

Late spring brought muggy weather, increased humidity, and pollution, which made Nell feel sluggish. One rainy day, she spent several hours at the Parsons School of Design, talking to students about their work. Afterward, she bought summer shoes and splurged on dinner at an Italian restaurant, which (she noted wryly) used up most of her Parsons earnings. Mealtime was always important to Nell during her postpolio years. It was one of the few relaxing aspects—along with reading—of a day-to-day existence that was otherwise entirely consumed by the rituals of having her personal needs tended to and the hours she spent either painting or recovering from exhaustion after a long working night.

On May 18, Nell received an honorary doctor of fine arts degree from Virginia Commonwealth University; decades earlier, it had taken over the Richmond Professional Institute.[114] This was the second time she had been offered this honor; in 1983, she hadn't wanted the bother of traveling south, but now that she was told all her costs would be covered by the university, she didn't want to seem ungrateful. Concurrent exhibitions of her work were held at the Reynolds/Minor Gallery (recent paintings, drawings, and etchings) and the Anderson Gallery at VCU (paintings from Richmond collections). Traveling with Carolyn, Jestina, and Peter, she received a hero's welcome, with a limousine and driver at her disposal. Peter recalled that Nell worried about being able to balance properly if she had to sit in the back seat. The seat was too big, she said, and there was nothing to hold on to to keep herself upright. She asked the driver if she could sit in the front with him. After some hesitation, he agreed. "So we drove all over Richmond with her giving us a tour."

Nell's pleasure at being the center of attention was somewhat dimmed by the exhausting effort it took to get ready and to recuperate afterward. But she was glad to see that her former teacher Theresa Pollak looked "the picture of daintiness"—Nell reverted to a turn of phrase from her youth—and remained "alert, alive and interested."[115] Pollak was among the guests at a luncheon held in Nell's honor by collector Jack Blanton, then vice president of the Federal Reserve Bank of Richmond and curator of its art collection. The degree ceremony took place at the vast Richmond Coliseum, which had opened in 1971; nearby streets were blocked off, and crowds of students and parents surged through the arena. Edmund F. Ackell, president of VCU, read a lengthy tribute

to Nell. He lauded her "independence and courage in developing her own style," noted that "her mature work has been compared to that of Bonnard and Matisse," and praised her energy, resourcefulness, and fortitude. But he never mentioned that she had polio.

Five years later, Nell would receive another honorary doctorate, from the Moore College of Art and Design in Philadelphia. Her speech, which briefly summarized her history as a painter, emphasized the importance of being "totally immersed in the experience of painting and do[ing] it for the love of it alone." Although it was important never to stop "being harshly self-critical," she said, "when I feel like a bird, flying but not thinking how I fly—or that I'm flying circles around other birds—then things turn out well."[116] The bird metaphor reflected Nell's great love of avian creatures. As she wrote, "The sight of a new bird can make my day."[117]

During a summer in Gloucester marked by continuing strained relations with Carolyn, Nell rejoiced to see the opening of the poppies in her garden, intrigued by their "sculptural quality and lovely geometry...as they moved and started drooping."[118] After a period of brooding, Midi's visit in late August got Nell out of the house for dinner and a drive around Cape Ann, and helped regulate her emotional temperature. She noted happily that the Folly Cove Inn actually had ramps for her chair as well as tasty scallops and french fries.

In September, Jackson Pollock's cobiographer Steven Naifeh interviewed Nell by phone. She dredged up a memory of a friend of Pollock's from the 1940s and recalled seeing the artist, "looking bloated and disfigured by alcohol," toward the end of his life. Thinking he was a bum, the manager of a downtown shoe store had thrown him out. Nell, who was passing by, made a point of explaining to the man who this was. "But the name Jackson Pollock meant nothing to him. It was heartbreaking."[119]

That autumn, she responded to a range of issues important to her. In addition to sending small donations to Women's Action for Nuclear Disarmament and to Planned Parenthood, she wrote to President Reagan to ask him—in the formal, deferential manner that dated back to her teenage years—to support freedom of choice for women ("you are a compassionate person I am sure, but not in this particular matter").[120] Musing about critics—always a target of her scorn, despite largely positive reviews of her own work—she compared them to "school teachers treating us all like slightly stupid younger folk."[121] Nell was contemptuous of art critics' reliance on "pat theories" instead of close attention to the work itself. Two decades earlier, labeling critics as "the discouragers," she had railed against their habit of "misinterpret[ing]

artists and the message their work conveys" and dismissed their "phoney moral tone."[122] The tendency to value novelty in art also drew her ire; she firmly believed that artists need to be free to borrow from the past without being accused of being out of date. Critics who were not painters had a way of overlooking "the purely visual" in their commitment to literary or political concepts, she wrote, unlike "visually sensitive" nonartist writers like Ashbery and Schuyler. Her final blast was directed at the way dealers and curators blindly accepted the critical anointing of Andy Warhol as a major artist "in spite of the obvious commercialism of his work." Nell was far from alone in undervaluing Warhol, a blind spot for many painters nurtured by the high seriousness of Abstract Expressionism.

A larger malign force was on the horizon: Hurricane Gloria. In her diary, Nell drew a picture of curling waves, drooping flowers, jagged clouds, rain, and giant fan blades. She was worried about the trees on the property, especially a towering white pine. On the day of the hurricane, "our anticipation and anxiety was great," she wrote, "especially mine and Jestina's." Fortunately, the gale's strength dissipated before it hit Cape Ann, and there were no floods. A week later, enjoying glorious October weather, she wrote, "I cursed the need for publicity and deadlines that interfered with my best days for painting."[123] Nell was irritated that she had to work on the chronology for a facsimile edition of pages from her sketchbooks, to be published the following year with a concurrent exhibition of her work at the Metropolitan Museum of Art.

Midi had a heart attack just before Christmas, particularly worrisome because she lived alone, up five flights of steps. More bad news was that Nell's dealer, Aladar Marberger, was gravely ill. She wrote to her cousin that he had cancer, perhaps to shield this unworldly woman from the truth. AIDS had been given its name by the Centers for Disease Control just three years earlier; that autumn, Rock Hudson was its first high-profile fatality.[124]

The things Nell enjoyed could be as ordinary and unpredictable as a plant in a florist's shop: in January 1986, she was entranced by the lifelike quality of a "really jolly cactus partly hairy partly prickly with elliptical arms and top-knot." Later that month, on a visit to her gallery to see a friend's show, she noticed that Marberger was very thin. She hoped that the color in his face was a good sign. "He wanted to talk and pinned a medal on me that he picked up in a Paris flea market," she wrote, adding a reflexively condescending thought she would never have wanted applied to herself: "He is so touching." The next stop that day was an attempt to view the crowded Toulouse-Lautrec show at

the Modern ("I felt suffocated and exhausted"), followed by a look at the permanent collection and dinner at the museum.[125]

On February 12, Nell was the youngest of six women—the others were painters Leonora Carrington and Lois Mailou Jones, sculptor Sue Fuller, dance photographer Barbara Morgan, and curator Dorothy Miller—who were honored by the Women's Caucus for Art at Cooper Union in New York. "A little video filming took place first," she wrote, describing the evening ceremony. "I was very shy and my nose was dripping constantly most embarrassing!" She felt "really quite touched" by the standing ovations given to each award winner, and sent a grateful letter to the WCA president, praising the "rousing and robust spirit" and asking about potential media publicity and copies of photos taken at the event.[126] Nell might hate the distortions created by public relations efforts—and the resulting publication of error-filled articles about her life and work—but ever since her leadership of the Jane Street group, she was well aware of their value.

Nell's show at the Met's Mezzanine Gallery opened on April 8,[127] when she was recovering from a serious bout of flu and exhausted from signing hundreds of copies of the sketchbook. But the champagne-and-canapés reception, attended by many people she hadn't seen in years—including "several disabled friends who were especially spunky"[128]—buoyed her spirits. Her deal with the Fischbach Gallery, which allowed the Met to retain 15 percent of sales, was that she would get 50 percent, with the remaining 35 percent going to the gallery. A notation she made while working out prices for a gallery in Boston that was interested in her work suggested that the remaining prints of *Gloucester Bouquet*—an edition of fifty—could sell for $1,000 ("including frame!"). She had crossed out "$1,400" and "$1,200," because "I have to consider Met is undercharging."[129]

Nell's sketchbook, issued by The Arts Publisher, was produced in Italy by Stamperia Valdonega, which she described as "an elegant old world printing firm of real distinction."[130] The insightful preface is by John Ashbery. Nell had insisted on asking him to write it; Jimmy Witt, owner of The Arts Publisher, who had no idea who the poet was, paid him about $1,000.[131] Inside the book were her glorious drawings of her garden, which she called "the center of my life in Gloucester,"[132] as well as views from the house in Austria and tabletop images. She had kept insisting on more colors, sending successive proofs back with tracing-paper corrections taped to the pages. "She wanted it to look as close as possible to her real sketchbook," Peter Dickison said. "She'd say, 'That yellow isn't right,' and they'd have to add another two colors." She told him, "Nobody will take the trouble to make it as good as it can be except me." Witt

recalled her as "very demanding," adding diplomatically, "like a lot of great people can be." For some reason she insisted on the drab mustard color of the paper slipcase for the trade edition, whereas the slipcase for the deluxe edition of one hundred—which included an original etching by Nell—is an elegant mint green.

Her works in this volume are untitled, in keeping with the sketchbook theme. The drawings range from a life-size sketch of two bird-of-paradise flowers, with featherlike leaves that casually poke into the preceding page, to a vivacious rendering of the abundance of growing things alongside Eudora Cottage. Alongside the flurry of marks (mostly too generalized to identify as particular flowers) that nearly fill two facing pages, the blank white area indicating a pathway is startling in its emptiness. Nell's luscious watercolor images are the most compelling elements in the book—close-up views of floral profusion and evocative Tyrolean and Gloucester landscapes. Suffused with the freedom and delight that mark Nell's late style, this project is a testament not only to her virtuosity but also to her zealous oversight of production values. But it was impossible to control everything. Having dedicated the sketchbook to Witt, she was irritated that he allowed the Virginia Museum of Fine Arts to sell copies of the signed and numbered trade edition for $90 apiece instead of the agreed-upon price of $125.

In what would be the first of a grim procession of deaths of friends from AIDS, David Acker, who had been Nell's assistant for six years, beginning in 1975, died in May at age thirty-two. He had played a major role in setting up the Gloucester studio and shoring up the garden. Nell attended the memorial at the Prince Street Gallery, which included a showing of paintings and slides of his work, and pronounced it "fantastic." Although she wrote in her diary that his death was "an enormous loss to me personally," she couldn't help adding that she was "partly still hurt at his leaving" and somewhat miffed at his intense ambition—"but maybe he knew somehow that he did not have long to live."[133] How could Nell complain about a young artist's ambition, given her own burning desire, as a young woman, to succeed? This is an example of the selfishness that Carolyn found difficult to live with. After Acker's memorial, Nell recovered her sense of proportion, calling him a "friend, helper and like a son to me…bright alert and <u>utterly charming</u>."[134] She wrote to Theresa Pollak that Acker "became a strong lyrical painter in the last years of his young life."[135]

In June, Nell—in line with her compulsive micromanaging of her work beyond the studio—told Arthur Cohen which museums would be appropriate

for his donation of two of her paintings. For one, the Modern was at the top of her list, followed by the National Museum of Women in the Arts; she wanted the other one to go to the Contemporary Arts Museum in Houston. Later that month, she attended a dinner party at John Cage's loft in honor of pianist Grete Sultan's eightieth birthday. Hundreds of plants on a raised bed of gravel gave the space a jungle-like atmosphere. Nell's assistant Peter Dickison recalled that rectangles of colored paper were set out on the coffee table: a collage to which guests were invited to contribute. Nell enjoyed the macrobiotic refreshments (beans, rice with seaweed, tofu pie) and—partly because his address on 18th Street was near her old apartment—was reminded of "my pre-polio life."

She always kept up with Jane Freilicher's work. On a snowy January night in 1979, Nell worried about getting to Jane's early evening opening at the Fischbach Gallery. "Will I make it?" she asked herself in her diary.[136] She did, and even managed to attend the party afterward. As usual, she found Jane's work "superb." Now, in late August, after a visit to Fischbach to see Jane's latest solo show, Nell wrote to her to praise the way she handled light and other challenges: "You got so many varieties of foliage and inventively handled the growth with solid earth under it. A miracle! And your skies are all air, mist, light and changing vapors." Nell also thought the early works in the show looked "better than ever." The entire group of paintings testified to Jane's "great sense of spaciousness and amplitude and tenderness, attentiveness to nature."[137]

Nell and Jane were the two leading painters of their generation with the most similar subject matter (landscapes, aerial city views, still lifes) and influences (the sensual quality and intimacy in work by Matisse, Vuillard, and Bonnard). They had other things in common: certain stylistic aspects (figuration inflected with abstraction, a strong coloristic sense), study with Hans Hofmann, and a fascination with window views from their homes. Jane's canvases include views from the top floor of a tenement on East 11th Street (in the early fifties); an apartment on West 11th Street (after her second marriage in 1957); and finally a penthouse apartment on lower Fifth Avenue (from the midsixties onward). These images reveal a Manhattan vista exquisitely reduced to blurred geometric shapes. Like Nell, Jane also had a home in the country—in Water Mill, Long Island, where she painted many views of the misty local landscape.

But the women's paintings were distinctly different. Nell's did not share Jane's relaxed, seemingly off-the-cuff quality, which Jane described as the "quick, lively blur of reality as it is apprehended rather than analyzed."[138] She

once told an interviewer that impetus to paint could be "an inner impulse that wants to be expressed, or a sensation of color or atmosphere or arrangement of shapes...the peculiar brightness or clarity or softness and smogginess of a day."[139] For her, a subject was simply "a vehicle for painting."[140] In her paintings, flowers—which did not affect her emotionally, as they did Nell—were often abstracted into spots of color. Invention could be as valid as observation, as in *The Lute Player* (1993), which features both a postcard reproduction of Watteau's painting[141] and a fantasy image of the musician in the landscape she saw through her window. For all Nell's sterling qualities, she lacked the witty sensibility that led Jane to paint *The Outside World* (1985), in which a wall-mounted phone and a radio compete for the viewer's attention with a view through sliding glass doors of the corner of a swimming pool, a swath of lawn, and sailboats gliding on the water.

"The ordinary is really never ordinary when one examines it closer," Nell once wrote. Most landscapes "hold rich potential to stir the imagination," with a "thrilling complex of shapes" and light that "bathes and keeps the colors at a certain pitch."[142] Her approach stemmed from her intense scrutiny of objects and her tightly wound personality. Views from her Riverside Drive window capture the scene precisely as she saw it; landscapes contain abundant detail expressed with an insistent rhythmic patterning. As an artist whose happiest childhood memories involved visits to the countryside, her relationship to the natural world was overwhelmingly personal. She believed that a work of art should have "a sense of mystery and psychological probing," of either the subject or the artist, and that artists should try for "a feeling of oneness with nature."[143]

Each woman was a master of her own style of painting, both remained vital artists to the end of their lives, and both were vehemently opposed to the notion that an artist should strive to be trendy or innovative. Yet Jane, who was married to a successful businessman, did not experience the financial anxieties that constantly dogged Nell. And of course, as an able-bodied woman, she was no more stymied by the mechanics of daily living than any other artist.

In late September 1986, Nell was upset that she had to withdraw $15,000 from the bank to pay her taxes. "For the first time in my life I earn enough to make a trip and cannot use the money," she wrote. "It must go for weapons—disgusting. If only more went for...social purposes." News of the Iran-Contra affair did not break until early November,[144] but Nell was probably expressing a more generally negative view of the Reagan administration's priorities. It

was a fraught time. Carolyn was once again in the throes of seeking a new studio. The tiny room in a building that had provided no space to hang or store her work despite the $200 monthly rent was no longer available. And Nell, despite all the financial pressure she was under, with bills due for the house and apartment, was temperamentally opposed to turning out paintings specifically for her next show ("a no-no in my book"[145]).

A month later, she wrote to Jimmy Witt about her financial straits: "This is my neediest time November thru April—practically no income." Money was a perpetual problem during the years between her New York shows; as she once remarked to a friend, she was "not a saving person" and tended to use up all her earnings to hire more helpers. Nell explained to Witt that she could not sell her new pictures before her 1987 Fischbach exhibition, and that her financial situation was such that she was unable to afford needed doctor visits. Adding to her desperation, she now realized that she would make no money on sales of her sketchbook after paying for printing of both the book and the special print for the deluxe edition, which involved hiring a helper. Printing costs alone came to about $30,000. The Met retained 40 percent of sales, and the publisher kept 50 percent of the balance, leaving her with only $80 (deluxe edition) or $37.50 (trade edition) per book. Nell asked Witt to either give her half of the sales proceeds or return the money she spent on printing.[146] Another disappointment was the failure of *House & Garden* magazine to follow through on a potential article about her garden that she hoped would help sales of the book.

Meanwhile, Peter Dickison had decided that he needed "to be out from under the shade of this big tree." A former job had opened up, and it seemed time to move on. Breaking the news to Nell involved "the most difficult conversation I ever had," he said. "I didn't want her to take it personally—that's how much I admired her....She was a very formidable person, large in her exuberance, her will, her passion, her personality."

Fortunately, Nell's new helper, twenty-one-year-old Stephen Colley, started out on the right foot by bringing her a "beautiful peony" from a florist for her to paint. She praised his strength, sweetness, and hard work. And there was a bonus: his fiancée was willing to "fill in once in a while cooking and spelling Carolyn."[147]

The opening of Nell's 1987 Fischbach Gallery exhibition, on March 28, was "the best" she could remember. Nell listed all the guests in her diary. They included Bob Dunn ("looking like an old movie star"); Midi; Marshall Clements; Jane and her husband, Joe Hazan; Yvonne and Rudy Burckhardt;

Wolf and Emily Kahn; Al, Pat, and Elizabeth Kresch; Lee and Ulla; Elinor Poindexter; and gallery director Hal Fondren. Jed Perl seems to have been the only critic who wrote at length about this show, probably because the controversial Whitney Biennial loomed so large that spring. He was bowled over by Nell's "cozily ebullient" canvases "that take you into a normal but beautiful world" and praised the "toughness" that enabled her to paint in this unfashionable way. In his view, her show's "urgency" and "immediacy" outclassed all other art shows in the city.[148]

Gallery visits the following month included exhibitions of work by Léger, Dufy, and Géricault—the latter a show Nell called "a real shocker." She described the nineteenth-century French painter, who died young, in the breezy shorthand she sometimes used when trying to summarize her feelings about an artist or author: "so intense so talented—yet so sad." The gallery director had given her a copy of the Géricault catalogue, especially welcome because it cost twenty-five dollars. ("I was amazed that he knew me by name and thanked me for coming!")[149] In contrast, another New York gallery, which had a show of John Henry Twachtman's Gloucester paintings, left her and Carolyn to fend for themselves while struggling up the steps and responded to questions with "snobbish" replies. In early May, a benefit for the Vermont Studio Center

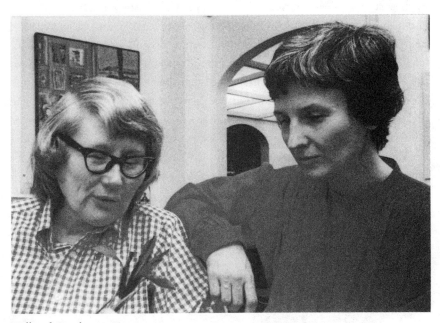

Nell and Carolyn, 1980s.
Photo: Ellen Thompson. Courtesy of Carolyn Harris.

("a very glamorous evening" with "quality food, décor, music, speeches") brightened Nell's spirits. She happily noted the presence of several old friends, including Tibor de Nagy, Larry Rivers, Wolf Kahn, Bob De Niro, and Grace Hartigan ("extremely warm and friendly…<u>covered</u> in sequins").[150]

Nell wrote to Martin Ray that she "couldn't seem to get down to work—feeling fatigued."[151] Painting a watercolor was a struggle, because when the paper was tilted back so that the colors wouldn't run, it was hard to reach with her right arm. If only she could stand up and lift that arm! Although she tried working with her left arm, she was unhappy with the distortion she saw in her painting of a bouquet with Shasta daisies that Jestina had given her. Similar problems would bedevil her when she made etchings, despite enlisting Carolyn to keep adjusting the table and the etching plate.

At the end of July, Nell and Carolyn set off once again for the Vermont Studio Center. Her lecture was "a physical torture" because of problems with the microphone; the sound quality was distorted, and the angle of the mic strained her neck and back. Typically unmindful of the number of slides her audience would reasonably want to see; she had arrived with four hundred of them. Nell was also somewhat disconcerted that the students liked her flower paintings best.[152] Critiques were the next order of business, a grueling day of three sessions with students whose ages ranged from twenty-two to sixty. Each session involved about twenty-five crits of eight to twelve pieces of work and a sheet of slides that Nell had trouble seeing clearly. She was gratified to be told that she had nailed each student's strengths and weaknesses.

On August 6, in Gloucester, she painted "the first oil of summer," a view of the Annisquam River in late afternoon. Carolyn had to push Nell up and down hills until she found the right vantage point. The spot she chose had flickering light; she needed to have some shade on the canvas, and this was the best compromise. The rocky ground was uneven, requiring Carolyn to stabilize the wheels and level the table with pieces of wood. Getting ready took a long time and "much energy"—Nell was self-centeredly referring only to her own output—so she wound up working on the painting until it was nearly dark and still didn't quite finish it to her satisfaction.

12

Alive Still

DURING NELL'S LAST YEARS, friends' shows served as major social occasions. At Jane Freilicher's opening in April, she observed that Rudy Burckhardt looked "very thin and frail but sparkles with life"; his artist wife, Yvonne, "quite handsome and pretty (both!)." Always supersensitive to social gaffes, Nell was embarrassed when Midi, introduced to James Schuyler, appeared not to realize that he was a noted poet. A skeletal Aladar Marberger, who would live for just seven more months, was "very intense and moving to be with." She sat with him at the after-party at Jane and Joe's apartment, eating a dinner of chili, chicken salad, and ham. "Every now and then he seemed to freeze," she noted, "and a glazed look came over him whether from drugs or pain I couldn't determine."[1]

Nell set out for New Haven in early June 1988 to jury a Connecticut Women Artists show. On the way back, her driver felt tired, so they stopped at a McDonald's. When they finished eating, it was raining heavily and the engine would not start. Roadside assistance cost fifty-five dollars she could ill afford. Yet despite the hardships of traveling to the venue and the exhaustion involved in dealing with people all day, Nell kept up her exhibition jurying. This activity eventually led her to believe that the "innocent eye" of amateur artists was a "purer creative spirit," unspoiled by "conflicting theories and slick commercial interests."[2]

In October, she worked on a painting of the birch tree at her Gloucester house that she wanted to call *Autumn Park* or maybe *Autumn Peak, Harbor and Rocks*, or *Autumn Gardens by the Harbor*. At about 4:30 a.m., after being captivated by "tiny embossed white clouds spaced across the sky in a precise way like in early Italian painting," she fell asleep in her chair.[3] Three hours later, supplied with fresh underwear and fortified with a soup-and-sandwich meal, she returned to the painting. This was fortunate, because a storm with gale-force winds was ripping the brilliant red, yellow, and orange leaves off the trees. Nell wished she could always work this way—in the early morning, when the light hit the far shore and she could see clearly—rather than at

midday or early afternoon, when the quality of the light was less interesting and the angle of the sun blinded her. But she realized that this schedule would ask too much of Carolyn.

In early December, Nell thought she was in the grip of agoraphobia when she felt extreme anxiety about eating at a Chinese restaurant after the opening of Al Kresch's new show. A noisy wedding party and food that took too long to arrive put a damper on the event. But she was happy to be able to speak with Jane and visit with other old friends. For some reason, Nell waited until the last day of Kresch's exhibition to see it and wound up trading a painting of his that she owned for a more costly one "even though I probably can't afford to."[4]

Her own show—her forty-ninth solo exhibition—opened at Fischbach on April 1, 1989, with prices ranging from $2,500 (for works on paper) to $38,000. The forty-seven pieces included a generous array of watercolors of views in Gloucester and New York, and numerous paintings and drawings of flowers. As usual, the preceding weeks were bogged down with Nell-style difficulties. With her self-described "block against math and commerce," she took a long time to develop a suggested price list for the different sizes of her work. Hanging the show was difficult because the pictures were small and the gallery space large. "Of course, it doesn't help that I go [to the gallery] tired and hungry,"[5] she wrote. And it didn't help that she refused to leave this chore to gallery personnel.

The artist-dealer relationship is never without friction. Nell privately railed against dealers' common practice of giving discounts of as much as 20 percent to good clients, which meant that she received half of the remaining 80 percent—less than 50 percent of the selling price. "The artist is always getting screwed," she wrote.[6] After Aladar Marberger died, Larry DiCarlo became the Fischbach Gallery's director. Nell had always preferred dealing with Marberger. She would be furious that DiCarlo allowed the painting she considered the "star" of one of her shows to be removed from the gallery (presumably by the person who bought it). Another year, she was upset when he sold her "best" landscape for a 40 percent discount without asking her first.[7] But her work was selling, she had loyal collectors—including Sharon and Jay Rockefeller and attorney Neale Albert[8]—and she remained with the gallery.[9]

In a newspaper interview published the day before the April opening,[10] after Carolyn explained that the flowers in Nell's paintings came from the Gloucester garden, Nell announced, "I'm not a gardener. I'm more of an instigator, a garden promoter." Asked about her use of color, she said that it was "the most elusive and difficult of all the elements in a painting." Poking fun at

her early abstract work, she described these paintings as the product of paint built up in layers and scraped: "tortur[ing] it, the hair-shirt method." She read aloud a statement Matisse had made in his last years, when he worked from a wheelchair or from his bed, about the effortfulness of his earlier work compared to the "free and detached" work he was making now. The *Art/World* reviewer wrote that Nell's "passionate view is tempered by a hard nosed ability to simplify forms, shapes and palette." She compared Nell's way of harkening back to visual memories of the backwoods of Virginia to the sense memory of an actor schooled in the Stanislavsky method.[11] The best news about the show was financial: nearly all the works had sold by the time it closed.

This year, the drive to Gloucester in early July—which began at midnight and took seven hours—went more smoothly than usual because of the cool weather and lack of traffic. Nell wrote to a friend that her current helper, Jack, who drove the van, "led all the way until the end when Carolyn [in the car] pulled ahead in a triumphant spirit."[12] She delighted in the few plants that were in full bloom, including the Shasta daisies, "loaded with white splashes like paint strokes."

Returning to the soothing atmosphere of Cape May always boosted Nell's spirits. But she was troubled by the increasing curvature in her back, which frequently tired her and made dressing and getting on and off the toilet more difficult. Her joints ached, and her hands, arms, shoulders, and neck—the parts of her body most engaged in making a painting—were painful. Taking short naps during the day seemed the best way to replenish her stamina, though this erratic schedule was inconvenient for her helpers. In an interview, she declared that she experienced "no loss of pleasure in the painting"; the loss was "not being able to use the whole body." In the old days, Nell reminisced, she used to "run up to the canvas from halfway across the room to make a stroke," just for fun. But those paintings "always had the feeling of too much effort."[13] Now, as she said on another occasion, she was "forced to simplify nature."[14] Because she worked "so fast and so rhythmically," she sometimes did not bother to count the petals on the flowers she painted.[15]

In early 1990, Nell borrowed some of her paintings from Arthur Cohen. She wrote to him that she liked to see the old ones again, especially certain favorites; not having them around meant a loss of continuity in her current work. Aware of his mortality, Cohen—who was being treated for cancer and would die the following year—had already given dozens of her paintings to public institutions. Nell's 1958 painting *Wharf Studio* appropriately entered the collection of the Cape Ann Museum in Gloucester, along with *Rubrum*

Lily (1980, plate 23). Praising Cohen as "a great human being" and the one person whose support helped her "perhaps more than all [others] put together," she begged him to take care of himself. In a pointed reference to her own experience, she noted that his "wonderfully positive attitude about life…is the number one survival technique."[16] Her own method of making her peace with encroaching old age, as she wrote to her cousin Charlotte, was "to keep working & being involved & to have young people as well as contemporaries around."[17] Learning that Charlotte had decided to put off moving to a retirement home, Nell wrote to second her decision: "Never retire is my motto!"[18]

For Nell, this was a time of intense delight in everyday sights. One night in May, she was rapturous about the way the moon's reflection on the river looked like a Munch painting and the "aqua lights interspersed along the Jersey Shore were clear necklaces strung in two rows in an undulating pattern." She was "aching to paint it" but had to settle for making a small drawing in ink stick and wash, *Night by the Window*.[19] A bouquet of lilies she sketched elicited a gushing description: "heartbreakingly beautiful luscious delicious flamboyant baroque masterpieces of extravagant wonder magical and fragrant too!"[20] Even the garbage on a scow towed down the Hudson by a tugboat looked to her eyes "like a pile of pressed flowers."[21]

In May, at the American Academy and Institute of Arts and Letters, Nell received the Louise Nevelson Award for painting—a curious choice of award, since Nevelson was a sculptor. The citation praised the "wonderful spontaneity of execution" and "grasp of form and gesture" that gave Nell's work "its sense of both liberation and balance—effulgence and discretion."[22] Nell was in the orchestra section in her wheelchair, directly opposite Garrison Keillor, sitting in the front row onstage. She wrote on the seating plan that he "made a great speech & was hilarious." As she waited for the elevator at the "garbage and garage entrance" of the building, Nell saw poet and novelist Reynolds Price in his wheelchair. He smiled "knowingly" at her. Five years earlier, when Price was fifty-one, a tumor on his spine was discovered; it eventually rendered him a paraplegic. At the end of his memoir about this devastating experience, *A Whole New Life*, he wrote that his "new life" was actually a good thing, because it "forced a degree of patience and consequent watchfulness" on him. It also led to "the slow migration of a sleepless and welcome sexuality from the center of my life to the cooler edge" and spurred "the increased speed and volume" of his writing.[23]

Like Nell, Price had loyal friends who came to his rescue at crucial moments; unlike her, he was able to draw on a succession of responsible students

at Duke University, where he taught, to serve as personal aides. A worrisome new health crisis struck Nell this year: flashing white lights in her right eye. Then came episodes of clouded vision and even "altered color perception," which led her to consult an ophthalmologist. She was diagnosed with cataracts and band keratopathy, a condition resulting from calcium deposits on the cornea. A year later, another examination showed that her vision had worsened; she was given a prescription for sunglasses, in an effort to stave off further eye damage.

In June, the car's broken air conditioner compounded the miseries of the annual trek to Gloucester on "the hottest possible day for driving" (actually, the high was 82 degrees). Nell became ill and vomited on the long drive— four hours just to reach New Haven. When they arrived at the house, she discovered that the garden was in bad shape, and the continuing skunk invasion made the house smelly. Humid weather left Nell choking and gasping, and unable to paint. As soon as the heat wave subsided, she busied herself with preparations for a still life of a two-day-old bouquet of red gerberas and balloon flowers. This took a long time, what with drooping blooms, lights that needed readjusting, and the lack of a blank canvas with the right dimensions. (Nell had to ask Carolyn for one of hers.) So much for her remark that the best still lifes "just happen."[24] Days later, Nell was interrupted by the drop-in visit of a local couple. Ignoring hints at how busy she was, they made no move to leave even after she announced that she really had to get back to work. By the time they left, she was exhausted.

Nell had illustrated a book of poetry by Marge Piercy, *The Earth Shines Secretly: A Book of Days*, published earlier that year by Zoland Books. Like Nell, Piercy, who lived on Cape Cod, found her subjects in nature and her daily life; her titles include "Putting the Gardens to Sleep" and "September Afternoon at Four O'Clock." The two women worked independently;[25] Nell was asked to supply seasonal images that would serve as a counterpoint to the poems rather than illustrating them directly. The cover reproduces one of her paintings of the view from her house. In late August, Nell signed copies of the book at an evening event at the Bookstore of Gloucester. She noted happily that at least sixty-seven people bought a copy.

On December 3, Nell joined a panel at the 92nd Street Y—"Poets and Painters," with John Ashbery, Larry Rivers, and Kenneth Koch—which accompanied a painting show. "The foursome proved both stimulating and hilarious!" Nell wrote in her diary. "The audience was ample and responsive....Kenneth was lively and I loved it when he included my name. Larry was ridiculous and silly at times but a good showman at others—very funny."

Afterward, Rivers waved to her "sweetly and cutely from the steps—sort of a little tickly fingered wave."[26]

In her 1991 diary, under the printed line *In the event of an accident, please notify*, Nell wrote: "Everybody! Dr. [Arthur] Figur C H [Carolyn] M G [Midi] C C Charlotte Clark." This was her current inner circle. In January, she alerted Charlotte to the inclusion of a landscape painting of hers in the Abbeville 1991 desk calendars *American Watercolors* and *Women Artists*,[27] and to a forthcoming *Yankee* magazine piece about her. Privately, the article aroused her "feminist ire." She found parts of it "demeaning & troubling" for unstated reasons, though she believed that the author was probably unaware of his transgressions.[28] It is hard to fathom what there was to complain about in this brief article, which quoted her on Gloucester ("an authentic working class town") and on the worthiness of painting a New England fishing village, subject of so many hackneyed renditions. Her response: "If you're a vigorous painter, no subject is taboo."[29] Perhaps the problem was the caption that said she was "confined to a wheelchair." She was understandably touchy about being labeled in this way.

News of the Gulf War riveted Nell, who spent hours watching CNN. She rued that "the weaponry makes all kinds of global horrors possible now. When a man such as Saddam has power mania we cannot rest. As a <u>pacifist</u>, I am <u>torn</u>."[30] In a letter to Charlotte, two weeks after the launch of Operation Desert Storm, Nell remarked that it was "like some obligatory game the big boys play. Trying to put my painting in order with a proper peaceful state of mind is difficult."[31]

Spring brought a new state of household upheaval, what with an injury to Jestina's arm, which prevented her from performing her usual lifting duties, and her departure for Grenada after the death of one of her sisters. It was unclear when she would be able to return. Meanwhile, as the sole juror for a gallery show, Nell was saddled with more than nine hundred slides to review. But there were always compensations of one sort or another. In April, after attending a "superb" reading by Denise Levertov at the 92nd Street Y, Nell was ecstatic. "Her poetry [is] imaginative, compassionate, intense, earthy, concise, pertinent extraordinary.... Isn't she the <u>best</u>? It was also good to see her if only for a moment."[32]

At the reading, she was accompanied by Carolyn and Eric Brown, a young painter who had graduated from Vassar College the previous year. He had known Nell ever since he was ten years old, when she hired his attorney father, Neal, to deal with the complexities of her inherited properties from Howard

Griffin. "She was the first real artist I had ever met," Brown said, recalling how he had copied her watercolors when he was a child. "She was the ideal of a real artist, how they lived—integrity, approach to values, all that. It was very formative." Nell and Brown corresponded while he was in college, and he helped her in the studio during winter breaks. When he had his first show, she urged him not to harbor doubts about his work. "I'm sure confidence will come with time & lots of experience," she wrote, adding that she herself "vacillate[d] between overconfident arrogance & shrinking feel of failure," a trait she put down to being "so damned neurotic."[33]

After graduation, Brown had spent six months working for her in Gloucester, tending to the garden and running errands as well as serving as her studio assistant. Nell's notes to him, scribbled on odd bits of paper, are filled with precise directives, mild scoldings, and occasional praise, sometimes accompanied by tiny drawings. One day, he was to put three houseplants outside for the afternoon, "if not too windy."[34] A color-coded list explained which ones were to be watered, dosed with vitamins, or both. There was a constant stream of instructions about deadheading flowers (a chore that "must get speedier as familiarity and rythm [*sic*] take over"), sprinkling lime, pulling weeds, staking flowers, bagging topsoil, and removing "junk wood." Another day's list urging an outdoor cleanup "to clinical neatness" was followed by an exhortation: "Try for the impossible!" That year, Nell also sent Brown to scout out birthday presents for Carolyn, based on a list of potential items, and to purchase "2 good cards 1 crazy 1 sweet? or handsome or sentimental but not icky."

He was fond of Nell—in order to be able to lift her, he had put himself through a six-month workout regimen—and tolerant of her excesses. "She had what she called a mothering instinct," he said. "She let me know how to do certain things—even my penmanship. She would talk about 'getting the rhythm of it down.'"[35] Nell thought of Brown as a "dear sweet and very pretty boy."[36] To her cousin Charlotte, she described him as "a cheerful person—and most intelligent & willing worker with a wonderful personality. Good company too."[37] To Brown himself, she sent silly cards with loving messages. But after enlisting him to help with some grubby, non-art-related household projects, she became exasperated with his work habits. "He is never thorough—not on gardening not any of these menial jobs…there is no consistency at all—except—the desire to chat—and the warm friendly sweetment [*sic*] of temperament he always displays."[38] Yet he was helpful in the studio, and she rewarded him with a table she was fond of that was taking up too much space in the apartment. "FAREWELL TO A TABLE!" she wrote in her diary.[39] In

autumn 1991, Brown became assistant director of the Tibor de Nagy Gallery. Two years later, after de Nagy died, Brown and Andrew Arnot, who had served as director, became co-owners of the gallery. Nell would have four solo posthumous exhibitions there, accompanied by illustrated catalogues with thoughtful essays, and her work was included in several Tibor de Nagy group shows.[40]

The catalogue for Night and Day, Nell's spring 1991 show at Fischbach—her fiftieth solo exhibition—described her attachment to recording every nuance of the Gloucester landscape, in all seasons and weathers. Although still lifes dominated the show, there were also paintings of the Eudora Cottage garden and the view toward the harbor, as well as atmospheric images of the Hudson River in winter. Catalogue essayist Martica Sawin compared Nell's approach to landscape to that of traditional Chinese painters, "in which the universal is expressed through a combination of…water, atmosphere, rock and organic growth."[41] The *Artforum* reviewer was especially enthusiastic about Nell's watercolors, with their "peerless tactile control." She called the atmospheric tour de force *Fog Coming In* (1990) "simply breathtaking."[42] An anonymous writer in *The New Yorker* suggested that Nell's still lifes looked as though "they were made by someone who, fearful of losing the pleasure of scent and sight, couldn't wait to get down one set of impressions and move on to the next."[43] Of course, Nell had once feared exactly that.

Having struggled to continue her life as a painter, she was dismayed to learn that another artist was spearheading a fight to ban her beloved cadmium oil paints as a carcinogen. Nell, who loved the vivid colors and permanence of these metal-based pigments and hated acrylic paints, expressed her point of view in a passionate letter: "Everything is hazardous when you come down to it! The earth we walk or roll on, the air we breathe (of course!) but the paints we use are for some of us the very source of life and joy—and if used with care…they're safer than breathing!…Color is my life, my means, my freedom.…Don't take away my cadmiums!"[44]

The Fauve Landscape: Matisse, Derain, Braque and Their Circle, an exhibition at the Met, was the sort of show Nell could not bear to miss, though she caught it on its penultimate day, May 4, 1991. She found the "big Matisse" to be the most impressive painting; three small Matisse works were "fine little jewels rather perfect." Nell rated "about 1/3" of the paintings "very good" and one-tenth "very fine."[45] Her insistence on quantifying an aesthetic experience was in line with her obsessive diary notations (money spent, expected, received, and deposited; bills and wages paid; letters mailed; precise dimen-

sions of completed paintings). By listing these things, she was able to exert a measure of control over her life, in other respects so dependent on others. Months later, pondering her enjoyment of "chores that would seem tedious to most people…organizing, wrapping," she realized that "actually I find it calming."[46]

Trying to come up with a title for a book she wanted to write, Nell toyed with *Drawing and Remembering*, *Drawings in Time*, *Souvenirs from Nature*, and other variations. She rejected *Afternoon Souvenirs* because it sounded "too sentimental."[47] Other title ideas—*Friends in Art*, *Art and Life with Friends*, *Life Sketches*[48]—more clearly suggested the kind of book she was contemplating: a memoir of her life in the 1940s and '50s. Yet memory could be an accusatory companion. A poem Nell composed in late June contains these lines: "If I think about Death / I see my Mother / Lying in her coffin / a shell / a carapace: / Waxy / Dead dead dead / I never said goodbye / or held her hand."[49] Perhaps it is not surprising that this book remained unwritten.

Nell once wrote to a friend that even at times when lack of exercise and the weariness of her helpers had slowed her down, "I find more energy in the summer and fall in Gloucester due to heightened visual stimulus"[50]—largely created by her garden blooms. But her pleasure was a solitary one, all too easily marred by the well-meaning efforts of others. In mid-August, Rosemary Kent, features editor of *Countryside* magazine, interviewed her about her garden.[51] The photographer, Lizzie Himmel, and her helper wanted an outdoor shot of Nell painting a watercolor, which she found "nervewracking." Then it started to rain, and umbrellas were set up. "The 3 women were all over the place—my easel was in jeopardy and by evening I'd 'broken out'—my skin a mess." The next day, Nell woke up feeling poorly. She regretted having agreed to the interview, calling Kent's behavior "abrasive, overly aggressive and volatile" and labeling her ordeal in all caps: "INVASION OF THE BODY SNATCHERS."[52]

When Leland Bell died, on September 18, Nell was so devastated that she felt physically ill. "Lee was my brother in art and a great inspiration throughout my adult life," she wrote. Although he had suffered from leukemia for several years, she had counted on him to regain his strength, "and to go on lecturing painting teaching inspiring young students."[53] Two days later, the death of an injured goldfinch Carolyn had rescued seemed somehow related to her loss. For Bell's memorial on November 19 at the New School, Al Kresch chose Lester Young records, and a jazz pianist played. Speakers included poet John Hollander and artists Mercedes Matter, Robert De Niro, and Kresch. In

Nell's account of her long friendship with Bell, she said that he "was the most passionate lover of art" she had ever known. In the early 1950s, she related, he came into his own as a teacher at The New School, making "century-jumping comparisons" between art and artists.[54] She credited him for "opening my ears to jazz"—he would bring over records of Lester Young, Count Basie, Chu Berry, and Coleman Hawkins, and insist that she listen to them—as well as for his influence on members of the Jane Street group. She also appreciated the way he "rail[ed] against the incredible commercialism and junk that passed for ART so much of the time in the Sixties on[ward]."

After a visit to the Stuart Davis exhibition at the Museum of Modern Art in January 1992, Nell thought his work was better, for the most part, than she had remembered. She took a philosophical view of the varying quality of his paintings: "I see this more and more as the human condition!"[55] She was less sanguine about her *personal* condition, worried about new "dizzy sensations" when she bent over or moved quickly. When Gene Smithberg and his wife, Lorraine (both now psychoanalysts), came to dinner, she found herself telling them her troubles, "which always seem to pop out and MOUNT!" One issue was insufficient time to prepare for her upcoming show at the Reynolds Gallery in Richmond,[56] which involved choosing the pictures, as well as organizing, framing, and packing them—chores that fell to Carolyn—and working on the catalogue design. Nell viewed the show as "a gamble in many ways—health, mine and Carolyn's ... and who knows if anyone will buy."[57] She wrote to a friend that her "crazy dreams & ambitions [and] insecurities arise at show time.... I never meet my standards & my work seems a modest miniature of my capabilities—the physical limits drive me nuts!"[58]

Accustomed to good relations with the interns who came to her via the NY Arts Program of the Great Lakes Colleges Association, Nell was extremely upset that one young woman she interviewed ("lovely girl") chose instead to work at a gallery in Soho. "I believe this gal would have learned a lot from me," Nell fumed. "If she wanted to be a painter that is."[59] Meanwhile, she had a private student, hardworking but lacking talent and seriously troubled, whom she longed to abandon but felt obliged to humor. The woman's angry moods were unpredictable, and she had hit a friend of Nell's at one of her openings. It was a relief when the student canceled two sessions.

Nell's own irritable state—which she blamed on "galleries closing down and those still open mostly not selling"—extended to complaints about the cost of the slides duplicated from Martin Ray's photos of the garden. Three pages of a letter to him were devoted to this issue, after which she explained

that her frugality was all in the name of "the <u>life</u> <u>blood</u> of the garden!"[60] Compounding her worries, crucial services at the Riverside Drive apartment building—elevator, heat—were breaking down, and the management was doing nothing about it. Yet when two friends dropped in at the worst possible time—after she had gone three days with little sleep, in her frenzy to complete work on the frames and announcements for the show—their visit turned out to be "a delightful and refreshing relaxation from my turmoil."

The car trip to Richmond in late April was not an easy one. Joseph Endriss, Nell's new garden helper, whom she described as "a sweet quiet person and most obliging,"[61] drove the Cadillac. But Nell was tired and achy, and unable to eat. On arrival, she was heartened by the "amazing supportiveness and incredible enthusiasm" of gallery owner Beverly Reynolds.[62] In addition to work from the past decade, the fifty-two-piece show included *Children Dancing*, an abstract watercolor from 1957, and a few paintings from the 1960s. The local paper sent its arts writer to interview Nell. Obliged once again to translate her intense feelings about nature into feature-article fodder, she was quoted as saying, "So much beauty is concentrated in a flower."[63] Carolyn was described as the "companion, housemate and fellow painter" who stood by "serenely" as people greeted Nell at the opening. She found time to visit her cousin Charlotte, whom she found "perfectly groomed," and her former teacher Theresa Pollak, now ninety-two and living in a retirement home.

The following month, coal miner Roger Coleman, a fellow Virginian, was executed after being convicted of the rape and murder of his sister-in-law. The case drew national attention from the anti-death-penalty movement—Coleman was on the cover of the May 18, 1992, issue of *Time* magazine—because he repeatedly claimed he was innocent. Nell had called the governor of Virginia in an effort to stay the execution; when it proceeded, she was so upset that she was unable to sleep. (Years later, DNA evidence, unavailable at the time, conclusively proved that he committed this crime.) That summer, Nell also pursued a different sort of personal appeal: she wrote to the Scott Paper Company to complain that, as "a loyal user of 'Scotties' facial tissues...for several DECADES!" she was unhappy that the texture of the product—which she used to blot her watercolors—had been unacceptably altered. "Go back to the old Scotties, Please!" she implored.[64]

Three weeks before Nell's seventieth birthday, Eric Brown and his father threw a party for her. Many of her old friends brought gifts, and Carolyn and Jestina made dinner, which included a "sumptuous chocolate decorated cake."[65] Nell celebrated her actual birthday on July 10 in Gloucester on "a fine

day weatherwise," with more gifts, from Carolyn, Jestina, and local friends. The Summer Olympics was another bright spot that July. Nell thought the bronze equestrian medalist this year was the same man who used to live on the floor above her and Carolyn, "banging inconsiderately on the piano" and refusing to close his window or play more softly. As if unaware of the passage of time, Nell mistook the young medalist, born in 1956, for his namesake, the elderly composer Norman Dello Joio.

At the end of the month, a return to the Vermont Studio Center to give a slide lecture about her work was an "exhausting and anxiety provoking" ordeal but one she believed necessary to avoid "laps[ing] into isolation and lazy mindedness." Nell's physical condition had deteriorated in the five years since her previous trip. But she appreciated that the critiques were held in one place this time, so that she didn't need to be "hauled" from one room to another.[66]

Larry Rivers's autobiography, *What Did I Do?*, was published that autumn, and Nell—whose reminiscences Larry had tape recorded three years earlier—had a lot to say about it, not entirely complimentary. She enumerated various errors in the book, from the spelling of Louisa Matthíasdóttir's name to Rivers's claim that he began painting earlier than he actually did. Although Nell enjoyed his humor and found the book "strangely touching as a self por-

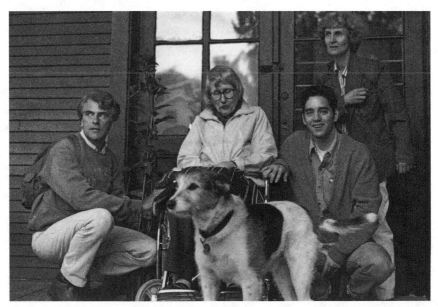

Nell and Carolyn with Joe Endriss and Eric Brown at Vermont Studio Center, 1992.
Photo: Louise von Weise. Courtesy of Carolyn Harris.

trait," she railed at what she saw as his "cruelty" in using the "L word" to de-
scribe her and some of her friends even though he knew it was "painful and
insulting to me." She hated "labeling" and did not see herself as a lesbian: "I
like men too, always did and it implies my marriage was a lie."[67]

Granted, someone who perceived her sexual identity as fluid would not
want to be pigeonholed. If she had not become disabled and heavily depend-
ent on the two women who shared the last thirty-seven years of her life, she
might have continued the bisexual experimentation of her twenties and thir-
ties (which surely did not preclude a genuine fondness for her husband). But
her rejection of the lesbian label in a public document—as opposed to the
frankness of her diary—was likely due to her sense of propriety and the innate
reserve that made her unwilling to expose her personal life to the world. It is
telling that Martica Sawin's monograph about Nell, written with her cooper-
ation, omits any mention of the true nature of her relationships with Dilys
and Carolyn.

On December 7, Nell attended the belated memorial for Fairfield Porter,
who had died in 1975. The speakers included Tibor de Nagy; poets John
Ashbery, Kenneth Koch, and Ron Padgett; and Porter's daughter Lizzie.[68]
Before the service, organized by Eric Brown, Nell reminisced about Porter
with de Nagy and looked at the show of the artist's work at the gallery. She
had nothing further to say about Porter, but offered high praise for his wife,
the poet Anne Elizabeth Channing: "a truly remarkable and unique person—
creative and a fine writer, modest in behavior while surrounded by large asser-
tive egos...gentle but strong."[69]

The big event in January 1993, other than the inauguration of Bill Clinton,
was a sidewalk shootout at the corner of 93rd Street and Riverside Drive, just
steps from Nell's building. She was sitting at the dining room table when "a
loud fusillage [*sic*] of bullets shattered a peaceful lovely morning...40 or 50
shots in quick succession," mingled with "the noise of police sirens and loud
shouts."[70] Nell couldn't see what was happening, but Carolyn, who was inter-
viewed twice by police investigators, watched with binoculars and saw the
gunman holding a woman hostage, one arm locked around her neck, the
other, waving his pistol. She was a forty-one-year-old public school teacher
who lived at 202 Riverside Drive, directly south of Nell's building, and hap-
pened to be standing in the doorway when a bank holdup involving fake
bombs "went awry," as a news report described it, "and two police officers
were shot in a running, four-block gunfight."[71]

On Valentine's Day, Dilys and her lover, Sheila, "dressed alike in black
slacks and sweaters with pointed brown shoes," stopped by, bringing cookies.

The visit was long, because they wanted to discuss insurance prices for the Blaine paintings they owned. The women praised her work, acting "as if they wanted to buy a picture," but it seemed that a business needed to be sold to free up cash. Nell enjoyed seeing the two of them yet felt torn as always ("old love…problems never die!").[72]

Many of Nell's friends came to the April 3 opening of her new show at Fischbach, including Midi, Al Kresch and his wife and daughter, Beverly Reynolds, Marshall Clements, Eric Brown, James Merrill, Dr. Arthur Figur, Ulla Matthíasdóttir, Rudy and Yvonne Burckhardt, and Elinor Poindexter, who looked very ill (she had emphysema). Jimmy Touchton brought long-stemmed white tulips, which Nell likened to "great pieces of sculpture." Later that month, she gave a talk at the gallery that wound up going over the allotted time, mostly because she also discussed work by Lee, Ulla, Al, Carolyn, and Jane. The audience seemed appreciative, but a younger painter "made rude bitchy remarks" about the length and lack of editing.[73] Just before the show closed, Carolyn managed to push Nell the forty-five blocks to the gallery without help, to Nell's delight.

In *Art in America*, Gerrit Henry wrote that she had "jazzed up her act" in the new work, which seemed to edge toward abstraction. He pointed out the debt *Oriental Lily* owed to Matisse and celebrated the "loopy good cheer" that animated her landscapes.[74] There were enough sales to cover the costs of framing, ads, her share of the catalogue production, and about two months' living expenses. But whether due to the faltering economy—the Black Monday stock market crash would happen six months later—or for some other reason, she wound up selling fewer pieces than she had in ten previous shows. She felt that a shadow was cast over the exhibition by the business reverses of some of her "most faithful collectors" and the death of Arthur Cohen, in 1991.[75]

In May, Nell attended the funeral of Robert De Niro, a friend of fifty years' standing, who had died of prostate cancer at seventy-one. She was moved to tears, yet "somewhat shocked" that he had a religious service. "This Catholic thing upsets me quite a lot," she wrote. "It seems so <u>sick</u>. It reminded me of when I had polio and at first was so next to death. I felt the priest and other Catholics were like vultures ready to pluck out my heart and brain." Afterward, she and Carolyn went to the Met to see The Greek Miracle: Classical Sculpture from the Dawn of Democracy, the Fifth Century BC, a loan show that included part of the Parthenon frieze and the Kritios Boy. Nell—in the *Time*-magazine- style tribute she often used in her diary—pronounced the major pieces "towering accomplishments of genius."[76]

A month later, Nell's persistent feeling of weakness was found to have a frightening cause: breast cancer. "The minute I heard the word 'positive' I felt a direct sensation of having been internally invaded," she wrote. "It returns at times, also a terrible feeling of sickness of the spirit—a kind of deep nerosis [*sic*]—sexual—strange, awful, dark."[77] She had an operation on her left breast on June 22. True to form, when Midi brought two wilting lily stalks to the hospital five days later, Nell was happy to see her but wondered whether her friend had not noticed the condition of the flowers. Despite *her* condition, Nell gave Midi birthday presents that included "some dough" enclosed in a card.[78]

Nell learned a few days later that she had a hematoma—a swelling of clotted blood—that had to be removed with a painful insertion of needles. Her oncologist, Dr. Alisan Goldfarb, told her that the invasive ductal tumor she had was "the worst kind." In her shock, she forgot to ask what this really meant. Reading *Dr. Susan Love's Breast Book*, recommended by Carolyn's landlady, was a big help. Dr. Goldfarb—whose "great confidence, frankness, skill & kindliness" Nell rated highly—paid house visits to follow up after the surgery.[79] "Her mood was unbelievably good for someone who had the issues she had," the oncologist recalled. "I was just amazed at her strength to fight things, the fact that she wouldn't take no for an answer."[80] Suffering from a heat wave with no air conditioner in the apartment—the women normally were in Gloucester in the summer—and annoyed that no one was answering the phone at appliance stores, Nell was relieved to discover that Dr. Goldfarb's nurse had a boyfriend in the business who was able to help.

A queasy-making trip to the dentist in early August marked Nell's first venture outside the apartment since the operation. A few weeks later, she and Carolyn finally were able to return to Gloucester. In a letter to Martin Ray, Nell regretted the lost weeks of her "favorite painting time in the gardens."[81] He had interviewed her months earlier, eliciting the remark that she "emphathize[d] with flowers as if they were characters."[82] During this truncated visit, there was just one social event, a Halloween celebration with Carolyn and the helpers. A neighbor couple brought holiday-themed accessories as well as silly and serious gifts to belatedly celebrate Nell's birthday. "All sorts of energy and glee went into this," Nell wrote. "Who can help but be charmed."

In early 1994, Nell interviewed art critic and poet Gerrit Henry to determine if he was the right person to write a monograph about her work. He had studied with Kenneth Koch, John Ashbery recruited him to write reviews for *ARTnews*, and his monograph about painter Janet Fish was published in 1987.

After their meeting, Nell wrote that Henry said "some embarrassingly sweet things about me and my work." She shrewdly perceived him as "an odd mixture of weak and strong…outgoing and shy, fearful and full of complexes!"[83] The complexes became a major problem. As the months went by, he proved unable to focus on the project. When he canceled four planned interview sessions in a row, Nell lashed out in a phone call. This enraged Henry, who felt that she was too demanding. Although worried that she would never recoup the $2,800 she had paid him—he had few resources and was supported by his family—she wrote to tell him that she valued his talent and hoped there were no hard feelings. The collaboration staggered on for months, with a looming deadline from the publisher, until Nell told art historian Martica Sawin—who had been waiting patiently in the wings—that she could take over as writer.

Despite an attack of nerves, which she ascribed to being stuck in the apartment most of the time, Nell delighted in "the quilt" of an early March snowfall, which transformed the window view "with white undulations and reflections." It is likely that the real source of her unease was the operation she was about to have, for a tumor on her right breast. Dr. Goldfarb performed the surgery at the Center for Specialty Care on East 69th Street, an outpatient clinic. Nell noted with satisfaction that this was a mansion decorated with flowers and antiques and staffed by "gentle empathetic nurses."[84] She was pleased that Dr. Goldfarb's office contained posters and prints by modern and contemporary artists, including Prendergast and Matisse. Afterward, Nell allowed her oncologist, whom she adored, to choose a painting as a gift. When she selected *August Pick*, which would have sold for $30,000, it was a bit disconcerting, but Nell was grateful and believed that the painting reflected Dr. Goldfarb's personality ("bright and fresh").[85]

The following day, Nell was pleased to see that her nipple was still there. But the surgical drain was clipped onto an Ace bandage wrapped tightly around her torso, which constricted her breathing. Dilys came to the rescue once again, instructing Carolyn on how to empty the bottle attached to the drain and Nell on how to stretch her lung capacity. Touched that Dilys had come to her aid at a busy time, Nell wrote to thank her: "Your presence & expertise…was more meaningful and comforting than you could possibly realize.… You were wonderful.… I had known how busy you were and that you laid things aside so I am very touched. The fear attached to [cancer] is always great and you greatly diminished it."[86]

While she recuperated—weak but relieved that she would be able to use her right arm, which had been a big worry—Nell thought about her long

history with cats, beginning with King Rat in her childhood. She spent nine years with Snooky, "who walked away to die and was never seen again." In her twenties in New York, there was Kisa ("Icelandic for *cat*," as Nell learned from Ulla), a present from her neighbor Edwin Denby. Red, "a calico beauty," was rescued on 21st Street, "with workmen watching, bemused."[87] Fond of a long-haired cat she named Mimi Peaches Harris Blaine, who wandered into the women's lives while they were in Gloucester, Nell wrote to a friend that "she loves us wildly & it's too upsetting because I can't see toting her to New York."[88] But love won out. In letters to her cousin Charlotte, Nell wrote about the stray who came to stay: "a big tease, a flirtatious beauty dare I say a whore?" She was intrigued that the cat, fed by Carolyn on a vegetarian diet, also ate grasshoppers and moths ("I suppose grasshoppers are tasty").[89]

After a bad bout of choking in July, which she thought was probably due to fog and high humidity, Nell wrote a letter to President Clinton, asking him to toughen environmental laws. An otherwise pleasant visit from Dr. Goldfarb the following month brought bad news: Nell had two cancerous nodes under her right arm and "a tiny one" under the left arm. It was impossible not to dwell on this. One day, Nell broke down while speaking on the phone with Midi. "What will we do without you?" her old friend wailed. Nell privately resolved to hang on.[90]

Nell and Carolyn were finally able to travel to Gloucester in August. After two days of rest, Nell was wheeled out to see the gardens, but she was unable to sit for any length of time. On August 20, she painted her "first oil of the season," a flower still life. "The fumes from the paint and solvent bother my breathing and allergies," she wrote, "but I feel a great need to use oil."[91] Nell's goal was "to capture the inner rhythm of the flower…as well as its decorative essence."[92] She had a compulsion to record in paint "the beautiful objects that stir me visually and emotionally."[93] Whenever this was not possible, she suffered bouts of anxiety. "It's masochistic in terms of my health," she had told an interviewer years earlier, "but my kind of painting is based on spontaneity, the light of the moment, and my feelings about the flowers."[94]

Mondrian also had deep feelings about flowers, which Nell, as a great fan of his work, would have known. They were frequent subjects of his work in the early twentieth century, while he was developing his theories about landscape painting. In their close-grained simplicity, many of these images are closer to botanical illustration than still lifes; he preferred to draw or paint a single blossom in great detail, so that he could study its structure. Nell, who said that when she painted a flower she regarded it "as a piece of architecture," would have understood.[95] Although Mondrian's flower paintings more easily

found buyers than his more experimental work, they reflected his theosophi-
cal search for the deeper meanings of nature. In *Dying Chrysanthemum*
(1908), with its startlingly skull-like corolla, dangling remnants of petals, and
drooping leaves with disintegrating edges, he conveyed an intensely emo-
tional quality.

Other painters who chose flowers as a subject in the twentieth century
had widely differing motivations. Marsden Hartley believed that gardenias,
which he had discovered on a trip to Mexico, were the embodiment of a spir-
itual power. He painted them during one of his illnesses, as a means of "trying
to cure my soul."[96] Morris Graves began painting precise and delicate images
of flowers in his sixties, when his tortured search for spiritual meaning had
eased and he was able to appreciate the radiance of the blooms in his garden.
His paintings inevitably show them in simple vases lined up in a sacramental
fashion on a table and viewed from a reverential distance. In compositions
like *Summer Flowers for Denise* (1978), a fuzzy glow around the petals—like a
stop-motion image of pollen dispersing—gives the still life an other-
worldly quality.

Floral still lifes painted by the symbolist artist Odilon Redon in his sixties
reflect a uniquely ethereal exuberance. Although minutely observed—he was
a friend of the curator of the botanical gardens in his native Bordeaux—each
flower in his pastel *Bouquet of Flowers* (1905) seems at once more luminous
and more fragile than it is in life. In several of his paintings, Pierre Bonnard
evoked the luxuriously untamed garden at Le Bosquet, his home in southern
France.[97] But in his still lifes, he preferred flowers that were beginning to wilt,
evoking "the rapid, surprising action of time."[98]

Ellsworth Kelly's plant studies, exquisite line drawings in pencil or pen, are
the fruits of close observation and exacting standards. "Nothing," he wrote,
"is changed or added." A lifelong gardener and fellow devotee of Matisse, he
had a personal connection to plants that is in some ways similar to Nell's. In
his view, his drawings are "portraits of flowers" seen at a particular time and
place.[99] Observing the structure of the plants he drew and the effect of empty
(negative) space on the paper served as bridge to the abstract paintings for
which he is best known. His approach recalls Nell's remark about using paint
"to penetrate not only the spirit of the flower but the way it is made."[100]

Georgia O'Keeffe shared with Nell a fascination with the structure of
flowers. She was also a gardener, though not until her late fifties, when she
moved to a house in Abiquiu, New Mexico. Influenced by the cropping tech-
niques of modernist photography, *Oriental Poppies* (1928) allows us to peer
closely at twin orange blossoms whose petals stretch beyond the canvas.

Beginning with an assertion by her lover, photographer Alfred Stieglitz, much has been written about whether this work was meant to refer to female genitalia. Although O'Keeffe firmly and repeatedly disavowed that intent, and these images are appealing in other ways, their sensual aspect is undeniable.

The most famous artist who painted his flower garden was Claude Monet. His vast *Water Lilies* series (also known as *Nymphéas*) was the focus of the final decades of his long life. Monet's garden—which included patterned plantings of flowers on the land[101] as well as the famous lily pond—is in the village of Giverny, in northern France. Japanese prints were his inspiration for the pond, created by diverting water from a nearby stream, and its footbridge. Much like Nell, Monet wrote a constant stream of instructions to his gardeners, including detailed designs. The large-scale *Water Lilies* evoke the sensation of observing sunlight on water and petals with bursts of purples, blues, greens, and yellows. Monet's vision was fading,[102] but his preoccupation with the effects of color—he had even analyzed the colors on the face of his beloved wife after her death from tuberculosis—endowed these paintings with a shimmering radiance.

In his late seventies, Cy Twombly (whose home in Gaeta, Italy, had fruit trees but no flower garden) made paintings of repeated brightly colored flower shapes in his scribbly style. These images suggest an impulse to defy the corrosive action of aging and—after a lifetime of creating works with erudite allusions—to embrace the purely visceral. Yet there is also another dimension: Twombly's series *Blooming: A Scattering of Blossoms and Other Things* (2006–7) contains inscribed haikus by Japanese poets Basho and Kikaku that salute the peony, whose beauty was said to cause a warrior to remove his armor and thus reveal his vulnerability.

Nell's polar opposite in the world of flower renderings was Andy Warhol. It's not clear whether she knew that his *Flowers* lithographs were based on photographs lifted without permission from the June 1964 issue of *Modern Photography*,[103] but this transgression would have further hardened her heart against his work.

While still lifes involved less physical preparation on Nell's part than landscape painting, she had to contend with the brief life of cut flowers. The colors and fragility of blooms seemed to appeal to her in equal measure—the colors, as a sensual delight; the fragility, as the kind of challenge she enjoyed. She wanted to celebrate "their moment of glory." *Rubrum Lily* (1980, plate 23) was one of many paintings she made of this fragrant late-summer bloom. Nell muted the colors and shapes of other flowers in the bouquet to focus tightly on the rhythms of the lily's petals and leaves, and the pattern of stems min-

gling in a glass of water. In this work, a tightly furled bud contrasts with the lavish display of a bloom at its opulent peak.

As a modern artist, Nell did not view her work in terms of the traditional *vanitas* or *memento mori* ("remember you must die") still life, in which the brief lifespan of a flower or the fleeting pleasure of music or wine symbolizes the futility of worldly things in the face of certain death.[104] She once told an interviewer that the wilted rose in one of her paintings struck her as funny, like a flower "on an old lady's hat."[105] When a critic seeking a deeper meaning drew her attention to what appeared to be a dead fly in one of her still-life paintings, she informed him that it was a dead bee that happened to have died while she was working on the piece.[106] Yet one of her late still lifes suggests a humorous riff on the *vanitas* theme. *Alive Still* (1991) presents a vase filled with drooping daisies and other flowers; a fresher daisy lies on the table, looking as though it's trying to escape from the others.

Carolyn traveled to North Carolina to see her hospitalized mother in October 1994, leaving Nell feeling bereft. "No one [else] is experienced with helping me...due to my particular physical losses," she wrote. Jestina, who had a bad back, was now unable to lift her properly.[107] But Eric Brown often came to her rescue. On one of her trips to the hospital for cancer treatment, driven and lifted by him, she learned that she weighed 110 pounds—the first time she had stepped on a scale in thirty-four years.

The following January, Nell wrote to Martin Ray, telling him the good news about her cancer ("receding in the gland") and announcing her two solo shows on 57th Street—at the Fischbach and Tibor de Nagy galleries—that would be mounted in the spring. She praised him and his wife for making her life "exciting," listing the flowers that had given her so much joy: zinnias, begonias, impatiens, petunias, dahlias, Mexican sunflowers, lilies . . . But when she got to the butterfly weed, she couldn't resist asking, "Is there any way it can be helped along, strengthened?"[108]

Nell had been told that the lump in her right armpit had shrunk, but she still needed a great deal of care. As she wrote in her diary, "Carolyn chafes under her difficult life."[109] Her tasks these days included measuring frames as well as setting Nell up to paint and all the other things she had to do to make her lover comfortable. In March, Nell's eyesight had become worse, and she suffered from hand spasms and shaking. It was hard for her to sign the watercolors for the April 6 opening of her Fischbach show. Once again, her friends rallied, among them Jane Freilicher, Dilys, Dr. Goldfarb, Jim Touchton, Midi, Al and his wife and daughter, Gene Smithberg, and painters Leatrice Rose and Charles Cajori.

Three days later, she went to the opening of her show at the Tibor de Nagy Gallery—work from the Arthur W. Cohen Collection. Although he had donated many of his Blaines to museums, a core group remained in his possession. This show ran concurrently with the Fischbach exhibition. "It was very unethical," DiCarlo said later. "We'd been working with her for years."[110] Eric Brown, who was then codirector of Tibor de Nagy, responded to this charge by saying that "Nell felt strongly" that the Cohen Collection show "should take place at my gallery.... She obviously felt great affection for Arthur and wanted to honor him.... And to have two exhibitions at once, each one amplifies the other." In a glowing review of both shows in the *New York Times*, Roberta Smith praised the way Nell's images "pulsate with a kind of molecular energy," noting "her pleasure and fluency in the eye-to-hand connection, her modest yet penetrating attention."[111]

In May, Nell made a list of the deceased people she missed: Jean Garrigue; Frank O'Hara; May Sarton; Arthur Cohen; Hyde Solomon; her former husband, Bob Bass ("especially I miss...the musical Bob"); Bob De Niro; Bob Dunn. "Have you been welcomed elsewhere?" she asked them, clinging to a vestige of her faith in an afterlife. "Is it better where you are? Missing with no message is hard."[112] Listening to a recording of Marlene Dietrich singing "The Ruins of Berlin," Nell was stirred anew by nostalgia. "Marlene! I see your empty wheelchair and your single room and know you were mortal but all the more loved.... The power of theatre and sex!" She felt "an awareness of the great mystery of life." Was this feeling a "physical and mental yearning? Sadness?"[113] No words seemed adequate to explain it. In Gloucester that fall, talking with friends about Dietrich, Nell kept thinking of the actress's "amazing sensual energy."

Over the years, Nell had paid loving attention in her diary to the lives and deaths of female movie stars and singers. A viewing of the Busby Berkeley musical *Dames* elicited a paean to Joan Blondell ("at her loveliest"), the choreographic and camera wizardry, and the overwhelming effect of "girls dancing, prancing girls, girls, girls!"[114] Reading a biography of Ingrid Bergman ("such an alive person...a great glowing natural beauty"), she was surprised to learn that the actress was "so promiscuous," despite "the cultivated image."[115] When Irene Dunne died, Nell reminisced that the actress was "almost a CRUSH!" during her early teenage years, when she liked to sing songs from Dunne's starring role in the 1935 musical *Roberta* ("Lovely to Look At," "Smoke Gets in Your Eyes"). She even pasted into her 1991 diary a news item about Sophia Loren tripping her sister's mugger in Rome. As Nell's life began to contract, her vicarious emotional connection to famous women kept her fantasy world alive.

"[Nell] was not well close to the end," Dr. Goldfarb recalled, "but she kept painting; she had things to say."[116] Her last Gloucester work is *Rock Shadows* (1995, watercolor and pastel). If the title hints at closure and the brushwork displays a certain vagueness, it is countered by an almost gridlike underlying order and a sense of the continuous rhythms of life. The flowers register as soft blobs of color; the rocks, as swaths of Nell's favorite cobalt violet. In the foreground, two birds refresh themselves at a birdfeeder; in the distance, the water is crowned by ethereal pale violet hills. *Blue Sunset* (1996, plate 28), one of her last New York works, shares a similar feeling. Cobalt-violet shadows cloak much of the view from the Riverside Drive window: the neighboring buildings, the trees in the park. A dense yellow glow spreads across the sky and leaks onto the water. Up the street, a row of lights has come on, glimpsed as dashes of orange. The life of the evening has begun.

Postpolio syndrome is the name given to disabling symptoms—notably, increased fatigue and muscle weakness—that appear, on average, thirty to forty years after the initial onset of the disease. Nell had two risk factors: hers was an acute form of polio, and she acquired it as an adult. Now, weakened chest muscles made it hard for her to breathe, which caused fluid and mucus to build up in her lungs. Stricken with pneumonia, Nell was rushed to the emergency room at Mount Sinai on June 30, 1996, and moved to the respiratory intensive care unit. She had a tracheotomy on July 2; days later, she was fitted with a stomach tube. At first, she was still her old self. She had fun with the Passy Muir valve that allowed her to speak. Carolyn remembered how Nell was "delivering throwaway lines and disembodied sounds with the touch and timing of the most deft entertainer."[117]

During Nell's last months, Eric Brown would take the bus up Madison Avenue from the gallery to see her in the evenings. They watched the Democratic Convention and the World Series together. "Her life was always hard," he said, "so she had a way of being as positive as possible."[118] At one point, she told him, "Death isn't my cup of tea." Because he could often read her lips, he would sometimes get a call from the hospital, asking him to come and decipher what she was saying.

In September, Geoffrey Richon, the builder she had worked with in Gloucester, bicycled to New York for AIDSRide '96. When he completed the trip, Richon took a taxi to the hospital to see Nell and put his AIDSRide beanie on her head. Peter Dickison also came to visit that fall. "If she wanted to speak in a normal way, she would just whisper," he said. He stood close to her as she told him that the hospital insisted on sending her home, but she did

not want to go, because she would no longer be under the care of doctors—a dangerous risk. "I think we were both wondering if we were saying good-bye," Dickison said, "and we really were."

The last entry Nell made in her diary, on October 7, was businesslike: about the company that was going to set up a portable ventilator at the apartment after her discharge in late October. Meanwhile, Carolyn was learning how to feed Nell through a tube. With help from Marshall Clements, Carolyn had spent a year inventorying all of Nell's work, "from the smallest sketch to the largest painting—2,238 items," so that it could be sold.[119] During her last months, Nell had told Carolyn that she did not want her to have to deal with her racks of paintings, many of which were not in good shape. When Neal Brown, Nell's attorney, discussed the drafting of her will, she wanted to know all the ways a trust could be formed. He suggested a charitable remainder trust, a legal agreement that generates a potential income stream to one or more beneficiaries. Upon the death of the beneficiary—in this case, Carolyn—the remaining assets are distributed to a public charity or private foundation.

"I didn't realize what it all entailed," Carolyn said later, "never dreaming that Neal Brown"—who became the trustee—"would take over the paintings." When Nell agreed to the trust, "I could hear Neal quietly drawing in his breath," Carolyn said. "He said, 'You don't want to do that.' I don't know if Nell heard. So the will was drawn up, a terrible will. It doesn't say much but it says enough. I would get nothing." According to Carolyn, when Nell asked if her lover would be as well off with a charitable remainder trust as she would be if she inherited the paintings outright, Neal said, "About the same." Carolyn discovered that this was not the case. "I kept very good records of the sales," she said. "Tibor de Nagy [Gallery] was doing a lot better than I was doing." Nell's trust received 60 percent of sales, and Carolyn's portion came from the remaining 40 percent that went to the gallery. (She said that her annual distribution is based either on sales or 5 percent of the current appraised value of Nell's work—whichever is less.) When Nell's large 1958 painting *Imaginary View of Mexico* was sold to the daughter of the gallery's longtime financial supporter for about $135,000, Carolyn said, the trust received $81,000 and $54,000 went to the gallery. She eventually received $9,000— less than 7 percent of the sales price.

"On October 29," Carolyn recalled, "Neal came into [Nell's hospital] room in the early afternoon and said that he had decided—he!—to give me the paintings. He came that day just to get Nell's assent. He said, 'I'm going back to the office and write a memo to my file of what has just trans-

pired.' . . . The last thing he said was, 'I will make the change in the will *tout de suit*. And we'll get signatures.'" But this never happened. "I have always viewed [his actions] as smoke and mirrors," Carolyn said, adding that she viewed the gallery's shows of her own work in 2004 and 2008 as a contrivance "to shut me up." Pressured by an attorney she hired, Neal Brown finally agreed to resign as trustee in 2010. Subsequently, and without any prior discussion, she said, the gallery returned all of her unsold paintings.

Nell had been stricken with a new bout of pneumonia. By early November, her vision and hearing were failing. Yet on November 6, she was brought home by ambulance—"discharged from the hospital, which never should have happened," Carolyn said. "She got home about four in the afternoon and had nurses around the clock." Eric asked Nell, who was on a respirator, if she wanted him to put up a particular artwork at the foot of the bed. She motioned to him in a way he deciphered as "No, don't worry about it—I'm going to be around." But the morning nurse didn't know how to suction her. In a panic, she roused Carolyn. "Nell was already in trouble," she said, "and I didn't know how to do it either, so I called for an ambulance, which came quickly. The EMT people put her on the floor and tried to resuscitate her—she had been without air for eight minutes, so she was brain dead. They took her back to Sinai, took her off life support."

During Nell's last days, Carolyn busied herself with the chores of a survivor. She discussed with Eric the contents of the obituary that would be sent to the *New York Times*. She visited Midi—now in a home for the aged, and unable to speak—to relay the sad news and called a long list of friends. Plans were made for a memorial fund at Yaddo. Nell's organs would be donated to the Mount Sinai School of Medicine, and her remains would be cremated and buried at Cypress Hills Cemetery in Brooklyn. The memorial announcement card would have a reproduction of *White Lilies, Pink Cloth* (1990) on the cover.

According to Carolyn, among those gathered at Nell's bedside on the morning of November 14 were Eric Brown, Martica Sawin, Joseph Endriss, and Mary Weissblum, a friend from Gloucester. After she was removed from life support, "Nell hung on and hung on," Joe recalled. "She didn't want to leave." Eric was the last of the group to arrive in the room. The monitor had been showing little movement up until then, "but as soon as he came into the room it got excited," Joe said. "It spiked as he went to hold her hand." Mary recalled that only she and Eric were present in the room after Nell's life support was removed. "I thought it was significant that Carolyn was not there,"

Mary said, adding that she understood her absence.[120] At 8:35 a.m., when Nell's life ended, Carolyn looked out the window: a light flurry of snow was falling.

Three days later, a small group of Nell's friends gathered at the home of Gene and Lorraine Smithberg to reminisce. The formal memorial was held on January 8 at the New York Society for Ethical Culture, chosen by Eric because she had once said something favorable about it. The speakers were artist friends (Jane Freilicher, Al Kresch, Wolf Kahn), poet friends (Kenneth Koch, Galway Kinnell), and people who had written about her work (Martica Sawin, James Mellow, and Jed Perl). The program was illustrated with a reproduction of *Autumn Afternoon, Gloucester, October* (1994) and the 1959 photo of Nell walking on the beach in Dendera, Egypt, with the woman from her cruise ship—a reminder of her venturesome spirit.

The following year, Carolyn was busy shoring up Nell's output ("inventorying, storing, preserving, framing, transporting, photographing and keeping

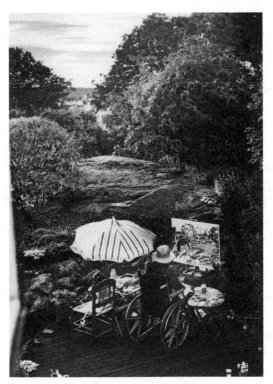

Nell painting *Autumn Afternoon*, 1994.
Photo: Carolyn Harris. Courtesy of Carolyn Harris.

records for the trust, all for what is a 'salary.' ") And now, it was finally her turn "to paint the view from the window on Riverside Drive, the view I never intruded upon. It's time I painted it in all its sweep and grandeur, the arc of the drive, the panoply of trees in all seasons. Green, yellow, bronze and brown, with the monument rising like some ancient tomb."[121]

Focusing, in her postpolio work, on a limited repertoire of subjects—a garden, a bouquet, a table set for dinner, the view from her window—Nell presented them as worthy of fresh scrutiny. She believed that "the ordinary is really never ordinary when one examines it closer, thus most views may hold rich potential to stir the imagination."[122] What she achieved in paint is akin to the way poet James Schuyler's minute attention to detail evokes a hidden aspect of a familiar experience. The alchemy Nell performed in making a familiar sight dazzle in a fresh way was the result of her often unusual color choices and the rhythmic freedom of her brush—harnessed to a sensibility, formed as an abstract painter, that valued the discipline of structure.

Nell shared her belief in painting as an adventure and in the importance of spontaneity with the Abstract Expressionists, even though most of them did not venture as far as she did into the realms of landscape and still life. Writing after her death, a critic observed how her postpolio work "just got better and better: brighter, more confident, more lucid." In terms of "risk"—the existential touchstone for Abstract Expressionists—he noted that Nell faced it constantly after 1959, yet her "paintings speak not of angst but of grateful admiration."[123] As she herself explained, the kind of risk she embraced was "the risk of being unpopular, unsuccessful and going through awkward periods."[124] The relative scarcity of her work from the 1940s and '50s (and the larger size of those paintings) has caused it to be priced substantially higher in the secondary market.[125] Yet, it was only from the 1960s onward—parallel with her postpolio rebirth as a painter—that her initial awkwardness with figurative elements dropped away, and she joined the ranks of America's great watercolorists. It is a great pity that no major museum saw fit to give her a solo show during her lifetime. Let's hope this oversight will be corrected soon. Nell's work may not be fashionable, but it is a source of unalloyed delight—welcome balm for difficult times.

Comparing her later work to her early abstract paintings, she once noted that "confronting nature" took her outside her own preoccupations: "Nature is bigger than you are.... And somehow, it's liberating." While asserting the value of "the intimate world of immediate sensation," Nell told an interviewer that she was "interested in creating something with equilibrium"—a sensibility

that she traced to the influence of Mondrian.[126] Ashbery summed up this key duality in her approach when he wrote that the "sensuality in [her] works is backed up by a temperament that is crisp and astringent."[127] These were elements that not only made her work unique but also enabled her to paint more economically and urgently, and with a greater appreciation of the world around her, after she viewed it from the perspective of a wheelchair. As Nell once said, "I can't stand up, but I can go on.... My painting comes first; it's a life or death matter."[128]

Acknowledgments

IT IS ALWAYS A PLEASURE to acknowledge the many people whose memories help paint a portrait of my subject's personality and rescue long-ago moments and impressions from oblivion. For this book, my greatest debt is to Carolyn Harris, who has devoted five decades to Nell, as intimate companion during her lifetime and faithful keeper of the flame after her death. I deeply appreciate her belief in this project and her clear-eyed assessments, as a gifted painter who was obliged to subjugate her own career to that of the woman she loved. (I should add, however, that Carolyn did not read the manuscript before publication, and that the depiction of Nell's career and personality in these pages is based on my own point of view.)

I am most grateful to Nell's trustee, Ron Horning, for permission to reproduce her artwork, and to Andrew Arnot, Salvatore Schiciano, and Elizabeth Ivers of the Tibor de Nagy Gallery, for locating and allowing me to use images of many of her oil paintings and watercolors reproduced in this book. At Oxford University Press, I am delighted once again to thank my wonderful editor, Norm Hirschy; Joellyn Ausanka, OUP's superlative senior production editor; Lauralee Yeary, assistant editor; and copy editor India Cooper for their expertise, flexibility, attention to detail, and great warmth and understanding. My agent, Emily Forland, who has been helpful in many ways, suggested the main title of this book. Martica Sawin's monograph, *Nell Blaine*, has been especially useful for its gorgeous reproductions, extensive bibliography, and photographs of Nell's circle of friends.

Special thanks also go to Nell's former nurse and lover, Dilys Evans, for her memories and mementoes; to painter Albert Kresch, who retains priceless memories of art and jazz in the 1940s; and to his daughter, Elizabeth Kresch, who helped make my phone interviews possible. In Gloucester, Massachusetts, I want to thank artist Celia Eldridge, for a lovely afternoon of conversation,

and for her loan of Nell's correspondence; Martin Ray, for allowing me to spend a long afternoon at his home, collecting detailed information about Nell's gardens; Mary Weissblum, who had great stories to tell; Greg Gibson, for filling me in on aspects of Nell's Gloucester life; Ian and Amy Kerr, who graciously allowed me to see the interior of Nell's former home; and Geoffrey Richon, who kindly drove me around to let me see Gloucester through Nell's eyes.

In New York, my thanks go to Florence Janovic and Edwin Fancher, who remembered Nell in her *Village Voice* days; to Eric Brown, close friend and former dealer of Nell's, who loaned a portion of his personal archive of Nelliana; to Dr. Alisan Goldfarb, who treated Nell for breast cancer; to Temma Bell, daughter of painters Lee Bell and Ulla Matthíasdóttir, and to Dr. Barry Weiner and Phyllis Weiner. Other people whose help I greatly appreciate include Michael S. Bank and Barbara Bank Fussiner, who filled in crucial parts of Nell's time in Greece and in a German hospital; Barry and Mary Louise Gifford, who recalled Marshall Clements's role in Nell's life; Lawrence DiCarlo, director of the Fischbach Gallery; Jim Touchton, a reliably terrific source of anecdotes; Peter Dickison and Joseph Endriss, who vividly related their experiences as Nell's helpers; Jack Blanton, for his memories and his generosity in having one of his Blaine paintings photographed for this book; and also James Bohary, Ed Eichel, Elizabeth Hazan, and Norman Stone.

Turning to archival sources, I want to give special thanks to Laura Muskavitch, accessioning and processing archivist, Special Collections & Archives, James Branch Cabell Library, VCU Libraries, for yeoman work in making the Nell Blaine Collection and Theresa Pollak Papers available to me. Also high on my list of wonderful-to-work-with archivists are Marisa Bourgoin, head of reference services, and Elizabeth Botten, reference specialist, at the Archives of American Art, Smithsonian Institution; and Bryan Griest, Glendale (Calif.) Central Library Reference. Other invaluable help has come from Cape Ann Museum and Archives, Gloucester, Massachusetts; Rare Book & Manuscript Library and Columbia Center for Oral History, Columbia University; Fales Library, New York University; Harry Ransom Center, University of Texas; Houghton Library, Harvard University; Library of Congress; Lilly Library, Indiana University Bloomington; New York Public Library; Tim Noakes, head of public services, Department of Special Collections, Stanford University Libraries; Heather Smedberg, Special Collections and Archives, University of California, San Diego; Department of Special Collections, Washington University Libraries; and Watson Library, Metropolitan Museum of Art.

On a personal level, I want to thank several people whose wise counsel and cheerleading supported my work on this book. In alphabetical order: Patricia Albers, Svetlana Alpers, Douglas Crase, Deirdre David, Terence Diggory, Rachel Gibson, Anne Heller, Vanda Krefft, Linda Leavell, Barbara Mack, T. R. M. (who prefers anonymity), Heath Hardage Lee, Marc Leepson, Alexandra Lightning, Pam Lindberg, Janice Page, Fred Schwartz, Peter Anthony Schwartz, Judith E. Stein, Will Swift. Finally, a friendly shoutout to Ramona Faherty, proprietor of the Rocky Neck Accommodations in Gloucester, which gave me a delightful taste of Nell's seaside life on Cape Ann.

Notes

CHAPTER I

1. The family lived at 3201 Barton Avenue.
2. Her mother later told her that this disability occurred after Nell stared intently at a hanging toy on her crib, but it is unlikely that staring caused Nell's strabismus. Each eye has six muscles that control its movement. Strabismus is caused by problems with these muscles, with the nerves that receive signals from the brain, or with the part of the brain that controls eye movements. Congenital estropia (a type of strabismus in which the eye turns inward) can appear in infants at the two-to-four-months stage.
3. Nell retained a lifelong anger at the surgeon, who decided to remove her tonsils at the same time and abandoned her in a hospital hallway for what seemed like an eternity before performing the operation.
4. Diary, July 11, 1970.
5. "Reminiscences of Nell Blaine," Skillion interview.
6. Quoted in Eleanor Munro, *Originals: American Women Artists* (New York: Simon & Schuster, 1979), 263.
7. Letter to Jane Freilicher, undated, Freilicher Papers, AAA.
8. Walden was her maternal grandmother's maiden name.
9. Quoted in Munro, *Originals*, 263.
10. Eudora Catherine Garrison Blaine, unpublished reminiscence of childhood and youth, Blaine Diaries and Correspondence, Harvard. She wrote that she had seen *The Helping Hand* (by Émile Renouf) at the Met, but in the early twentieth century, this sentimental painting of a fisherman and a little girl was in the collection of the Corcoran Gallery. The reason for the trip—which she took with her sister Nelly Susan, Nelly's husband, Jack, and their young son—was to visit Jack's parents; these were not people who traveled to see cultural sights.
11. She died in 1920, at age sixty-six.

12. From notes by Nell for a speech to young women painters, 1970s, cited by John Goodrich in his introduction to *Nell Blaine* (Gloucester, MA: Cape Ann Historical Museum, 2000), 3.

13. Nell's remark to Martica Sawin about her father's anger when Garrison took over her bedroom and she had to move into her parents' room does not ring true; the old man was already living in the house. (Sawin, *Nell Blaine: Her Art and Life* (New York: Hudson Hills Press, 1998), 15.

14. Notes written by Nell on a photocopy of a *Richmond News Leader* photo of members of the Main Street Business Association, published January 26, 1927, Blaine Papers, AAA.

15. Edward Garrison Jr. quoted in Maurice Dean, "Monitor-Merrimac Fight Recalled by an Eyewitness, E. C. Garrison," *Richmond News Leader*, November 1, 1935.

16. Relationships with servants were in a different category. In an unpublished reminiscence, Nell's mother wrote about "our faithful servant Millie Baker," an African American woman who did the family's laundry and "would play with me and do thoughtful, nice things for me." Blaine Diaries and Correspondence, Harvard.

17. Decades later, Nell wrote to a friend that she had "lived with the Spences several summers" (letter to Jack Blanton, April 27, 1985, Blanton Papers). Their home was in Baltimore, but they summered in small-town Virginia.

18. Letter to Charlotte Clark, January 20, 1979, Blaine Collection, VCU.

19. Diary, April 10, 1973.

20. Diary, August 16, 1981.

21. Quoted in (Munro, *Originals*, 262–63).

22. Corrective surgery for strabimus may not prevent a return of this eye condition. Jimmy Witt, who knew Nell in the 1980s, said that she looked "slightly crossed eyed." Eric Brown, who was close to her in the 1990s, agreed that her eyes "may have appeared slightly crossed-eyed." Author's telephone interview with Witt, January 20, 2018; email from Brown, February 10, 2018.

23. Diary, May 29–30, 1973.

24. Diary, February 22, 1968.

25. According to Sawin (*Nell Blaine*, 16), Nell took a correspondence course in commercial art during her high school years. A Spanish-language newspaper covering the activities of the school's Spanish club and societies was an unusual feature of this otherwise traditional all-American school, with its wiener roasts and picnics. Latin was the leading foreign language taught in American high schools during this period, few Americans traveled abroad, and the influx of Spanish-speaking immigrants was decades in the future.

26. Nell is quoted in Sawin (*Nell Blaine*, 16) as saying that she and this friend had season tickets to the ballet and symphony. But Richmond's short-lived symphony orchestra of the early 1930s folded before her high school years. It does not seem likely that she and her friend would have made the long journey to the Norfolk Civic Symphony Orchestra (forerunner of the Virginia Symphony Orchestra),

which began offering season tickets in 1935. There also was no local ballet company, but perhaps she saw performances of the Ballets Russes at the Mosque (now Altria Theater) in the late 1930s.

27. Junkin (1905–77) was also associate director of the School of the Arts at the Richmond Professional Institute.

28. Pollak (1899–2002) was a fellow Richmond native. In 1928, after earning a degree in chemistry from the University of Richmond and studying at the Art Students League in New York, she founded the Art Department of the Richmond School of Social Work and Public Health, predecessor of the Richmond Professional Institute. Her introduction of nude models to studio classes was viewed as an assault on middle-class morality. But it wasn't until after Nell left Richmond that Pollak became strongly influenced by Matisse. In the summer of 1958, Pollak studied with Hans Hofmann in Provincetown, Massachusetts—sixteen years after her pupil had studied with him in New York. A longtime member of the Richmond Artists Association, she taught at the School of the Arts of Virginia Commonwealth University.

29. Theresa Pollak, unpublished statement, May 6, 1982, Pollak Papers.

30. Letter to Charlotte Clark, September 25, 1986, Blaine Collection, VCU; Diary, dated October 1974 (on March 25, 1969, page). According to Sawin (*Nell Blaine*, 17), Nell's mother called Pollak to complain that she had a bad influence on Nell's style.

31. Quoted in "A.S.L. Opens Art Exhibition," *Proscript* (Richmond Professional Institute newspaper), n.d., Blaine Papers, AAA. In view of her later abstract work, it's noteworthy that the title of Nell's first publicly exhibited painting—in 1940, at the Tenth Annual Richmond Artists Show, Academy of Sciences and Fine Arts— was *Angles, Chutes and Buildings*.

32. In the early 1940s, Nell would find Rouault's (and Léger's) paintings especially meaningful, because of what she saw as their intuitive sense of form and rhythm, and the large scale of their work.

33. Oral history, AAA. She recalled that the exhibition was of work from the Chrysler Collection, a show in 1937 or '38 that predated the well-documented 1941 exhibition at the museum. I have not been able to find information about this earlier show.

34. Quoted in Sawin, *Nell Blaine*, 12.

35. "Reminiscences of Nell Blaine," Skillion interview. Many of the facts in this chapter that are not otherwise credited are taken from this document.

36. Quoted in Roy Proctor, "Blaine Memorabilia Add Depth to Reynolds Show," *Richmond Times-Dispatch*, April 29, 2001. Proctor wrote that this event happened when Nell was in high school, but Scott did not appear in her first movie (as Emily in *Our Town*) until 1940.

37. Margaret Mead's book *Sex and Temperament in Three Primitive Societies* was published in 1935.

38. Nell's college years are often wrongly cited in chronologies of her life; she enrolled in 1938 (not 1939) and dropped out in 1941 (not 1942).

39. The firm's clients included the Virginia Chamber of Commerce, the YMCA, Colonial Williamsburg, and Reynolds Metals, for which she drew a portrait of the company president.

40. Virginia Artist Series No. 16: Esther Worden Day, October 24–November 13, 1941, listed in "Virginia Museum of Fine Arts Exhibition History, 1940–1949," vmfa.museum/library/wp-content/uploads/sites/16/2013/12/ExhibitionHistory.1940-1949.pdf.

41. This exhibition was on view at the museum May 12–30, 1942. Daura (1896–1976), a Spanish artist married to a woman from Virginia, was a member of the Cercle et Carré group of abstract artists, formed in opposition to Surrealism. Other members of the group included Jean Arp, Wassily Kandinsky, Piet Mondrian, and Fernand Léger. Hélion, who eventually settled in New York and had a great influence on Nell's painting, will be discussed in chapter 2.

42. Wörden Day (she rarely used her first name) was a painter, printmaker, and sculptor, born in Columbus, Ohio, in 1912 (she claimed 1916). She grew up in Virginia and earned a B.A. from Randolph-Macon College. In New York, while working in a factory, at odd jobs, and on a WPA project, she studied at the Art Students League. In Richmond, she took over Pollak's classes at the Richmond Professional Institute during the 1941–42 academic year. In later years, Day taught at several institutions in New York, including the Pratt Institute, New School, and Art Students League (concurrently earning an M.A. from NYU). She died in 1986.

43. Vaclav Vytlacil (1892–1984) was a founding member of American Abstract Artists. In addition to his longtime position at the Art Students League, he taught at several colleges. His students included Louise Bourgeois, Robert Rauschenberg, and Cy Twombly. In 1938, Day won a scholarship to study with Vytlacil; see "Esther W. Day Gets Prize for Oil Work," *Richmond Times-Dispatch*, April 4, 1943. See chapter 2 for information about Hans Hofmann (1880–1966).

44. Day encouraged Nell to read Virginia Woolf's book-length essay *A Room of One's Own* and "activated a lot of strivings for me," as she said later (Sawin, *Nell Blaine*, 18). It is likely that Day also understood Nell's attraction to women; see note 45.

45. Despite these tales, Nell wrote (after Day's death at age seventy-three from cancer) that her teacher had led "a very lonely, deprived life emotionally" and was one of those people for whom "the lack of a partner seems to create a sense of frustrated longings." The inference is that Day was unable to find lasting love with another woman. As if feeling guilty for expressing these thoughts, Nell added that Day was "a strong, vibrant artist and a dedicated artist" who provided "crucial help & supportiveness" in the early 1940s. Letter to Theresa Pollak, February 25, 1986, Pollak Papers.

46. In one version she told of this story, her mother finally wound up packing her "suitcase" (Munro, *Originals*, 266) or "trunk" (Sawin, *Nell Blaine*, 18).

47. Sawin, *Nell Blaine*, 18.

CHAPTER 2

1. Nell recounted several versions of this story, some of which include only Hofmann's praise. See the oral history interview, AAA; Eleanor Munro, *Originals: American Women Artists* (New York: Simon & Schuster, 1977), 265; and "Reminiscences of Nell Blaine," Skillion interview (which includes both comments).

2. "Reminiscences of Nell Blaine," Skillion interview.

3. Kresch, who studied at Brooklyn College during the day, paid a discounted tuition (five dollars a month) at Hofmann's school by serving as a monitor. He later explained that this job "mean[t] you took care of the model, you came in on Saturday and mopped up" (interview by Deborah Garwood, *Artcritical*, March 1, 2005, http://www.artcritical.com/2005/03/01/albert-kresch/). His fellow student Perle Fine said that Hofmann was "very charitable to poor students," providing "a large number of scholarships to deserving people." Quoted in Kathleen L. Housley, *Tranquil Power: The Art and Life of Perle Fine* (New York: Midmarch Arts Press, 2005), 39.

4. Nell remembered Miz, who had given up her own painting career, as "gifted domestically in both gardening and making a wonderful place…with a great sense of color." Brown interview.

5. Hans Hofmann, "About Myself, My Work, My School," handwritten draft, ca. 1930–55, Hofmann Papers.

6. Wolf Kahn, "Hofmann's Mixed Messages," *Art in America* 78 (November 1990): 189–91, 215. All quotes from Kahn are taken from this article.

7. Munro, *Originals*, 266.

8. Quoted in Housley, *Tranquil Power*, 32.

9. Letter to Theresa Pollak, May 16, 1943, Pollak Papers.

10. Nell's roommate Polly Bates was in analysis with a Dr. Schweitzer; he and Hofmann knew each other by reputation and joked about competing for students.

11. In her May 16, 1943, letter to Pollak, Nell asked for a recommendation for this fellowship, adding that she was "sincerely very anxious to teach," presumably on the college level. But nothing came of her plans to complete her degree, "with part time courses in philosophy, psychology, math, and languages at either Hunter College or Brooklyn College."

12. Quoted in Pat van Gelder, "Close to Home," *American Artist* 54 (February 1990): 32.

13. Quoted in Munro, *Originals*, 265.

14. Wolf Kahn, "Hofmann's Mixed Messages," *Art in America* 78 (November 1990): 189–91, 215. All quotes from Kahn are taken from this article.

15. Quoted in David Hirsh, "Paint, and an Open View," *New York Native*, May 1, 1989.

16. Interview by Robert Doty, February 6, 1986, in Robert Doty, ed., *Jane Freilicher: Paintings*, exhibition catalogue (New York: Taplinger, 1986), 47. Freilicher studied at Hofmann's New York and Provincetown schools in 1947.

17. Quoted in Charlotte S. Rubinstein, *American Women Artists from Early Indian Times to the Present* (New York: Avon, 1982), 286.

18. Oral history, AAA. This trip was to the summer home of her in-laws, the year she married.

19. Quoted in Patricia Barnett Karlsen, "A Portrait: Nell Blaine," June 25, 1985, original manuscript for *Careers in the Arts* (Washington, DC: National Endowment for the Arts and President's Committee on Employment of the Handicapped, 1986), AAA.

20. Hoffmann, "About Myself, My Work, My School."

21. It is not clear whether this watercolor is based on a viaduct somewhere in upstate New York or on a remembered view of the land near the CSX Railroad viaduct in Richmond. "Gay" in the title is simply a reference to the cheerful ambiance of the scene.

22. Nell had previous music experience in Richmond as a teenager, when she learned to play piano pieces by Prokofiev and Stravinsky.

23. Nell preferred "opposition"—which she also used to describe the structure of poetry and choreography—to Hofmann's term, "push-pull." Diary, August 4–5, 1989.

24. Nell Blaine, "Getting with Lester and Mondrian in the Forties," in *Jazz and Painting*, exhibition catalogue (Keene, NH: Louise E. Thorne Memorial Art Gallery, Keene State College, 1972).

25. Munro, *Originals*, 266. Nell later told Eric Brown (interview, October 1990) that the building management turned off the heat early in the evening, and that a friend used to bring scavenged pieces of wood to burn in the fireplace. It is not clear whether she was confusing the heat source of her first 21st Street loft with her second one, or whether she misremembered the kerosene stove. But the facts of her poverty and inadequate heat are not at issue.

26. Edith Schloss Burckhardt, *The Loft Generation*, unpublished manuscript, courtesy of Jacob Burckhardt.

27. Quoted in Ivan C. Karp, "Portrait of an Artist with a True and Tender Sensibility," *Village Voice*, April 18, 1957, 10.

28. Nell told Eleanor Munro they cost forty cents (*Originals*, 266); years later, she told Eric Brown they were fifty cents (interview, October 1990).

29. Nell Blaine, typescript draft of statement about Guggenheim and Art of This Century, July 1984, prepared for Virginia Dortch, ed., *Peggy Guggenheim and Her Friends* (Milan: Berenice Art Books, 1994), quoted in Jennifer Sachs Samet, "Painterly Representation in New York, 1945–1975" (Ph.D. dissertation, City University of New York, 2010), 253n19.

30. Olinsey (1910–2001) was a painter who studied at Hofmann's school (and also at the Art Students League and Cooper Union); an intimate of architect Frederick Kiesler for decades, she finally married him in 1964.

31. Martica Sawin writes that Nell "was demoted to a runner" at the firm, but Nell told other interviewers that she was fired. Sawin, *Nell Blaine: Her Art and Life* (New York: Hudson Hills Press, 1998), 19.

32. The necktie-painting job led to Nell's brief experiments with paintings on silk, one of which (*Provincial Marketplace*) she showed to an interviewer from her hometown newspaper in 1952.

33. Nell later told an interviewer that she earned about twenty-five dollars a week in the early 1940s (Munro, *Originals,* 266).

34. Admiral and De Niro separated in 1943 and divorced in 1945 but remained friendly, and Admiral (1915–2000) took care of De Niro during his last years. She was a Hofmann student at the Art Institute of Chicago and in Provincetown, Massachusetts, where she met De Niro. In New York, she was close to poet Robert Duncan (a former lover of De Niro's) and other writers, including Anaïs Nin. She sold a painting to the Museum of Modern Art in 1942, earlier than any of the other downtown artists.

35. Kresch interview, http://www.artcritical.com/2005/03/01/albert-kresch/.

36. Jean Hélion, who had extensive previous experience with artists' groups in France, was instrumental in the founding of American Abstract Artists in 1936. He returned to France in 1940, during World War II, to join the armed forces. In the autumn of 1942, he made another trip to the United States, to raise money for the Free French by lecturing about his war experience as a prisoner in a Nazi forced labor camp. Hélion visited New York again briefly in 1944. He never returned to the United States and died in Paris in 1987.

37. The couple later divorced, and Pegeen eventually committed suicide.

38. Quotes from author's telephone interview with Albert Kresch, September 30, 2016.

39. Remarks at the memorial for Leland Bell, 1991, Blaine Papers, AAA.

40. Quoted in Holly Beye, "Sherry and Art down on Jane Street," *PM*, November 25, 1945. Another ardent follower in the early 1940s was Lee Krasner, also a student of Hoffmann's.

41. Matthíasdóttir (1917–2000) studied art in Denmark and Paris in the 1930s. She attended the Art Students League before studying with Hans Hofmann. Her first solo show was at the Jane Street Gallery (see chapter 3).

42. According to Sawin (*Nell Blaine*, 22), the couple were married by a Baptist minister after being turned away at City Hall because she was underage (not true—on July 12, 1943, she turned twenty-one) and because they came from different religious backgrounds (Bass was Jewish). Because of Nell's own interest in jazz, in later years Bass was sometimes erroneously described as a jazz musician.

43. Quoted in Sawin, *Nell Blaine*, 32.

44. Nell quoted in Munro, *Originals*, 266.

45. Diary, May 6, 1967, "Gloucester Reminiscences." All Blaine quotes in this and the following paragraph are from this source. According to Sawin (*Nell Blaine*, 24), Nell and her husband also visited Provincetown on this trip, meeting Jackson Pollock and Perle Fine, another painter in thrall to Mondrian. But Pollock did not visit that Cape Cod town until 1944, when he and Lee Krasner (who had studied with Hans Hofmann) stayed briefly at Hofmann's home. (See Steven Naifeh and Gregory

White Smith, *Jackson Pollock: An American Saga* [New York: Clarkson Potter, 1989], 484.) Blaine also cited 1944 as the year she met Pollock in Provincetown.

46. In August 1946, a report from Gloucester in *ARTnews* noted Nell's inclusion in the second annual exhibition of the Gloucester Society of Artists; she was among the six artists singled out as "outstanding."

47. According to Rivers, he met Nell ("in a way the first artist I knew") through Jane Freilicher, but both Nell and Freilicher remember the sequence of events as I related them. Rivers said that Nell "was already a rather advanced painter in relationship to myself.... She was a lot like Léger and Hélion. She used to paint every day, which was unheard of." Oral history interview with Larry Rivers, 1968, AAA.

48. Burckhardt, *Loft Generation*.

49. Jane Freilicher's marriage to Jack Freilicher was annulled in 1948; she married Joe Hazan in 1957.

50. Freilicher interview in Doty, *Jane Freilicher: Paintings*, 47–48.

51. Oral history interview with Rudy Burckhardt, January 14, 1993, AAA.

52. Burckhardt, *Loft Generation*. Rivers did study with Hofmann, in 1947 in New York, and in the summer of 1948 at his Provincetown, Massachusetts, school. It was there that "a desire to draw like the Old Masters swept over me," he wrote later. His interest in figuration would eventually lead to his breakthrough work, *Washington Crossing the Delaware* (1953), which reinterprets Emanuel Leutze's heroic painting of that title from 1851 as the miserable experience—a snowy day on an icy river in late December—that it actually must have been.

53. Burckhardt, *Loft Generation*.

54. Larry Rivers with Arnold Weinstein, *What Did I Do? The Unauthorized Autobiography* (New York: Thunder's Mouth Press, 1992), 105, 109.

55. Author's interview with Celia Eldridge, Gloucester, Massachusetts, July 25, 2017.

56. Edith Burckhardt, "Nell Blaine: From Richmond, Va., to Athens to the Future," *Village Voice*, December 9, 1959.

57. Oral history, AAA.

58. Nell and her friends also attended the landmark "X-Mas '49" Carnegie Hall concert featuring Parker, Miles Davis, Bud Powell, Sarah Vaughan, and other members of the bebop pantheon.

59. Diary, July 6, 1991.

60. Blaine was among a small group of painters—including Josef Albers, Ilya Bolotowsky, George L. K. Morris, and, notably, four other women, Perle Fine, Irene Rice Pereira, Alice T. Mason, and Esphyr Slobodkina—singled out by *New York Times* critic Edward Alden Jewell ("Abstract Artists Marking Birthday," March 26, 1946), for their work in the tenth annual American Abstract Artists group exhibition.

61. Lee Krasner in Munro, *Originals*, 110.

62. Housley, *Tranquil Power*, 76.

63. "Reminiscences of Nell Blaine," Skillion interview.

64. "Reminiscences of Nell Blaine," Skillion interview.

65. McMurray interview.

66. Quoted in Sawin, *Nell Blaine*, 21.

67. Munro, *Originals*, 267.

68. More than three decades later, Nell's patron Arthur Cohen bought the painting from Blaine and—at the suggestion of Thomas Hess, then head of the Department of 20th-Century Art at the museum—donated it to the Metropolitan Museum of Art.

69. Renée Arb, "Artists under Thirty: They're Painting Their Way," *Harper's Junior Bazaar*, May [?] 1947, 81. *Junior Bazaar* was a short-lived *Harper's Bazaar* spin-off launched in 1945; in 1948, it was folded into the parent magazine.

70. Diary, written on April 24, 1969, pages but dated "1988 or 9 I think."

71. Burckhardt, "Nell Blaine: From Richmond, Va., to Athens to the Future."

CHAPTER 3

1. The Jane Street Gallery was the precursor of notable cooperative galleries in New York in the 1950s—all originally located on or near 10th Street—including the Hansa (1952–59), Tanager (1952–62), Camino (1956–63), March (1957–60), and Brata (1957–mid-1960s).

2. Oral history, AAA. Over the years, Nell offered several variations of this quote, including "We thought we were missionaries for abstract art. We really had blinders on—just like young people today who are so sure of themselves." Diane Cochrane, "Nell Blaine: High Wire Painting," *American Artist* 37 (August 1973): 24.

3. Kenneth L. Beaudoin, "Nell Blaine," *Credo: Iconograph: Quarterly Supplement*, Fall 1946, 6.

4. In addition to Hyde Solomon, these artists included Ken Ervin, Janet Marren, Howard Mitcham, and Josiah Lancaster.

5. Jed Perl, "Matthiasdottir in Full Color," *New Criterion* 12 (May 1994): 49.

6. In the 1950s, Bacher hand-printed silkscreens by his friend poet Kenneth Patchen.

7. When Judith Rothschild (1921–93) married Anton Myrer, who later became a novelist, she moved to California. A graduate of Wellesley College and the Cranbrook Academy of Art, she also studied with Hofmann and Karl Knaths, with Stanley William Hayter at Atelier 17, and at the Art Students League. During the mid-1970s, she began making abstract reliefs that combine figurative and abstract elements. Rothschild served as president of American Abstract Artists, an editor at the journal *Leonardo*, and a trustee of several prominent art organizations. Her foundation supported projects involving lesser-known artists who died between 1976 and 2008.

8. Diary, January 23, 1975, page, but written on January 22.

9. According to Nell, Elaine de Kooning wrote a press release for Ida Fischer that referred to the "jukebox colors" in her collages. Diary, January 24, 1975.

10. Diary, January 22, 1975.

11. Clement Greenberg, "Review of Exhibitions of Jane Street Group and Rufino Tamayo," originally published in *The Nation*, March 8, 1947, in Greenberg, *The Collected Essays and Criticism,* vol. 2, *Arrogant Purpose, 1945–1949* (Chicago: University of Chicago Press, 1988), 132.

12. Eckstein would survive Fischer, who died of cancer in 1956; Nell and Elaine de Kooning organized her last show, at the Hansa Gallery.

13. "Reminiscences of Nell Blaine," Skillion interview.

14. The patron system appears to have begun in 1948, when the gallery moved to Madison Avenue and Nell wrote a notice detailing this new program. Other perks included invitations to all gallery events.

15. Oral history, AAA.

16. Quoted in Holly Beye, "Sherry and Art down on Jane Street," *PM*, November 25, 1945.

17. In another version of this story, Guggenheim claimed that the poster was "too big" ("Reminiscences of Nell Blaine," Skillion interview). The work no longer exists; the paint flaked off the poster.

18. The jurors were James Thrall Soby, James Johnson Sweeney, Alfred Barr (all prime movers at the Museum of Modern Art; Sweeney would later direct the Guggenheim Museum), Marcel Duchamp, and Piet Mondrian.

19. Most of the other artists, who included Lee Krasner, Louise Bourgeois, and Kay Sage, were married to up-and-coming artists. (Bourgeois's husband, Robert Goldwater, was an art historian.) Guggenheim's first all-woman show was Exhibition by 31 Women, in 1931.

20. Oral history, AAA.

21. Nell Blaine, "Mondrian and 'The New Spirit,'" 1944 [?], Blaine Papers, AAA.

22. Piet Mondrian, "An Interview with Mondrian" (1943), in *The New Art—The New Life: The Collected Writings of Piet Mondrian*, ed. and trans. Harry Holtzman and Martin S. James (Boston: G. K. Hall, 1986): 357, quoted in Jennifer Sachs Samet, "Painterly Representation in New York, 1945–1975" (PhD diss., City University of New York, 2010), 92n71.

23. Jean Hélion, "Poussin, Seurat, and Double Rhythm" (Paris, December 1934), *Axis* 6 (Summer 1936): 9–17, rpt. in *The Painter's Object*, ed. Myfanwy Evans (London: Gerald Howe, 1937), 94–107, quoted in Samet, "Painterly Representation in New York," 94n29.

24. Author's telephone interview with Al Kresch, September 30, 2016.

25. The star of this first English-language production of the play was the young Felicia Montealegre, who would later marry the composer and conductor Leonard Bernstein. According to Al Kresch, García Lorca's brother, who was teaching at Columbia University, loaned the manuscripts.

26. Quoted in Sue Dickinson, "Quadruple Artistic Career Keeps Nell W. Blaine Busy," *Richmond News Leader*, November 6, 1952.

27. Unsigned [Renée Arb], "Nell Blaine," *ARTnews* 44 (November 1945): 30, Blaine Papers, AAA.

28. Beye, "Sherry and Art down on Jane Street."

29. Nell Blaine, "Statement," Credo: Iconograph: Quarterly Supplement, Fall 1946, 4. A brief essay about her work in another issue of this journal noted that "the Blaine canvas...is a piece of abstract drama most carefully calibrated, quite boldly presented." Kenneth L. Beaudoin, "Young Female Painters," *Iconograph*, Summer 1946, 6.

30. Quoted in Larry Campbell, "Blaine Paints a Picture," *ARTnews* 58 (May 1959): 62.

31. Greenberg, "Review of Exhibitions of the Jane Street Group and Ruffino Tamayo."

32. Margaret Elliott, "Young Artists Sweep Uptown on Own Steam: Start Humbly in Village, Now Have Gallery," *New York World-Telegram*, October 6, 1948.

33. Unsigned [Elaine de Kooning], "Nell Blaine," *ARTnews* 47 (October 1948): 46. She noted that Nell's latest work contained a greater range of colors, increased fluidity, and visible traces of brushstrokes.

34. Clement Greenberg, "Review of Exhibitions of Ben Nicholson and Larry Rivers," *The Nation*, April 16, 1949.

35. Hélion's English-language memoir, *They Shall Not Have Me: The Capture, Forced Labor, and Escape of a French Prisoner in World War II* (published in 1943 by E. P. Dutton), was one of the earliest eyewitness descriptions of daily life in the camps. Fellow prisoners and members of the French Resistance enabled him to escape in February 1942. This harrowing experience inspired his new dedication to figuration—a preoccupation with relationships between people, the only source of hope in dark times.

36. "Reminiscences of Nell Blaine," Skillion interview.

37. Note, May 30, 1948, "Notes and Journal Excerpts," Blaine Papers, Cape Ann Museum Research Library and Archives.

38. Martica Sawin, "Abstract Roots of Contemporary Representation," *Arts* 50 (June 1956): 108.

39. Quoted in Martica Sawin, *Nell Blaine: Her Art and Life* (New York: Hudson Hills Press, 1998), 46.

40. Nell later recalled meeting Jackson Pollock for the first time at the Hofmann school in Provincetown, probably in 1944.

41. Quoted in Eleanor Munro, *Originals: American Women Artists* (New York: Simon & Schuster, 1979), 268.

42. "Reminiscences of Nell Blaine," Skillion interview.

43. Interview by Jennifer Samet, April 22, 2002, quoted in Samet, "Painterly Representation in New York," 92.

44. Diary, November 4, 1970.

45. Note, May 30, 1948, "Notes and Journal Excerpts," Blaine Papers, Cape Ann Museum Research Library and Archives.

46. Ad Reinhardt, "How to Look at Modern Art in America," *PM*, June 2, 1946,

47. Oral history, AAA.

48. Nell's "abstract discoveries" were shown at the Virginia Museum of Fine Arts in the exhibition Three Virginians, which opened on November 27, 1947, and also included sculptor Wolfgang Behl and painter Russell Vernon Hunter.

49. Brown interview.

50. Diary, May 23, 1972.

51. Larry Rivers with Arnold Weinstein, *What Did I Do? The Unauthorized Autobiography* (New York: Thunder's Mouth Press, 1992), 134.

52. Quoted in Steven Naifeh and Gregory White Smith, *Jackson Pollock: An American Saga* (New York: Clarkson Potter, 1989), 488. The account of Cannastra's antics also comes from this source.

53. The divorce seems to have been amicable. In 1972, Nell and Bass met to discuss collaborating on a book, with his photos and her reminiscences, but this project never got off the ground. In a 1977 interview, Nell said that Bass was "a painter and gallery owner" and that they were still friends. Jerry Tallmer, "At Home with Nell Blaine," *New York Post*, March 9, 1977, 17. According to Sawin, the marriage was annulled, but there would have been no grounds for that action, since neither party had been underage, mentally ill, married to someone else, or incapable of having sexual relations.

54. Sawin, *Nell Blaine*, 32.

55. Nell later recalled that during her first year in New York, Bennett "put a bowl on her head and with Polly's help"—this was her friend from Richmond—"my hair was whacked off." Letter to Janice Ritter McMurray, October 18, 1970, Blaine Collection, VCU.

56. Smithberg (1922–2014) was an engineering student at the time, but he had studied with Hans Hofmann and was an art collector. Part of the art scene in the late forties and early fifties, he came to Blaine's studio parties. Smithberg married Lorraine Marie Hamel in 1953; the couple remained friendly with Blaine, and their daughter, Madeleine, wrote a review of her work in the May 1983 issue of *Art/World*. At age seventy-nine, Smithberg would receive a degree from the Center for Modern Psychoanalytic Studies and become a psychoanalyst.

57. Letter to Charlotte Clark, July 8, 1983, Blaine Collection, VCU.

58. Diary, April 13, 1969.

59. Diary, January 8, 1969.

60. Edith Burckhardt, "Nell Blaine: From Richmond, Va., to Athens to the Future," *Village Voice*, December 9, 1959.

CHAPTER 4

1. Nell usually mentioned this connection, but in one interview she said the job came through an in-law of painter Leatrice Rose.

2. McMurray interview.

3. Nell designed sets and costumes for Goff's dance company's performances in the 1940s and '50s. Goff also danced with the Martha Graham and Merce Cunningham companies.

4. Edith Burckhardt, "Nell Blaine: From Richmond, Va., to Athens to the Future," *Village Voice*, December 9, 1959.

5. Letter to Eric Brown, March 15, 1992, courtesy of Eric Brown. The gender of this person isn't mentioned in the letter but is in the list of lovers on her diary page for April 13, 1969.

6. The rent was the equivalent of twenty-five dollars a month.

7. Letter to Jane Freilicher, September 20, 1950, Freilicher Papers, Harvard.

8. Letter to Jane Freilicher, August 27, 1950, Freilicher Papers, Harvard.

9. Quoted in *Nell Blaine: Artist in the World* (New York: Tibor de Nagy Gallery, 2003), unpaginated.

10. Oral history, AAA. If not otherwise specified, all quotes in this chapter are from this source.

11. Quoted in Eleanor Munro, *Originals: American Women Artists* (New York: Simon & Schuster, 1979), 269.

12. Quoted in *Nell Blaine: Artist in the World*.

13. Letter to Jane Freilicher, August 15, 1950, Freilicher Papers, Harvard.

14. Quoted in Sue Dickinson, "Quadruple Artistic Career Keeps Nell W. Blaine Busy," *Richmond News Leader*, November 6, 1952.

15. Oral history, AAA.

16. Richard Caldwell Brewer (1923–2014), a figurative painter known for his male nudes, was part of the New York circle that included Nell, Robert De Niro, and Leland Bell. He lived in Northern California beginning in the early 1970s.

17. Letter to Jane Freilicher, August 27, 1950, Freilicher Papers, Harvard.

18. Letter to Jane Freilicher, August 27, 1950, Freilicher Papers, Harvard.

19. Letter to Jane Freilicher, September 28, 1950, Freilicher Papers, Harvard.

20. Letter to Jane Freilicher, September 4, 1950, Freilicher Papers, Harvard.

21. Letter to Jane Freilicher, August 27, 1950, Freilicher Papers, Harvard.

22. Augsberger later turned up in New York and lived with Nell for a brief period, until she formed a relationship with a man with whom Nell was also involved

23. Diary, "1950, Rome & Paris." In a July 6, 1954, postcard from Gloucester, Massachusetts, to Jane Freilicher (Freilicher Papers, Harvard), Nell mentioned "the gossip in my life": her former girlfriend Ali and "Lennie," who was briefly her lover, were now a couple. Blaine viewed this development as "kind of neat, if irregular."

24. Burckhardt, "Nell Blaine: From Richmond, Va., to Athens to the Future." .

25. "The Dream," Diary, "1950, Paris–Florence." One person ("J.") was likely artist Jane Watrous, with whom Nell had a protracted but troubled affair.

26. *Kangaroo* (1923), based on Lawrence's own experiences, is about an English writer and his wife who resettle in Australia, hoping for a peaceful postwar life. Instead, they encounter the leader of a secret fascist paramilitary organization.

27. In one interview, Nell credited her stay with Midi Garth as the way she came to meet Kenneth Koch, who lived in Garth's building.

28. Diary, June 17, 1959.

29. For example, on November 2, 1966 (noted in her diary), Nell sent Garth a check for her rent.

30. "Midi Garth, Nona Schurman, Stuart Hodes," a performance on April 15, 1951. The pianist was David Tudor, later known for his experimental music. Martin's review praised Garth's "remarkably lyric body" and her "imagination, intuition and courage" in making good use of music (from four centuries) by Hovhaness, Dowland, Rameau, Schönberg, and Bartók.

31. Midi Garth's unadorned choreographic style was a legacy of her studies with Sybil Shearer, best known for her modern dance solos, and with the socially conscious New Dance Group.

32. Letter to Robert Duncan, March 18, 1958, in Robert J. Bertholf and Albert Gelpi, eds., *The Letters of Denise Levertov and Robert Duncan* (Stanford, CA: Stanford University Press, 2004), 103.

33. Allen Hughes, "Midi Garth, Aided by a Small Group, Performs Dances," *New York Times*, December 9, 1963.

34. Don McDonagh, "Midi Dances Old and New Works," *New York Times*, April 29, 1969.

35. Clive Barnes, "Dance: On the Mysticism of Boredom," *New York Times*, March 21, 1967.

36. Brown interview.

37. Diary, December 26, 1971.

38. Diary, October 28, 1977.

39. Diary, January 4, 1969. (She was looking at a page from her calendar from July 25, 1966, the day O'Hara was killed by a dune buggy on the beach at Fire Island.)

40. Nell told an interviewer that she decided not to join her friends in the Hamptons during the summer because she feared that the constant socializing would keep her from getting enough work done. One reason she later chose to summer in Gloucester was her belief that even the more accomplished local artists did not share her interests, so she wouldn't be tempted to hang out with them.

41. Diary, October 28, 1977.

42. Diary, July 24 [?], 1977.

43. Diary, April 13, 1991.

44. Diary, on January 14, 1969, page, but marked as written in 1970.

45. David Lehman, *The Last Avant-Garde: The Making of the New York School of Poets* (New York: Anchor Books, 1999), 62–63.

46. According to Martica Sawin, Larry Rivers and John Myers of Tibor de Nagy Gallery—who would become Blaine's dealer two years later—carried her furniture across the street. Sawin, *Nell Blaine: Her Art and Life* (New York: Hudson Hills Press, 1998), 46.

47. According to Al Kresch, in 1943, when Robert De Niro left his artist wife, Virginia Admiral, after the birth of their infant son, she hatched a plan (never carried out) to visit Monte Carlo with a mathematician friend and "break the bank." To prepare, she studied the little roulette wheel at Nell's apartment to figure out how many times it came around. Author's telephone interview with Kresch, September 30, 2016.

48. Letter to Donald Allen, "Oct. or Nov. '75," Blaine Diaries and Correspondence, Harvard.

49. "Reminiscences of Nell Blaine," Skillion interview.

50. Ashbery interview with Karen Roffman, quoted in Roffman, *The Songs We Know Best* (New York: Farrar, Straus & Giroux, 2017), 185n32.

51. Author's telephone interview with Albert Kresch, October 27, 2016.

52. "Reminiscences of Nell Blaine," Skillion interview.

53. Elinor Poindexter opened an eponymous gallery in 1955; Blaine joined the Poindexter Gallery the following year.

54. Letter to May Swenson, February 15, 1970, Swenson Papers.

55. Diary, December 3, 1990. Two of her poet friends were missing: O'Hara was long dead, and Schuyler, who died the following April, was too ill to attend.

56. Unfortunately, when the poet and art critic Bill Berkson asked Nell to contribute to *Homage to Frank O'Hara*, a lovingly assembled group of writings, photographs, and art reproductions published in 1978, she couldn't locate the originals of these drawings and dismissed the painting as "incomplete and a nothing." (Copy of letter in Diary, July 12, 1977.) But she did contribute a drawing of New York rooftops to *In Memory of My Feelings: A Selection of Poems by Frank O'Hara*, edited by Berkson (Museum of Modern Art, 1967).

57. James Schuyler, "The View from 210 Riverside Drive," *ARTnews* 67 (May 1968): 73.

58. Letter to James Schuyler, May 22, 1968, Schuyler Papers.

59. The Artists' Theatre production of "The Heroes" was presented at the Comedy Club, a converted firehouse at Sniffen Court—a row of houses converted from stables in Murray Hill (East 36th Street between Third and Lexington Avenues)— May 18–23, 1953.

60. Roffman, *The Songs We Know* Best, 184.

61. The director of these plays was Herbert Machiz, cofounder of the Artists' Theatre with Tibor de Nagy Gallery director John Bernard Myers. Machiz "changed his mind so often it was maddening," Nell recalled. "Just before the performance he made major alterations in the staging and timing." Diary, March 10, 1969.

62. Diary, May 24–25, 1991.

63. *Nell Blaine Sketchbook* (New York: The Arts Publisher, 1986).

64. Diary, March 10, 1969.

65. Quoted in Munro, *Originals*, 269.

66. Dickinson, "Quadruple Artistic Career Keeps Nell W. Blaine Busy" .

67. She also pointed out that canvas and paint for a big picture could cost as much as $60 (about $542 in 2017 dollars).

68. According to Sawin (*Nell Blaine*, 42), Clement Greenberg had suggested that the gallery represent Nell. However, she recalled that the impetus came from Rivers.

69. Nell was also one of nine painters in a group show at Tibor de Nagy that was reviewed by Stuart Preston in the *New York Times* on December 15, 1951 ("Art Show Covers Historical Range"). Preston wrote that Nell and John Grillo "conform to strict and luminous patterns," whatever that was supposed to mean. He also singled out critic Clement Greenberg, who had a "scrupulously observed" landscape in the show. The other painters were Jane Freilicher, Leatrice Rose, Friedebald Dzumas, Lanita Manry, and D. Heller Grunig.

70. The twenty-four-page book, *Prints—Nell Blaine/Poems—Kenneth Koch*, was issued in an edition of three hundred and sold for five dollars. Nell had learned in high school to make woodblock prints and linocuts, in which a piece of linoleum is used for the relief surface. (Another selection of her woodblock prints was published by Archangel Press in 1948.) In 1946, supported by a grant from the Virginia Museum of Fine Arts, she studied with Stanley William Hayter at Atelier 17. This was the New York incarnation of a famous printmaking studio Hayter had founded in Paris, where it attracted leading artists, including Picasso, Miró, and Giacometti, as well as beginners. Jackson Pollock and Mark Rothko were among the artists who made prints at the Manhattan studio, initially located at The New School, then on the top floor of a brownstone in Greenwich Village. Hayter was also a painter; in New York, his interests expanded from engraving to experimental color processes, using the techniques of screenprinting and woodcut.

71. Diary, Tuesday, January 11, 1955.

72. Diary, January 19, 1950. She told Martica Sawin (*Nell Blaine*, 45) that Charles Godley, the New School registrar, gave her and her friends jobs as "ticket takers and monitors for classes."

73. Holtzman, a longtime friend of Mondrian's, had sponsored his immigration to the United States and inherited his estate at his death in 1944.

74. Nell would have another connection with Auden years later, when she became friendly with poet Howard Griffin, who had been Auden's secretary in the 1940s. See chapters 8, 10, and 11.

75. Letter to Thomas Bonn, 1980, Blaine Diaries and Correspondence, Harvard.

76. A decade later, freelance cover-designer pay for Vintage ranged from $150 to $200 per book.

77. The others were John Wilcock (who became news editor), Norman Mailer, and Howard Bennett.

78. Letter to Theresa Pollak, November 5, 1955, Blaine Collection, VCU.

79. Author's telephone interview with Florence Ettenberg Janovic, August 29, 2017.

80. Author's telephone interview with Edwin Fancher, September 11, 2017.

81. Email to author from Florence Ettenberg Janovic, September 11, 2017.

82. Author's telephone interview with Edwin Fancher, September 11, 2017.

83. Larry Rivers with Arnold Weinstein, *What Did I Do? The Unauthorized Autobiography* (New York: Thunder's Mouth Press, 1992), 175.

84. Diary, August 4, 1989. This was part of a reminiscence she sent to Larry Rivers when he was working on his autobiography.

85. Seymour Krim postcard to Nell Blaine, October 23, 1952, Blaine Diaries and Correspondence, Harvard.

86. James Fitzsimmons, "Art," *Arts & Architecture*, October 1953, 9. Fitzsimmons was later editor and publisher of *Art International.*

87. Stuart Preston, "Diverse Openings," *New York Times*, September 20, 1953.

88. Sidney Tillim, "Nell Blaine," *Art Digest* 29 (November 1, 1954): 23.

89. Letter to Theresa Pollak, November 5, 1955, Pollak Papers.

90. Diary, August 26, 1955.

91. *"Tout s'éclaire et la peinture est en plein vibration,"* quoted in John Elderfield, "Seeing Bonnard," in Sarah Whitfield and John Elderfield, *Bonnard* (New York: Abrams, 1998), 43n99.

92. The cabin was near the home of parents of a friend who was staying there at the time. (He later remembered playing games of hearts in which she gave him chocolate kisses when she lost, and he gave her flowers for her paintings when he did.) Paul Mattick, "Painting in the World," in *Nell Blaine: Artist in the World—Works from the 1950s* (New York: Tibor de Nagy Gallery, 2003), unpaginated. The cabin was also near the home of Clara Winston; a half sister of Blaine's former husband, Bob Bass, she and her husband, Richard, had lived on 21st Street in the 1940s. Other neighbors included Helen and Scott Nearing, who lived in a pacifist, vegetarian community, and photographer Rebecca Lepkoff, whose shots of Nell in her studio provide a valuable record of her prepolio painting practice.

93. Diary, Saturday, January 1, 1955.

94. Diary, Tuesday, January 4, 1955.

95. Diary, Friday, January 7, 1955.

CHAPTER 5

1. Thomas B. Hess, "U.S. Painting: Some Recent Directions," *ARTnews Annual* 25 (1956): 75, 81. Hess's fatal heart attack on July 13, 1978, would prompt a grieving note in Nell's diary (July 26, 1978). His death was "a profound loss for art in America & especially for painting," she wrote. Describing him as "a youthful & brilliant advocate of vitality in art," and "a true friend," she wrote that "he was the critic who <u>cared</u> the most for art & artists."

2. Hess, "U.S. Painting," 194.

3. Hess, "U.S. Painting," 71.

4. This is an odd criticism, since Hess proposed that Nell, Bell, Kahn, and Solomon formed a group separate from younger artists who insisted on either abstraction or realism and from those who refused to be limited in any way in terms of painting

style or subject matter. He wrote that Nell, Bell, and De Niro were among those who were wedded to drawing from nature. In a particularly acute observation, Hess noted that Nell and Bell viewed the subjects they painted as having "a value, an electric charge or valence, which must be studied isolated and brought back into the painting."

5. Letter to Theresa Pollak, November 5, 1955, Blaine Collection, VCU.

6. This is the title given to the reproduction of this painting in the catalogue for The Fifties: Aspects of Painting in New York, an exhibition at the Hirshhorn Museum and Sculpture Garden in 1980.

7. Leo Steinberg, "Month in Review: Contemporary Group at Stable Gallery," *Arts* 30 (January 1956): 46.

8. Louis Finkelstein, "New Look: Abstract-Impressionism," *ARTnews* 55 (March 1956): 36.

9. Quoted in Ivan C. Karp, "Portrait of an Artist with a True and Tender Sensibility," *Village Voice*, April 18, 1956, 10.

10. Author's telephone interview with Peter Dickison, September 26, 2017.

11. Author's interview with Eric Brown, New York, November 8, 2017.

12. "Is There Still Life in Still Life?" Artists Talk on Art panel discussion, April 27, 1979, AAA.

13. An outlier in this show was *Merry-Go-Round* (1955), Blaine's unresolved attempt at portraying the colorful whirl of a carousel—probably the one in Central Park—with twin dummy-like figures as riders. Trying to indicate motion, Nell bogged down in a welter of blue and orange shapes that have a tentative feel. Grace Hartigan also tried to depict this subject, in *Carousel* (1952–53), a canvas she struggled with and wound up destroying.

14. Stuart Preston, "Gallery Variety: Triple Showing," *New York Times*, April 29, 1956.

15. Fairfield Porter, "Nell Blaine," *ARTnews* 55 (May 1956): 51.

16. Many of these artists are now forgotten, but the successful entrants included Mary Abbott, Josef Albers, Leonard Baskin, Herbert Bayer, William Brice, Morris Graves, Ellsworth Kelly, Andy Warhol, and Blaine's friends Jane Freilicher and Larry Rivers.

17. Lois Reamy, "Interests Fostered in Richmond Spell Success for Woman Artist," *Richmond Times-Dispatch* (no date on clipping, but likely summer 1956), Blaine Collection, VCU.

18. Laurie Lisle, *Louise Nevelson: A Passionate Life* (New York: Summit Books, 1990), 181.

19. Larry Rivers with Arnold Weinstein, *What Did I Do? The Unauthorized Autobiography* (New York: Thunder's Mouth Press, 1992), 298.

20. Diary, February 17, 1984.

21. Diary, April 27, 1984.

22. By the midfifties, most of the notable guests had been writers; the few famous names among the artist alumni were Milton and Sally Avery, Clyfford Still, Jacob

Lawrence, Ralph Steiner, and Beauford Delaney (who shared a house there with the poet Elizabeth Bishop in 1950).

23. Nell had listed 80 St. Marks Place for Elaine de Kooning—her first address after she separated from Willem de Kooning—but Elaine wound up spending little time there after discovering that the apartment was above a nightclub.

24. Hyde Solomon letter to Elizabeth Ames, March 7, 1957, Yaddo Records.

25. Thomas Hess letter to Elizabeth Ames, March 13, 1957, Yaddo Records

26. Karl Knaths letter to Elizabeth Ames, February 21, 1952, Yaddo Records.

27. Diary, April 13, 1969.

28. All quotes from Barbara Guest are from a typed note, "Nell Blaine at Yaddo in the 1950's," sent to Eric Brown in January 1987, shortly before Blaine's memorial; courtesy of Eric Brown.

29. Levertov met Kresch around 1948; written in the early fifties, her poem "Kresch's Studio" describes the work of several artists working in different media ("some with loud pens in the silence") to capture a model's pose.

30. Nell mentions this in passing in a postcard to Levertov, September 7, 1971 (Levertov Papers).

31. Letter to Denise Levertov, February 12, 1987, Levertov Papers. In fact, Levertov's time in Mexico was plagued by myriad problems, including her son's serious illness, the temporary absence of her husband, and disruptions by workmen fixing up the house.

32. Diary, July 17, 1958.

33. Nell Blaine quoted in Martica Sawin, *Nell Blaine: Her Art and Life* (New York: Hudson Hills Press, 1998), 50.

34. According to Sawin (*Nell Blaine*, 51), Nell also visited Na Bolom, a center founded in 1950 to conserve the cultural and natural heritage of Chiapas.

35. Oral history, AAA.

36. Author's telephone interview with Temma Bell, December 6, 2017.

37. Edith Burckhardt, "Nell Blaine: From Richmond, Va., to Athens to the Future," *Village Voice*, December 9, 1959.

38. Notebook, summer 1958, "Notes and Journal Excerpts," Blaine Papers, Cape Ann Museum Research Library and Archives.

39. John Myers letter to Admissions Committee, March 21, 1952, MacDowell Colony Records, Box 7.

40. Hans Hofmann letter to Edward MacDowell Association, March 25, 1952, MacDowell Records. Hofmann's letter differed slightly from the one he sent on Nell's behalf to Elizabeth Ames at Yaddo in 1951: her "talent" was now a "great talent," and he added a description of her as "an inspiring friend" with "a well balanced nature."

41. Karl Knaths letter to Edward MacDowell Association [received April 14, 1952], MacDowell Records.

42. Theresa Pollak letter to Dr. Hobart Nichols, Chairman, Admissions Committee, March 28, 1952, MacDowell Records. While this letter is substantially the same as

the one Pollak sent to Elizabeth Ames at Yaddo a month earlier, the remarks about "warmth and assurance" are new.

43. Hyde Solomon letter to Admissions Committee, March 18, 1957, MacDowell Records.

44. Thomas Hess letter to Edward MacDowell Association, n.d. [ca. 1957], MacDowell Records.

45. Elaine de Kooning letter to Mrs. Peter Aylen, Admissions Committee, March 19, 1957. MacDowell Records.

46. Letters from Muriel Aylen to Nell Blaine, March 22, April 3, and May 14, 1957, MacDowell Records.

47. Jane Mayhall (1918–2009) grew up in Kentucky. She met her husband, Leslie Katz, at Black Mountain College, where she studied music. The couple moved to New York, where Katz—who printed some of Nell's book projects—founded Eakins Press in 1966. Its publications included art books and Mayhall's poetry. He was previously the publisher of *Arts* magazine.

48. May Swenson (1913–1989), who grew up in a Swedish-speaking household in Utah, moved to New York in 1935. She later worked at New Directions press and was a poet in residence at several universities.

49. Diary, December 4, 1989.

50. McCullers had also stayed at Pine Tree Studio in December 1942, when she learned that her close friend Annemarie Clarac-Schwarzenbach had died in Switzerland after a bicycle accident, and in the summer of 1944, when her father died in Georgia.

51. Card to Elizabeth Ames, December 21, 1973, Yaddo Records.

52. *Pine Tree Studio* (1958) was donated in 1981 to the Brooklyn Museum by Arthur Cohen.

53. Letter to May Swenson, December 5, 1957, Swenson Papers. (The archive wrongly dates this letter to *November* 5; Nell wrote "Thursday," which corresponds to the December date.)

54. Kathleen Ayres, "Nell Blaine Discusses New Approach to Art," USIS Feature, WP-529, Blaine Papers, AAA . This release, distributed to newspapers, magazines, and radio stations, was accompanied by a photograph of Blaine by Rebecca Lepkoff. The USIS, a federal agency, was founded to promulgate a positive, anti-Communist image of the United States.

55. Her work was in Réalités Nouvelles, an American Abstract Artists 1950 exhibition sponsored by the US State Department that traveled to Paris, Rome, Munich, and Copenhagen, and she was included in an American Abstract Artists group show that traveled to Tokyo in 1955 and Hawaii in 1956.

56. Karp, "Portrait of an Artist with a True and Tender Sensibility," 2.

57. Dore Ashton, "Shows Feature Nell Blaine and Two Groups," *New York Times*, April 8, 1958. (In a mixed review of Nell's 1954 show at the Peridot Gallery, another reviewer also praised her watercolors as "more delicate": Stuart Preston, "Vitality Marks Frank's Work, at Peridot," *New York Times*, October 28, 1954.) In late May

and June, Nell was also in an exhibition at the Virginia Museum of Fine Arts of work by artists who had received a museum fellowship. A May 1980 VMFA show honored the entire group of fellowship recipients, including Nell and Cy Twombly.

58. Dorothy Sieberling, "Women Artists in Ascendance," *Life*, May 13, 1957, 74–77.

59. Information from a letter Nell sent to "Hal and Betty," 1985, Blaine Papers, Cape Ann Museum Research Library and Archives.

60. Lawrence Campbell, "Nell Blaine," in *Nell Blaine: Watercolors* (Richmond, VA: Reynolds Gallery, 2001), 4.

61. This painting was in the collection of the Bernard Gimbel family, but it appears to be lost, according to Carolyn Harris, who tried to locate it in 2009.

62. As mentioned in note 54, Rebecca Lepkoff also shot the studio at this time, with *Harbor and Green Cloth* on an easel alongside the round table, vases of flowers, spindle-back chairs, and casement windows that can be seen in the painting.

63. Lawrence Campbell, "Blaine Paints a Picture," *ARTnews* 58 (May 1959): 38 .

64. Another pair of young fishermen appear in the poem "Tide at Gloucester," by Jean Garrigue, who visited Blaine at West Wharf that summer: "two boys in a dory / ... With their skimming oars as spiders / That walk upon and pleat the waters." A dory is a flat-bottomed boat.

65. *Wharf Studio, Gloucester* (1958) is in the collection of the Cape Ann Museum in Gloucester.

66. Quoted in Eleanor Munro, *Originals: American Women Artists* (New York: Simon & Schuster, 1979), 270.

67. Although Campbell wrote that the Whitney Museum acquired the first version, the museum actually purchased the second one.

68. "Notes and Journal Entries," Blaine Papers, Cape Ann Museum Research Library and Archives.

CHAPTER 6

1. Mary Moore Mason, "Richmond Artist Plans Studio in Greece," *Richmond News-Leader* (no date on clipping; probably spring 1959), Blaine Collection, VCU.

2. James Schuyler letter to John Ashbery, February 4, 1959, in *Just the Thing: Selected Letters of James Schuyler* (New York: Turtle Point Press, 2009), 93.

3. Among those gathered at the dock were poets Denise Levertov, Barbara Guest, and Storm de Hirsch; painters Anne Tabachnick, Hyde Solomon, Robert De Niro, Leland Bell, and Louise Matthíasdóttir; art critic and painter Lawrence Campbell and his wife, Audrey; and a neighbor, Beatrice Gazzolo.

4. Launched in 1953, the SS *Cristoforo Colombo* was a luxurious ocean liner, larger than her Italian Line twin ship, the *Andrea Doria*.

5. Postcard to Denise Levertov, Hotel Britannique, Naples, undated, with unreadable postmark, Levertov Papers.

6. *Diary*, April 13, 1969.

7. Where not otherwise noted, quotes are from the oral history interview, AAA.

8. Nell had originally chosen the island of Hydra as her destination, on Kaldis's recommendation, but the studios there were being renovated.

9. The fabric colors found their way into her painting *Interior at Delphi* (current whereabouts unknown; formerly part of the fabled art collection of financier and philanthropist Laurance Rockefeller).

10. Postcard to May Swenson, April 12, 1959, Swenson Papers.

11. Nell met the Banks through Barbara Fussiner, Michael Bank's sister, and her husband, painter Howard Fussiner.

12. Diary, June 26 and June 28, 1959.

13. Diary, July 17, 1959.

14. Information from "Cy Twombly: Chronological Notes," at http://www.cytwombly.info/twombly_biography.htm.

15. Marshall Clements, who grew up in Baton Rouge, Louisiana, would later work at the Phoenix Book Shop in Greenwich Village, run by Nell's good friend Robert A. Wilson. (See chapter 7.)

16. In her 1967 AAA oral history interview, Blaine says that Dunn ran a "hotel bar." In Martica Sawin, *Nell Blaine: Her Art And Life* (New York: Hudson Hills Press, 1998), 59, he is described as running a restaurant. In an interview that Nell gave in 1989, she said that Dunn ran "a small hotel and restaurant." I am inclined to go with the AAA oral history, because it is the earliest of these reminiscences. (I should add that this Robert Dunn was not the postmodern dancer, Robert Ellis Dunn.)

17. Jack Kroll, "Jane Streeters," *Newsweek*, September 1963. This work was one of several similarly titled oil paintings and watercolors.

18. Paintings of Greece, March 21–April 16, 1960, Poindexter Gallery.

19. L[awrence] C[ampbell], "Nell Blaine," *ARTnews* 59 (April 1960): 13.

20. J[ames] R. M[ellow], "Nell Blaine," *Arts* 34 (April 1960): 54.

21. Sue Dickinson, "Nell Blaine Returns to Art," *Richmond Times-Dispatch*, September 11, 1960.

22. Letter to Edna [Andrade], September 11, 1959, Blaine Diaries and Correspondence, Harvard. Andrade was an abstract painter and a fellow Virginian.

23. Lawrence Campbell, "Blaine Paints a Picture," *ARTnews* 58 (May 1959): 38–41, 61–62.

24. In her AAA interview, Nell mentions actress Helen Hayes as one of the notables who bought a painting, but in Sawin (*Nell Blaine*, 60), she is quoted is saying that although the actress praised her "opalescent colors," she thought the prices were too high.

25. Denise Levertov letter to Robert Duncan, September 28, 1959, in Robert J. Bertholf and Albert Gelpi, eds., *The Letters of Denise Levertov and Robert Duncan* (Stanford, CA: Stanford University Press, 2004), 212.

26. Letter from Jane Freilicher, September 11, 1959, Blaine Diaries and Correspondence, Harvard.

27. Polio, short for poliomyelitis—based on the Greek words for "gray" and "marrow" (references to the contents of the spinal cord)—is an intestinal infection caused by exposure to fecal material. Infants in areas with poor sanitation often caught mild forms of the disease that gave them immunity for the rest of their lives. In the United States and other developed countries, improved sewage disposal and clean water made this form of immunity impossible. Before the development of the polio vaccine in 1955, thousands of people died in epidemics that spread the virus via exposure to droplets of moisture from the throat of an infected person.

28. Nell also suggested that she might have been infected six months earlier by a tainted batch of polio vaccine. However, the tainted vaccine from Cutter Laboratories that caused paralysis in more than two hundred people was reported to regulators in 1955, years before her vaccination. A virus in rhesus monkey kidney cells (SV40) contaminated stocks of the Salk vaccine and early Sabin vaccine, but SV40 has been associated with cancer, not polio. See Regis A. Vilchez and Janice S. Butel, "Emergent Human Pathogen Simian Virus 40 and Its Role in Cancer," National Institutes of Health, *Clinical Microbiological Review* 17, no. 3 (July 2004): 495–508, PMC452549, at https://www.ncbi.nlm.nih.gov/pmc/articles/PMC452549/.

29. Le Clercq died of pneumonia in 2000 at age seventy-one.

30. In the ballet, the stricken girl recovers after children throw dimes at her; thus the title.

31. Prominent people in the arts who contracted polio in childhood include actors Mia Farrow, Alan Alda, Donald Sutherland, and Johnny Weissmuller; musicians Joni Mitchell, Itzhak Perlman, Renata Tebaldi, and Neil Young; and artists Frida Kahlo and Dorothea Lange.

32. Author's telephone interview with Michael S. Bank, May 3, 2017. Bank said that the Greek Air Force had crashed all but one of the helicopters they received under US military aid, which accounted for their unwillingness to send out the last one.

33. In her AAA interview, Nell suggested that the helicopter may have arrived from Gibraltar, which is highly unlikely, according to Bank.

34. The iron lung was invented in 1928 by Philip Drinker, Louis Agassiz Shaw, and James Wilson at Harvard University.

35. Diary, September 8, 1990.

36. Quoted in Sawin, *Nell Blaine*, 68.

37. "Reminiscences of Nell Blaine," Skillion interview.

38. Quoted in Jack Kroll, "Jane Streeters," *Newsweek*, September 22, 1963.

39. Dickinson, "Nell Blaine Returns to Art."

40. Jane Freilicher letter to Nell Blaine, September 13, 1959, Blaine Diaries and Correspondence, Harvard.

41. Denise Levertov letter to Nell Blaine, September 24, 1959, Blaine Diaries and Correspondence, Harvard.

42. "CFM" was probably meaningful to Nell, but it is unclear what the initials stood for. Frank O'Hara telegram to Nell Blaine, c/o Bob Dunn, September 24, 1959, Blaine Diaries and Correspondence, Harvard.

43. Edith Burckhardt letter to Nell Blaine, September 25, 1959, Blaine Diaries and Correspondence, Harvard.

44. Tom Hess letter to Nell Blaine, October 2, 1959, Blaine Diaries and Correspondence, Harvard. Other friends who wrote to Nell in October include poets Pauline Hanson, May Swenson, Daisy Aldan, and James Merrill.

45. Author's telephone interview with Barbara Bank Fussiner, May 10, 2017.

46. Nell's flight to the United States was paid for by the Polio Foundation (formerly the National Foundation for Infantile Paralysis); she later said that the rescue operation cost more than $10,000.

47. "Reminiscences of Nell Blaine," Skillion interview.

48. "Richmond Native, Victim of Polio, Is Flown to New York from Greece," unidentified clipping from a Richmond newspaper, Blaine Collection, VCU .

49. William Kienbusch letter to Nell Blaine, October 18, 1959, Blaine Diaries and Correspondence, Harvard.

50. Elaine de Kooning letter to Nell Blaine, undated but probably October 1959, Blaine Diaries and Correspondence, Harvard. The previous year, when she lived in New Mexico and often drove to Ciudad Juárez, Mexico, to watch the bullfights, Elaine had begun painting bulls.

51. Pauline Hanson letter to Nell Blaine, October 5, 1959, Blaine Diaries and Correspondence, Harvard.

52. Nell would later express her dislike of Flavin's "unfeeling" approach to his brother and—as someone who hated most post–Abstract Expressionist art movements— the "great blown up claims" he made for his work. Letter to Theresa Pollak, August 29, 1969, Pollak Papers.

53. Diary, August 14, 1992. Dr. Sweet had died the previous day.

54. "Reminiscences of Nell Blaine," Skillion interview.

55. Author's telephone interview with Dilys Evans, January 24, 2017. All quotes from Evans are from this interview unless otherwise noted.

56. Denise Levertov letter to Robert Duncan, November 3, 1959, in Bertholf and Gelpi, *The Letters of Denise Levertov and Robert Duncan*, 219.

57. Patricia Barnett Karlsen, "A Portrait: Nell Blaine," June 25, 1985, in the original manuscript for *Profiles in the Arts*, ed. Marcia Sartwell and Robert Ruffner (Washington, DC: National Endowment for the Arts and President's Committee on Employment of the Handicapped, 1986) , including handwritten emendations by Blaine; Blaine Papers, AAA.

58. Dickinson, "Nell Blaine Returns to Art."

59. Denise Levertov letter to Robert Duncan, November 25, 1959, in Bertholf and Gelpi, *The Letters of Denise Levertov and Robert Duncan*, 223.

60. Dickinson, "Nell Blaine Returns to Art."

61. Unsigned [Thomas B. Hess], "Homage to Nell Blaine," *ARTnews* 58 (December 1959): 34.

62. Author's telephone interview with Carolyn Harris, October 25, 2016. Harris said that Bass had remarried in the interim but his second wife had died.

63. "Reminiscences of Nell Blaine," Skillion interview.

64. This was the entrance where trash was collected. Such were the indignities in an era before the passage of the Americans with Disabilities Act Act.

65. Large folded announcement for Paintings of Greece, Poindexter Gallery, with reproduction of *Stupa*, courtesy of Dilys Evans.

66. This time, Evans was admitted to the United States as "a visitor for pleasure" until April 3, 1961.

67. Karlsen, "A Portrait: Nell Blaine," 6.

68. Nell Blaine, "The Act of Painting," *Women and Art*, Summer/Fall 1972.

CHAPTER 7

1. Preface to a catalogue, ca. 1980s, Blaine Papers, Cape Ann Museum Research Library and Archives. Aware of Nell's lithographs of this view for Tanya Grossman's Universal Limited Art Editions press, Barbara Guest asked her to illustrate a book that was to be called *Poems on the Hudson*. Nell told an interviewer in 1961 that the commission came about "partly because of my interest in the river view from my window." For some reason, this book was never published. Sue Dickinson, "Polio Poses No Painting Problem to Richmond-Born Artist in N.Y.," *Richmond News Leader*, September 18, 1961.

2. Sue Dickinson, "Art Dehumanization Irks Ex-Richmonder," *Richmond Times-Dispatch*, October 4, 1970.

3. Richard Ellman letter to Nell Blaine, July 28, 1960, Blaine Papers, AAA.

4. Elizabeth Bredrup, "VCU Alumnus [*sic*] Nell Blaine Returns, Receives Honorary Degree," *VCU Today*, [1985], Pollak Papers

5. Unfortunately, it is not possible to track Nell's increasing mastery over the months it took to produce an acceptable painting. She left no comments about this, and Dilys Evans, who was eighty-one at this writing, no longer recalls the details.

6. "Longwood Features Art Work by Blaine," *Rotunda* [Longwood University, Farmwood, VA], January 9, 1963.

7. Nell Blaine, preface to *Nell Blaine: Oils, Watercolors, Drawings* (Richmond, VA: Reynolds Gallery, 1996.

8. Despite the ADA Title II requirement of curb ramps at pedestrian crossings, navigating New York City streets in a wheelchair is still fraught with difficulties. See Winnie Hu, "Disabled New Yorkers Face Trouble with Curbs," *New York Times*, October 9, 2017. In 2018, federal prosecutors accused the Metropolitan Transportation Authority of violating the rights of disabled people when the $27 million renovation of the Middletown Road subway station in the Bronx failed to

install mandatory elevators. See Sarah Maslin Nir, "Subway Work Violated Rights of Disabled, Prosecutors Say," *New York Times*, March 14, 2018.

9. Letter to Lillian Kiesler, April 16, 1969, Kiesler Papers, AAA.

10. She was also included in Collectors Graphics at the Peridot Gallery in April, which displayed her lithograph of Dilys.

11. Jean Lipman and Cleve Gray, "The Amazing Inventiveness of Women Painters," *Cosmopolitan*, October 1961, 62–69. At that time, this was a general interest magazine, not the "Cosmo" of the Helen Gurley Brown era. Lipman was editor of *Art in America*; Gray, married to the writer Francine du Plessix Gray, was an abstract painter.

12. Letter to May Swenson, September 12, 1961, Swenson Papers.

13. Prices for the twenty-one works ranged from $150 for a recent watercolor to $1,600 for a landscape painting from 1959.

14. In the early 1960s, "gay" had only one meaning to the general public; it was not widely known in its homosexual sense.

15. Christmas card to Theresa Pollak, [1962], Pollak Papers.

16. After working in an abstract, mosaiclike style, Jan Müller (1922–1958) became a figurative painter in 1954, the year of the operation that placed a plastic valve in his heart, which was damaged by rheumatic fever. Unfortunately, this medical intervention did not prevent his early death.

17. Several of Nell's paintings (and many by the other artists) were purchased by financier and mega-art-collector Joseph Hirshhorn, who opened a museum named for himself in Washington, DC, in 1974. The Hirshhorn Museum and Sculpture Garden currently owns *Stupa Garden with Urn* (1959), *Round Table and Heather* (1963), *Rooftops, Rain* (1967), and a drawing, *Churches at Santorini* (1959).

18. Leslie Katz, introduction to *5 American Painters* (New York: M. Knoedler, 1963).

19. Lawrence Campbell, "Five Americans Face Reality," *ARTnews*, September 1963.

20. Irving Sandler, "In the Art Galleries: 5 American Painters," *New York Post*, September 22, 1963.

21. John Gruen, "5 'Loners' with High Standards," *New York Herald Tribune*, September 22, 1963.

22. Martica Sawin, "Good Painting—No Label," *Arts* 37 (September 1963): 38.

23. Charles A. Wagner, "World of Art," *New York Mirror*, September 22, 1963.

24. Jack Kroll, "Jane Streeters," *Newsweek*, September 23, 1963.

25. Stuart Preston, "A Tour of Variety Fair; Whitney Retrospective[;] A Realist Quintet," *New York Times*, September 22, 1963.

26. Robert A. Wilson, *Seeing Shelley Plain: Memories of New York's Legendary Phoenix Book Shop* (New Castle, DE: Oak Knoll Press, 2001), 4. The book's dedication reads: "For Marshall Clements, who reawakened my interest in books and poetry, and most importantly took me to the Phoenix Book Shop for the very first time."

27. Nell's collections of stamps and shells—like her obsessive cataloguing of her artworks—reflected her drive to manage the few aspects of her postpolio life over which she was able to exert control.

28. Elizabeth Ames letter to Nell Blaine, October 2, 1963, Yaddo Records.

29. Letter to Elizabeth Ames, October 8, 1963, Yaddo Records. Nell and Evans stayed at what was then known as Finnerty's Wharf in the summer of 1963.

30. Howard Griffin, "Nell Blaine—Paintings of Greece," unpublished essay, 1962, Blaine Collection, VCU.

31. Galway Kinnell (1927–2014) won the Pulitzer Prize in 1983 for his book *Selected Poems* (1982); it was also one of the two National Book Award winners that year. Significantly, Nell once wrote to him that his poem "The Avenue Bearing the Initial of Christ into the New World" (from *What a Kingdom It Was*, 1960) was one of her "favorite poems of all time—of <u>any</u> time." The setting of this long poem is Avenue C on the Lower East Side. Beginning with the sounds of baby birds and tugboats, a pushcart, a blaring horn, and the squealing brakes of a bakery truck, the poem introduces an elderly Jew near death and a cigar-puffing Catholic embalmer, a cross-cultural jumble of shop signs, an old woman who sells newspapers she can't read, damaged produce, slaughtered animals, and dead fish. In its trajectory, the poem folds in other forms of death—Christ on the cross, Jews murdered in concentration camps, imminent death (a man trapped in a burning building), and death memorialized (by church bells). A street that initially seemed so alive becomes "This God-forsaken avenue bearing the initial of Christ."

32. Ned Rorem, *The Later Diaries of Ned Rorem: 1961–1972* (New York: Da Capo, 2000), 91 (March 10, 1964).

33. Quoted in Joan Peyser, *The Music of My Time* (New York: Pro/Am Music Resources, 1995), 85.

34. Headquartered in New York, the Longview Foundation gave grants to the International Ladies' Garment Workers' Union and other organizations to start an art collection, with the intention of helping up-and-coming artists. (They included Leland Bell, Robert De Niro, Hyde Solomon, Alfred Leslie, Kenneth Noland, and Milton Resnick.) The art committee included Meyer Schapiro, Hans Hofmann, Adolph Gottlieb, and Thomas Hess. In 1963–64, the foundation published two issues of a magazine, *Location*, edited by Hess and Harold Rosenberg.

35. Although the museum still owns several of Nell's early and late prints in various media, none of her paintings are part of the current collection.

36. "Dilys Evans," Report No. 1662 [To accompany HR 9054], House of Representatives, 87th Congress, May 8, 1962, 3.. The report describes Nell's assets as being "in excess of $25,000"—surely an exaggeration—and notes that "Miss Evans is not paid any salary for [her] services but does receive room, board, and an occasional gift from her patient." Of course, it would not have helped her case to disclose the true nature of her relationship with Nell.

37. Sue Dickinson, "Richmond-Born Artist Has New York Exhibit," *Richmond News Leader*, April 24, 1966.

CHAPTER 8

1. Postcard to Edith Burckhardt, February 4, 1963, Blaine Diaries and Correspondence, Harvard.
2. Letter to Elizabeth Ames, "Friday 3rd day out" [probably April 17, 1964], Yaddo Records.
3. In Paris, Nell and Evans would dine with the Blys and Ashbery. Unfortunately, no details about this get-together have surfaced.
4. Letter to Ames, "Friday 3rd day out" [probably April 17, 1964], Yaddo Records.
5. Nell reported this journey as "2-1/2 miles," but it is actually just a little over one mile.
6. Howard Griffin (1915–76) typed the manuscript of Auden's book-length, Pulitzer Prize–winning poem, *The Age of Anxiety*, published in 1947.
7. Letter to Bob Wilson, August 16, 1964, Wilson Papers.
8. A framed lithograph Nell made of a Dorset garden view appeared in an ad for Celanese Arnel in a midsixties issue of a fashion magazine. The model, wearing an embroidered coat, glances away from the print as if unsure of her selection. (Further identifying information is missing in the tearsheet, Blaine Papers, AAA.)
9. The six-day Harlem Riots began on July 18, two days after a police officer fatally shot a fifteen-year-old African American boy wielding a knife.
10. Letter to Bob Wilson, October 1, 1964, Wilson Papers.
11. Whether or not he said it, this was not true.
12. Postcard to Elizabeth Ames, October 19, 1964, Yaddo Records.
13. Letter to Lee Bell, September 8, 1965, courtesy of Temma Bell. Nell mentioned in the letter that John Ashbery (who was then working as the art critic at the *International Herald Tribune*) had taken her to the studio.
14. Author's telephone interview with Dilys Evans, January 24, 2017. In 1964, sixty-year-old Hélion had been married for two years to his third wife, but was likely not above flirting with a pretty stranger.
15. Author's telephone interview with Dilys Evans, January 24, 2017.
16. Letter to Bob Wilson, July 29, 1965, Wilson Papers.
17. Banana cultivation began in the 1920s, replacing the once-dominant sugarcane industry (which lost out to worldwide cultivation of sugar beets); bananas became the major crop in the 1950s. In 1979, St. Lucia became an independent member of the British Commonwealth.
18. *St. Lucia Environmental Profile*, prepared by the Caribbean Conservation Association for The Government of St. Lucia, Ministry of Planning, Personnel, Establishment and Training, 1991, 21, http://www.irf.org/wp-content/uploads/2015/10/StLuciaEnvironmentalProfile.pdf.
19. Letter to Bob Wilson, July 29, 1965, Wilson Papers.
20. Letter to Leland Bell, September 8, 1965, courtesy of Temma Bell.
21. Letter (written on the backs of several postcards) to May Sarton, September 8, 1965, Sarton Papers.

22. Quoted in Alan Gussow, *A Sense of Place: The Artist and the American Land* (San Francisco: Friends of the Earth Foundation, 1997), 136, 138.

23. Letter to Galway Kinnell, August 6, 1965, Kinnell Papers.

24. Letter to May Swenson, September 8, 1965, Swenson Papers.

25. May Swenson, *Nature: Poems Old and New* (New York: Mariner Books, 2000), 199–201.

26. Author's telephone interview with Dilys Evans, January 24, 2017.

27. Letter to Galway Kinnell, August 6, 1965, Kinnell Papers.

28. Postcard to Galway Kinnell, April 22, 1965, Kinnell Papers.

29. Letter to Galway Kinnell, June 30, 1965, Kinnell Papers.

30. In 1968, Kinnell also contributed a poem to a Christmas card designed by Nell, which reproduced her drawing of wildflowers in a glass. She had pursued him for several years about this project, suggested by book dealer Robert Wilson,

31. Letter to Swenson, September 8, 1965, Swenson Papers.

32. Quoted in Sue Dickinson, "Richmond-Born Artist Has New York Exhibit," *Richmond Times-Dispatch*, April 24, 1966.

33. Letter to Galway Kinnell, June 30, 1965, Kinnell Papers.

34. Quoted in Dickinson, "Richmond-Born Artist Has New York Exhibit."

35. Local police contacted Scotland Yard, and the sender of the letter was eventually apprehended.

36. Letter to Galway Kinnell, August 6, 1965, Kinnell Papers.

37. See letter to May Swenson, September 8, 1965, Swenson Papers.

38. John Gruen, "Nell Blaine," *New York Herald Tribune*, April 9, 1966.

39. John Ashbery, "Nell Blaine," *ARTnews* 65 (April 1966): 14.

40. Letter to Robert Wilson, July 29, 1966, Wilson Papers.

41. Letter to Galway Kinnell, May 22, 1966, Kinnell Papers.

42. Postcard to Galway Kinnell, August 10, 1966, Kinnell Papers.

CHAPTER 9

1. Letter to May Swenson, October 2, 1966, Swenson Papers. Sixteen months later, Nell's simmering anger resurfaced in her diary, in a note about how Dilys had burned her letters. "That was the 1st major pain you caused me, dictated by your cowardice. I can feel some forgiveness but not complete forgiveness for you did this at the peak of your supposed love! I should have taken more note of this action at the time." Diary, February 2, 1969.

2. Diary, October 23, 1966

3. Diary, January 16, 1967.

4. Diary, January 18, 1967.

5. Diary, January 19, 1967.

6. Diary, August 21, 1967.

7. Dr. Peyser (1925–2015) was affiliated with the Mount Sinai Medical Center Department of Psychiatry from 1965 to 2015. According to "Herbert Peyser

Obituary" (*New York Times*, April 14, 2015), he was "admired for his vast intellect and erudition, unflinching directness, dedication to this patients, and his way with a joke."

8. Carolyn Harris, "The Story of C," unpublished narrative, 1997, courtesy of Carolyn Harris. All quotes from Harris in this chapter not otherwise attributed are from this document.

9. In correspondence, Clarence Harris disputed details in published accounts of the sit-in and its aftermath. He was primarily concerned with the resulting loss of business from white customers. To ease the burden on his store, he initially proposed to eleven local restaurant owners that Woolworth's would desegregate if the others would follow suit. See UNC Greensboro Civil Rights Collection, http://libcdm1. uncg.edu/cdm/search/collection/CivilRights/searchterm/Clarence%20Lee%20 Harris/order/nosort.

10. Carolyn Harris believes that the character of Margaret in one of Bertha Harris's novels (a woman who commits suicide) is based on her. Bertha Harris died in 2005.

11. Diary, July 20, 1972.

12. Author's interview with Carolyn Harris, New York, February 13, 2017.

13. Author's interview with Celia Eldridge, Gloucester, Massachusetts, July 25, 2017. Carolyn related this to Eldridge after Nell's death. This proscription apparently did not extend to group exhibitions; Carolyn showed work at the National Academy of Design Annuals in 1982, 1984, 1990, and 1996, and at small galleries, as well as in Sun and Sea: American Watercolors at the Tibor de Nagy Gallery in 1993. By the 1990s, Nell may have been too preoccupied with her health to keep tabs on this activity, or to protest.

14. Author's interview with Mary Weissblum, July 25, 2017, Gloucester, Massachusetts. Similarly, Beverly Reynolds, Nell's Richmond dealer, recalled that when her ten- and eleven-year-old children played the board game *Sorry!* with the artist, she "won and mischievously delighted in her victory." Beverly Reynolds, "Visits with Nell Blaine," in *Nell Blaine: Sensations of Nature* (Richmond, VA: March Art Gallery, University of Richmond Museums, 2001) 9.

15. Author's telephone interview with Barry Gifford, a friend of Clements, October 3, 2017.

16. Franju is best known for his documentaries, including *Le sang des bêtes* (about the workings of a slaughterhouse) and *Hôtel des invalides*, about a veterans' hospital. He also made the horror film *Les yeux sans visage* (*Eyes without a Face*).

17. Baker was a Welshman, a friend of Richard Burton; he played tough guys in Hollywood movies, including a commander in *The Guns of Navarone*.

18. Diary, "Schedule for Marion," September 14, 1975.

19. Diary, November 19, 1966.

20. Diary, January 14, 1967.

21. Letter to Nell Blaine, undated, with no signature visible, Blaine Papers, AAA.

22. Diary, May 16, 1967.

23. Diary, August 14, 1967.

24. Letter to Mary Kohler, described in Diary, September 12, 1967.

25. Diary, July 25, 1968.

26. Diary, January 29, 1969.

27. Nell wrote to Theresa Pollak in mid-April 1969 that she wished she could see Pollak's New York show, but she couldn't leave the apartment because her aide was new.

28. Diary, May 22, 1968.

29. Letter to Galway Kinnell, October 2, 1969, Kinnell Papers.

30. Diary, January 9, 1970.

31. Diary, May 25, 1971.

32. Diary, March 30, 1973.

33. Diary, November 28, 1974.

34. Diary, April 8, 1973.

35. Diary, August 1, 1968.

36. Letter to Charlotte Clark, November 7, 1977, Blaine Collection, VCU.

37. Letter to Charlotte Clark, April 27, 1985, Blaine Collection, VCU.

38. Letter to Charlotte Clark, July 13, 1986, Blaine Collection, VCU.

39. Diary, May 17, 1982.

40. Diary, January 18, 1984.

41. Diary, August 29, 1978.

42. Author's interview with Carolyn Harris, New York, November 13, 2017.

43. Diary, July 20, 1977.

44. Author's telephone interview with Dr. Barry Weiner, October 12, 2017.

45. Author's interview with Mary Weissblum, July 25, 2017, Gloucester, Massachusetts.

46. Diary, June 22, 1968.

47. Diary, August 15, 1969.

48. Diary, February 24, 1968.

49. Diary, March 13, 1971.

50. Diary, April 16, 1974.

51. Kriezi left him in May 1971 to return permanently to Greece. Clements was previously married to a lesbian.

52. Barry Gifford's novel *Landscape with Traveler: The Pillow Book of Francis Reeves* (New York: Seven Stories Press, 1980) is based on Clements's life as a gay man who lived in Paris, Mykonos, and New York.

53. Diary, January 17, 1979. Gifford subsequently wrote an introduction about Clements, published in the 2013 edition of the book.

54. Author's telephone interview with Phyllis Weiner and Dr. Barry Weiner, October 12, 2017.

55. James Schuyler, "The View from 210 Riverside Drive," *ARTnews* 67 (May 1968): 37. Blaine painted this canvas in 1967 from a neighbor's north-facing apartment, a view she would employ again twelve years later for another rooftop painting.

56. The women returned to the house, owned by James and Ursula Henderson, in July and August 1969.

57. Quoted in Alan Gussow, *A Sense of Place: The Artist and the American Landscape* (San Francisco: Friends of the Earth Foundation, 1997), 136. All quotes from Blaine in this paragraph are taken from Gussow's essay. Blaine was especially pleased with this "really lovely" book.

58. *Art Now: New York* 2 (January 1970), quoted in Edward Bryant, "Nell Blaine," in *Nell Blaine* (Hamilton, NY: Picker Gallery, Colgate University, 1974), exhibition catalogue, unpaginated.

59. Diary, March 9–11 and March 13, 1969.

60. Letter to May Swenson, January 30, 1969, Swenson Papers.

61. Diary, February 1 and February 6, 1969 (but dated September 28, 1974).

62. Nell mentions this in a letter to Theresa Pollak, February 17, 1971, Pollak Papers. She wrote that she was "pondering the matter and wondering if I could manage this and not break my continuity in painting. A most difficult decision!" (I have not been able to discover which "great publisher" proposed this book.) Nell was still pondering months later, when she mentioned her dilemma to Denise Levertov (postcard to Levertov, September 4, 1971, Levertov Papers).

63. Transcribed in Diary, April 24, 1971.

64. Diary, January 30, 1969.

65. For what it's worth, Theresa Pollak, Nell's former teacher in Richmond—who would have been well aware of Dora Blaine's antipathy to her daughter's modernist tastes in art—had written to Blaine in 1962 that her mother "seems to have become genuinely interested in art and is certainly wholeheartedly 'with you.'"

66. Letter to Galway Kinnell, December 29, 1967, Kinnell Papers.

67. Dora Blaine letter to Nell Blaine, Monday, April 15, [1968].

68. Letter to Janice Ritter McMurray, January 11, 1971, Blaine Collection, VCU.

69. Letter to Theresa Pollak, 1971, Pollak Papers.

70. Letter to Theresa Pollak, February 17, 1971, Pollak Papers.

71. Diary, February 3, 1971.

72. Diary, January 31 and March 8, 1971.

73. Letter to May Swenson, January 30, 1969, Swenson Papers.

74. Daisy Aldan (1918–2001) was a former child star, a member of the cast of *Let's Pretend* on CBS radio, which offered adaptations of classics and fairy tales. She was twelve when her first poem was published, in the influential magazine *Poetry*. Grace Hartigan painted Aldan and her lover, Olga Petroff, in fancy dress in *Two Women*.

75. Robert Duncan letter to Denise Levertov, June 10, 1959, in Robert J. Bertholf and Albert Gelpi, eds., *The Letters of Denise Levertov and Robert Duncan* (Stanford, CA: Stanford University Press, 2004), 177. Duncan wrote that he and Jess "have the highest admiration for her work."

76. Aldan was a cofounder of the press with Richard Miller, her husband-in-name-only, and master printer Floriano Vecchi, who was Miller's lover.

77. See Terence Diggory, "*Folder* and *A New Folder*," in *Encyclopedia of the New York School Poets* (New York: Facts on File, 2009).

78. Blaine letter to Daisy Aldan, "Thursday" [postmark illegible, but 21st Street address and handwriting indicate prepolio date], Aldan Papers.

79. Letter to Galway Kinnell, December 6, 1968, Kinnell Papers.

80. Quoted in Bryant, "Nell Blaine."

81. Diary, written on February 21–23, 1969, pages but dated "Summer 1971." She copied the letter on these pages.

82. Lawrence Campbell, "Nell Blaine," *ARTnews* 69 (September 1970): 10.

83. Gerrit Henry, "New York Letter," *Art International* 14 (November 1970): 72; letter to Theresa Pollak, 1971, Pollak Papers.

84. James R. Mellow, "The Flowering Summer of Nell Blaine," *New York Times*, October 11, 1970.

85. Sue Dickinson, "Art Dehumanization Irks Ex-Richmonder," *Richmond Times-Dispatch*, October 4, 1970.

86. It was standard practice for an artist exhibiting at a gallery to be required to pay for all or a share of catalogue and announcement printing expenses and mailing costs. Whether justified or not, Nell also had a number of complaints about the Poindexter Gallery, which she spelled out in a March 5, 1970, letter to director Hal Fondren. Among her worries was the whereabouts of her painting *Boats at Gloucester*, for which she claimed she was never paid. Letter copied into her March 5, 1970, diary entry.

87. Diary, May 8, 1974.

88. Diary, October 15, 1970.

89. Diary, October 24, 1970.

90. McMurray interview.

91. Diary, July 11, 1976.

92. Diary, March 5, 1982.

93. Diary, March 7, 1971.

94. Diary, March 29, 1971. Two days later, Calley was sentenced to life imprisonment and hard labor at Fort Leavenworth; the following day, President Nixon ordered him transferred to house arrest at Fort Benning; he served just three and a half years.

95. Letter to Charlotte Clark, June 26, 1971, Blaine Collection, VCU.

96. Letter to Theresa Pollak, July 13, 1971, Pollak Papers. In reality, the house is too far from the water for those sounds to be heard.

97. Letter to Theresa Pollak, January 11, 1972, Pollak Papers.

98. It was published by Knopf in 1980.

99. The drawing appears on the cover of catalogue no. 100 (undated). Nell wrote to Wilson to persuade him to have the cover printed by a printer she had worked with for a quarter century. She offered to pay the difference between his charge and what Wilson's printer would have charged—typical of her dedication to high-quality printing despite her financial straits.

100. Postcard to Theresa Pollak, July 13, 1971, Pollak Papers.
101. Diary, June 26, 1971.
102. Diary, July 12, 1971.
103. Diary, July 30, 1971, continued on July 31 page.
104. Diary, August 9, 1971.
105. Diary, August 25, 1971.
106. Diary, October 6, 1971.
107. Diary, October 12–13, 1971. As it happened, the *Post*'s ownership was of short duration; Milton and Judith Esterow purchased *ARTnews* in 1972.
108. Diary, October 22, 1971.
109. Letter to May Swenson, February 15, 1970, Swenson Papers.
110. Diary, December 26, 1971.
111. Diary, December 31, 1971.
112. Nell Blaine, "Getting with Lester and Mondrian in the Forties," in *Jazz and Painting*, exhibition catalogue (Keene, NH: Louise E. Thorne Memorial Art Gallery, Keene State College, 1972).
113. Nell's work was also part of an earlier Kansas City Art Institute group show, Six Painters (1963).
114. Diary, April 8, 1972.
115. Denise Levertov letter to Robert Duncan, June 14, 1959, in Bertholf and Gelpi, *The Letters of Denise Levertov and Robert Duncan*, 178.
116. Nell Blaine, "The Act of Painting," *Women and Art*, Summer/Fall 1972.
117. Letter to Theresa Pollak, May 20, 1971, Pollak Papers.
118. Diary, May 18, 1972. This was a significant amount, corresponding to more than $24,000 today, accounting for inflation.
119. Diary, July 25, 1972, copy of letter to First National City Bank. Banks had begun issuing general-purpose credit cards in 1966.
120. Diary, June 15, 1972.
121. Letter to Charlotte Clark, June 24, 1972, Blaine Collection, VCU.
122. Author's telephone interview with Norman Stone, July 5, 2017. Nell recalled that the Stones paid her aide's salary as well as Harris's and provided studios for both of them. Ray interview.
123. Ray interview.
124. Diary, August 14, 1972.
125. Diary, July 20, 1972.
126. Lawrence Campbell, "Nell Blaine," *ARTnews* 71 (December 1972): 10.
127. Nell Blaine letter to Eric Brown, March 15, 1992, courtesy of Eric Brown.
128. Diary, January 3, 1972.
129. Diary, written on March 5, 1969, page but dated " '73."
130. Diary, March 7, 1973.
131. Diary, written on April 18–19, 1969, pages but dated "5/29-30/73."
132. McMurray interview.

133. Letter to Galway Kinnell, undated but probably early 1973, Kinnell Papers.
134. Diary, May 4, 1973.
135. Diary, written on March 15–20, 1969, pages but dated "June 11, 1973."
136. Diary, October 22, 1970.
137. Diary, June 6, 1973.
138. Diary, October 17, 1975.
139. Letter to Dilys Evans, December 11, 1977, courtesy of Dilys Evans.
140. Diary, June 21, 1973
141. Diary, written on February 29, 1969, page but dated "1972 or 3."
142. Diary, June 22, 1972.
143. McMurray interview.
144. Diary, May 30, 1973. Written after she had painted all night.
145. Months before the women set out for this trip, Elinor sent a letter with detailed diagrams of possible adjustments in a bathroom so that Nell's wheelchair could be accommodated.
146. Diary, October 10, 1973.
147. Two years earlier, Nell had lamented the fact that the museum collection contained only two watercolors of hers, one of them a "studentish" one. A VCU student, Janice Ritter, had interviewed her for a class project and persuaded a local church to show one of her paintings, in hopes that the museum director would want to purchase it, but that did not happen. Nell Blaine letter to Theresa Pollak, May 20, 1971, Pollak Papers.
148. Diary, November 19, 1973.
149. Barbara Green, "City Native Pays Rare Visit as Her Art Goes on Display," *Richmond News Leader*, November 20, 1973.
150. Card to Theresa Pollak, January 13, 1974, Pollak Papers.
151. Diary, December 26, 1973.
152. Diary, January 4, 1974.
153. Diary, January 30, 1974.
154. Diary, April 16, 1974.
155. Diary, April 7, 1974.

CHAPTER 10

1. The exhibition—Nell Blaine: Works, a Selection of 65 Oils, Watercolors, Drawings, and Prints, from 1955 to 1973—was organized by the Picker Art Gallery, Colgate University, Hamilton, New York, and circulated by the Gallery Association of New York State to four venues within the state.
2. Malcolm Preston, "Joyous Impressions," *Newsday*, July 31, 1974.
3. West Wharf no longer exists; it collapsed into the water in August 1996.
4. Letter to Charlotte Clark, April 11, 1974, Blaine Collection, VCU.
5. Card to Elizabeth Ames, director of Yaddo, December 16, 1974. Yaddo Records.

6. Carolyn Harris letter to author, July 13, 2017, courtesy of Carolyn Harris.

7. Rosie Sultan, "Nell Blaine's Paintings Recapture Gloucester's Past" [2001], *Gloucester Times*, Blaine Papers, Cape Ann Museum Research Library and Archives.

8. The title is confusing: Rackliffe and Wiley are parallel streets.

9. However, Nell was not supposed to eat spicy food, because of damage to her throat when a tube was removed during her hospital stay in 1959.

10. Diary, August 21, 1974.

11. Diary, July 22, 1974.

12. Letter to Charlotte Clark, August 24, 1974. Blaine Collection, VCU.

13. Eleanor Munro, *Originals: American Women Artists* (New York: Simon & Schuster, 1979), 270.

14. Letter to Charlotte Clark, August 9, 1974, Blaine Collection, VCU.

15. According to Martica Sawin, *Nell Blaine: Her Art and Life* (New York: Hudson Hills Press, 1998), 100.

16. Diary, December 26, 1974.

17. The application was dated December 2, 1974.

18. Letter to Charlotte Clark, January 21, 1975, Blaine Collection, VCU.

19. Norman Stone doesn't recall this request or his response.

20. Diary, May 7, 1975.

21. Letter to Charlotte Clark, January 21, 1975, Blaine Collection, VCU.

22. Deadheading is the activity of removing dead flowers from a plant to encourage further blooming.

23. Untitled statement, n.d. [probably 1980s or 1990s], Blaine Papers, Cape Ann Museum Research Library and Archives.

24. Quoted in Rosemary Kent, "The Passionate Gardner: Nell Blaine," *Countryside*, November/December 1992, 67.

25. Letter to Martin Ray, March 22, 1982, courtesy of Martin Ray.

26. Martin Ray, "Painter in the Garden—Working with Nell Blaine," unpublished PowerPoint talk, courtesy of Martin Ray. All quotes not otherwise identified are from this source.

27. Letter to Martin Ray, January 28, 1993, courtesy of Martin Ray.

28. Letter to Martin Ray, February 3, 1990, courtesy of Martin Ray.

29. Letter to Jane Freilicher, n.d., Freilicher Papers, Harvard.

30. Author's telephone interview with Martin Ray, June 16, 2017.

31. Letter to Martin Ray, July 8, 1987, courtesy of Martin Ray.

32. Author's telephone interview with Peter Dickison, September 26, 2017.

33. Diary, June 26, 1977.

34. Ray, "Painter in the Garden—Working with Nell Blaine."

35. Diary, August 16, 1982.

36. Diary, July 22, 1977.

37. Diary, November 5, 1975.

38. Quoted in Pat Van Gelder, "Close to Home," *American Artist* 54 (February 1990): 69.

39. Beginning in 1863, the factory made copper paint for the maritime industry. The paint protected the hull of a vessel from barnacles and grasses, replacing the heavy and expensive copper sheeting used previously.

40. Quoted in David L. Shirey, "Nell Blaine's Cheerful Palette at the Parrish Museum," *New York Times*, July 21, 1974.

41. Gloucester also figures in literary history: Nineteenth-century visitors included Hawthorne, Emerson, Thoreau, and Rudyard Kipling. Henry James sat for a charcoal portrait by Cecilia Beaux in 1911. T. S. Eliot, who had spent summers in Gloucester, memorialized the rocks known as the Dry Salvages in 1941 in the eponymous third poem of *Four Quartets*: "And the ragged rock in the restless waters, / waves wash over it; fogs conceal it…" Poet Charles Olson settled in Gloucester in 1956.

42. Born Nathaniel Rogers Lane, Fitz Henry Lane (1804–65) changed his name as a young man; until a discovery in 2005, he was known by art historians as Fitz *Hugh* Lane. His Transcendentalist beliefs seem to have been reflected in his tranquil paintings. Although Nell's canvases were utterly different, she admired his work.

43. There are no known women artists of stature who painted Gloucester scenes during the first half of the twentieth century. Cecilia Beaux—who summered in Gloucester beginning in 1905 and died there in 1942—was a highly regarded portrait painter, but her work did not reflect her environment.

44. For information about Sloan and Davis in Gloucester, I am indebted to Britt Crews's essay and Helen Farr Sloan's introduction in *The Red Cottage* (Gloucester, MA: Cape Ann Historical Society, 1992) .

45. Over five summers in Gloucester, Sloan completed nearly three hundred paintings.

46. In later years, Davis stayed with his mother, who owned a house in East Gloucester.

47. Stuart Davis, "Autobiography," in. in *Stuart Davis*, ed. Diane Kelder (New York: Praeger, 1971), 25.

48. Statistic is from wall label, Cape Ann Museum, Gloucester, Massachusetts.

49. Marsden Hartley letter to Alfred Stieglitz, August 2, 1920, quoted in Townsend Ludington, *Marsden Hartley: The Biography of an American Artist* (Boston: Little, Brown, 1992), 152n2.

50. Marsden Hartley, *Somehow a Past: The Autobiography of Marsden Hartley* (Cambridge, MA: MIT Press: 1996), 143, cited in Martha Oaks, *Marsden Hartley: Soliloquy in Dogtown* (Gloucester, MA: Cape Ann Museum, 2012), 9n12.

51. Hartley held the still lifes and other work of Helen Stein (1888–1965) in high regard. She settled in Gloucester, after studies at the Art Students League and Cooper Union and in Paris, and married Ernest Thurn, who ran an art school; unfortunately, the two men detested each other.

52. Marsden Hartley, "Somehow a Past," autobiographical sketch, Beinecke Rare Book and Manuscript Library, Yale University, quoted in James F. O'Gorman, "Marsden Hartley: 'The' Painter of Dogtown," in Oaks, *Marsden Hartley*, 18n25.

53. Marsden Hartley letter to Adelaide S. Kuntz, October 22, 1931, quoted in Ludington, *Marsden Hartley*, 201n36.
54. Another jarring experience occurred after striking up a conversation on East Main Street, near his lodgings, with a man who invited him into a small hut, showed him pornographic postcards, and undid his fly. Hartley was gay, but he hated vulgarity. See Ludington, *Marsden Hartley*, 39.
55. James Mellow, "Nell Blaine" (tribute for her memorial service, January 1997), published in *Nell Blaine* (Gloucester, MA: Cape Ann Historical Museum, 2000), 5.
56. Oral history interview with Sally Michel Avery, November 3, 1967, AAA.
57. In the early thirties, a trio of fellow New York painters and their wives came to visit the Averys: Adolph Gottlieb, Barnett Newman, and Mark Rothko. But none of them appear to have memorialized Cape Ann; Rothko's gloomy beach scenes of the early thirties were painted near Portland, Oregon.
58. The Granite Shore Gallery in Rockport, Massachusetts (Fall Show, 2000)— Carolyn Harris was also among the six artists in the exhibition—and the Valerie Carberry Gallery in Chicago (Landscape, 2005), with Stuart Davis, John Sloan, John Marin, William Glackens, Carolyn, Louisa Matthíasdóttir, Robert De Niro, Alex Katz, and others.
59. Author's interview with Mary Weissblum, Gloucester, Massachusetts, July 25, 2017.
60. Author's interview with Celia Eldridge, Gloucester, Massachusetts, July 25, 2017.
61. Diary, October 18–19, 1974.
62. Diary, October 19, 1974.
63. Nell was annoyed that the Literary Guild Book Club edition, titled simply *Love Poems*, "will be [the Guild's] typical crappy production. Shockingly cheap paper and boring type." Letter to Charlotte Clark, August 24, 1974, Blaine Collection, VCU.
64. The royalties went to a frail, impecunious older sister of Garrigue's.
65. Another award she had unsuccessfully applied for in the midfifties was a UNESCO (United Nations Educational, Scientific and Cultural Organization) grant; she was told that she was one of two finalists.
66. Diary, November 14, 1974.
67. Diary, November 17, 1974.
68. Founded in 1940 as Professional Arts Group of Washington Heights, this group met at the site of John James Audubon's homestead; hence the name, officially adopted in 1942. See "Our History" at audubonartists.org.
69. Diary, January 6, 1975.
70. Diary, January 8, 1975.
71. Diary, January 10, 1975.
72. Diary, January 19, 1975.
73. Diary, February 22, 1975.
74. Diary, June 7, 1975.
75. Diary, July 13, 1975.

76. Diary, August 15 and September 14, 1975.

77. Diary, January 13, 1976.

78. Diary, September 18, 1975.

79. Auden's grave is in Kirchstetten, near Vienna.

80. Diary, October 7, 1975. Decades earlier, she had declared her dislike of "psychologically morbid" work, which struck her as "weighted down on one end like a see-saw with one rider" (Diary, July 17, 1958).

81. Author's telephone conversation with Carolyn Harris, March 26, 2018.

82. Letter to Charlotte Clark, March 27, 1977, Blaine Collection, VCU.

83. Alonzo Gibbs, "The Kinsman Affair," *Long Island Forum*, October 1976, 228, Blaine Collection, VCU (Blaine wrote "true" next to this description).

84. Howard Griffin, "Nell Blaine: Paintings of Greece," typed essay, London, 1962, Blaine Collection, VCU.

85. Letter to Charlotte Clark, January 5–6, 1976, Blaine Collection, VCU.

86. They are now at the New York Public Library, in the Howard Griffin Collection of Papers, 1942–75.

87. Edward Field, *The Man Who Would Marry Susan Sontag* (Madison: University of Wisconsin Press, 2007), 67.

88. Grey Fox Press publisher Donald Allen kept Nell apprised of sales, which tapered off precipitously in the mid-1980s, and sent royalty checks to her (Allen Collection).

89. *Conversations*, like *Howard Griffin: Four Poems*, was published by San Francisco–based Grey Fox Press.

90. The artists included William Coldstream, Malcolm Morley, and Duncan Grant. Nell also noted the inclusion of a "somewhat sentimental & naïve but well painted…touching & sincere" canvas by David Lichtenfeld, *Dying Soldier, Bidding Farewell to His Horse*. Letter to Charlotte Clark, March 27, 1977, Blaine Collection, VCU.

91. Hugh Trevor-Roper's brother, Patrick, an eye surgeon and gay rights activist, eventually bought the house for about $30,000. Author's interview with Carolyn Harris, New York, February 13, 2017.

92. Diary, August 19, 1976. One Christmas, apparently rather desperate to find a suitable gift for her beloved cousin Charlotte—who always sent her clothing and delectable foodstuffs—she looked through her collection of books from Howard Griffin's library and choose a dusty volume about the painter J. M. W. Turner.

93. Robert A. Wilson, "Encountering Auden in an Obscure Mountain Village," *W. H. Auden Society Newsletter* 15, November 1966, http://audensociety.org/15newsletter.html.

94. Draft of letter to Judith Goldman, February 3, 1976, Blaine Papers, AAA.

95. Patricia Mainardi, "Nell Blaine," *ARTnews* 75 (Summer 1976): 180. In a departure from previous catalogues, Blaine added a sentence on the inside back cover thanking "the painter Carolyn Harris for her tireless and unselfish help" as well as her helper David Acker.

96. Diary, July 14, 1976.
97. Diary, July 16, 1976.

CHAPTER 11

1. Letter to Robert Wilson, n.d. [page 1 missing], Wilson Papers.
2. Postcard to Charlotte Spence, postmarked August 21, 1979, Blaine Collection, VCU.
3. Postcard to Celia Finberg [Eldridge], August 19, 1978, courtesy of Celia Eldridge.
4. Card to May Swenson, November 25, 1979, Swenson Papers.
5. According to Martica Sawin (*Nell Blaine: Her Art and Life* [New York: Hudson Hills Press, 1998], 110), this remark is in Nell's letter to Charlotte Clark, January 17, 1980, but that letter (in the Blaine Collection, VCU) does not contain this quote. In fact, none of the letters to Clark in this collection contain these words. Yet they sound like something Nell would write.
6. Letter to Theresa Pollak, May 8, 1979, Pollak Papers. In another letter to Pollak, Nell mentioned having seen mountains only "once or twice when I was a child."
7. Author's interview with Carolyn Harris, New York, February 13, 2017.
8. Diary, August 6, 1979. In addition to the pine and fir trees, there were beeches and hemlocks, surrounded by farmland.
9. Diary, August 18, 1979.
10. Diary, August 25, 1979.
11. John Ashbery, "Icing on the Divine Cake," *New York Magazine*, May 17, 1979, 90.
12. Letter to Theresa Pollak, n.d., postmarked August 25, 1979, Pollak Papers.
13. Diary, September 26, 1979.
14. Diary, September 29, 1979. Mantegna's fresco cycle in the Cappella Ovetari, largely destroyed by Allied bombing during World War II, was visible only in fragmentary form.
15. Diary, September 30, 1979.
16. Diary, July 17, 1980.
17. Blaine told an interviewer that her prices at Poindexter ranged from $1,200 to $8,000 ("something like that") for an oil painting. Jerry Tallmer, "At Home with Nell Blaine," *Village Voice*, March 9, 1977, 17.
18. Letter to Charlotte Clark, January 8, 1977, Blaine Collection, VCU.
19. Letter to Charlotte Clark, January 20, 1979, Blaine Collection, VCU.
20. Unfortunately, as she wrote after the show was over, while seventeen pictures sold, "expenses were so high there's barely any profit—after the gallery takes 50%," because of labor charges she incurred for printing (announcements, the catalogue), postage, and advertisements. Letter to Celia Eldridge, May 24, 1979, courtesy of Celia Eldridge.
21. "Is There Still Life in Still Life?" Artists Talk on Art panel discussion, April 27, 1979, AAA.
22. Ruth Bass, "Nell Blaine," *ARTnews* 78 (May 1979): 166.

23. Gerrit Henry, "Nell Blaine at Fischbach," *Art in America* 67 (September 1979): 134.

24. Ashbery, "Icing on the Divine Cake," 93.

25. Diary, November 1, 1979.

26. Prices of $8–$14 in 1980 are roughly equivalent to $23–$38 in 2017; $50 is equivalent to about $146 in 2017 dollars.

27. Earlier that autumn, Nell's work was in Nell Blaine/Alan Gussow, a two-person show at the Virginia Museum of Fine Arts. Gussow had included an interview with Nell in his book *A Sense of Place: The Artist and the American Land*, published seven years earlier.

28. Letter to Charlotte Clark, November 2, 1972, Blaine Collection, VCU. In response to this letter, Clark sent a check for an unknown amount, which enabled Blaine to travel to Richmond. After she offered Clark her choice of watercolor as a thank-you gift, her cousin asked about the value of art as investment. Nell replied that, although her own work was now worth ten times more than what it sold for twenty-five years earlier, "one has to know trends, fashions and art as well and it is NOT the reason to purchase art!!! It is a despicable reason." Letter to Charlotte Clark, February 18, 1980, Blaine Collection, VCU.

29. Letter to Lilian Kiesler, April 3, 1977, Kiesler Papers; $300 in 1977 is approximately equal to $1,200 in 2017 currency,

30. Diary, December 31, 1979, continued on January 1, 1980, page.

31. Letter to Celia Eldridge, January 10, 1980, courtesy of Celia Eldridge.

32. Letter to Charlotte Clark, January 17, 1980, Blaine Collection, VCU.

33. Ruth Vaughn Michelle letter to Nell Blaine, May 9, 1980, Blaine Diaries and Correspondence, Harvard.

34. The exhibition was at the Hirshhorn Museum and Sculpture Garden from May 22 to September 21, 1980.

35. Letter to Charlotte Clark, June 29, 1980, Blaine Collection, VCU; "Art: Paintings of Gardens," *Architectural Digest* 37 (June 1980): 70–75.

36. Letter to Charlotte Clark, June 29, 1980, Blaine Collection, VCU. Nell reported that the sales included six watercolors, three drawings, and seven paintings.

37. Author's interview with Celia Eldridge, Gloucester, Massachusetts, July 25, 2017.

38. Ray interview.

39. Diane Cochrane, "Nell Blaine: High Wire Painting," *American Artist* 37 (August 1973): 22.

40. Carolyn Harris letter to Celia Eldridge, January 6, 1980, courtesy of Celia Eldridge.

41. McMurray interview.

42. Quoted in Avis Berman, "A Decade of Progress, but Could a Female Chardin Make a Living?" *ARTnews* 79 (October 1980): 73.

43. Nell Blaine, "A Lack of Wholeness," *Women and Art*, Summer/Fall 1972.

44. McMurray interview.

45. Diary, March 12, 1983.

46. Author's telephone interview with Jim Touchton, August 31, 2017.

47. Author's telephone interview with Lawrence DiCarlo, September 6, 2017.

48. In Gloucester, Nell also showed at the Lovisco Gallery, which included work by her, Carolyn, and seven other local painters in an August 1978 group exhibition. The gallery, owned by Sophie and Niel Lovisco, closed the following year.

49. Author's telephone interview with Greg Gibson, June 25, 2017.

50. Touchton recalled that his special price was $2,000, for a painting that retailed for $10,000 to $12,000. He was so fond of the painting—which he eventually had to sell for financial reasons—that he took it with him every summer to a house he rented in East Hampton.

51. Letter to Charlotte Clark, April 3, 1981, Blaine Collection, VCU.

52. Margaret Sheffield, "Nell Blaine, Gwen John," *Art/World*, April 18–May 16, 1981, 1, 11.

53. "She's bright—was Phi Beta Cappa [*sic*]—but conventional in the main," Nell wrote to a friend, describing Charlotte Spence Clark. Letter to Jack Blanton, April 27, 1985, Blanton Collection. Years earlier, Nell mused that in her correspondence with relatives, "we never write about what really concerns us." Was it because they had no other interests, other than the lives of other relatives? "More likely they're afraid that anything of a serious nature would mean a clash of opinions," she added. Diary, January 13, 1970.

54. Letter to Charlotte Clark, April 3, 1981, Blaine Collection, VCU.

55. Diary, July 29, 1981.

56. Letter to Charlotte Clark, July 23, 1981, Blaine Collection, VCU.

57. The Reynolds/Minor Gallery show (April 30–June 5, 1982) consisted of oil paintings, watercolors, drawings, and serigraphs, mostly from the 1970s and early '80s. The top price was for *Cot and Table with Flowers* (1959). Other oil painting prices ranged from $2,500 to $9,500. Watercolors were priced from $2,000 to $2,800.

58. Blaine wrote that Gazzolo had married an older man when she was very young, "afraid of sex and innocent." She left him, never remarried, and "seemed scarred for life." Diary, January 10, 1969, page, but "written late '69 or early '70s."

59. Diary, April 6, 1982.

60. Letter to Celia Eldridge, October 16, 1986, courtesy of Celia Eldridge.

61. According to Carolyn Harris, the two women met once a year to "haggle about the rent & the chores that could lessen the rent. It would always be a long evening, something that Nell dreaded, and she was worn out by it." Letter to author, July 13, 2017, courtesy of Carolyn Harrris.

62. Letter to Celia Eldridge, May 12, 1982, courtesy of Celia Eldridge.

63. Letter to Celia Eldridge, May 20, 1982, courtesy of Celia Eldridge.

64. Letter to Celia Eldridge, July 7, 1985, courtesy of Celia Eldridge.

65. Diary, August 31, 1982.

66. Diary, January 3, 1983.

67. Letter to Theresa Pollak, February 4, 1983, Pollak Papers.

68. Letter to Martin Ray, January 7, 1983, courtesy of Martin Ray. She was probably referring to gallery clients who purchased work on an installment plan.

69. Author's interview with Mary Weissblum in Gloucester, July 25, 2017.

70. Author's telephone interview with Peter Dickison, September 26, 2017.

71. Diary, May 14, 1983. Among the Neo-Expressionists in the show were Eric Fischl, David Salle, and Julian Schnabel.

72. Fay S. Joyce, "I.R.S.'s Lithographic Challenge," *New York Times*, May 17, 1983.

73. Diary, July 13, 1983.

74. Letter to Charlotte Clark, January 20, 1986, VCU.

75. McMurray interview.

76. Nell was hugely sympathetic to the plight of wild animals. Carolyn's rescue of a Yorkshire terrier abandoned by her owner led Nell to speak feelingly about baby seals and mountain lions. "When we think of protecting animals," she told an interviewer, "we're really protecting the human race." Sue Dickinson, "Art Dehumanization Irks Ex-Richmonder," *Richmond Times-Dispatch*, October 4, 1970.

77. Letter to Jack Blanton, October 31, 1986, Blanton Collection.

78. Author's telephone interview with Peter Dickison, September 26, 2017.

79. Westin Boer, "Gloucester Is the Pull for Blaine," *Gloucester Daily Times*, July 21, 1983.

80. Author's interview with Mary Weissblum, Gloucester, Massachusetts, July 25, 2017.

81. Diary, October 15, 1979.

82. Letter to Martin Ray, January 10, 1991, courtesy of Martin Ray.

83. Gerrit Henry, "Nell Blaine at Fischbach," *Art in America* 71 (November 1983): 223.

84. Other grants included a Guggenheim Fellowship (1974), a National Endowment for the Arts grant (1975), a Creative Artists Public Service Program (CAPS) grant (1972), and Longview Foundation grants (1964, 1970).

85. Diary, January 2, 1984.

86. Letter to Mike Ward, editor, *Artists' Magazine*, August 21, 1987, courtesy of Eric Brown.

87. Diary, January 12, 1984.

88. Mentioned in Diary, May 1, 1984.

89. Diary, May 30, 1984.

90. Diary, June 15, 1984.

91. Diary, August 10, 1985.

92. Letter to Celia Eldridge, n.d. [ca. early 1984], courtesy of Celia Eldridge.

93. Letter to Celia Eldridge, May 16, 1984, courtesy of Celia Eldridge.

94. The "Hills Are Alive" sequence in *The Sound of Music* was actually filmed in Salzburg, 150 miles east.

95. Postcard to Jack Blanton, August 8, [1984], Blanton Collection.

96. Quoted in Sue Dickinson Durden, "Nell Blaine: The High Priestess of Light, Color," *Richmond News Leader*, April 22, 1979.

97. Diary, August 19, 1984.

98. Diary, August 28, 1984.

99. Letter to Celia Eldridge, August 26, 1984, courtesy of Celia Eldridge.

100. Diary, September 8, 1984.

101. Diary, September 8, 1984.

102. Author's telephone interview with Peter Dickison, September 26, 2017.

103. Diary, September 25, 1984.

104. Millicent Dillon, *A Little Original Sin: The Life and Work of Jane Bowles* (New York: Holt, Rinehart & Winston, 1981).

105. Diary, last pages [undated], 1984.

106. Carolyn Harris letter to Celia Eldridge, December 2, 1985, courtesy of Celia Eldridge. In contrast, the rent for Nell's spacious three-bedroom rent-controlled apartment increased to $617 the following December.

107. Jed Perl, "Nell Blaine," in *Nell Blaine: Recent Oils, Watercolors, Drawings* (New York: Fischbach Gallery, 1985), unpaginated.

108. Diary, March 30–31, 1985.

109. Diary, April 1, 1985.

110. By November, however, Rockefeller and the doctor had not yet paid for their works. "Collectors especially the richer ones (& these are they!) are particularly prone to this end of year payment," Nell wrote. Letter to Celia Eldridge, November 11, 1986, courtesy of Celia Eldridge.

111. Richard F. Hunnewell, "Callahan, Blaine, Leigh, Villiet, Vagliono," *Art/World*, April 17–May 17, 1985.

112. Diary, February 13, 1985.

113. Diary, December 12, 1987.

114. Nell's teacher Theresa Pollak had received an honorary doctorate from VCU in 1978.

115. Diary, May 17, 1985.

116. Typescript of lecture delivered by Nell Blaine at Moore College of Art and Design, Philadelphia, 1980, AAA.

117. Letter to Charlotte Clark, October 7, 1980, Blaine Collection, VCU.

118. Diary, August 8, 1985.

119. Steven Naifeh and Gregory White Smith, *Jackson Pollock: An American Saga* (New York: Clarkson Potter, 1989), 760.

120. Diary, September 9, 1985.

121. Diary, September 17, 1985.

122. Diary, October 1964.

123. Diary, October 11, 1985.

124. In 1988, when asked to make a scarf to be auctioned at an AIDS benefit, Nell painted flowers on silk—reminiscent of her necktie-painting job in the late 1940s.

125. Diary, January 23, 1986.

126. Diary, February 12 and February 20, 1986.

127. During these years, the Mezzanine Gallery at the Metropolitan Museum of Art exhibited and sold limited-edition prints and photographs by leading artists.

128. Letter to Celia Eldridge, April 9, 1986, courtesy of Celia Eldridge.

129. Diary, March 2, 1988.

130. Letter to Charlotte Clark, January 20, 1996, Blaine Collection, VCU.

131. Author's telephone interview with Jimmy Witt, January 30, 2018. Witt's own pay took the form of one of Nell's paintings.

132. Letter to Martin Ray, May 25, 1986, courtesy of Martin Ray.

133. Diary, May 2, 1986.

134. Diary, May 11, 1986.

135. Letter to Theresa Pollak, October 2, 1986, Pollak Papers.

136. Diary, January 6, 1979.

137. Letter to Jane Freilicher Hazan, copied in Diary, August 22, 1986.

138. Gerrit Henry, "Jane Freilicher and the Real Thing," *ARTnews* 84 (January 1985): 78–83.

139. Interviewed by Robert Doty, in Doty, ed., *Jane Freilicher: Paintings* (New York: Taplinger, 1986), 51.

140. Interview in Doty, *Jane Freilicher*, 56.

141. Antoine Watteau, *Mezzetin* (1718–20), Metropolitan Museum of Art.

142. Diary, March 22–23, 1969, pages, but probably written in the summer of 1973 or 1974, based on her notes.

143. Letter to Eric Brown, August 21, 1987, courtesy of Eric Brown.

144. This was the secret sale of weapons to Iran by the United States, part of an effort to fund the Contras in Nicaragua and free US hostages in Lebanon.

145. Diary, November 1, 1986.

146. Diary, October 28, 1986.

147. Letter to Charlotte Clark, July 13, 1986, Blaine Collection, VCU.

148. Jed Perl, "The Shows Must Go On," *The New Criterion* 6 (September 1987): 65–66. In April, Nell's show was a "Critic's Choice" in *Time* magazine; she was called "a premier American artist whose spontaneous brushstrokes and brilliant colors enrobe nature in a tender intimacy."

149. Diary, April 24–25, 1987.

150. Diary, May 8, 1987.

151. Letter to Martin Ray, July 8, 1987, courtesy of Martin Ray.

152. Diary, July 31, 1987.

CHAPTER 12

1. Diary, April 2, 3, and 4, 1988.

2. Diary, May 14, 1990.

3. Diary, October 21, 1988.

4. Diary, December 21, 1988.

5. Diary, March 30 1999.

6. Diary, May 25, 1988.

7. Diary, June 30, 1994.

8. According to DiCarlo, Albert went out of his way to introduce his wealthy clients to Nell's work.

9. In the 1991 Fischbach exhibition, prices for Nell's oil paintings from recent years were mostly in the mid-$20,000s. Watercolors were $10,000. One reason for the relatively low prices is that these works are quite small, not much larger than two feet by two feet.

10. Jerry Tallmer, "Inciting a Riot of Color," *New York Post*, March 31, 1989.

11. Ginnie Gardiner, "Nell Blaine's Wild Space," *Art/News*, April–May 23, 1989, 1, 7.

12. Letter to Eric Brown, July 2, 1989, courtesy of Eric Brown.

13. Quoted in David Hirsh, "Paint, and an Open View," *New York Native*, May 1, 1989, 23–24.

14. Quoted in Roy Proctor, "'Green Thumb': Blaine's Vibrant Flowers Grow," *Richmond News Leader*, May 1, 1992.

15. Ray interview.

16. Diary, April 5, 1990.

17. Letter to Charlotte Clark, August 23, 1988, Blaine Collection, VCU.

18. Letter to Charlotte Clark, October 4, 1989, Blaine Collection, VCU.

19. Diary, May 2, 1990.

20. Diary, May 26, 1990.

21. Letter to Charlotte Clark, April 19, 1990, Blaine Collection, VCU.

22. Copy of citation from American Academy and Institute of Arts and Letters, Blaine Collection, VCU. Nell appended a handwritten note about the dismay of her friend Academy member Jane Freilicher about a typo in the printed document—"a fulgence" for "effulgence." She added, "efulgence [*sic*] is a wonderful word!" (It means "radiant splendor.")

23. Reynolds Price, *A Whole New Life: An Illness and a Healing* (New York: Scribner, 1994), 189–90.

24. Diary, 1989 (first pages).

25. My letter to Piercy elicited an email from an assistant, stating that Piercy never had any contact with Blaine.

26. Diary, December 3, 1990. Poets and Painters (the painting show) was on view from December 3, 1990, to January 11, 1991.

27. Nell's work also had been reproduced on 1986 calendars: two published by Abbeville and one by the Bank of New York.

28. Diary, January 13, 1991.

29. Edgar Allen Beem, "Drawn to Gloucester," *Yankee*, June 1991, 76–79. I asked Beem what she might have objected to, and he had no idea; this piece was one of several profiles of well-known artists associated with New England, including Wolf Kahn and Janet Fish.

30. Diary, January 17, 1991.

31. Letter to Charlotte Clark, January 31, 1991, Blaine Collection, VCU.

32. Diary, April 22, 1991. Decades earlier, after attending a poetry reading by Levertov, Blaine wrote, "Your poetry always goes right to my heart." Letter to Levertov, January 27, 1967, Levertov Papers.

33. Letter to Eric Brown, April 25, 1990, courtesy of Eric Brown.

34. All quotes are from undated notes to Eric Brown, courtesy of Eric Brown.

35. Author's interview with Eric Brown, New York, November 8, 2017

36. Diary, March 15, 1990.

37. Letter to Charlotte Clark, July 24, 1990, Blaine Collection, VCU.

38. Diary, May 8[?], 1991.

39. Diary, May 7, 1991.

40. Nell's solo posthumous exhibitions at the Tibor de Nagy Gallery include Nell Blaine: The Abstract Work (2001); Nell Blaine: Artist in the World, Works from the 1950s (2003); Nell Blaine: Image and Abstraction, Paintings and Drawings, 1944–1959 (2007); and Nell Blaine: A Glowing Order, Prints and Watercolors (2012). Nell's work was also in several Tibor de Nagy Gallery group shows, including Drawing on Friendship: Portraits of Painters and Poets (1994), Sun and Sea (1994), The Jane Street Gallery: Celebrating New York's First Artist Cooperative (2003), and Painters & Poets: Tibor de Nagy Gallery (2011).

41. Martica Sawin, "New Work by Nell Blaine," in *Nell Blaine: Night and Day* (New York: Fischbach Gallery, 1991).

42. Ronny Cohen, "Nell Blaine," *Artforum* 29 (Summer 1991): 112.

43. "Galleries—57th Street Area: Nell Blaine," *The New Yorker*, April 15, 1991.

44. Letter to Sandra Aronson, April 25, 1991, courtesy of Eric Brown.

45. Diary, May 4, 1991.

46. Diary, January 5, 1992.

47. Diary, May 11–12, 1991.

48. Diary, written on undated last page of 1991 book. Nell mentioned the memoir on the January 9, 1992, page. She had spoken to Eric Brown about a possible collaboration with her.

49. Diary, June 28, 1991.

50. Letter to Theresa Pollak, February 16, 1972, Pollak Papers.

51. Rosemary Kent, "The Passionate Gardener: Nell Blaine," *Countryside*, November/December 1992, 66–71.

52. Diary, August 9 and 10, 1991.

53. Diary, September 19, 1991.

54. Remarks at the memorial for Leland Bell, 1991, Blaine Papers, AAA.

55. Diary, January 24, 1992.

56. Formerly known as the Reynolds/Minor Gallery, it had mounted a show of Nell's work in 1982, with two dozen paintings and watercolors spanning twenty-one years—from *Cot and Table with Flowers* (1959) to *Table with Flowers and Fruit* (1980). The exhibition included a sampling of her seasonal landscapes (*Haderlehn*

Summer; *Summer Snow, Acherkogel*; *Ledge in November*) and twilight Gloucester watercolors (*Cape Ann, Evening*; *Prow, Dusk*).

57. Diary, April 11, 1992.
58. Letter to Eric Brown, March 15, 1992, courtesy of Eric Brown.
59. Diary, January 7, 1992.
60. Letter to Martin Ray, January 2, 1992. The previous year, she suggested that "perhaps they [the flowers] are my muse." Letter to Ray, May 23, 1991. Both courtesy of Martin Ray.
61. Letter to Martin Ray, June 1, 1992, courtesy of Martin Ray.
62. Diary, April 28, 1992. Reynolds, famed for bringing major artists to Richmond in the gallery she founded in 1977, died of cancer at age sixty-eight in 2014.
63. Proctor, " 'Green Thumb' ".
64. Letter to Consumer Relations Department, Scott Paper Company, June 27, 1992, courtesy of Eric Brown.
65. Diary, June 14, 1992.
66. Diary, July 31 and August 1, 1992.
67. Diary, November 14, 1992.
68. I am using Nell's list of the speakers. Porter's biographer, Justin Spring, did not provide information about the memorial in *Fairfield Porter: A Life in Art* (New Haven, CT: Yale University Press, 1999) .
69. Diary, December 9, 1992.
70. Diary, January 29, 1993. Police later said there were ten to twelve shots; the slain woman's brother, who was with her but obeyed the gunman's order to step inside the building, said he heard twenty to twenty-five. In fact, in addition to the gunman's shots, city police and transit officers were found to have fired twenty-nine additional shots, so Nell's guesstimate was quite accurate.
71. Robert D. McFadden, "Gunman and Hostage Are Killed after Manhattan Bank Robbery," *New York Times*, January 30, 1993. It was later determined that the three shots that killed the woman were fired by police; in 1999 a jury awarded the woman's family $5.7 million. David Rohde, "Jury Awards $5.7 Million in Police Killing of a Hostage," *New York Times*, July 21, 1999.
72. Diary, February 14, 1993.
73. Diary, April 3–4 and 21, 1993.
74. Gerrit Henry, "Nell Blaine," *Art in America* 81 (December 1993): 107. .
75. Letter to Martin Ray, April 8, 1993, courtesy of Martin Ray.
76. Diary, May 5–6, 1993.
77. Diary, June 11, 1993.
78. Diary, June 27, 1993.
79. Letter to Charlotte Clark, July 12, 1993. Blaine Collection, VCU.
80. Author's telephone interview with Dr. Alisan Goldfarb, March 23, 2018.
81. Letter to Martin Ray, July 31, 1993, courtesy of Martin Ray.
82. Ray interview.

83. Diary, January 26, 1994.

84. Diary, April 25, 1994. The center, founded in 1985 to provide a quiet, elegant alternative to city hospital operating rooms, closed in 2016.

85. Diary, May 9, 1994.

86. Card to Dilys Evans, May 11, 1994, courtesy of Dilys Evans.

87. Diary, April 29, 1994.

88. Letter to Eric Brown, August 28, 1992, courtesy of Eric Brown.

89. Letters to Charlotte Clark, May 14 and September 27, 1993, Blaine Collection, VCU.

90. Diary, September 8, 1994.

91. Diary, August 20, 1994.

92. Diary, September 11, 1994.

93. Diary, October 12, 1994.

94. Quoted in Sue Dickinson Durden, "Nell Blaine: The High Priestess of Light, Color," *Richmond News Leader*, April 22, 1979.

95. Quoted in Kent, "The Passionate Gardener," 67.

96. Marsden Hartley letter to Rebecca Strand, late May 1930, quoted in Bruce Weber, *The Heart of the Matter: The Still Lifes of Marsden Hartley* (New York: Berry-Hill Galleries, 2003), 61n263.

97. Bonnard's *The Garden* (ca. 1935) is a gorgeous example of his style. It is now at the Metropolitan Museum of Art in New York, but Nell was not alive when it was acquired.

98. Quoted in Sarah Whitfield, "Fragments of an Identical World," in Whitfield and John Elderfield, *Bonnard* (New York: Abrams, 1998), 28n141.

99. Marla Prather, "Interview with Ellsworth Kelly," in *Ellsworth Kelly: Plant Drawings* (Munich: Schirmer/Mosel, 2011), 213.

100. Letter to Martin Ray, January 28, 1993, courtesy of Martin Ray.

101. Monet's late painting of the land-based garden (*The Garden at Giverny*, 1922–24) has a kinship with Nell's method of indicating depth with bands of different colors that remain on the surface instead of appearing to recede into space.

102. Monet had cataracts; after successful operations on his eyes, he had three years left to paint before his death in 1926.

103. The photographer, Patricia Caulfield, sued Warhol; the case was settled out of court, allowing him to exhibit the ten prints at the Leo Castelli Gallery later that year.

104. *Vanitas* still-life painting developed in the Netherlands in the sixteenth and seventeenth centuries. While most of these works contained images of skulls as markers of the fleeting nature of human life, flowers were one of several symbols of ephemerality.

105. Ray interview.

106. Jed Perl, "New York Diarist," *The New Republic*, May 22, 1995, 42.

107. Diary, October 22, 1994.

108. Martin Ray, "Painter in the Garden—Working with Nell Blaine," unpublished PowerPoint lecture, courtesy of Martin Ray.

109. Diary, January 10, 1985.

110. Author's interview with Lawrence DiCarlo, September 6, 2017.

111. Roberta Smith, "Precisely Cultivating a Lively Garden," *New York Times*, April 21, 1995.

112. Diary, May 8, 1995.

113. Diary, June 22, 1995.

114. Diary, August 6, 1978.

115. Diary, July 7 and July 11, 1990.

116. Author's telephone interview with Dr. Alisan Goldfarb, March 23, 2018.

117. Quoted in John Goodrich, "Nell Blaine," in *Nell Blaine: Sensations of Nature* (Richmond, VA: Marsh Art Gallery, University of Richmond Museums, 2001), 17.

118. Author's interview with Eric Brown, New York, November 8, 2017. All quotes from Brown in these final paragraphs are from this interview.

119. Author's telephone interview with Carolyn Harris, October 25, 2016.

120. Author's interview with Mary Weissblum, Gloucester, Massachusetts, July 25, 2017.

121. Carolyn Harris, "The Story of C," unpublished manuscript, courtesy of Carolyn Harris.

122. Diary, March 22, 1969.

123. Roger Kimball, "Nell Blaine: Paintings and Watercolours 1975–1996," *The Spectator*, December 26, 1998, 93.

124. Letter to Eric Brown, August 21, 1987, courtesy of Eric Brown.

125. For example, in a 2007 show at Tibor de Nagy, Nell's early paintings were priced at $45,000 to $95,000 (with works on paper at $10,000 to $20,000), while most of the post-1960 works were priced from $30,000 to $40,000. Daniel Grant, "Works by Nell Blaine Climb Steadily in Price," *ARTnews*, March 2007, www.art-news.com/2007/03/06/works-by-nell-blaine-climb-steadily-in-price/.

126. Quoted in Martica Sawin, "Nell Blaine," *Woman's Art Journal*, Spring/Summer 1982, 38.

127. John Ashbery, preface to *Nell Blaine Sketchbook* (New York: The Arts Publisher, 1986), unpaginated.

128. Quoted in Durden, "Nell Blaine: The High Priestess of Light, Color".

Bibliography

AAA = Archives of American Art, Smithsonian Institution, Washington, DC.

PRIMARY SOURCES: NELL BLAINE
Interviews

Oral history interview with Nell Blaine, June 15, 1967. AAA.

Janice Ritter McMurray interview with Nell Blaine, 1970 [fragmentary], Nell Blaine Collection, Special Collection & Archives, VCU Libraries.

"Reminiscences of Nell Blaine," 1979. Interview with Anne Skillion. Columbia Center for Oral History, Rare Book & Manuscript Library, Columbia University.

Patricia Barnett Karlsen, "A Portrait: Nell Blaine," June 25, 1985. Original manuscript for *Profiles in the Arts* (Washington, DC: National Endowment for the Arts and President's Committee on Employment of the Handicapped, 1986) with handwritten emendations by Blaine. AAA.

Interview with Eric Brown, October 1990. Courtesy of Eric Brown.

Interview with Martin Ray, September 3, 1992. Courtesy of Martin Ray.

Nell Blaine Diaries and Correspondence, ca. 1947–2002 (MS Am 2658), Houghton Library, Harvard University. [Diary entries cited in the notes as "Diary," with date.]

Published Writings and Public Appearances

Nell Blaine, "Statement," *Credo: Iconograph: Quarterly Supplement*, Fall 1946, 4.

Nell Blaine, "Getting with Lester and Mondrian in the Forties." In *Jazz and Painting.* Exhibition catalogue. Keene, NH: Louise E. Thorne Memorial Art Gallery, Keene State College, 1972.

Nell Blaine, "A Lack of Wholeness," *Women and Art*, Summer/Fall 1972.

Nell Blaine, "The Act of Painting," *Women and Art*, Summer/Fall 1972.

"Is There Still Life in Still Life?" Artists Talk on Art panel discussion, April 27, 1979. AAA.

Typescript of lecture delivered by Nell Blaine at Moore College of Art and Design, Philadelphia, 1980. AAA.

Nell Blaine, "Reminiscence," in Claude Marks, *World Artists, 1950–1980* (New York: H. W. Wilson, 1984).

Archives

Nell Blaine Collection, Special Collections & Archives, James Branch Cabell Library, Virginia Commonwealth University, Richmond, VA.

Nell Blaine Papers, 1930–1985, AAA.

Nell Blaine Papers, Cape Ann Museum Research Library and Archives, Gloucester, Massachusetts.

Other Primary Sources

Daisy Aldan Papers, Harry Ransom Humanities Research Center, University of Texas at Austin.

Donald Allen Collection, Special Collections & Archives, University of California, San Diego, Library.

Oral history interview with Bill Berkson, September 25–October 2, 2015, AAA.

Jack Blanton Collection, Longwood Center for the Visual Arts, Farmville, Virginia.

Edith Schloss Burckhardt Papers, Rare Book & Manuscript Library, Columbia University.

Oral history interview with Rudy Burckhardt, January 14, 1992, AAA.

Oral history interview with Nicolas Carone, May 11–17, 1968, AAA.

Jane Freilicher Papers, 1945–1995 (MS Am2072), Houghton Library, Harvard University.

Jane Freilicher Papers, 1952–1996, AAA.

Oral history interview with Jane Freilicher, August 4–5, 1987, AAA.

Barry Gifford Papers, Department of Special Collections, Stanford University Libraries.

Hans Hofmann Papers, AAA.

Thomas Hess Papers, AAA.

Lilian and Frederick Kiesler Papers, AAA.

Galway Kinnell Papers, Lilly Library, Indiana University, Bloomington.

Denise Levertov Papers, Special Collections, Stanford University.

MacDowell Colony Papers, Box 7, Library of Congress, Washington, DC.

Oral history interview with Elinor F. Poindexter, September 9, 1970, AAA.

Poindexter Gallery Records, AAA.

Theresa Pollak Papers, Special Collections & Archives, James Branch Cabell Library, Virginia Commonwealth University.

Larry Rivers Papers, Fales Library, New York University.

Oral history interview with Larry Rivers, 1968, AAA.

James Schuyler Papers, Special Collections and Archives, University of California, San Diego.

May Swenson Papers, Department of Special Collections, Washington University Libraries.

Robert Wilson Papers, AAA.

Yaddo Records, 1870–1980, Series V. Manuscripts and Archives Division, New York Public Library.

SECONDARY SOURCES

Agar, Eunice. "Watercolor Painting Techniques." *American Artist* 47 (February 1983): 16.

Arb, Renée. "Artists under Thirty: They're Painting Their Way." *Harpers Junior Bazaar,* May[?] 1947, 81.

[Arb, Renee] Unsigned. "Nell Blaine." *ARTnews* 44 (November 1945): 30.

"Art: Paintings of Gardens." *Architectural Digest* 37 (June 1980): 70–75.

Arthur, John. *Spirit of Place: Contemporary Landscape Painting and the American Tradition.* Boston: Little, Brown, 1989.

Ashbery, John. "Icing on the Divine Cake." *New York Magazine,* May 17, 1979, 90.

Ashbery, John. "Interview: John Ashbery, Poet in the Theatre," taped by Roger Oliver, October 1978. *Theatre Arts Journal* 3 (Winter 1979): 15–27.

Ashbery, John. "Nell Blaine." *ARTnews* 65 (April 1966): 14.

Ashbery, John. Preface to *Nell Blaine Sketchbook.* New York: The Arts Publisher, 1986.

Ashbery, John. *Reported Sightings.* New York: Knopf, 1989.

Ashton, Dore. "Shows Feature Nell Blaine and Two Groups." *New York Times,* April 8, 1958.

Barnes, Clive. "Dance: On the Mysticism of Boredom." *New York Times,* March 21, 1967.

Bass, Ruth. "Nell Blaine." *ARTnews* 78 (May 1979): 166.

Beaudoin, Kenneth L. "Young Female Painters." *Iconograph,* Summer 1946, 3–8.

Beem, Edgar Allen. "Drawn to Gloucester." *Yankee,* June 1991, 74–79.

Berkson, Bill, ed. *In Memory of My Feelings: A Selection of Poems by Frank O'Hara.* New York: Museum of Modern Art, 1967.

Berman, Avis. "A Decade of Progress, but Could a Female Chardin Make a Living?" *ARTnews* 79 (October 1980): 73.

Bernier, Rosamond. *Some of My Lives.* New York: Farrar, Straus & Giroux, 2011.

Bertholf, Robert J., and Albert Gelpi, eds. *The Letters of Denise Levertov and Robert Duncan.* Stanford, CA: Stanford University Press, 2004.

Beye, Holly. "Sherry and Art down on Jane Street." *PM,* November 25, 1945.

Boer, Westin. "Gloucester Is the Pull for Blaine." *Gloucester Daily Times,* July 21, 1983.

Bredrup, Elizabeth. "VCU Alumnus [sic] Nell Blaine Returns, Receives Honorary Degree." *VCU Today* [1985].

Bryant, Edward. *Nell Blaine.* Exhibition catalogue, Picker Gallery. Hamilton, NY: Colgate University Press, 1974.

Bullard, CeCe. "A Dance across a Canvas." *Richmond Times-Dispatch*, May 8, 1996.

Burckhardt, Edith. "Nell Blaine: From Richmond, Va., to Athens to the Future." *Village Voice*, December 9, 1959.

Campbell, Lawrence. "Blaine Paints a Picture." *ARTnews* 58 (May 1959): 38–41, 61–62.

Campbell, Lawrence. "Five Americans Face Reality." *ARTnews* 62 (September 1963): 25–27, 54.

C[ampbell], L[awrence]. "Nell Blaine." *ARTnews* 59 (April 1960): 13.

Campbell, Lawrence. "Nell Blaine." *ARTnews* 69 (September 1970): 10.

Campbell, Lawrence. "Nell Blaine." *ARTnews* 71 (December 1972): 10.

Campbell, Lawrence. *Nell Blaine: Watercolors*. Exhibition catalogue. Richmond, VA: Reynolds Gallery, 2001.

Campbell, Lawrence. Preface to *Nell Blaine*. Exhibition catalogue. Richmond: Virginia Museum of Fine Arts, 1972, 9.

Canaday, John. "Pieces of Paper with Beautiful Lines; Other Current Shows." *New York Times*, May 4, 1968.

Canaday, John. "Sparkling Vigor in Blaine Work." *New York Times*, December 2, 1972.

Cochrane, Diane. "Nell Blaine: High Wire Painting." *American Artist* 37 (August 1973): 20–25.

Cohen, Ronny. "Nell Blaine." *Artforum* 29 (Summer 1991): 112.

Cotter, Holland. "Generosity of Everyday Surrealism," *New York Times*, December 15, 2014, C1.

Davis, Stuart. "Autobiography" (1945). In *Stuart Davis*, ed. Diane Kelder. New York: Praeger, 1971.

[de Kooning, Elaine] Unsigned. "Nell Blaine." *ARTnews* 47 (October 1948): 46.

de Kooning, Elaine. "Subject—What, How or Who?" In de Kooning, *The Spirit of Abstract Expressionism: Selected Writings*. New York: George Braziller, 1994. Originally published in *ARTnews* 54 (April 1955): 26–29, 61–62.

Devree, Howard. "San Francisco Artists at the Riverside: Others One by One." *New York Times*, February 16, 1947.

Devree, Howard. "Shows Feature Nell Blaine and Two Groups." *New York Times*, April 8, 1958.

Dickinson, Sue. "Art Dehuminization Irks Ex-Richmonder." *Richmond Times-Dispatch*, October 4, 1970.

Dickinson, Sue. "Nell Blaine Returns to Art." *Richmond Times-Dispatch*, September 11, 1960.

Dickinson, Sue. "Polio Poses No Painting Problem to Richmond Born Artist in N.Y." *Richmond News Leader*, September 18, 1961.

Dickinson, Sue. "Quadruple Artistic Career Keeps Nell W. Blaine Busy." *Richmond News Leader*, November 6, 1952.

Dickinson, Sue. "Richmond-Born Artist Has New York Exhibit." *Richmond Times-Dispatch*, April 24, 1966.

Diggory, Terence. "*Folder* and *A New Folder*." In *Encyclopedia of the New York School Poets*. New York: Facts on File, 2009.

Doty, Robert, ed. *Jane Freilicher: Paintings*. Exhibition catalogue. New York: Taplinger, 1986.

Durden, Sue Dickinson. "Nell Blaine: The High Priestess of Light, Color." *Richmond News Leader*, April 22, 1979.

Edgar, Natalie, ed. *Club without Walls: Selections from the Journals of Philip Pavia*. New York: Midmarch Arts Press, 2007.

Elliott, Margaret. "Young Artists Sweep Uptown on Own Steam: Start Humbly in Village, Now Have Gallery." *New York World-Telegram*, October 6, 1948.

Esplund, Lance. "Truth or Dare." *Modern Painters*, March 1999, 106–7.

Field, Edward. *The Man Who Would Marry Susan Sontag*. Madison: University of Wisconsin Press, 2007.

Finch, Christopher. *Chuck Close: Life*. New York: Prestel, 2010.

Finkelstein, Louis. "New Look: Abstract-Impressionism." *ARTnews* 55 (March 1956): 36.

Fitzsimmons, James. "Art." *Arts & Architecture*, October 1953, 9.

"Five Americans." *Village Voice*, October 3, 1963.

Gallagher, Hugh Gregory. *FDR's Splendid Deception*. New York: Dodd, Mead, 1985.

"Galleries—57th Street Area: Nell Blaine." *The New Yorker*, April 15, 1991.

Gardiner, Ginnie. "Nell Blaine's Wild Space." *Art/News*, April–May 23, 1989, 1, 7.

Gibbs, Alonzo. "The Kinsman Affair." *Long Island Forum*, October 1976, 228.

Gibson, Ann Eden. *Abstract Expressionism: Other Politics*. New Haven, CT: Yale University Press, 1997.

Gifford, Barry. *Landscape with Traveler: The Pillow Book of Francis Reeves*. New York: Dutton, 1980.

Goodman, Cynthia. "Hans Hofmann as Teacher." *Arts Magazine* 53 (April 1979): 120–25.

Goodrich, John. *Nell Blaine*. Exhibition catalogue. Gloucester, MA: Cape Ann Historical Museum, 2000.

Goodrich, John. "Nell Blaine." In *Nell Blaine: Sensations of Nature*. Exhibition catalogue. Richmond, VA: Marsh Art Gallery, University of Richmond Museums, 2001.

Grant, Daniel. "Works by Nell Blaine Climb Steadily in Price." *ARTnews*, March 2007, www.artnews.com/2007/03/06/works-by-nell-blaine-climb-steadily-in-price/.

Green, Barbara. "City Native Pays Rare Visit as Her Art Goes on Display." *Richmond News Leader*, November 20, 1973.

Greenberg, Clement. "Review of Exhibitions of Ben Nicholson and Larry Rivers." *The Nation*, April 16, 1949.

Greenberg, Clement. "Review of Exhibitions of Jane Street Group and Rufino Tamayo." In Greenberg, *The Collected Essays and Criticism*, vol. 2, *Arrogant Purpose, 1945–1949*. Chicago: University of Chicago Press, 1988. Originally published in *The Nation*, March 8, 1947.

Gruen, John. "Five 'Loners' with High Standards." *New York Herald Tribune*, September 22, 1963.

Gruen, John. "Nell Blaine." *New York Herald Tribune*, April 9, 1966.

Alan Gussow, *A Sense of Place: The Artist and the American Land*. San Francisco: Friends of the Earth Foundation, 1997.

Henry, Gerrit. "Jane Freilicher and the Real Thing." *ARTnews* 84 (January 1985): 78–83.

Henry, Gerrit. "Nell Blaine." *Art in America* 73 (November 1985): 223.

Henry, Gerrit. "Nell Blaine." *Art in America* 81 (December 1993): 107.

Henry, Gerrit. "Nell Blaine at Fischbach." *Art in America* 67 (September 1979): 134–35.

Henry, Gerrit. "Nell Blaine at Fischbach." *Art in America* 71 (November 1983): 223.

Henry, Gerrit. "New York Letter." *Art International* 14 (November 1970): 72.

[Hess, Thomas B.] Unsigned. "Homage to Nell Blaine." *ARTnews* 58 (December 1959): 34–35.

Hess, Thomas B. "U.S. Painting: Some Recent Directions." *ARTnews Annual* 25 (1956): 75, 81.

Hirsh, David. "Paint, and an Open View." *New York Native*, May 1, 1989.

Housley, Kathleen L. *Tranquil Power: The Art and Life of Perle Fine*. New York: Midmarch Arts Press, 2005.

Hu, Winnie. "Disabled New Yorkers Face Trouble with Curbs." *New York Times*, October 9, 2017.

Hughes, Allen. "Midi Garth, Aided by a Small Group, Performs Dances." *New York Times*, December 9, 1963.

Hunnewell, Richard F. "Callahan, Blaine, Leigh, Villiet, Vagliono." *Art/World*, April 17–May 17, 1985.

Joyce, Fay S. "I.R.S.'s Lithographic Challenge." *New York Times*, May 17, 1983.

Kahn, Wolf. "Hofmann's Mixed Messages." *Art in America* 78 (November 1990): 189–91, 215.

Karp, Ivan. "Portrait of an Artist with a True and Tender Sensibility." *Village Voice*, April 18, 1956.

Katz, Leslie. Introduction to *5 American Painters*. New York: M. Knoedler, 1963.

Kaufmann, David. "James Schuyler's Specimen Days." *Jacket 2*, June 20, 2012, http://jacket2.org/article/james-schuylers-specimen-days.

Kent, Rosemary. "The Passionate Gardener: Nell Blaine." *Countryside*, November/December 1992, 66–71.

Kenyon, Paul B. "Remarkable Nell Blaine." *North Shore Magazine, Gloucester Daily Times*, September 17, 1977.

Kernan, Nathan, ed. *The Diary of James Schuyler*. Santa Rosa, CA: Black Sparrow Press, 1997.

Kertess, Klaus. *Jane Freilicher*. New York: Harry N. Abrams, 2004.

Kimball, Roger. "Nell Blaine: Paintings and Watercolours, 1975–1996." *The Spectator*, December 26, 1998, 92–93.

Kramer, Hilton. "Down on Jane Street, Brilliant Painters Formed Cooperative." *New York Observer*, July 21, 2003.

Kramer, Hilton. "The Triumph of Nell Blaine, Underappreciated Genius." *New York Observer*, December 1998, 1, 36.

Kroll, Jack. "Jane Streeters." *Newsweek*, September 23, 1963.

Kunitz, Daniel. "Nell Blaine: The Abstract Work." *New Criterion* 19 (April 2001): 49–50.

LeGendre, Lyn. "Poet Marge Piercy, Painter Nell Blaine Combine Talents on 'A Book of Days.'" *North Shore Magazine*, August 16, 1990, 1, 4.

Lehman, David. *The Last Avant-Garde: The Making of the New York School of Poets*. New York: Anchor Books, 1999.

Lipman, Jean, and Cleve Gray. "The Amazing Inventiveness of Women Painters." *Cosmopolitan*, October 1961, 62–69.

Lisle, Laurie. *Louise Nevelson: A Passionate Life*. New York: Summit Books, 1990.

Longaker, Jon D. "Blaine Works Shown Here." *Richmond Times-Dispatch*, September 9, 1962.

"Longwood Features Art Work by Blaine." *Rotunda* [Longwood University, Farmwood, VA], January 9, 1963.

Ludington, Townsend. *Marsden Hartley: The Biography of An American Artist*. Boston: Little, Brown, 1992.

Mainardi, Patricia. "Nell Blaine." *ARTnews* 75 (Summer 1976): 180, 181.

Mason, Mary Moore. "Richmond Artist Plans Studio in Greece." *Richmond News-Leader* (no date on clipping; probably spring 1959). Blaine Collection, VCU.

Mauner, George. *Manet: The Still-Life Paintings*. Exhibition catalogue. New York: Abrams, 2000.

McCullough, Judith. "The Legacy of Cape Ann: Generations of Artists Drawn to Its Shores." *American Art Review* 6 (February–March 1994): 88–97, 156.

McDonagh, Don. "Midi Dances Old and New Works." *New York Times*, April 29, 1969.

McGee, Micki. *Yaddo: Making American Culture*. New York: Columbia University Press, 2008.

Mellow, James R. "The Flowering Summer of Nell Blaine." *New York Times*, October 11, 1970.

M[ellow], J[ames] R. "Nell Blaine." *Arts* 34 (April 1960): 54.

Mellow, James. "Nell Blaine" (tribute for her memorial service, January 1997). In *Nell Blaine* (Gloucester, MA: Cape Ann Historical Museum, 2000).

Merritt, Robert. "Reynolds Show Reveals the Poetry of Blaine's Artistic Soul." *Richmond Times-Dispatch*, May 3, 1992.

Munro, Eleanor [E.C.M.]. "Nell Blaine." *ARTnews* 52 (September 1953): 50.

Munro, Eleanor. *Originals: American Women Artists*. New York: Simon & Schuster, 1979.

Naifeh, Steven, and Gregory White Smith. *Jackson Pollock: An American Saga*. New York: Clarkson Potter, 1989.

Nell Blaine. Exhibition catalogue. Gloucester, MA: Cape Ann Historical Museum, 2000.

Nell Blaine: The Abstract Work. New York: Tibor de Nagy Gallery, 2001.

Nell Blaine: Artist in the World—Works from the 1950s. New York: Tibor de Nagy Gallery, 2003.

Nell Blaine: A Glowing Order. New York: Tibor de Nagy Gallery, 2012.

Nell Blaine: Image and Abstraction—Paintings and Drawings, 1944–1959. New York: Tibor de Nagy Gallery, 2007.

Nell Blaine: Night and Day. New York: Fischbach Gallery, 1991.

Nell Blaine: Oils, Watercolors, Drawings. Richmond, VA: Reynolds Gallery, 1996.

Nell Blaine: Recent Oils, Watercolors, Drawings. New York: Fischbach Gallery, 1995.

Nell Blaine: Recent Paintings. New York: Poindexter Gallery, 1972.

Nell Blaine: Selections from the Arthur Cohen Collection. New York: Tibor de Nagy Gallery, 1995.

Nell Blaine: Sensations of Nature. Richmond, VA: Marsh Art Gallery, University of Virginia Art Museums, 2001.

Nell Blaine Sketchbook. Preface by John Ashbery. New York: The Arts Publisher, 1986.

Nell Blaine: Watercolors. Richmond, VA: Reynolds Gallery, 2001.

Oaks, Martha. *Marsden Hartley: Soliloquy in Dogtown*. Gloucester, MA: Cape Ann Museum, 2012.

Oaks, Martha. "Painting the American Scene on Cape Ann and along the Shore." *American Art Review* 29, no. 4 (2017): 48–53.

Oshinsky, David M. *Polio: An American Story*. New York: Oxford University Press, 2005.

Panero, James. "Exhibition Notes: Nell Blaine, Artist in the World: Works from the 1950s." *New Criterion* 22 (May 2003): 47–48.

Pavlouskova, Nela. *Cy Twombly: The Late Paintings, 2003–2011*. New York: Thames & Hudson, 2005.

Perl, Jed, ed. *Louisa Matthiasdottir*. Reykjavik, Iceland: Nesútgáfan Publishing, 1999.

Perl, Jed. "Matthiasdottir in Full Color." *New Criterion* 12 (May 1994): 49.

Perl, Jed. "Nell Blaine." In *Nell Blaine: Recent Oils, Watercolors, Drawings*. New York: Fischbach Gallery, 1995.

Perl, Jed. *New Art City: Manhattan at Mid-Century*. New York: Vintage, 2007.

Perl, Jed. "New York Diarist." *The New Republic*, May 22, 1995, 42.

Perl, Jed. "The Porter Paradox." *The New Republic*, October 2, 2000, 31–37.

Perl, Jed. "The Shows Must Go On." *The New Criterion* 6 (September 1987): 57–66.

Peyser, Joan. *The Music of My Time*. New York: Pro/Am Music Resources, 1995.

Porter, Fairfield. "Nell Blaine." *ARTnews* 55 (May 1956): 51.

Prather, Marla. "Interview with Ellsworth Kelly." In *Ellsworth Kelly: Plant Drawings*. Munich: Schirmer/Mosel, 2011.

Preston, Malcolm. "Joyous Impressions." *Newsday*, July 31, 1974.

Preston, Stuart. "Diverse Openings." *New York Times*, September 20, 1953.

Preston, Stuart. "Gallery Variety: Triple Showing." *New York Times*, April 29, 1956.

Preston, Stuart. "A Tour of Variety Fair; Whitney Retrospective[;] A Realist Quintet." *New York Times*, September 22, 1963.

Preston, Stuart. "Vitality Marks Frank's Work, at Peridot." *New York Times*, October 28, 1954.

Price, Reynolds. *A Whole New Life: An Illness and a Healing*. New York: Scribner, 1994.

Proctor, Roy. "Blaine Memorabilia Add Depth to Reynolds Show." *Richmond Times-Dispatch*, April 29, 2001.

Proctor, Roy. "'Green Thumb': Blaine's Vibrant Colors Grow." *Richmond News Leader*, May 1, 1992.

Reamy, Lois. "Interests Fostered in Richmond Spell Success for Richmond Artist." No newspaper name or date on clipping; probably summer 1956. Blaine Collection, VCU.

Reinhardt, Ad. "How to Look at Modern Art in America." *PM,* June 2, 1946.

Rice, Linda. "Beauty, Not Protest, Termed Function of Art." *Richmond Times-Dispatch,* November 10, 1973.

"Richmond Native, Victim of Polio, Is Flown to New York from Greece." Clipping with no identifying information, [October 1959]. Blaine Collection, VCU.

Rivers, Larry, with Arnold Weinstein. *What Did I Do? The Unauthorized Autobiography.* New York: Thunder's Mouth Press, 1992.

Roffman, Karin. *The Songs We Know Best: John Ashbery's Early Life.* Farrar, Straus & Giroux, 2017.

Rorem, Ned. *The Later Diaries of Ned Rorem: 1961–1972.* New York: Da Capo, 2000.

Rosenzweig, Phyllis. *The Fifties: Aspects of Painting in New York.* Washington, DC: Hirshhorn Museum and Sculpture Garden, Smithsonian Institution Press, 1980.

Rubinstein, Charlotte S. *American Women Artists from Early Indian Times to the Present.* New York: Avon, 1982.

Safran, Rose. "Nell Blaine's Art Is Inspired by Her Garden." *North Shore Magazine,* July 6, 1989, 5.

"St. Lucia Scenes on Show in N.Y." *Voice of St. Lucia* [West Indies], April 9, 1966.

Samet, Jennifer Sachs. "Painterly Representation in New York, 1945–1975." Ph.D. dissertation, City University of New York, 2010, http://jennifersamet.com/pub/pdfs/large/dissertation.pdf.

Sandler, Irving. "In the Art Galleries: 5 American Painters." *New York Post,* September 22, 1963.

Sartwell, Marcia, and Robert Ruffner, eds. *Profiles in the Arts.* Washington, DC: National Endowment for the Arts and President's Committee on Employment of the Handicapped, 1986.

Sawin, Martica. "Abstract Roots of Contemporary Representation." *Arts* 50 (June 1976): 106–9.

Sawin, Martica. "Good Painting—No Label." *Arts* 37 (September 1963): 36–41.

Sawin, Martica. "Nell Blaine." *Woman's Art Journal* 3 (Spring/Summer 1982): 35–39.

Sawin, Martica. *Nell Blaine: Her Art and Life.* New York: Hudson Hills Press, 1998.

Sawin, Martica. "New Work by Nell Blaine." In *Nell Blaine: Night and Day.* New York: Fischbach Gallery, 1991.

Schuyler, James. *The Diary of James Schuyler.* Santa Rosa, CA: Black Sparrow Press, 1997.

Schuyler, James. *Just the Thing: Selected Letters of James Schuyler.* New York: Turtle Point Press, 2009.

Schuyler, James. "The View from 210 Riverside Drive." *ARTnews* 67 (May 1968): 36–37, 73–74.

Scott, Martha B. "Virginian Nell Blaine Has 33rd Solo Exhibit." *Richmond Times-Dispatch,* May 16, 1976.

Sheffield, Margaret. "Nell Blaine, Gwen John." *Art/World,* April 18–May 16, 1981, 1, 11.

Shirey, David L. "Nell Blaine's Cheerful Palette at the Parrish Museum." *New York Times*, July 21, 1974.

Sieberling, Dorothy. "Women Painters in Ascendance." *Life*, May 13, 1957, 74–77.

Silver, Julie, and Daniel Wilson. *Polio Voices: An Oral History from the American Polio Epidemics and Worldwide Eradication Efforts*. Westport, CT: Praeger, 2007).

Smith, Roberta. "Art in Review: Nell Blaine—'The Abstract Work.'" *New York Times*, March 2, 2001.

Smith, Roberta. "Nell Blaine." *New York Times*, April 5, 1991.

Smith, Roberta. "Nell Blaine, 74, Painter Who Blended Styles." *New York Times*, November 15, 1996.

Smith, Roberta. "Precisely Cultivating a Lively Garden." *New York Times*, April 21, 1995.

Smithberg, Madeleine. "Nell Blaine." *Art/World*, May 1983.

Soussloff, Catherine M. "Nell Blaine: Essay from Interview." In *Virginia Women Artists: Female Experience in Art*, ed. Patricia Mathews. Exhibition catalogue. Blacksburg: Virginia Foundation for the Humanities, 1985.

Spring, Justin. *Fairfield Porter: A Life in Art*. New Haven, CT: Yale University Press, 1999.

Steinberg, Leo. "Month in Review: Contemporary Group at Stable Gallery." *Arts* 30 (January 1956): 46–47.

"St. Lucia Scenes on Show in N.Y." *Voice of St. Lucia*, April 9, 1966.

Sultan, Rosie. "Nell Blaine's Paintings Recapture Gloucester's Past." *Gloucester Daily Times*, [2001]. Cape Ann Museum and Archives.

Swenson, May. *Nature: Poems Old and New*. New York: Mariner Books, 2000.

Tallmer, Jerry. "At Home with Nell Blaine." *New York Post*, March 9, 1977.

Tallmer, Jerry. "Inciting a Riot of Color." *New York Post*, March 31, 1989.

Temin, Christine. "Blaine Exhibit Reevaluates a Big Talent." *Boston Globe*, August 23, 2000.

Tillim, Sidney, "Nell Blaine." *Art Digest* 29 (November 1, 1954): 23.

Van Gelder, Pat. "Close to Home." *American Artist* 54 (February 1990): 28–35, 69.

Wagner, Charles A. "World of Art." *New York Mirror*, September 22, 1963.

Weber, Bruce. *The Heart of the Matter: The Still Lifes of Marsden Hartley*. New York: Berry-Hill Galleries, 2003.

Weber, Nicholas Fox. *Leland Bell*. New York: Rizzoli, 1986.

Whitfield, Sarah, and John Elderfield. *Bonnard*. New York: Abrams, 1998.

Wight, Frederick S. *Morris Graves*. Berkeley: University of California Press, 1956.

Wilson, Robert A. "Encountering Auden in an Obscure Mountain Village." *W. H. Auden Society Newsletter* 15 (November 1966), http://audensociety.org/15newsletter.html.

Wilson, Robert A. *Seeing Shelley Plain: Memories of New York's Legendary Phoenix Book Shop*. New Castle, DE: Oak Knoll Press, 2001.

Zaferatos, Olga. *Painting the Still Life*. New York: Watson Guptill, 1985.

Index

NOTE: Many artists and other individuals whose full names are listed in this index **are identified only by their last names in the text**, because they are well known or because only the last name is mentioned in a quote.